NOTEBOOKS

VOLUME 1: 1998-1999

THE
SEAGULL
LIBRARY OF
GERMAN
LITERATURE

ANSELM
KIEFER
- - -
NOTEBOOKS
VOLUME 1: 1998-1999

TRANSLATED BY TESS LEWIS

LONDON NEW YORK CALCUTTA

GOETHE
INSTITUT

This publication has been supported by a grant
from the Goethe-Institut India

Seagull Books, 2019

First published as Anselm Kiefer, *Notizbucher, Band 1, 1998–1999*
© Suhrkamp Verlag, Berlin, 2011

First published in English translation by Seagull Books, 2015

English translation © Tess Lewis, 2015
Notes to the English Edition © Seagull Books, 2015

ISBN 978 0 8574 2 704 5

British Library Cataloguing-in-Publication Data
A catalogue record for this book is available from the British Library

Typeset by Seagull Books, Calcutta, India
Printed and bound by WordsWorth India, New Delhi, India

NOTEBOOKS
VOLUME 1: 1998-1999

8/3/98

8.30 P.M. after a certain period of time. what is this 'certain period of time'? according to the files, it's been a good two years since i last wrote anything much, amazing my fingers can still find the right keys, even if a bit hesitantly. what prompted me to turn on my laptop were thoughts about continuing work on my mosaic, now called les reines de france, 560 x 750 cm.[1]

15/3/98 sunday

8.40 P.M. seven years, what kind of time span is that? seven years, by then you're already in school, have been for at least a year. there's also the cursed seventh year and the replacement of cells every seven years. and the flying dutchman comes ashore every seven years, seven-armed candelabras, etc., etc., etc. and this laptop has been in use for seven years now. in use, it's more than that. everything i've written in the past seven years is in it. strange, as if it were a being seven years old, but not like a seven-year-old typewriter, that's nothing, because this has a memory, a memory that spans seven years—yes, the memory's there but it's a memory only for certain things that were typed in. and this memory belongs to no one, is at no one's disposal. seven years, that's not a short time. but oh, so little has been written here. a mere fraction of all that happened in those seven years . . .

on sunday, continued work on the picture with the tesserae (560 x 750 cm). started that a few years ago, too: gluing small stones as a special act, as an actuality, something that makes time pass. something you don't (shouldn't) think possible: that something should slip in, slip out, slip away. a short-circuit, for example, taking literally the word 'sand' in 'märkischer sand'.[2] the individual parts, the tesserae, the special technique by which the whole consists of individual parts. vermeer, for example, the many grains on the canvas. today the spaces between them would be filled in with colour, jointed, so to speak. that makes it morbid: the colour inserted between the tiles and smeared on them. in the places where the tiles have been painted over, it looks like the tiles have fallen out, thus an annulment of the mosaic—a mosaic that has lost its tiles.

A MOSAIC THAT HAS LOST ITS TILES

the question that has preoccupied the painter today is: how many tiles can be lost before it's no longer a mosaic? at the very top right, too many tiles seem to be missing in one spot, there's only some kind of base layer. and something else, but that's not what we want, we want something specific, but what is 'something specific'? what is 'something'?

SOMETHING SPECIFIC

something is a hollow mould. 'doing something' can mean anything, something can contain everything. is there anything that doesn't fit into something? yes! nothing. something can be anything except nothing. and so as it applies to the mosaic: some kind of base layer on which anything can happen is not what we want. we want to remove from the mosaic only the exact number of tiles that will let it remain something specific. because when all the tiles are left on the mosaic, then it's a specific mosaic and not 'something specific. a specific mosaic is limited, it can be described and classified, for example, you can count the tiles and so on. . . . but something specific is a particular thing and it can't be classified so easily. a few tiles have to remain in very specific spots so the rest can be added—in one's head. and only there can the rest, all the tiles that were lost or removed, be added, and, in fact, added more quickly than with the most powerful computer. it's the same with relics, you've got only one nail left of the cross, just a lock of hair from this or that saint. the rest is secretly present. the rest is secretiveness.

SECRETIVENESS

a truly romantic mosaic is one that is missing as many tiles as
possible.

26/4/98 sunday

summary of contents, on the occasion of the publication of the book 20 years of solitude by éditions du regard, made in new york in 1993 at 20 east 20th street.

summary of contents

the book's actual contents is dried human semen, ejaculated by the author onto individual pages on successive days. this is both the book's material contents (because the individual honey-yellow spots are visible) as well as its virtual contents if you consider the million-fold unrealized possibilities contained in a single drop of this dried fluid.

this virtual aspect of the 'contents' gives rise to a whole series of reflections that are connected to the following themes:

the legend of lilith (the hag from the apocrypha of the old testament) with the codex juris canonici (above all, the ban on condoms); then tannhäuser's pilgrimage to rome and his condemnation on charges of sexual debauchery;[3] additional themes are time, represented by the craft of bookbinding, then the relation to time that occurs in a book, to time in life (one's lifetime) with particular consideration of the end of a lifetime, the final *end*. and, closely associated with it, the idea of waste, the spillage of semen and letters, which leads in turn to reflections on the relationship between matter and mind.

the book's very first page, before i even had the idea of the ejaculations, reveals an obvious horror vacui. because it's not a book

that was conceived first from its contents and bound after the pages were printed. it was already bound and: empty. through a process of automatic writing, he tries for 16 pages to put something in the empty book. only then does a structure, a rhythm develop, the external stimulation coming entirely from waiting for the next ejaculation, then waiting for the same to dry. this delay elicits reflections on art, time and authenticity. there is, for example, a ponderous consideration of how the procedure might be simplified. you could ejaculate on unbound pages and then bind them together after they've dried, so that you wouldn't have to wait an entire day for every page until the particular ejaculation is dry. this faster procedure, however, is not acceptable because it would give rise to doubts about the project's authenticity. these considerations overflow into the problem of a medium's authenticity, of the virtuality of wars, etc., these considerations are concluded with a sentence adapted from the Polish national hymn: 'As long as one still lives who squirts his seed into a real book, all is not lost.'[4]

these reflections are constantly grounded, so to speak, when they are associated with allusions to the book's technical and material production. for example, the way the thread surfaces in certain sections of certain pages and then disappears again. on p. 96, it says: 'when it's all done, the thread with which the book is bound emerges the way blossoms bloom again on the severed branch.' (the branch was first mentioned on p. 12.)

or, on p. 120 it says: 'if you untie the thread's knot, it's finished for the book, just as the millions of possibilities in dried sperm within the book are finished.'

6

another example of how enormous concepts like destiny, fate, art and life are handled in the most metaphorical way is on pp. 184ff. there is an account of the ejaculate that was intended for p. 184 (= destined, destiny or fate) but, squirted too far, missed the book and landed on a photograph that happened to be lying there and so had nothing to do with the book. this spatial 'miss' is seen from this point on as the part of life that passes alongside one's work on a book, a painting, etc., as that which isn't transformed into the book, painting, etc. on p. 190, there is even a mention of jealousy for that which occurs alongside the painting or book. in other words, of the discrepancy between art and life.

pp. 190–215 are about the unborn, a more malleable description of the endless unrealized possibilities. snow falls upon the unborn. under the snow, the unborn turn into letters, thus into another kind of unborn.

from p. 246 to the end of the book, the only problem discussed is how to conclude. just as earlier there was the question of how to begin, now the question is how to end. namely, because at the start there was no content for which a vessel had to be found but, instead, a vessel (the empty book) that needed content, it's entirely possible that the content, once found, is larger or smaller than the vessel. in the end, you could also say that the book remained empty because the contents didn't fit.

23/5/98 (?) sunday, in any case

11 A.M. was in the auvergne, a day's drive there, stayed one day, drove home on the following day (yesterday). the many colourful dots of the flowers in mind, yellow, blue, white, red, the fields doused with yellow, white, the word 'doused' isn't right, since there were individual dots. what was special, what was enchanting about this splendour that resembled the splendour of a morning after a night's snowfall, when everything is transformed, everything is white? it's no doubt the case that an extreme transformation, a catastrophic upheaval occurred that precipitated this shock and elicits questions, leads you to search again for words after such a long time. far beneath these keys. these flowers, as numerous as the stars in the firmament.

STARS FLOWERS BENEATH THE KEYS

for two weeks there has been a poppy field on the ribotte[5] as well, for the first time.

28/6/98 Corsica

Strange dream, but not so strange if you look at it as a variation of a basic pattern. Which basic pattern? The pattern of tears, spread out rather evenly (as is the case in a pattern) over the ribbon of life. What are tears made of: salt → mild electrolysis. Where do they come from? Always from the same realization— that there is no correspondence between what is desired and what is gained. Or better: nothing is 'gained', there is no kingdom (no praised land, no Promised Land). The journey has no goal. But now, before it's stretched too far, the dream: from earlier, with my parents (and siblings?) in our car, new, its paint gleaming. A few parts were raised, glued on, but not just spattered with dirt, rather they were either intentional irregularities or random blemishes made when the car was painted. There was talk of whether the car should be returned because flawed. . . . It's not clear to the dreamer what the significance is of the cramped, airless atmosphere from back then, always experienced as a flawed situation and utterly present in the dream, as if you'd been plunged back into that frigid situation with all its parameters. In the midst of this indigestible stew an event occurred which is the reason for even recounting the dream: a girl from somewhere else was visiting—it's not clear who she was but she could have been someone like, say, Catherine Fontaine. This girl was probably a friend of the dreamer's sister and therefore temporarily integrated into the family unit, therefore trivialized. Nevertheless, she came from elsewhere and would only be staying a short time. This girl was the object of desire. And the fact that she was 'approachable', that she lived with our family, didn't diminish the desire. On the contrary, it strangely exacerbated the longing. The spatial proximity itself—the fact that the

9

dreamer could see her as often as he wished—the very banality of it all made the impossibility of reaching her only more painfully obvious. There was no bridge between the triviality of daily togetherness—the airless, even despised family situation—and the marvellous openness beyond it, embodied by this girl. Or perhaps, put a different way: this girl was not a way to the other. She was merely a representation of it. Back to the dream: one day, the dreamer saw the girl sitting in the car with his sister. Both were in front, the girl in the middle (back then, front seats were still one continuous bench), the driver's seat was empty. A wonderful, utterly impossible situation. The dreamer as driver; the girl next to him. But how to get there. Even the question of which route to take was difficult, because he hadn't spoken much with his sister. And since the situation was set (they were ready to leave and were only waiting for the driver, surely some-one in the family), it was possible that something marvellous might happen—if the dreamer were to take the wheel. And yet: the appearance of the girl was *also* a sign of *impossibility*. More exactly: by appearing, the girl also disappeared. Appearance was disappearance. Is that right? Or is it not rather the case that her appearance remained because there was no reality to it? What was it you wanted then? To drive away with her. And then what? To be with her. And then? There was no prospect of reassurance. Even more: through the classification (the attempted classifica-tion), there was both the marvellous (the unknown girl) and the hollow reassurance of the trivial (the cramped family situa-tion). What exactly was triggered by this image of the unknown girl? Why the tears? They were only partly the tears shed in front of the closed gates on the Rue du Faubourg St Honoré, because they were trivial. There, the walls were immaterial.

Where, exactly, is the aporia here? The fact that the dreamer didn't speak to the girl, didn't approach her, can't be explained by shyness (precisely not), it was something else: what he saw and what caused his tears was just the semblance of what he wanted (desired), and, because he realized this, he made no attempt at all. He knew that the semblance of what he saw didn't originate from what he desired.

29/6/98 tuesday

11.20 A.M. just one day left in this quarter. away for four weeks in scotland, in madrid, in the alhambra, in valencia, then in paris, then in corsica.

in orkney, on the island with balfour castle, the garden with the flowers and other edible plants. surprising on the windswept island. but protected by high walls. an island, so close to the sea and so far away, there the garden becomes a sign of survival, there you can see its possibility in the walls around the garden. there everything is over when the wall falls, just as everything is over when one's head falls. still, when heads are chopped off, walls don't fall. because one's head isn't necessary for the wall to remain standing, but walls surrounding the garden are essential to keeping one's head.

1/7/98 wednesday

7.30 A.M. what else was there in scotland? the park, the trees, the water at night in skibo castle.[6]

11.15 A.M. in the park at night in scotland: surrounded by water, under a canopy of tall trees that seem to be reflected in the water at night. then clearings with wet grass as room for several particularly tall trees. the park, never completely forest, even where the trees grow more densely, around the lake, for example, never artificial yet never simply natural. considered chance.

CHANCE CONSIDERED

they sank ships in orkney after the war. you can still see a few sticking out above the surface of the water at low tide. there are tours to show divers the ships under water. the ships are a hundred times more interesting underwater than when you can simply board them for a tour. under the water's surface, everything is made secretive. even marriage (the frog prince, for example, or the city whose bells toll from the depths of the lake). trip in 1991 through the GDR shortly after its dissolution, when the experience was compared to driving around the perimeter of an empty reservoir. in other words, where the magic line of the water's surface was erased. where what had long been hidden lay exposed to daylight. lay, in the actual sense of the word.

DRAINED RESERVOIR SPEECH ABOUT GERMANY

2/7/98 thursday

9.40 A.M. the meadows in the park in scotland.

3/7/98 friday

6.35 P.M. writing down the time at which entries are made is as pointless as recreating the floor plan of each hotel room you stayed in while travelling. there might be a point to indicating an entry's date, but the time? it makes no difference later if this or that was written in the morning or in the evening. because before anyone ever, anyone ever, anyone ever might read it, it will have to be read through and reordered. that's clear. and so it makes no sense to write the time, just as it makes no sense to draw the layout of a particular hotel room. if you do, then others say: there's nothing to draw, anyway nothing it would be essential to draw, because you wouldn't take the time (valuable time if you consider the end) to draw up such floor plans if you could find anything better to do. so you draw up these plans to have at least something for a later time, because what remains then??

HOTEL ROOM FLOOR PLANS

you don't know how to draw the essential, so you simply draw what is most superficial (or, you could say, what is most external), what is the least binding, the least essential: you draw the room's layout by hand. and just as some objects suddenly become important for no obvious reason—like sand or dirt in a particular part of your home country or some piece of cloth—so these floor plans of old hotel rooms become fetishes. is this true? a fetish is always associated with a smell, an idea, a longing, something unfulfilled. a photograph of an old hotel room could become one, but a floor plan . . .

FETISH *

a floor plan is not a photograph. a map of a region is not a land-scape. and yet there is an odd connection between a landscape and its map, as you can see, for example, when you fly over it in a plane (or, even better, in a helicopter). when you fly over a land-scape that you've known for a long time, with all its details, and in which particular objects have associations, etc., when you fly back and forth over a landscape like that at different altitudes, you're moved by the interplay between a landscape and its map, because looking at a landscape from above is like looking at a map of it, and yet not entirely, because there are things in it that are not on the map, real things, potential fetishes. and now, with the hotel room floor plans, how does it work with them?

LANDSCAPE—FLYING OVER—MAP

in a hotel-room floor plan all you see is a diagram, without any emotional or mythological connotations. and that's why such plans are so useful, because they indicate a distance between the incident referred to (the trip) and its depiction. a distance that can't be measured, endless, curious, that's why it's best to locate these hotel room floor plans in the starry skies since everything is already endlessly distant there.

all this isn't what had been intended to be written when the lap-top was opened but, instead, something about scotland and the parks and the water, the water in which ouroboros and behe-moths swim.[7] the water that encircles the world is not accessible to our senses. the ophites.[8] the veil between god and his cre-ation, a veil of water, of 'higher waters' in jakob boehme's words,

or, you can also say, if you want to remain in water: since the time of the great flood, men have been prisoners of the sea, of time and of space. when the soul in its incarnation has crossed the sea with ouroboros, it descends along the orbits of the seven planets and on this journey everything becomes worse: venus, for example, imbues the soul with extravagance, mercury with miserliness, jupiter with vanity and so on. . . . then, after death, when the soul re-ascends, it must traverse these seven spheres again,[9] and it can only accomplish these difficult crossings if it knows the words and signs = gnosis. only those who still know the secret word for the karfunkelfaerie on the golden bridge will pass. but i must tell you, it melted away with the last traces of snow in the garden. a grain of ice in his beak, he will survive the summer.[10]

10.40 P.M. the new garden this year on the west slope of the hill. seen from here now, with all the plants growing, the beans, the eggplants, the peas, etc. . . . the field now also appears in a different light than it did last fall.

how it all takes shape.

5/7/98 sunday

5 P.M. sometimes you turn your laptop on for no reason. and turning it on isn't the same as sitting down in front of a blank sheet of paper or a typewriter. once you've turned it on something moves, the drive whirs, alerts appear then immediately disappear, leaving an empty space on which you can write (of course, you can't write on this field, because this field is only a sign, no, not a sign, because its emptiness is the opposite of a sign, what is this 'field', actually? it's the surface onto which you can assemble signs and symbols gathered from the depths).

at the same time, these characters are not stored as signs but as data. when the process is finished (drive, signs as data, etc.), then you have to look for what you wrote last in order to continue where you left off, only then . . . and so you find yourself caught up in a stream of activity before you've done a thing, before you've come up with a single thought worth writing down—turning on the computer supplants thought, as is obvious from this page: without any reason to turn the laptop on or anything to write down, almost an entire page has been filled.

ABSENCE OF THOUGHT

back to scotland: on that island in the orkneys with the castle and flower gardens behind it. the blossoms' special glow, the wonderful way the colours ignite in the evening light, the colours of the lupins, the roses, the pale, ashen green wind that ruffles this fully stretched-out carpet . . .

the word 'ash' must be disconcerting here, as are the last few awk-
ward lines in general, but there's a reason 'ash' appears here,
because blossoms are plants *in extremis*, in plant life this is
especially evident up north where they stand out (or: jump out)
from the levelling fog that glazes everything with grey.

ASH-FOG FLOWER

for a plant, blossoming is so intense, it dies from it. the plant
incarnates itself as fully as possible, actually even beyond the
possible, so that it's consumed in the effort. thus the image of
ashes and before that the exhibitionism, already even a hint of
self-destruction in the release of the flower's perfume, consider
the store of dried roses in the attic.

in general, people like flowers very much, there are lots of flower
shops and you can have them sent anywhere. there's a reason.
we feel a bond with the dying flowers because we have the sense
that they're dying for us.

THOSE WHO DIED FOR US

you buy a bouquet and place this spectacle (offering) on the
table. it becomes an altar, a sacrificial altar.

it's a still life. every true still life contains this drama, this extrem-
ism. *still life is exciting.*

skulls are often included in floral still lifes. but they're not at all
necessary.

STILL LIFE

the still lifes that will soon take shape have a direct connection
to last year's brick paintings or paintings of ruins.[11] creation and
death in the factory. when the brickworks caught fire (compare
the burning, the incineration of plants when they bloom, wither),
when it caught fire and the brickworks were completely burnt
down, the stones became material for a new building.

7/7/98 tuesday

9.50 A.M. before scotland was auvergne. the photographs arrived
today. the photos are always so inadequate compared to what
took place. you have to assemble so much. They're flat, not pale,
you could also say: poor, impoverished, but they do help, they are
holy helpers.

HOLY HELPERS

they're like the holy helpers, those faded statues of auxiliary
saints that were placed in the window to guard against rain and
thieves. but how do they actually help? they help find paths on
the way to a painting that won't have any connection to nature
or to the photographs themselves once it's finished. the thin
structure captured in the photograph sparks the painting. par-
ticularly now, before one reaches for any materials or tools. as a
catalyst or a focal point? as if it were a substance, lead, for exam-
ple? you look at it for a long, long, long time, and after you've
called to the material long enough, an answer or something else
that had been enclosed inside it emerges. is the photograph
such a substance? not exactly, because with lead, for example,
you've got something in your hand, a counter-part, and sand runs
through your fingers and forms a covering layer and then dunes,
it settles onto something. but a photograph? a photograph has
no substance (is not a substance), and yet it sets something in
motion, it unleashes something. it leads to something. it's like
the substance that spoke to you, one already chosen. this sub-
ject, this landscape, this section, you didn't choose any of them
by chance.

NOT BY CHANCE

lead, sand, straw . . . they do not speak by chance.

but a photograph doesn't speak. it neither speaks intentionally, nor by chance, it doesn't speak at all. what does it do then? it offers a prospect.

OFFERING A PROSPECT

it says: this is a departure point, maybe you can give it a try. if you accentuate this and that, if you bring out this and that, this path, barely visible in the photograph, these two lines that meet, the yellow flowers scattered in the foreground and the way they condense into one yellow stripe in the background, like a band of poisonous fog. therefore you don't question too deeply, you don't listen too closely to the call (a photograph doesn't call), but you begin manipulating, rearranging. you've got a point of departure and you've made a start, because you've chosen a section. still, you can't linger there, because it isn't calling out to you. as soon as you do linger, you become indifferent, increasingly indifferent, and soon you're disillusioned. a photograph, then, is an illusion. because at first you believe you've got something complete, or at least in progress, but you haven't even got a promise in your hand, since a photograph promises nothing. (consider the photographs of the installations in buchen that looked so wonderful that some people even wanted to recreate in the amsterdam museum the original installation that served as the basis for those photographs.)

with a substance like lead, you start from an assumption of abundance, an abundance of meaning, and this abundance calls to you, and, when you manipulate this substance in certain ways, it calls forth even more; a photograph doesn't speak to you at all. on the contrary, it's eloquent in its very meagreness. it's diaphanous, thin in its poverty. it emits no call but you still manipulate it, 'work on it,' you don't want to leave it as it is, so transparent, so invisible, so insignificant. that's what's decisive: you don't want to let it remain so insignificant. with other substances, such as lead, the significance is already there before you. you need only find it.

so: with your materials, you must be receptive to their call, but you must bring something to photographs. for example, no one bestows meaning on lead (it already contains meaning), but you have to give meaning to a photograph: it doesn't have any meaning initially.

8/7/98 wednesday

11.50 A.M. a large hole was dug in the woods. when the excavator drives through the forest with a raised bucket, it looks like a swaying tower crashing through the undergrowth. why do people like to move earth so much? there's no particular thought involved. where is the spirit of clay? is it a substance like lead, etc.? clay has been imprinted with characters. naturally, but: no matter what kind of material you're using, whether you're digging a hole that will eventually be filled with water or creating a mound of earth or a ditch (not a ditch, a grave), what is it to move masses of earth? or when lava flows down a mountainside or an avalanche of enormous boulders thunders into a valley (pakistan, hunza valley). what is the strange sense of satisfaction one feels when masses of earth shift? when new roads are constructed, streets, etc., valleys, etc., etc., etc.?

9/7/98[12] thursday

12.40 P.M. the colour photographs with artificial tones will be reworked with chalk and titanium white. the colours must be broken, they're only hues, the word 'colour' no longer applies. it's just multi-hued, drably colourful.

12/7/98 sunday

12 NOON. why can't you simply paint these flowers? the photo-graphs from scotland, from auvergne, from la ribaute[13] have been developed. why do you always need more? because you think. why do you think? why can't you just let them be? but be how? just leaving them as they are isn't a solution because you don't know exactly what 'as they are' means. as soon as you come into contact with these flowers (through sight, touch or smell), the process inevitably begins: the questioning, spurred by the indeterminacy of longing.

LONGING

you would like to cool this indeterminate, consuming, boundless emotion by thinking, and so you begin to question. although this questioning is equally boundless (it may well get caught in the same endless loops that emotions do). but the process of ques-tioning and the resulting answers create a skeletal structure which you can't claim about this emotion. this 'structure' is merely provisional, of course, because there is no end to the questioning, a new question lurks behind every answer. in this play of questions and answers you can't make any real progress (can you make progress with emotions?). you don't advance, as it were. why then, you ask yourself, why do these flowers put you in a certain state? why can't you just leave them as they are? why not simply paint them as they are, as if trailing behind them, following them, tracking them. why reflect on this, when these reflections themselves seem illusory? yet what should you do? you cannot exist without flowers. flowers lead you into this vicious circle, with no way out. of course, you can come up with

justifications for the painted flowers. that each one has a corresponding star in the sky.[14] that they are consumed in their blossoming. that their blossoming is a climax. that they then expire but are transformed once they've passed through the extremity of blossoming, etc., etc., etc. these are a few reflections that should explain why you paint flowers. because it's a way of saying: one cannot exist without flowers.

ONE CANNOT EXIST WITHOUT FLOWERS—VANITAS

when you see such a field of red poppies: the meadow drenched in red, in this very particular shade of red, almost everyone finds it attractive. and it is irresistible, addictive. you drive thousands of kilometres to see one, then another, and if possible to find one even more beautiful. you sow a field with poppies and one day discover that the field has turned red, has covered itself with this shade of red. and you'd like to hold it fast, preserve it, to preserve the flowers in this extreme state. that is the moment you say you'd like to paint them. and then you realize it's not so easy. this must be explained.

4.10 P.M. it's strange: you're not working, there's no painting in progress, in other words, nothing is making any demands of you, requiring discipline, etc.

and this condition is weightless, floating, unsettling, hardly believable, a state of being. no, it's not actually a state of being but, rather, an aimless hovering, also a feeling of becoming ever lighter, of emptying out, yes, a flowing out, this must be how it feels when you slit open your veins in a bathtub. what's strange about this sense of being drained is that you'd expect to experience it in the

opposite case, namely, while engaged in a large-scale project, one that is very demanding. but that's just it: when you're working, when it 'flows', you don't think about it all, perhaps you don't even have any feelings then, at least none that you're conscious of. rather, you've a sense of climbing. of climbing upward, you hope. you fall down again and again, yet that happens without thought. and now this pause, when suddenly everything seems possible again, when it seems that each idea could run in many directions. when everything is open, and yet you know that almost nothing is possible, that, on the contrary, you'll have to exert all your strength, intelligence, cunning to find an escape route. but while pausing, especially when the pauses are of long duration (as the entire time since my return from scotland, almost three months now), then everything still seems possible. precisely because of the many possibilities, there is no path to follow, only blank spaces remain, as in a salt desert. the lavishness of the desert.

13/7/98 monday

9.15 P.M. many bright flowers on the floor, the colourful painted photographs like a patterned carpet. there are simple formulas for the poppies, the roses take a bit longer because they have a different structure. the rapeseed stalks are new. there are also the irises and daisies, as well as courgette blossoms.

went out in the courtyard earlier because of the sky and the mountains. a gathering storm and the sunset created an especially dramatic effect of the light. happened to glance at the remains of a messerschmitt plane and went over to it. these few remains exerted a strange attraction. you can, in fact, still see a small piece of the control stick with bits of wire attached. but what about it, exactly, makes you want to linger? after all, the thing has been sitting here for several years. it was even in a picture. it was too direct for the painting, too complete. and yet, it's just 'complete' enough without a painting to form an imaginative unity. if there were more to it, or if it were whole, it would be too much (as is evident in museums). one could also express it thus: the remains of the plane create a space in the observer in which it can achieve full expression—and 'full expression' includes all attendant implications and connotations. yet there is something else that can't be expressed through connotations. perhaps you should approach the problem this way: first ask yourself what you've heard about these planes. battle of britain, etc. can you find something in these pieces of metal that will provide a point of departure, a focal point, for everything you know about it, especially everything that you've forgotten but that is still there. however, next to this plane wreckage, such knowledge doesn't manifest itself as knowledge but as feeling. the knowledge, all the knowledge associated with such

planes mutates into emotion. like the conversion of elements in extreme conditions. or is a feeling, rather, already present as you acquire this knowledge, by reading accounts of air battles, for example, which suddenly achieves full force at the sight of the wreckage. neither the one, the transformation of knowledge into emotion, nor the other, the release of an independently accumulated emotion through knowledge, is completely correct. there must be something between the two.

17/7/98 friday

7.30 P.M. what kind of a day is it (if you think in days at all), when there's no one here, when everything is quiet and you're reading something light, the newspaper, for example (newspapers are always light. why? because they refer to things currently taking place, topics that don't require a long time to enter into, that have a certain parallelism, so to speak. something happens and you read about it in the newspaper almost simultaneously). what, then, have you just read? if someone asked you what you read? about the president of germany, that he does want to serve a second term if elected. about the world cup in soccer and that the french government wants to use it as an occasion to grant citizenship to more foreigners than before. after all, there were foreigners on the french national team who played well. and much more that you can't remember. you read these things then with some interest, because if you had no interest you wouldn't have read them. and yet, they left no trace. also read some gottfried keller: a village romeo and juliet. and ingeborg bachmann's franza. what traces, in turn, did the latter leave? self-aggrandizement through the stripping bare of suffering. nothing is 'exalted' in the poetry, instead there is a breaking down of categories, nothing 'becomes', nothing is shown. what is in the poetry (what has come to a standstill) is subject to a different gravitational pull, a return to what is indisputable. a return to its original space, to shelter . . . ?

franza is suffering, a personal suffering, suitable for a history wall. or also suffering caused by history and become personal and then written on the history wall. a pedagogical suffering, so to speak, entirely believable, authentic.[15] look here, i cannot bear

it. is a poem devastating? no, but something very like it and yet different. elevating? (sursum corda, lift up your hearts) it's the right word but it can't be used because it's been used so often already. the poem causes our world to shrink. it's the counterpart of tzimtzum.[16]

TZIMTZUM

in tzimtzum, when the world was created, a space was cleared, a space distinct from the absolute to give the world (our world) some room. the poem causes our world to shrink again, that is, it gives space back to the infinite (ein sof). the notes from the desert in franza create space in our world. anything and every-thing happens in this space, suicide, murder, suffering . . . nothing occurs in the poem. pseudoreality prevails.[17]

PSEUDOREALITY PREVAILS

18/7/98 saturday

4.20 P.M. is it already time to write? for whom the bell tolls. the cock crows for each at his appointed hour. you could also start up the laptop frivolously, without having a reason for writing and, of course, you can also just as easily miss something that would have been important to note down. and no one really knows if it's more the one case or the other. one time you find you've written down something that seems superfluous, another time you didn't write down something essential. on the other hand: is there such a thing as 'something superfluous'? if something has occurred, can it truly be called superfluous?

ARE THERE SUPERFLUOUS THINGS? MISSED THINGS?

and if something hasn't happened, can it be considered something missed? because something missed is something that hasn't occurred, but can nothing be something? is something missed nothing? isn't it, rather, some thing, namely, *that* which has been missed, some clearly delineated thing? you think you know what it is you've missed (a train, for example), but with writing it's not the same as with a missed train. because if you fail to grab your laptop when you should have, then you'll never know what you would have wanted to write. that's precisely the problem, that you never know exactly if it would have been essential to sit at the computer. the slightest spur can lead to something important. what appears vitally important can turn out to be almost nothing. you say: 'almost' nothing, knowing full well that there is no such thing as nothing as long as anything whatsoever has been written. the greater can be the lesser and the lesser the greater. as the sophists teach.

33

SOPHISTS

and then of course you're up against big terms like 'wasted life'. when you talk about something that you missed writing down, you immediately and inevitably associate it with missed opportunities in life, with a wasted life. literature is full of these, whether business travellers or kings, towards whom, all of a sudden, forests begin to move (yes, well, can someone towards whom forests move really have missed out on something . . . ?)

WASTED LIFE

with the expression 'wasted life', it's the same as with writing that wasn't done: you have to know what you've missed out on, otherwise you can't speak of missed opportunities. because what has been missed is not nothing, it's something, namely, it's that which you've missed. in other words, you've made the wrong decision, specifically, the decision that led to missing out. there's also the expression 'an empty life,' but that, again, is difficult because is a life of missed opportunity an empty life? the substance of such a life lies in the missed opportunities, the substance is the precondition for the missed opportunities. or, even better, the substance's function becomes clear only through what has been missed. if nothing were missed, there would be no substance. a banality, at best, if it were anything at all. just as life would be nothing without death, or at best banal. what missed opportunities are to a life's substance, so is death to life.

missed opportunities (examples: cf. 68, etc., etc.) are the precondition for the marvellous empty spaces that have grown and, with time, will be described.

EMPTY SPACES

20/7/98 monday

1.10 A.M. there was a point this afternoon, while painting the yel-
low flowers, when there was a reason to write something down,
something that came to mind while painting the flowers but was-
n't directly related to the flowers, therefore couldn't be painted
but could be written about. now, however, it's gone, forgotten.
the laptop was then turned on, no doubt to see if there were any
traces of what had been forgotten. once it's clear there are no
traces, it will be turned off again.

21/7/98 tuesday

8 P.M. glued photographs onto various formats, for example, 190 x 560 cm, 190 x 280 cm, a number of them, and started going over them without being drawn to them at all, in fact even finding them unpleasant, unattractive, leaning against the wall so flat, colourful, mute. processed material. why does the smoothness repel you so much? best to describe what it is with negative assertions, in other words, by describing what it is not, what it can't do. but all these 'nots' don't have a repellent effect. they are evocative.

and so went over them without élan, without any excitement, without response, without without without without. and that's occasionally the source of wonderful things. this state is sometimes overcome in the strangest ways—overcome is not the right word, because you don't resolve to overcome it, it's simply that you allow a state that is utterly 'without' to persist, but you don't let it persist by doing nothing, rather by acting as if you must do something that's not explicitly necessary. got past these photographs' ugliness by painting over them. they're so ugly and without any prospect of occasioning something beautiful. and yet, precisely this situation could be connected to the empty spaces already described.

25/7/98 saturday

1.35 P.M. four cats are sitting around the laptop and they some-
times step on the keyboard, with unexpected results. for exam-
ple, all the text might shift to the left, so that only half of it
remains visible and it's impossible to undo it without turning the
laptop off and starting again. but they can just as easily delete
entire sections, because, given enough time, everything possible
will, in fact, occur. as it does in geological periods when, inciden-
tally, as is well known, everything that can happen does happen.
because the time spans are long, and since cats also don't
measure time in years, everything can happen with them too. so
that in the end there could be nothing left on the laptop. they
could finally erase everything and not write anything new. thus
the contents in the laptop would diminish, rather than increase,
would be constantly simplified, according to the law of entropy.

2.20 P.M. a meadow, 190 x 560 cm, on a colour-photograph
background of the auvergne, a meadow with yellow flowers and
another, in the same format, with red poppies. it's not so easy
with the predominant red, in terms of surface area, red does not
predominate because there aren't so many poppies in the fore-
ground, where the red, that particular shade of poppy red seems
to have been poured out, poured out, poured out. of course,
there are just as many flowers in the foreground as in the back-
ground, but in the background all the poppies are wedded into
one, one, one single red. therefore, when you paint the entire
canvas red, then you've got a shade of red, or even the red of
the poppies, but not the poppy field. the poppy field is something
other than the red of the poppy flowers. so why then don't you
want to portray that red with multiple layers, to give it a real,

expressive shade of red, then it could be labelled poppy red. you already did that in the books from the 60s. but that was something else. for example, with the red, that was seen by a bomber pilot as a burning city. it was an arbitrary little swatch of red stuck on a page in the book. it was a free, a very free act, an example of effortlessness, omnipotence.

26/7/98 sunday

1.35 P.M.

10 P.M. turning the device off. why was it turned on?

27/7/98 monday

5.10 P.M. two photographs of fields in the auvergne (190 x 280 cm and 190 x 560 cm) painted over. so that now they're clearly a soft, flower-filled meadow. the light red petals lie on a richly coloured grey, actually emerge from it, since they're already contained in the grey. the same colours evident in the petals swimming on the expanse of grey are also visible within the grey although in a different arrangement. it's a beautiful meadow. and why is it there? above all, why ask this question. you ask this question because you've already seen and painted real poppy fields. but faced with real ones, no one asks why they're there. shouldn't we also ask 'why?' about a canvas representing this poppy field. we ask the question because we'd like something more than just the field again. added value.

ADDED VALUE

29/7/98 thursday

6.05 P.M. don giovanni in aix-en-provence. a young orchestra—
all between 22 and 28 years old, the conductor is 22. sat right
next to the orchestra pit and so could see into it. the musicians
talking to one another, fooling around. the conductor sometimes
disappeared when the orchestra wasn't playing, when it was just
the singers, you couldn't see him but you could tell by the
flautists' facial expressions that he was staging some practical
joke. of course the musicians were playing for us, the audience,
but they were there together: they were playing with one another
and for one another, they were amusing themselves. a strange
experience you have had before. something else is developing:
the sense of being at once attracted and excluded. there's no
sense of exclusion without a sense of attraction, and, without a
sense of exclusion from the object of attraction, there's no allure.
the wonderful music, the young people, a few of whom were evi-
dently infatuated with each other and so there were lines con-
necting the musicians you could only guess at. these lines you
couldn't cross, you were shut out from these interactions for sev-
eral reasons: because of age, the clear division of the orchestra
pit and because you're not here to look at the musicians but to
listen to the music (this is all very incompletely expressed). but
it especially needs to be expressed with situations in which there
are these kinds of connections. for example: st ulrich, family,
F. slightly different in this and in similar situations. then it wasn't
a matter of being excluded by ties between others but by the
inaccessible objects themselves. because in the case of the
musicians yesterday, it wasn't so much that the individuals them-
selves were 'inaccessible' but that the ties connecting them
formed a closed system.

30/7/98

2.35 P.M. about the streams on the ribotte: if you turn right imme-
diately after the gate, after about 20 m, you come upon a small,
lead-roofed hut housing the pump that draws water up from a
depth of 220 m. this water is fed through pipes approximately
300 m to the east, where it drains into the lake. there's another
pump in the lake. the newly planted trees, the olive trees, the
fruit garden, the greenhouse, the vegetable garden on the south
side of the hut and the large vegetable garden to the west (not
far from the entrance to the pump station). this pump in the lake
also feeds the two ponds below the hut as well as the two forest
ponds to the west. and so it's an extensive network of waterlines.
it's strange how you can get water through so many detours. the
water that reaches the large vegetable garden, for example, has
had to cover the entire stretch over the hill to the lake and then
back up the hill and down again to the vegetable garden. there's
another watering system on the property—the well by the hut, for
example, from which water is drawn to irrigate the fields of irises.
also the water from the roof gutters that's collected with the
water from the larger farm and fed into the same chute as the
water from the sandy soil around the water basin. the overflow
from the pool also runs through these channels, so when it rains
a large quantity of water comes in from different areas. just a
few weeks ago, this water was flowing through the woods (in fact,
it had created a small riverbed), now it's drained through an
underwater pipe into a new forest pond from which it subse-
quently flows, when the pond is full, through the woods and onto
the property in the same place it had ended up before, thus sev-
eral detours have been created in order to preserve the water a
bit longer and use it in a wide variety of applications. it's like the

sensation of going through a labyrinth. you know there's an eas-ier way, but you make your way through the labyrinth and that delays you. but only with such a delay do you finally sense how you're suspended between everything. you sense your existence. the labyrinth forces you to linger. if there's nothing that can make you linger, then you're certain the way you've chosen is the short-est, and that's something only someone who knows what he wants can do. he who knows what he wants never goes through a labyrinth. he who always knows what he wants has forgotten his existence.

LINGERING IN A LABYRINTH = EXISTENCE

the water here is channelled through ditches and pipes, other-wise it would do what it wants, namely, choose the shortest way. it took a few years to study how water takes the shortest path, even finding the shortest way in heavy rainstorms = destruction. dams were always built in such areas or waterfalls formed into which the water pours because of gravity and from which it's drained through pipes into collection points. as a result there's almost no place where the water can take the shortest path. sometimes it even goes back to its starting point, that is, where it pours out, the surplus is collected in drainage pipes under ground that then empty into ditches that lead to the lake and from there, where, indeed, it's mixed with other water, it is pumped into the irrigation pipes. therefore, when you're standing in a spot where you hear trickling or where it's oddly damp, then you know you're standing (lingering) in a place connected through an extensive system of detours. you linger because of the connection with detours.

DETOURS

31/7/98

10.40 A.M. where are you when you do the various yoga poses? with each pose there's a particular relation to space, to particular geometric figures, in which parts of the body delineate a part of the figure and the rest must be filled in. for example, in the pose in which you raise a leg perpendicular to the prone body, the leg is one side of a rectangle. the leg creates a space at the same time as it is this space, it feels the weight and holds it up. in holding up you're immediately also holding out, ec-sisting. each of these exercises, of these poses is holding, is holding out (moses' outspread arms at the slaughter, moses holding that pose until night fell). each of these poses creates its own space that doesn't depend on any other, greater, space, one that isn't next to, over or below another. it is in each case a space and nothing else. and each of these spaces only lasts as long as it's held. then, again, back to nothing. all these exercises are intended to defy the usual laws like gravity, direction, etc. for example, the one where you sit on the ground with your legs extended and then wrap one leg over the other and twist your body so that your head is facing the opposite direction.[18] this way, you're stretched in two different directions so that you melt, flow or, to put it differently, you consist only of a line that extends in these two, unbounded and opposite directions.

4.20 P.M.

4.35 P.M. sitting with my laptop, waiting. for what? what differentiates this waiting from waiting for a train or a flight? in both cases, you wait until something arrives. In the case of waiting for something to write, the waiting is already a part of what is to be

written down. because something is already 'at work' while you wait, which could end the wait. in the case of waiting for a train, something is also at work—the locomotive. however: is the locomotive working on shortening or ending the wait? it seems as though the locomotive has nothing to do with my wait. that isn't so certain because of course, in a particular way, the train is connected to my wait, in a particular way the train consists of my waiting.

WAITING

but what exactly does 'waiting' mean when referring to sitting in front of a laptop? you're not actually 'sitting in front of' it but lying in bed with the laptop on your lap. it was clearer with the old typewriters. then you really did sit in front of it. but now, whether you're sitting or lying, it doesn't change the waiting. perhaps it's more a matter of biding one's time? of course, this expression makes the difference with the train more clear because you don't bide your time until the train comes. biding your time, you're not as directly bound to the awaited object because you don't yet know exactly what you're waiting for. Rather, you focus on the things that appear, even if only indistinctly and occasionally out of context. but something does appear, and you bide your time until something more distinct appears. when that's the case, what are the things that appear hazily and with which you bide your time? isn't writing in general a biding of one's time? you write down this or that, some of which could well have waited longer. you write and bide your time. you write while you wait. it's usually the same with creating pictures. you paint while biding your time. you execute something on the canvas and some of that changes over the course of time, but you still bide your time,

still proceed hesitantly, you're still reluctant to act decisively. all the paintings in the containers, on the platform. all those paintings wait while the painter bides his time until he has found out what the paintings are waiting for. in this case, 'waiting' is the right word. the paintings wait, they don't bide their time. but their wait is yet another kind of waiting than our waiting for a train. do they know what they're waiting for? or should the painter know that already? they seem to possess the faculty for waiting, because when you pass them they call out, they place themselves in a context, break away, demand something.

PAINTINGS WAIT

6.10 P.M. in a few minutes you'll practice yoga again. one hundred minutes twice a day, and an additional hour of breathing exercises and walking in the countryside. so the pictures have a lot of time to wait. is it necessary to have time to wait? or better: must you take the time to wait? yes, because if you don't take the time, nothing will develop. that you've learnt from experience. the ability to bide one's time.

if you can't bide your time, you're not equal to events. then you won't see what's occurring in the painting or what's happening outside it or what might enter into it after a period of testing through waiting.

2/8/98 sunday

6.05 P.M. while breathing, the sensation of your ribcage as an
ever-expanding space. expanding without taking over the space
around it. expanding without connection. and so, not only was
your lying on the ground suspended (you no longer felt the pull
of gravity, the body's weight on the surface below it) but also the
sense of taking up room, in the sense of defining a particular
space (as described in the position with the raised leg forming
one side of a rectangle). nothing more happens. thus dissolution
through expansion.

DISSOLUTION THROUGH EXPANSION

thought about how you could evoke that in a painting. there are
enough ribs in a vault of red-fired terracotta. you could construct
a space, a chest (rib cage) with them. an implied space in the
universe. the problem of representing expansion could perhaps
be solved through the disproportion between the small rib cage
and the picture size.

3/8/98 monday

4 P.M. it's been cooler for three days. the water in the pool is still 28° celsius, so still warm. strange how this autumn air (of course, it's not autumn yet but the significant temperature makes you think it is, it would be more accurate to say late summer), how this autumn air, then (late summer air is not the right term since it has other connotations) carries so much more with it, contains more, is richer than the simple, scorching summer air. heat makes the air thin, empty, free of everything, just heat, no longer containing anything floating, moving or indeterminate.

LATE SUMMER

in addition, especially swimming in the pool, where the water has cooled a few degrees but is still warmer than the air above. lingering in the water is borderline unpleasant, but, because holding your head out of the water keeps you constantly aware of the comparison between the water and the ambient air, you stay in the water longer. you feel more suspended in the water than you do out of it, and this feeling of suspension comes from two things: first, the summer's heat is, as everyone knows, stored for a time in water, in lakes and in the sea because water is a heat reservoir; and second, this state between hot and cold (late summer temperatures) is a suspended one, or you could also say a sustained one, but suspended is a more complex concept because the thin, still air is itself a state of suspension. it's no longer a state but a movement, a transition. it's a transition in which you once again feel the past and passing bits of heat. they vanish like the snow in march.

the remaining heat, suspended in the water is pure luxury. precious in its impermanence. that, rather than the chill of the outside air, is the real reason you stay in the water longer. you want to feel the warmth again, now, in its state of suspension. because that's where it's most present, that's where it abides in its extreme possibility. and that is where you want to seek them, the bits of heat, in their utmost possibility. you don't want to linger in those conditions. you don't want to linger in any conditions, not even in the heat of high summer. you want to be in a state of suspension, in extremity, and what do you do there? you let yourself—and with water the meaning is literal—be supported. the utmost possibility supports you.

how can you establish a connection between this and 'i hold all india in my hand'? because these belong together: bits of late summer heat and the hand that holds all india. the connection is, on the one hand, one of water, because parts of india swim in water, as is well known, or are surrounded by water. but that isn't enough, because there are bits of late summer heat elsewhere too. they're also in the air. there must also be another, 'deeper' connection. also, the state of all india is one of suspension insofar as it's held in one hand.

I HOLD ALL INDIA IN MY HAND[19]

you can also express it metaphorically: holding all india in your hand is a luxurious state. an extreme one, one that is already past (moreover, before you've even formulated the thought), like the suspension of heat in the late-summer pool.

8.45 P.M. and so the warmth is either almost gone or completely gone when you feel it in the water. in fact, you've already said goodbye to summer, to heat. you're in advance with your farewell. time isn't linear. just as you can hold all india or let it drop. just as the prophet isaiah sees grass growing over cities. so we have three sentences circling one another: another late summer—over your cities grass will grow—i hold all india in my hand.

4/8/98 tuesday

1.15 P.M. the pool is now 27 degrees. one degree cooler each day. you don't go in the water as easily. you have to turn off your biological contingency, that is, you have to master yourself. whereas on previous days you slipped into the water as into a dream, now it couldn't even rekindle the ashes of a previous day's fire. why do you even go into the water—you no longer need to be cooled off so that you're no longer heavy.

5/8/98 wednesday

11.25 A.M. the pool is 25 x 10 m, one half—it's divided along the length—shallower, starting at zero—where the sand ends—and dropping within 5 m to a depth of 50 cm up to the line dividing the pool's two halves, at that point it drops perpendicularly along the centre under the part in which you can swim. the outlet for heated water is on the bottom in the middle of this half. when you swim over it, you can feel the stream of water before it quickly disperses. you feel a wonderfully warm stream, especially in the morning when the air is still cold. the source of this warm stream would be hard to determine if you couldn't see the outlet through the clear water, because it's not a definite stream, it seems to change direction. sometimes it feels warmer to the left, sometimes more to the right, sometimes more in front than behind. it's a very vague, changeable, ephemeral manifestation of heat. and that's what makes it so attractive, as attractive as the fleeting remains of heat in late summer or early autumn. it wafts towards you and is immediately gone again (carousel). it's a memory of heat. you could linger over the opening through which warm water is pumped, but you don't, you just swim past because you only want the memory, the memory of heat and nothing else. the remembered heat is different from real heat. it's a suspended warmth. swimming over the warm stream (and not lingering there) is, paradoxically, a way of fixing the heat (because, compared with current experiences, memories are 'fixed' or at least preserved. and so, in always passing over the warm spot, you favour the fixed over the flowing. a 'pass' becomes a 'preference'. when a pass becomes a preference, you trade experience for memory.

of course, it's also the case that in this particular line of inquiry, it would be impossible to linger in the warm water and thus to experience (instead of simply recalling) it, because you'd have to linger in that particular spot while swimming and so couldn't remain exclusively in the warm stream. and although the water is concentrated when it comes out of the outlet, it dissipates unevenly, and so it never remains warm in one and the same spot. instead, the warm spots fluctuate within an area the width of a hand's breadth. you can never know exactly where the warmest stream is at any point.

1.26 p.m. taking up where the entry left off earlier today (this isn't always the way it goes, hardly ever, in fact, usually it's about another subject once time has passed): when you arrive alone in a big city (paris in the 1960s) and stay there for a certain period of time, at least two weeks, you end up taking the same paths out of habit, paths that feel familiar. you think you know the city. the idea of the warm stream or current applies here too, although with qualifications—but let's skip the qualifications for now—here too we have, so to speak, a 'cold', unfamiliar sea of streets in which there are a few warm currents, but in this case the warm currents are set, you could draw them on a map. the so-called warm currents increase over time (as you get to know the city) but they don't change their course. on the other hand, you can slip from a warm stream into a cold one. if you don't pay attention on your walk, you suddenly end up 'at sea'.

6/8/98 thursday

4.25 P.M. time to write until five. but now, for reasons that can't be explained, it's time to go for a swim.

4.50 P.M. where did the thought go? the one that would have been written about between 4.25 and 4.50, in other words, during the time spent in the pool?

the sun draws lines with the water on the cement wall that rises about 3 m above the water's surface. the water is slightly ruffled. when you swim, more active lines appear on the wall. they're interesting, like lines on a monitor. for example, on cardiograms, seismographic charts, detectors, etc.

the ruffled surface of the water draws its waves on a smooth, perpendicular wall. the same (or just similar?) lines are drawn on the bottom of the pool. when you look at the bottom through your goggles, you can see them clearly. they are as enigmatic as the one on the wall. you swim from west to east and back again. when you swim towards the east, you see your shadow underneath you or cast at a slant in front of you, because at this time of day the sun is behind you. you can't see the entire shadow, because the water's surface around you is disturbed by your motions. all the more strange that you can see your hands drawn clearly on the bottom of the pool but the rest of your body is blurred. your hands are the foremost part of the shadow picture and thus distinct, the swimming body moves through all the lines, breaking them with a wave. around the body, the lines are undisturbed in their active, significant, ineffable movement. remarkable, these lines. you almost always see waves on the

water wherever there is water but rarely the lines they draw. and yet it's a simple physical phenomenon: the deflection of light rays according to the laws of physics. and when there's a wall, they appear on it. there are no walls on the open sea. but they break, and are lost????????????????????????????

BREAKING RAYS OF LIGHT IN THE POOL

the rather weak streams in otherwise cold water, created by the jet of warm water, correspond exactly to yellow light in the snow . . .

as on christmas cards: a chapel in the snow, lit from within. the warm yellow light, represented by the small rectangle of the window against the blue light of the snow. this cold blue light is everywhere, and in the middle of it this small square island. the tiny heat that only becomes a special heat when surrounded by ice.

7/8/98 friday

NOON. shortly before 12 a few lines added to the previous day's entry because the contents fit and there wasn't time to finish writing yesterday. exactly eight lines.

ku-li: the empty spaces that predate time are emerging ever more clearly. in various locations in donaueschingen, villingen, ottersdorf,[20] etc., etc., etc., etc. it's not so much the empty spaces that are defined by locations but emptiness as such, over the course of one's early life; events that didn't occur in your lifetime or, rather, events that occurred alongside you. for example, 1968. now completely different empty spaces are called up by yoga positions and the empty space of the chest cavity, defined by the ribs and the act of breathing.

and yet, as the term 'called up' makes clear, these are intentionally created spaces whereas those empty spaces that predate the time you began writing are a kind of tzimtzum.

TZIMTZUM

are these places filled when you describe them? when you convey their smell as far as possible, their expanse if possible, their 'emptiness'??? but empty is still empty, what's there to say about it? actually, there must be something to say about it, because they're not nothing, after all. yet they're not simply vessels either, because vessels are made to be filled and to contain something whereas these empty spaces from an earlier time are not intended for anything at all.

EMPTY SPACE IS NOT NOTHING, NOR IS IT A VESSEL

nor is it a vessel. although one can fill the special spaces I've been writing about. in fact, they even seem to be created in order to be filled in later, after a time, but of course you knew nothing of this at the moment of their formation—although, and this distinction must be made: you didn't even have the word 'empty' in mind. but the feeling of emptiness was always present. examples: looking at the ceiling, looking at the carpet (stripes), waiting through long sunday afternoons, long winters, long summers, long evening . . . rays of sun shining through closed shutters (and many more).

with regard to taimtaum you could also say that at the time everything was occurring alongside you, the space necessary for all that is meant to occur now was created.

3.25 p.m. what kind of time is this: just before half past three? in winter, it's the time just before evening when darkness has begun to fall. at least you know that at this time it will be dark soon. but not in summer, in summer it's still the middle of the day. is that better?

8/8/98 saturday

5.35 P.M. it's odd sometimes: after so many pages about empty spaces, a notice arrived in the mail about another empty space: ripuaria house in freiburg.[21] a picture from 1924 (twenty-fifth anniversary). the photograph shows a side view of the house, from which you later, in '66, '67, could no longer see that there were other houses surrounded by trees. otherwise it's the same, from 1924 to 1966 isn't such a long interval. forty-two years, exactly, so not much longer than from 1966 to today.

what do the empty spaces have to do with this postcard? my time in that student association was long ago.

EMPTY SPACES RIPUARIA HOUSE

nothing happened there. the other members are all forgotten. it's not quite accurate to say nothing happened, there were the long nights and the mornings afterwards in the mountains. there was the building at 20a lower mühlenweg which you could see from the house. so you can't say that nothing happened there, but those were empty spaces insofar as it all didn't happen at the same time. the night rides from the house to 20a lower müh-lenweg were all unreal insofar as they played out like an old musical score: welcome and farewell, my heart beat fast, a horse! away! quicker than thought i am astride . . . etc.[22] old score is not the right word. because the performance of a score is not something unreal. weren't you a part of it all? it's just now that you're not. you took part much earlier, namely, with your first reading of the poem. the transformation of the poem into a living painting was a virtual process. of course, the excitement was

there, but it was summoned from a distance. the meetings in the house were empty. you could just as well have done something else. it didn't concern you. it was the wrong place for you and so, for you, an empty place. there were long bike rides with no particular goal, past rows of houses, through fields, up mountains. for hours. now and then, 'actualizing' a poem from another time. travelled by train to lucerne with A.B. one day, a bit like don quixote. back then it was chivalric novels. only they had less action, almost none, in fact. admittedly, there were occasionally flashes of intense presence. for example, the ontology lecture by a professor named schmidt, the second fall of parmenides, then the list of women (also as if taken from a novel, or, rather, from an opera) that counts as one of the empty spaces, because the list was never anything more than a list.

9/8/98 sunday

5.05 P.M. have already written 31 pages today but under yester-
day's date, because the subject matter fits there. it was about
where you can find empty spaces and how you can represent
them. these thoughts were sparked by a slight shock occasioned
by something in yesterday's mail: the postcard of a house on
schlierbergstrasse in freiburg, schliebergstrasse, where you once
lived, a time that left an empty space behind, now waiting to be
filled. it will be filled by being described, just as the void left
behind ein sof from which the world was created. or, in a differ-
ent cultural context: entry into the empty space left by the dis-
appearance of the gods who protected us.

this empty space to be described doesn't appear at all elevated,
but more like a caricature because it has remained empty
through obtuseness, laziness, provinciality, etc. this, as it were,
vulgar development of the theory upturns the saying 'you can't
teach an old dog new tricks'. exactly what is meant by empty
space has still not been said.

EMPTY SPACE

the distances covered with no particular goal, for example, the
hours spent walking through streets lined with chestnut trees,
through valleys, in the mountains, the hours spent sitting around
with others which you hadn't intended. why does all this fall
under 'empty space'? because it was dark, adrift, unconscious,
expectant? because no decisions were made? is it romantic?
definitely not, because it lacked a context. nothing was con-
nected to anything else, as soon as two things are connected

you can no longer speak of an empty space. then you speak of interval, like the size difference between an electron and the atomic nucleus, which is an enormous one, proportionally that of a football to a football field.

INTERVAL

11/8/98 tuesday

3.15 P.M. a light is blinking on the telephone keypad, which means that someone is ringing at the gate to enter and make a delivery. at first you don't react, because everything's closed up and all the staff are on holiday, so no deliveries or mail are accepted. no one's here, so you don't pick up the receiver to ask who's there. the ringer is turned off in any case, only the light is blinking and you can't turn it off. and you wouldn't have noticed the light if you hadn't happened to be lying in bed with your computer on your lap. no, the laptop wasn't on your lap when the light flashed but you had a book in your hand and you took your laptop in hand or, better, onto your lap, only after you had something to write about the blinking light, specifically, that the longer it blinks, the more you think you probably should ask who's there after all. the message indicated by the flashing light seems to grow more important the longer it continues. that's odd because the message, which very well may be important, doesn't change in the slightest while the light blinks. or does it? or does it? or does it? or does it? or does it? or does it? it's still blinking. if it keeps on blinking, and maybe never stops, the message's importance will increase infinitely. but because it doesn't actually become infinitely important, there must be another reason for the fact that the message's importance, considered subjectively, increases with the length of time the light flashes.

and so it is today: the more persistently something is repeated, the more important it becomes for the observer (if he doesn't pay attention), you need to be told at least a hundred times that the sun's rays are dangerous for your bare skin before you

believe it and behave accordingly. the more it's repeated that a certain brand is best, the better it sells and so on.

it's still blinking. so it's got everything to do with you that something starts to seem more important the more frequently it appears and nothing to with the do thing itself. now the flashing has stopped. but that doesn't necessarily mean that the driver of the delivery van has only decided to leave just now. the blinking seems to remain in the system for some time if you don't pick up the receiver. this means that the message not only becomes more important through the transmitter's insistence but also simply through the telephone system itself.

6.15 P.M. the postcard of the house in freiburg is still lying there. if it lies around for a while, it will become trite. as soon as the shock wears off, the house becomes a banal black forest house. it has to be locked away. then it can recharge, like an old battery. such old (and also new) printed matter are like old batteries that run down very quickly. why do so many people set photographs out on tables and credenzas? they're so quickly exhausted.

17/8/98

11.25 P.M. there was a blockage with the entries, as is evident from the date. not so much a blockage as a hindrance, a blockage as a result of a hindrance. the last file was nowhere to be found, was gone. gone gone gone gone gone gone.

FILE GONE GONE GONE

on the 12th of this month took the laptop out on the beach. the light was so bright that you couldn't see what you were writing, and worse: you couldn't even see the keys you were hitting. and when you hit a key without any idea which one it is, it can have the following result: deletion. and so the result of my outing on the beach was that the files were suddenly nowhere to be found.

LOSS

the files started with scotland, written in june, then in august about yoga. a page or two each day. around 30 or 40 pages gone. a loss. but oddly, also a gain, although it's impossible to gauge how much or what kind of gain it represents. a shock in any case, and a shock is initially a gain in movement. a shock is initially value neutral. consider the healing effects of shock, in the adalbert stifter story, for example, in which a girl loses her sight after a flash of lightning and regains it after a second stroke of lightning.[23] if you look at things dynamically, then it's less that something has been lost than it has been transformed. now you have this void, this empty space due to the faulty use of your laptop.

EMPTY SPACE

there already was a similar incident in which you lost something for ever (apparently for ever), as in karlsruhe with the photographs of a girl that were destroyed because of a simple mistake in developing them. then in ireland, where two weeks of intense work were gone because the camera's lens had been put on wrong.

if you speak of an empty space in this context, then it's not the same kind of empty space that was discussed on the previous pages (tzimtzum, etc.). it's not that something is empty, it has simply vanished. on the contrary, it's simply a full space that is no longer suitable. because what was written down in june, july and august is still there, even if it can't be found in the laptop. and even if it were completely and utterly erased, which hasn't been proven, even then it's present. it's simply no longer set down (fixed). a lot happened, mentally, in that time, it's just no longer available in written form.

should it all be reconstructed from memory? but can what was written be separated from what was experienced at the same time? won't you reach for what you experienced at the time you were writing those entries to help remember what you'd written?

LIFE AS A MEMORY PROP

life as a memory prop for lost writing. when you read a book, you later recall things that had nothing to do with the objective development of the book or film how is it with your own book???

3.45 P.M. what turns this loss into consolation? shock has an element of solace in it. it's a shock-consolation. without the shock of loss there would be no shock-consolation. or does the content of what was written down and then erased determine whether or not the loss will become a consolation? what was written down? a passage about the small heat in the cold (using the pool as an example), then one about the simultaneous creation and dissolution of space in yoga poses. what else was there? it's no longer very clear, with time you would remember, bit by bit. it's most likely not the contents of what disappeared that's responsible for this strange, tranquil euphoria that has taken hold since the loss, like a bloodletting.

A BLOODLETTING

apparently a sense of euphoria sets in then too, especially when so much blood has been drained that there's none to spare. or the odd feeling when you've lost everything at the casino. that weightlessness. but it wasn't the same, because in this case not everything was lost, just pars pro toto, so to speak. if everything really had disappeared, the many pages of writing, what then? would it still feel euphoric or would there be a change in quality???????

in the meantime, a computer specialist has recovered the file. the file was saved twice, once as 'doc' and once as 'dos', and it was still there in the latter. so it had to be transferred from dos to doc, which the specialist did. the whole thing is odd. saved twice and lost once. and then it became clear, not immediately, but within one or two days, that the recovery was a second loss.

SECOND LOSS THROUGH RECOVERY

it's a little like the king's golden goblet that is thrown in the river, or was it the sea? no, it wasn't a goblet but a ring beyond price that the king threw into the sea to propitiate the gods of fate, who might assign him a bad end because of his great good fortune. so he brings them this offering to pacify them, but: the offering is not accepted. the ring returns in the stomach of a fish and then it's too late.[24] but if you mourn the recovery of your lost file long enough, then all is not yet lost.

GRIEF OVER THE REVERSAL OF LOSS

once again: why are you sad about the reversal of the loss? the loss was a withdrawal. what you had created (in writing) was gone. and in suffering this loss, you suddenly felt like you were on the trail of something great. the coat-tails slipped from your grasp. it was a banal WITHDRAWAL (what is more banal than being unable to locate a file?), but it's no less suited for all that to fool one into thinking a great philosophical loss occurred.

WITHDRAWAL

6.35 P.M. when pulling open the drawer with the sheets of paper and picking one up, the excitement of beginning, even when nothing is begun. at the moment, nothing is put to paper and yet: when the laptop is there on the table, even when it's open and ready for something to be written, nothing happens. it was the same with typewriter paper. nothing happened then either. but when you see the drawing paper in the drawer, when you take a sheet in your hand: you can feel it.

FEELING SOMETHING. HOW SOMETHING FEELS. CONTEMPLAT-
ING SOMETHING. CONTEMPLATION IS NOT FEELING.

what kind of excitement is it that comes over you when you feel
the sheets of paper? you picture them already filled up, filled in,
at least elevated from a mere sheet of blank paper to a level of
meaning. it's not always meaning, it's like a presentiment of
eating, of eating paper, of the disappearance of the blank page.
it's the empty space as such that calls.

BLANK PAGE. THE CALL OF EMPTY SPACE.

it's not so much the consumption of the blank page, it's much
more, and above all: the call of empty space, of open situations,
future possibilities. comparable to the many projects for a future
studio.

now, while others are stretching the canvas and making prepara-
tions, the time of empty space is very limited. it was wonderful:
the founding of the canvas, etc. thinking about the future painting.
thinking is not quite the right word. advent?

18/8/98 tuesday

2.45 P.M. it's hot with hardly any breeze. there's nothing urgent and nothing superficial to do. the staff are on holiday all of august. the paintings aren't coming along, there are no more cigars left, no coffee, no chocolate. everything seems to be whiling away. of course you could impose some task on yourself, pull something out of the blue and pursue it, the conditions are favourable: no exhaustion, you're well rested, no interruptions since everyone's gone, the telephone is unplugged, as is the bell at the gate. still: you're not going to start, pursue, undertake anything. just sitting in the motionless air. not even waiting. for what, after all. not even putting off something that really should be done. when you stretch out your arms, you don't bump into anything. so if someone were to ask what you're doing, you'd say 'nothing,' knowing all the while that the word 'nothing' doesn't clearly express all that you're not doing. you could also answer 'i'm writing' and then they'd ask what you were writing. again you'd say 'nothing,' naturally aware of the absurdity of simultaneously writing and not writing. the next insistent question you'd have to answer with 'nothing specific.' then they'd ask 'what do you mean by nothing specific?' is something written down always something specific? or can you also write something indefinite? what would you say if asked what you'd written in the last 35 minutes? after all, 35 minutes aren't nothing. well? you could say you tried to describe boredom.

BOREDOM

of course this boredom is related to the empty spaces mentioned earlier. these, however, are different from the empty spaces in

times past. those were spaces but that's not what you called them. they were actual empty rooms. the empty space overhead, for example, is already imagined as an empty room. even the external order is one: no telephone, no bell, etc., and the clarity as well, you can also say: the demarcation from other spaces. and the spontaneity: you could impose a task on yourself at any point. but not back then, back then there was nothing to pull out of the blue. then emptiness was usually converted into movement (riding on a bicycle) or plunging into illusions (studying movie posters).

and first and foremost another difference: the emptiness from that time is, so goes the theory, a precondition for the present fullness (insofar as the manifold empty spaces produced could be filled). the empty spaces from that time as vessels, then. and a vessel has a form. does boredom also have a form?

DOES BOREDOM HAVE A FORM?

did boredom have a form back then? definitely not. how can you give it one now? by saying: the boredom, the emptiness from that time is the precondition for the present fullness

4 P.M. the boredom we're talking about now has no form. can you say that something's missing because it has no form? it seems so at first, because the boredom's easily dispelled with entertainment or treats. that boredom is easily dispelled is still no indication that it's incomplete. on the contrary: nothing is missing, boredom is the embodiment of completeness.

BOREDOM = THE EMBODIMENT OF COMPLETENESS

8/19/98 wednesday

11 A.M. in three quarters of an hour, we leave for zürich. back tomorrow evening. before then another swim in the pool. it's not far and not for long, but it's written down as if in farewell. are you leaving something behind, is that why? closing something off? le dernier soupir du musulman.[25]

THE MOOR'S LAST SIGH

or: when the city is burning, you shouldn't turn back.

above all, when you're away, you think something unforeseen might happen. something unanticipated, not arranged in advance. you don't want to come back and find anything reduced to chaos. you want to find everything the way you left it. isn't that so? at the same time, you leave only because you want something to fall apart, but, hypocrite that you are, what you leave behind shouldn't be deregulated. something new, yes, but old things too.

DEREGULATION

19/8/98 Marseille airport

Before the flight to Zürich: the new terminal is almost unused, outside there's hardly any traffic (only a plane passed by). Few people in the terminal. Is it because the terminal is unspoilt that everything seems unreal? Over the loudspeakers: waltzes. Airports always make you feel powerless, always unaware of what's going on. There's always something going on of which you only see the final effects. Normally the feeling remains vague or surfaces as irritation about a change in the flight schedule, etc. But now there's a frozen situation because almost nothing is happening. Along with the intense heat outside, by which everything is subdued.

20/8/98 Trip from Zürich to Lucerne

What can you write? List the names of all the places? Name the river along which you're travelling? At what point does description turn into thought? Can a description be a thought? Yes, see the roses in *Indian Summer*.[26] To the left, the Sihl, flat over stones that stick up or: protrude. 'Sihlbrugge' on a shed next to the train line. There was no train line.

Heaven—Earth

At least you can't see them any more. The stones in the river that flows so levelly, are they holes in the ground or remains of earth in the sky? Are there also remains of the world? There is perhaps *the* remnant of the world, but no remains of the world in plural.

Yesterday in the museum. A few paintings by Munch, especially the portraits, the heads similarly concentrated, similarly constructed, as alive as in Manet's paintings. curious how the lines tightly contain the entire figure and yet lead into the surrounding space. The marvellous white of the woman's dress, and the astonishingly colourful snow (in another painting) or the picture of the children on a wide street with people to the left and right, in the centre, the children stand in front of a puddle of water. How the puddles in the empty space between the rows of houses to the left and right of the centre become seas! Or skies.

Surface of the water

How you suddenly feel the conversion of the familiar, the known, the surrounding (streets) to the furthermost, to the vague (water which mirrors the whole expanse of the sky and becomes a sea). You can also say the conversion of dwelling (building) to thinking or of place to idea, to the extent that vastness is an idea (since expanse is immaterial).

Return to Lucerne, again the Sihl river to the right, a glittering band between the trees, frequently torn open by rocks.

Laceration of the ≈

Where otherwise the water's surface is monolayer skin, is a water level, is the boundary of the secretive and the vessel is the boundary of dreams, something contradictory happened in the riverbed. The delicate boundary (of dream, of the watery world that is also an underworld) was there, but also lacerated by the many rocks. And a skin that is thin and delicate can only exist as a whole, it ends like the sublime turning to the ridiculous.

8.30 P.M. on the return flight

After Marseille in a two-engine turbo-prop SAAB 2000. The pilot sits with his legs crossed, his posture apparently carefree, as if he were in an armchair. The plane flies itself. It's on autopilot, obviously. Yet it gives the impression of a pilotless ghost plane, one that doesn't seem to belong to the crew. And there's another ½ hour before we prepare to land, when they'll go back to manual and indeed to the most precise control. You wonder, of course, if the pilot's manner might not feed into the plane's independence, so that in the end it overshoots the mark, imitating the pilot's nonchalance.

22/8/98

12.40 P.M. hitting page-down to get to the file's last page (it's already taken more than 10 seconds because so much was written in this quarter) is like looking down into flowing water. the letters twinkle strangely when they pass so quickly, alternating with blank spaces, like white-water rapids, like fast-flowing water. a canvas leans against the studio's south wall next to boxes on storage shelves, in disarray, with labels still blank, made for the exhibition in madrid. a photograph of the shelves set up in the courtyard forms the basis for the canvas. partially painted over with colour and whitewashed with a thin layer of pale grey. now a leaden bed stands in front of the canvas and the labels, like the letters, could fall into the water it holds, if you indicate their falling with thin lead strips that extend down from the labels into the water, you could write the names of the stars on the labels. and why do they fall into the water? the water here is thought of rather as the universal solvent: alkahest.[27]

ALKAHEST

the names, the numbers, that is the material that will dissolve in the water again—not so simple, because the material disintegrates into rays. depict them as rays? with the remains of an x-ray machine? maybe.

5.15 P.M. what is it like when you don't make anything any more? you get up in the morning after having got enough sleep, lie down in a cooling breeze and read, walk some, watch the cats. write for amusement, not much but some. watch the trees grow and the other plants, artichokes, eggplants, tomatoes, etc., etc., etc.,

etc., then you're free of it. but it's still not over, since you could begin creating again at any time. when you create something, it's easier to think about things being over, although creating something doesn't really allow you to think about things being over. sometimes it seems that creating something is a bridge to being done or that it delays being done, because you leave behind something called fame. but leaving something behind doesn't mean that you've deferred being done. on the contrary, your legacy shows that you're finished. actually, you'd rather not do anything at all because you're as lazy as the cats lying in the sun. but it doesn't end with laziness. why doesn't it?

why don't you leave the space empty? as you did when you were a child. the cats become active again only when they get hungry or are in heat. you can satisfy your hunger at any time without creating anything.

the whole process of inquiry is a kind of creation. producing questions.

PRODUCING QUESTIONS

can you be without questions?

diversion through questions.

fame through answers.

finished one way or another.

cats don't ask questions. is that known?

supposing those last five lines were a poem (which they aren't), what then? you would know that you created something. you'd be pleased, you'd close your laptop and feel good about yourself. why? because something would been created that hadn't existed before. because suddenly something would be there. but why should there always be something that hadn't existed before? what is the difference between having created something and having created nothing, like this afternoon?????? in the first case you feel like a bridge-builder or like someone who has built a ford, put stone upon stone, so that he can cross the river once the last stone is laid. in the other case, the case of this afternoon, it's—yes, well, how is it? empty.

EMPTINESS

what changes when you've created something? is it only you who has changed or has something changed in the world? the poems of ingeborg bachmann, for example, what is different, what exists that wouldn't have existed without them? nothing changed because of the poems, but, wherever the poems end up, what's around them looks different (put together differently). that's still not quite right. because there is so much correlation between what is and what is newly illuminated through the poems. the illumination ultimately exists independently of what is illuminated. but this is also true: without what already is and without what is illuminated, we wouldn't be interested in the illumination. it's fascinating that words can be put together in such a way that they're able to transform pain into beauty. you can't really put it that way. so how can you express it???? what effect does a particular order of words have? they suspend longing (they still it), by audaciously abolishing time and space, by lifting our human

contingency. in a poem, we no longer think from our vantage point outward, we no longer consider where we are and where we want to be, it's no longer necessary to desire, since everything is possible without desire. but not in a daydream. the poem exists in the here and now, without concern for time and space, without regard for the costs, without having to take responsibility, without ever turning back. and yet it retains a slight something, something of the mixed, of the conditional, just enough that the distance is suspended but still visible. the pain is still there, because it's not yet finished with. when it's over, then the poem is also finished for you. or not?

23/8/98

11.50 A.M. it takes exactly 13 seconds from the moment you open the file and hit page-down until the snow flurry stops. that is, until the file's written pages have fallen down (run down). at the end of the month, which is coming soon, a new file will be begun and this one finally printed when the secretary returns on the first of september. on the first of september, the nights will grow even cooler. then the first signs of autumn will appear. from stored heat (late summer) to remembered heat (autumn).

FROM STORED HEAT TO REMEMBERED HEAT

HEAT RESERVOIR MEMORIES

reservoir also in the sense of attic storage. cold reservoir: ice. heat reservoir: water.

picture: sheets of ice on the left, hard, crystalline lines on the right: water, soft, dissolving lines, possibly both in separate adjacent pools that are joined with pipes below. and there, where the two temperatures collide, is the picture. since it's a transition, a transformation. perhaps also with a sheet of glass between them as a membrane.

a sheet of glass also between the poppy field with the names of stars and the heavens.

4.30 P.M. came across something in the library without looking for it that is related to what was written yesterday about the poems of ingeborg bachmann:

to what extent can art exist more fully in the realm of what is than all other beings?[28]

ART martin heidegger : nietzsche

p. 142: 'nietzsche can declare with respect to the relation of art and truth that "art is *worth* more than truth." that is to say, the sensuous stands in a higher place and *is* more genuinely than the super-sensuous.'[29] although this being (namely, the super-sensuous) was previously valued most highly. nonetheless, art *is* more genuinely, art proves itself as the most genuinely existing of all being, as the fundamental event in the totality of being.

art is worth more than truth.

'the life of actual language consists in multiplicity of meaning. to relegate the animated, vigorous word to the immobility of a univocal, mechanically programmed sequence of signs would mean the death of language and the petrifaction and devastation of dasein.'[30] see dogma, computer language and works of pornography.

p. 147: there are historical reversals of meaning in language's fundamental word. 'the will to originality, rigor and measure in words is therefore no mere aesthetic pleasantry; it is the work that goes on in the essential nucleus of our dasein, which is historical existence.'[31]

7.50 P.M. worked on a watercolour. a meadow in auvergne, completely covered with yellow flowers. nothing came of it, so to speak. what was there in the beginning (you can't actually talk

about a beginning, since there is still no end and therefore no outcome)? so then, what was there an hour ago? it was the wish that could no longer be delayed (or would it be better to say: the will?) to free these flat photographs from their vulgarity. to finally say what it is they represent, to finally say why they're lying around here. why they're still lying around here. the result was hardly 'better' than the photographs themselves. and yet, it's not that there was much missing. or was everything missing? above all, they're not a beginning, not yet. only once they are a beginning, when nothing precedes them and they begin, when they don't accompany anything else and aren't for anything else but are incipient.

ONLY SOMETHING INCIPIENT CAN BE AGAIN

to be able to begin again. usually what you want most when you have something that came to nothing is to begin it again. that's how it is in life. in art, you mostly want to begin again with something that worked.

what is it that calls to you in these photographs of flowers? this shade of yellow? it's a natural fact that so many yellow flowers sprang up from the earth at the same time. such a celebration. and you are not a part of it. instead, you marvel at it. that was so often the question, with the red poppies, too, what makes them so attractive? can you figure it out by letting the watercolours bleed into one another?

24 (or 25)/8/98 tuesday

11.40 A.M. carried on with yesterday's watercolour. carried on in both senses of the word: in the sense of continued working on it, and in the sense of carried further, carried away, i.e. brought it to a different place, changed it, gave it another meaning. and, in fact, the depths of the field with the yellow flowers emerge more strongly now. the yellow glows more intensely thanks to the addition of other colours, violet as a complementary colour, for example, and the yellow sections partly covered with a grey-green-violet wash, so that the yellow becomes more sumptuous, more vibrant. it's now a field that can put itself on show. but what next? what next with this field?

WATERCOLOUR PRODUCTION

while painting watercolour on the photograph hung on the wall, in which the mountains of phuket seem to rise from the water, eaten away at the bottom so that it looks like teeth struck with periodontal disease. very strange (and surely already noted before) how the cliff pulls back at the waterline. so thought of these cliffs, painted in watercolour with a real tooth added. a small idea.

1.15 P.M. finished a watercolour painting: sunflowers on a table.[32] what to do with the sunflowers on the table when it's not a still life? because this isn't a still life, the sunflowers are neither in a vase nor lying on the table. they are upside down in the dirt, growing into the dirt on the table. well? sunflowers growing on a table, that means for a start that they begin at waist height. they don't grow from the ground but somewhere in-between. you

could say they're already transcendent, or: they're already a bit closer to the stars.

SUNFLOWERS ON THE TABLE

or: they're part of an attempt at order. they're being examined. they're isolated, removed from their environment. also: you can see them as piece of art nouveau furniture, as a table with vegetal extensions, and so a non-table. in addition, the sunflowers are, in relation to the geometric table, what those french parks are: geometric nature. the principle of geometrization also known as a mental illness.

floworpoto aro vcry popular, they're everywhere, some easy to care for, some more demanding, depending on whether one has time to look after them. the sunflowers on the table come from the potted-plant tradition.

FLOWERPOT

when you have lots of time, you can also talk to the flowers. they are receptive to it. they don't like disco music. they like mozart most of all, jazz a bit less, mostly classical music. this is well known because the flowers were studied.

11.30 A.M. there was a house for sale, the former winegrower's cooperative in st privat. a single house on the street (hardly any traffic), with a gorgeous view of the cévennes, a panoramic view of the mountains. about 30 x 40 m, 8 m high. simple, not attractive, the stones crudely joined. we learnt yesterday that it had already sold. is that a loss comparable to the loss of the files a few days ago? not when seen from the outside, or rather: not when you consider the process as such, but what went on had to do with conceptions, with the creation of illusion, with departure. of course it was suddenly gone, gone, gone. it's unrealistic to think you might ever have used this house. you don't even use your flat in paris. it is, so to speak, a craving for attenuation, for carrying on, always carrying on and then no longer being able to reach your goal. Naturally you could put a few paintings in such a space or, even better, you could leave it empty. but . . .

you could also have taken your laptop there and written, described the view. but . . .

it's a shame. but . . .

when no one's here (they all come back on monday), we also use the washing machines in the office. strange, the little round window where the central whirl spins (the creation of galaxies). you could confuse the circular concave window with a screen. on a screen the peephole is convex, but it doesn't make a big difference. a 'world' enclosed in itself, the casing doesn't move no matter how fast the drum spins. not a drop leaks out, even though it's full of water. there are holes in the drum (le tambour),

but the holes don't point to anything distant. you've already got the hermetically sealed casing. idea: fill the drum half way with clay that will crack as it dries. earth, in other words. the empty upper half of the drum would be the firmament, perforated by perceptions that extend beyond the horizon.

7.15 P.M. letter concerning a coat. strange: nothing's worked for days. the watercolours on the floor are dull, drab, mute. what was written here: forced, unattractive, etc., and then this letter about a coat, not even that. you envisioned: on the photograph of the chairs in the snow, a line should be drawn from the remaining heat in the pool, in the two senses of the word 'indian summer' to the unborn in the snow, represented in the photograph with pieces of clothing draped over the snow-covered chairs. the item of clothing could be a coat:

tatters of rags rattling in the wind, last remains, cf. remains of heat.

st martin, dividing.

skin, although in the case of fur, with the hair as it usually is.

the fingernails are, in a special way, the border between the body's exterior and all that surrounds it, between life and death (as is well known, fingernails and hair keep growing for several days after one's death). if you turn a coat of fur inside out, you've got the paradoxical situation of two outward forces aimed against each other, thus the hair of the fur against the body's hair, properly growing outward, that is: external space shrinks to zero. you're in constant close contact with another even if it's just an animal.

a way to hide something by expanding internal space.

all these may be fundamental considerations, but what should it look like? burlap inside and out, a mink turned inside out. and thus a coat packed in burlap. you're wearing something packed.

28/8/98 thursday[34]

11.05 A.M. cecilia bartoli upstairs. her voice like clear water leaping over stones down the mountainside, like the steps at 20 east 20th st in NY in earlier days.

strange how these sounds, these notes from there have come here. or from here to there? because: only here are they recognizable as being from there, when they were there long enough. long enough, that means intensely enough. it could have had the same effect after only a few seconds. in that case, however, cecilia bartoli lasted several weeks, if not months. that's why here, she recalls there, because at one point she came here from thoro. and yet: through the example of this music you can see that it's not about spatial relations. because the fact that the disc was brought here from there is meaningless in itself. it could just as well have been bought here. so, in fact, the notes did not come here from there. it's more a relation in time. you first heard the notes in NY and then here in barjac. when you've first heard something in a particular place and then hear it again in another, does it seem to be a spatial dislocation?

SPATIAL DISLOCATION ONLY THROUGH TIME

and so time produces spatial dislocations, without any forwarding address.

the same way the new libraries (internet) also can't be grasped physically. it starts right here when you're looking for something on your laptop. it's difficult because you can't orient yourself in a space as you can in a book, where you know if it was on the

right or left page, if it was closer to the beginning or the end of the book—so you can no longer speak of the donaueschinger nibelungenlied.[35]

LIBRARIES

but how does it work exactly, with time? do cecilia bartoli's notes from NY date from an earlier time than those in barjac? of course we're not talking about the notes when they were recorded in the studio (people say that C.B. is much better in the studio than on stage, which has absolutely nothing to do with our space–time problem, or does it???). we're talking about the notes as they hit your ears. you first heard them in NY and then in barjac. you can confirm that by referring to your journals. but what exactly are you proving? the time of the encounter. but once it's stored in your brain, the exact time of the encounter doesn't matter so much, because they're not perishable goods with an expiration date. unless your brain deteriorates and is finally, irrevocably gone.

GONE

so the notes are stored in the brain, both the notes from NY as well as those from barjac. and because you're no longer in NY, hearing them evokes NY for you. that's not exactly right. they don't evoke the place you heard them but build a space around themselves. they don't refer to an existing space but in sounding they create a new space modelled on the place in NY. or, to put it yet another way: these notes are associated with a particular space. but that sounds too rigid.

what has been overlooked until now: the notes don't just create a space but also a multifaceted event in this space. you could say they create an entire period. a personal era. the NY era.

it's the same with smells: they can also evoke eras. in the 60s, there was a fragrance for men from lanvin and one called moustache. no memory of the scents, but you remember only that they were memory-laden fragrances and so were kept for a long time (kept physically through several moves). Strange, now that they're no longer here (at one point everything was lost), there's also no memory left of the fragrances themselves, just the knowledge of some of things they recalled (maybe the house at 20a lower mühlenweg). and if you were to find these scents again, then very quickly, fast as lightning, everything associated with them would surface again. not exactly as it was at the time when they were lost, but altered, enriched with what occurred since the time they disappeared. mind you: although you couldn't have smelt them again because they were physically absent, they would be enriched were you ever to find them again.

strange: how these reflections correspond somewhat with what you recently found in martin heidegger on nietzsche. how, since plato, being-in-itself refers to the supersensuous, that which is removed and withdrawn from the mutability of the sensuous. for nietzsche, the worth of something is measured according to what it contributes to the increase of the reality of what exists. art is *worth* more than truth means: art as the sensuous *is* more genuinely than the supersensuous. although this being was previously valued most highly. nonetheless, art *is* more genuinely,

art proves itself as the most genuinely existing of all beings, as the fundamental event in the totality of being.

ART: THE MOST GENUINELY EXISTING OF ALL BEINGS. REVERSAL OF PLATONISM.

perhaps you should clarify a bit the relationship between the notes sung by cecilia bartoli and the reversal of platonism through nietzsche: the experience this morning of the notes sung by C.B. showed: there are no concrete ties between the notes and time or place. constant alteration, reversal, suspension of one's 'point of view' through sensory impressions so that you can't speak of a theoretical point of view.

1.15 P.M. again on the subject of odours as triggers of time and space:

ODOURS AS TRIGGERS OF TIME AND SPACE

there was a passage above about the fact that after the perfume bottle has not been available for several years, a scent will trigger more than it had before the gap, it will have become richer, will seem to have enriched itself without having been used. an analogous experience is the fact that sexual experiences in early childhood, experiences the child does not recognize as sexual, but merely as strange and impossible to categorize, acquire a sexual character in adulthood and become one's most salacious, most fascinating memories. every experience can, at any time, be reinterpreted. there are no drawers (perhaps one could even say ideas) in which an experience can be permanently preserved. there is no reliable storage.

STORES OF MEMORY NOT RELIABLE

WOMEN OF ANTIQUITY

for some time now, a new project. it has nothing to do with what was written above. the fates of several women, like the woman who gave her father her own milk to drink in prison[36] . . . clothing should be designed for all these women and set out or glued onto canvases, as pictures. in the process it has become clear that the clothing can't be designed for them, but that the clothes should first be made and then the appropriate piece for each woman selected from the pool. why is that?

29/8/98 friday[37]

12.50 P.M.

THE DEATH OF VIRGIL

yesterday, looked for something on the east wall of the library, it
was hermann broch's death of virgil.[38] it has been on my mind
constantly all year, like a heavy cloud, until it reached a certain
pitch, but this heightening can't be captured in words, it was
something incessantly out of breath. something incomplete, not
mastered, that weighs on your mind because it's incomplete or
has failed. so yesterday, sought it out again after many years,
took it down from the shelf and leafed through it, reading the
underlined or annotated passages. later, went to the library's
west wall to see when i'd read it. it was years ago on crete. there
on the shelf is a notebook with the word crete on the cover. it
was 1985, so 13 years ago. strange re-encounter, at once close
and distant. the impression that i'd carried with me for years of
'excess', a sense that the book was overreaching, overwrought,
quite simply unreadable was still exactly the same, in other
words, not the magnificent chant he speaks of in virgil's name.
my re-encounter with the book had a sense of recognition, of
confirmation. the other kind of re-encounter, the one that reveals
a distance, occurred with the sudden perception of aspects of
the book that shone through its failures. the perception of what
was not achieved. and it's always a *not yet,* because you also
aren't able to complete the book as it were. still, it's another kind
of *not yet,* one that is not verbalized but is more easily grasped,
a *not yet* that is within reach.

NOT YET

but can you grasp a *not yet*??

for example, in the passage where he talks about plants in relation to the stars. the colddust and the rootglow (words still in my memory). the interweaving of both realms, that and other aspects not noticed the first time.

but the truth is: descriptions of visions, ecstasies are usually boring. what else should one write in such a case?

then all writing is lost. then the letters fall into the water, a blow in the water, so to speak. the letters end up lying all jumbled together at the bottom of the water.

30/8/98 saturday[39]

8.40 A.M. storm yesterday. sunshade and awning torn. leaves in the pool, already yellow because of the long dry spell, early autumn. but green leaves were also torn down by the gusts of wind. throughout the night and all day.

but what was stranger than these leaves, which you know are going to fall: the sand was blown in drifts and you were immediately reminded of snow, of snow drifts.

SNOW DRIFTS

there were no visible traces left of feet, of the tractor tyres, they were dunes and oddly you didn't think of sand, deserts and sandstorms, but of snow. a few blades of grass, completely green, rose between the finely deposited snow drifts. it irritated, seemed almost ugly. that you couldn't tolerate it? when it doesn't fit the picture, when you've seen the snow, that isn't really snow and that almost never falls here. but it falls to you, where it wants or where you want? the cock crows for each at his appointed hour, the snow falls where it will, the grass grows in the snow.

it's said that the desert near jerusalem is sometimes covered with a thin layer of snow.[40] not everything is normal.

31/8/98 sunday[41]

11.45 A.M. in the morning went to the large lake that is slowly growing over, the weeping willows, the sallows, the reeds. a lake not surrounded by plants has no depth, but with reeds, something is missing: you miss any indication of the distance to the opposite shore (or to any part of the shore). you don't know where it ends. as small as the lake is, with reeds covering the shore, the edges are blurred and you no longer see the end. no end! the dissolution of boundaries applies to the bottom as well because you don't know how deep it is or how far it goes. as with a swamp. the sea of reeds.[42]

SEA OF REEDS BOUNDLESSNESS

the wonderful willows, the way they strive upward and bend back down as soon as they've attained any height. self-forgetful, lost in thought, downward, self-recollected, in a circle. you can't tell if they're carrying a burden that weighs them down. they want to go back down. ouroboros.

no, it's not an ouroboros. because twigs don't set down roots, they just hang down. they even hang in the water that feeds them.

WEEPING WILLOWS

out of this large lake, fed by a well drilled (220 m deep) on the other side of the property (capacity 4 cubic metres an hour). from this lake with the reeds, water is pumped into the many irrigation pipes. from these pipes water drips through hair-thin outlets onto

the earth according to a computer controlled schedule. strange, the idea of millions of little drops over the entire property, in all directions. this trickling like snow if you push your imagination somewhat. or else dripping from numerous tiny wounds. a stream divided into the most minute units, trickling.

IRRIGATION SYSTEM. TRICKLING FROM DRIPPING WOUNDS

it has hardly rained all year. where the dripping doesn't reach, the ground is scorched except near the large trees whose roots descend deeper to get water. like the drill hole that also provides the well with water, apparently independent of precipitation. if you think about it, 220 m is very deep, so very deep.

why does it give so much pleasure to set up something that surrounds us already, both natural (the water cycle from sea to land in the form of clouds and raindrops back into the sea) and manmade? why do you want to recreate it for yourself? when you already know how it works. why is it such a joy after a great deal of effort to achieve something that was completely predictable? you think you've accomplished something. in any case, you're happy it works. people evidently like repetition. they want to create a thing even if it exists already a thousandfold, many thousandfold, around us. as in religious rites, in which the same action is repeated over and over again, the creation of the world is enacted or the anniversary of a saint's death is celebrated. with the unnecessary irrigation you celebrate the water cycle, you think, of course, of the egyptians celebrating the rise or fall of the water level in the nile. but then it was absolutely necessary, or they all would have died. the irrigation system here is anything but necessary and if it were part of a some rite, however

modest, it could have been kept small. that would have been much more artful. you need only look to japan and how they depict a mountain and the sea and all large things in the smallest of spaces.

letter to zürich[43]

a friend recently sent me your article in the zürich newspaper about the exhibition in new york. in it you addressed a point (or one could say you hit a sore spot) that i've often thought about. and now, because of your article, i'm tempted to try to put my thoughts into words.

it's the passage in which you write that dedicating the paintings to ingeborg bachmann is obscene. i agree and have almost no objections to the word 'obscene'. it's the most difficult passage about the paintings, the passage, in any case, in which one must decide if the painting works or is a failure.

the reasons for your 'irritation' are of the factual kind: the spaces in the paintings are not bachmann's death spaces, fragment stands against totality, triumph against death, etc.

allow me to attempt to articulate the reasons for my misgivings about commemorating ingeborg bachmann in a painting. this might show that the particular character of the reasons *contra* are, paradoxically, exactly the reasons *pro* doing so. in any case, it will become clear that without these poems, the paintings wouldn't exist. (naturally, this does not prove that the paintings should exist. that would be a false *argumentum e contrario*)

the problem with the dedication (not fusion), though, is: usually any and all things that can be transformed are suitable material for a painting, things on a lower level, if you will, that can be enhanced. apples, for example, kitsch, tainted concepts, mis-used subjects, all sorts of imperfect configurations. a poem by

ingeborg bachmann, however, cannot be transformed. it already is a magnum opus. you can't add to it.

and yet, something was added, just not to the poem (you can't add to it) but to the painting. and even that's not quite accurate because: nothing was actually added to the painting, but it wouldn't exist without the poem. for two reasons: painting, in itself, doesn't interest me. explorations that have painting itself, as a medium, for a goal are necessary from time to time but not the ultimate goal (this is why, after a certain time, minimalist art in design reached a dead end).

painting refers to something. its archimedean points are external. it doesn't pull itself up by its own bootstraps. and yet, that doesn't mean it's illustration. quite the contrary: it should avoid conforming to its subject. for the most part, 'what the label says' relates to what has been done in the painting only through contrast.

so what then are these paintings that are all dedicated to ingeborg bachmann? stones piled up for the great poet, so she can be seen through the stones, through the gaps, the interstices . . . and where there are many gaps, the stones and the space between them expand. in those interstices, i spoke with ingeborg bachmann, not as a 'brother' but as one overcome.

1/9/98 monday

the first workday in four weeks. all day long things were dis-
cussed, pushed, loaded, begun. but what kind of things? things
that could just as well have been put aside. like the expansion
of the large lake. in some spots the reeds have grown so rampant
that the surface of the water has shrunk by several metres. the
lake has begun to silt up in some areas. after the reeds were cut
back, you could see, you could suddenly see the lake's original
shoreline. especially on the northern side where the water from
the well poured in, there was a large area overgrown with reeds,
small poplars and willows. the willows already towered over the
reeds, that's how tall the trees had grown. a real landscape had
formed that hadn't been there before. a landscape with indeter-
minate edges. once the reeds were cut back, you felt like you
could walk there with firm ground under your feet. but you sank
in. strange, after the reeds were cut back, you suddenly saw
what had been hidden. before there was nothing, just the well
water flowing in. a small river had formed, that washed matter
into the sea and had already formed a delta. you could see how
a river delta is formed.

RIVER DELTA. REEDS

this year everything was overgrown, better, everything was over-
run with reeds and you could no longer see anything. it had
turned into a forest of reeds. the reeds and the silt had also
partly suffocated the little river, so to speak, so that the water
from the western well could no longer flow directly into the lake,
but backed up in the drainage ditches. it was strange how this
forest of reeds spread out over the course of the summer right

before your eyes and you didn't do anything about it even though it bothered you. but: reeds are always a bit unsettling because you never know what's below them, you never know where the water line is, where it ends and where something else begins. you always want to know where something ends and where something begins. after all you say, 'that's where it all ends.'

and so: nothing was done despite the suspicion that the reeds could be the cause for the drop in the water level since the water from the western well no longer reached the lake. but because reeds are always unsettling, you left it alone. because you never look closely at whatever bothers you. after the reeds were cleared, the inflow of water from the western well was redirected right into the lake, without the stream and therefore without the possibility of forming a river delta.

RELOCATING A RIVER

what was most exciting about cutting back the reeds?

that you suddenly saw the ongoing transformation that had been hidden until then. that a process of development had been shielded for a time. that's actually nothing special. it happens with all growth if you don't watch for a period of time. you only have to be away for a certain time then you are in for surprises when you return. that's not quite the case here. it's not about surprises but about a kind of miniature history of the earth.

MINIATURE HISTORY OF THE EARTH

over millennia, a primeval forest grew that has now been cleared. and below it, the delta of a glacial era river, a delta that was barely recognizable as such since it had been swallowed up by the primeval forest.

GLACIAL VALLEY. ALTERING THE DIRECTION OF A RIVER'S FLOW

and the direction of a river's flow has changed too. as did the danube's flow in those days. it could just as well have flowed into the rhine.

reeds also always remind you of a basket woven of bulrushes, of moses + aaron.

2/9/98 wednesday

11.33 A.M. yesterday had the tiger brought to the vet to be castrated. after the operation he ran away and couldn't be found. he had been in the studio for more than a year and now he was gone. the day before yesterday, had the black and white cat, the mother of the four kittens that are now in the studio, put down. otherwise the kittens wouldn't have stayed in the studio. the cat was just as old as the tiger, who might come back. the black and-white cat did come back a few days ago. she was supposed to stay with my assistant about 1 km away. then she came back after a few days and now she is no more.

12.35 P.M. In august, kept rereading notebook entries from 14 years ago and from two years ago. strange how the writing really brings back those times. not complete with regard to facts but very dense in atmosphere, hue, mood and easily verifiable, much food for thought and reflection and above all the question of whether it should have been abandoned earlier or not. and why it wasn't. you could even sum it all up, all the books from that time: a record of long-lasting (for years) reflections on whether to give up on the attempt or not.

diary of a fixation, hence the impression of stasis, of endless incantations for the purpose of achieving greater clarity. and yet, at the same time, beautiful imagery, like the moons going to the beach, moist lips in the sand, etc.

strange, the way the spiritual, the intellectual (tzimtzum, etc.) pervades the banal and stagnant, which then led to new pictures. attempts at disembodiment in a real swamp. was it the

swamp that first made the new pictures possible? is that why you maintained it so long, even long after it was all clear? as you can see in the entries. it was clear and then again it wasn't. a curious dance in a tiny circle. like the temptation of st anthony.[44] what would the saints, the stylites, be without the body?[45]

there are a few loose pages from the period between 22/10/84 and 1/11/84. that was the trip to the usa to prepare for the tour two or three years later. sixty-seven pages written with a very fine pencil tip. the set was kept complete through all these years. so the pages must have been important. not any more? will always keep them. why? because of the remove. otherwise you don't have as clear a remove from the past, a distance you can measure whenever you want. distance measurer. are you at a distance? apart from that dramatic love affair, it was also the start of your brief fame. a time when some things still seemed open, when you could decide whether you wanted to be consumed so quickly. it was all very conscious back then. it's always nice to be able to see a thing as it no longer is.

3/9/98 thursday

8.50 A.M. the remarks on my impressions while rereading the pages written in america were interrupted by the arrival of L. and P. swam naked in the warm water (29° celsius) before dinner, a very nice image seen from above, the two naked bodies lying on the sand lit up by the spotlight so that it looks like snow. a gentle, wondrous shock. then went down and swam with them. odd intimacy, being in water with others. the water lifts the boundaries between the bodies. not like being in the sea. there you keep to yourself. the sea is too big to allow for this kind of intimacy. in the sea, you're as alone as you are in the face of death. and there's another reason why boundaries seem suspended in swimming pools: the edges. the enclosed space. and that's how you feel when you're enclosed in a small space with strangers, like in an elevator.

after swimming, in the shower. along with the harmless talk, the diversion, there's the second level of looking, of discovery. seeing something that was previously hidden is always appealing, whether a drained reservoir or a naked woman or a street after the fog lifts or the ground around a lake after the reeds have been cleared.

strange that these small incidents are happening just when the notebooks are being reread. haven't read them since they were written 14 years ago. but where is any correspondence? there is no correspondence, but something that sways you from one to the next: the beach at night, the illuminated sand, the staged aspect of the installation so that what was there could have been found anywhere.

8.35 P.M. the correspondence lies in the allure. in the scene in faust I in which mephisto shows faust a naked gretchen. the difference lies in the utter fixation evident in the notebook entries whereas yesterday's minor events evidence the opposite of fixation: they're images that remain free in terms of playing roles. the same with the number of roles or appearances.

4/9/98 friday

11.30 A.M.

3.40 P.M. as you can see from the two times given, there's a difference between the decision to write something and doing it. in this case it took more than three hours for the decision to be implemented. sometimes the decision to do something remains utterly isolated, is never implemented. a decision can last through an entire lifetime without ever being offset by its execution: the decision to stop smoking, for example, or to get divorced, to become a writer, or whatever other kinds of decisions are made.

DECISIONS WITHOUT IMPLEMENTATION

so, a life with an unfulfilled decision or, more often, lives with unfulfilled decisions are very rich lives because you've always got an intention. there's always something to do, without the wealth of tasks ever being diminished through their execution. many empty spaces have been lost through accomplishment. thus, you can decide to become rich, but once you have become rich that possibility is gone, to give a very simple and banal example. it's a bit more difficult if you want to become knowledgeable. in that case, it's harder to say that the decision has definitely been implemented successfully because with every advance in knowledge, the extent of the unknown increases. the same can be said about the decision to become wise. still, the word 'decision' doesn't quite fit, because you don't decide to become wise, though you can say that would like to become wise. at that point, the wish is fulfilled and you might think that an empty space

would then have been eliminated. but that's not true, because as one grows wiser, the empty space increases. how is that?

IMPLEMENTED DECISIONS = ELIMINATION OF EMPTY SPACES. EXCEPTION: DECIDING TO BECOME KNOWLEDGEABLE OR WISE

you have to distinguish enlightenment from knowledge, because increasing knowledge never eliminates empty spaces, but enlightenment does exactly that. for example, knowing that more land extends on the other side of the caucasus annihilates an empty space. but that's also not true. because with the discovery of the expanse beyond persia and the caucasus, in other words, with the discovery of india, there immediately came more empty space, you could even say that the empty space, the empty spaces, had suddenly multiplied.

for these reasons it's better to gain wisdom than wealth or fame, because implementing the decision to gain knowledge in no way destroys empty spaces but even increases them. of course, here knowledge should not be understood in the social-democratic sense of 'knowledge is power' or in la mettrie's sense that given enough knowledge, man could predict everything.[46] prophecy and interpreting dreams also do not destroy empty spaces as is evident in the example of joseph and his brothers. joseph's gift of prophecy led him on an extended period of wandering in the desert, a journey through truly empty spaces. empty in two senses. first through the desert as empty space, par excellence, and second as uncertainty about where it will lead. milk and honey are not exactly exhaustive geolocators.

EXODUS AS CREATION OF EMPTY SPACE IN TWO RESPECTS

7.15 P.M. when you note the time so precisely, others naturally want to know what happened in the interim. ideas came or better: insights. you saw into something that was previously unforeseeable. the advantage of empty space is that something happens. now, for example: the tub pressed flat, a layer of tub, a layer of lead and so on until it's a metre high, or a little more. on top of that a boat. title: boat-battery. that's rather complex: sediment under water, both geological and energetic. and the long journey. maybe sediment also with sunflowers: sun-ship.

PAINTING: BOAT-BATTERY SUN-SHIP[47]

5/9/98 saturday

sat on the bed in the studio, turned on the laptop and could hardly wait until it was ready (it now takes more than three minutes for it to get to where you can continue writing). could hardly wait, then, until the laptop was ready to write what? that nothing happened. not a thing written before and there's nothing to write now either. inspected the paths yesterday after the storm. restarted the pumps from the drill hole (they'd been turned off because of the risk of a lightning strike), then ate breakfast, then slept again, then went for a drive and a walk: rochegude, st ambroix (in between looked for a path to walk along the cèze but didn't find one. there it's a bit like on the old rhine, the poplars, the water), from st ambroix to st sauveur-de-cruzières (between the two on a path from which you can see st ambroix from above). then back, busy in the kitchen (the housemaid is on maternity leave, a month already).

this time without a goal (commission) is like old times when you had nothing at all to do when there was no homework. a so-called empty time. especially in the afternoons. what determines whether a time is empty or terrestrial? whim? what is a whim?

EMPTY TIME. WHIM?

to be sure, if an exhibit were announced, it would be a different time. but also without external reasons it could be another time. if something needed to be represented. if something were necessary. that has nothing to do with whims. do cats have whims? when they play, then sleep, then run around, then clean themselves, etc., on a whim. cats probably don't have whims and don't get bored.

BOREDOM IN CATS?

indeed, something was 'finished' today. all the loose sheets of paper have been read. that certainly filled the time. but you can't really say that. do you fill time by reading something that was written? you don't actually fill it yourself but it gets filled. because you aren't actively doing anything in the moment but are letting something happen to you. in the case of the entries, you're letting something happen to you again. in fact, something new is happening to you because it's a different time, because time has passed over the artefact of the notebook entries. time didn't really pass them by, that time is still present, that's why you wrote the entries in the first place, so that the time from that period could still be captured, now and for ever. but depending on how much time passes again, it will again be an altered time. time, therefore, has not passed by, but with each reading time passes through anew. time passes through.

TIME PASSES OVER OR: TIME PASSES THROUGH?

6/9/98 sunday

6.55 P.M. sitting in the greenhouse by the pool. looking at the cévennes. three rows of mountain ridges are visible. lower down on the hillsides, late sunflowers bloom. a brief delay in the course of the year, the other sunflowers are already as black as firmaments. those lower down on the hill (underneath which are the pumps) still have big yellow petals. the leaves of the trees flash in the sun. the sound of leaves in the wind. this late summer evening is so perfect, it contains many earlier evenings or, better: it betakes itself to earlier evenings, and further perfects the idea of late summer. the noise of the leaves is not yet a rustling but a constant suggestion of rustling. starting up and ending again, the beginning playful and ending in an escalation. right in front of my lounge chair: the grasses, that all return (have returned) after the rain two days ago. once again, a fresh green of spring. the grasses, the leaves glow brightly, the sun shines through them in their delicacy. at a slant behind them, to the left on the sloping hillside a young poplar that had seeded itself two years ago contributes to the general noise with its leaves fluttering in the wind, though its gentle sound can't be distinguished from the others. these trees are especially beautiful with their fine and transparent construction: the leaves hang from common stems that are long enough to allow each leaf its full expression. so it seems you can see almost every leaf individually. the leaves, transparently thin like the just sprouted grasses, i.e. where the leaves overlap, the chlorophyll is darker because the sun's rays can't shine through two contiguous membranes quite as easily.

7/9/98 monday

11.45 A.M. the tiger that had escaped from the veterinarian's office has come back. it was gone for six days. what did it experience?

8/9/98

It's like after a ceasefire. Nothing gets done, nothing is written because the laptop isn't working. I just wrote a bit here. Thought about my paintings and sculptures some, about this and that. A skirmish after the main event?

9/9/98 wednesday

6.45 P.M. spent the entire afternoon with a computer technician and the laptop. it didn't work at all. it was an electrical problem. in the office, it worked again. then learnt how you can save everything onto a diskette. and other things. now, about a million letters have been typed and you could type another seven million before the computer would be full. strange, such numbers. like drawing a hotel-room floor plan. what gets recorded is what is least revelatory.

swam yesterday evening. around eight o'clock. floating on my back, saw a star, the first of the evening, the evening star. it was strange, lying or floating in the water and the star above, following you, sometimes hidden by the trees, depending on exactly where you are as you swim the length of the pool. a beautiful and simple constellation between the water's surface and the star: the body. if you lie on the ground and look at the stars, it's different. you're on solid ground, and from there you look at the distant stars. lying in the water, you are first of all on a borderline (on the water's surface) and in a fluid. you're navigating, so to speak. and you no longer weigh anything, i.e. you're weightless, as you would be up there. you can say you've come closer to the star, to your star.

CLOSER TO THE STAR

saw schlöndorff's film yesterday: coup de grâce (marguerite yourcenar), at the end of the first world war in the baltics.[48] the frontlines are no longer clear. there are definite military actions without a definite situation. everything is constantly shifting. the

countess in the castle works with the communists although her brother and his friend (both privates first class) have returned and are fighting against the communists and their sympathizers. she is in love with her brother's friend (although he doesn't love her, or does he?), but still betrays all his plans to the communists. near the end of the movie, she's executed by the friend. a last cigarette. this kind of luxury. some small thing, completely negligible like a cigarette becomes something big because it's a luxury. something that is neither necessary in life nor in death: a cigarette.

LUXURY THE LAST CIGARETTE

9 P.M. read in the morning: notebook. about the pre-socratics. about elements of an offence, lawfulness and guilt, about the third documenta . . . and a few remarks like the ones about the white room. a strange text, mystical like hermann broch but not known at all at the time.

10/9/98 thursday

from ten o'clock until now, the tax advisor was here. so many sig-
natures. an end in itself. is there anything they don't want to see?
they require signatures and entire documents. then the compa-
nies' entire structures with holdings and subsubsubdivisions. get
a headache every time . . .

yesterday also read entries from 1972 and 1967 (in shorthand).
lingueglietta.[49] it opens with tactical considerations, all of which
are nonsense. the stenographic signs are beautiful, shorthand.
flowing, one time with more pressure, another time with a thin-
ner line. because the pressure exerted by the hand through the
pencil on the paper does not depend on the ruling emotion at
the time but on the sign's particular meaning, the writing has a
supra-personal quality. you also think of belshazzar, the writing
on the wall.[50]

STENOGRAPHY, LINGUELIETTA

you can associate the image of this writing with a résumé, let it
stand as something mysterious and write around it, as it were,
in a legible script. the idea of writing in and around all these
books begins to take over, not so much as a palimpsest but as
in the talmud. the talmud is a fitting concept insofar as the mar-
ginalia is commentary (even if not merely a commentary but also
an outline, even a demarcation of the contents).

DEMARCATION OF CONTENTS

here it's clear how something parenthetical can suddenly become an important umbrella term you can pull out, like the concept of a demarcation of contents, in all that writing there are, in fact, no contents, at times there isn't even any beauty, some of it is mortifying and you want to look away. that's why the talmudic technique is not quite analogous to what is intended to be done here. because in this process, the source text is meant to disappear in part, if not completely, under the commentary. so rather like a palimpsest after all.

TALMUD ‡ PALIMPSEST

1.20 P.M. now you can copy what's been written (actually it hasn't been written yet, just drawn with signs, so that I can't see it as writing but only provisionally, on the screen, but is it in fact written there???), so now you can copy (store) in only a few seconds what's been 'written' on a thin 10 x 10 cm card after each paragraph if you want or at the end of the day and you can carry it with you wherever you go. usually it's carried to the office and printed out. then you've got it on paper. the card is called a diskette.

DISKETTE

11/9/98 friday

1.10 P.M. just read two of the pages written in lingu" f="" glietta. won-
der if there's anything on those sheets that wouldn't exist in
memory if it hadn't been written down. still remember the nights
spent out-side her room. and yet the fact that it's written down
makes the difference, encourages associations with things long
past, even with mythology: waking in front of the door is, for
example, hagen's waking outside the hall of the nibelungs.[51]

HAGEN WAKES. LINGUELIETTA

furthermore: through what's been written you have dates that,
although useless, nonetheless satisfy your fetishism. to wit: exact
times record the length of time spent keeping watch before the
door, then time spent sleeping. nights were spent waking and days
sleeping. when you hold the pages now, in the year 1998, in the
room on the ribotte, when you display them, as it were, they offer
information on their own that would likely not be evident if you
didn't have any written record in hand.

nevertheless, the written record doesn't convey the density of
the emotions experienced at the time. there is a mention in the
text of a great, maybe even profound despair. you don't feel it
when you're rereading. it's there in the pages merely as an
empty concept. it's not interesting either. what is interesting is
the association with something else, whether stars, a thought,
a song . . .

4.25 P.M. strange attraction that these signs hold (stenography).
menetekel, the word menetekel is there to be used, so self-
evident and yet no longer used for quite some time. does it have
a verb form? to menetekel?

MENETEKEL (STENOGRAPHY)

the cats are sitting on the pages as if they were blank. they're putting the pages to a completely different use than the expected one. is this the difference between idea and execution? as when you start something with a particular notion in mind and it changes completely in the end? that's the way it always is with work. you start with one plan and that plan almost always changes. but without a plan you'd have nothing at all, even when the initial plan doesn't correspond to the execution. like the cats putting the pages to a completely different use. they're sitting on them. what then would you have liked to do with them? to read them later. later is now. thirty-one years later.

5.30 P.M. strange. from p. 30 on, it gets more dense, that is, once the girl left. a rhythm sets in, the thoughts only pass by her and are no longer directed at her. the thoughts, the sentences meander and are associated with other girls, with other things. there's a net and you can see through its mesh and these stenographic signs are themselves intervals. before, when she and my rival were still in the house, the entries were cramped, embarrassing to read because there was no playfulness.

9.50 P.M. took the path through the forest to the lake. red sky through the trunks of the pine trees. the red light of the setting sun competing with the light from the lamps lining the path. beautifully double-lit. see adam elsheimer,[52] see NY.

12/9/98 saturday

10.40 A.M. read through earlier entries. they're about considering whether or not to give up law for romance studies. and there are already thoughts of perhaps enrolling in an art school. what are you considering now? giving up painting? that doesn't need to be considered in so decisive a manner because the decision will happen on its own, the precipitation of a decision, as in chemistry when a solid is precipitated out from a solution.

PRECIPITATION OF A DECISION

a nice image, the precipitation of a decision. initially there's a solution in which something you can't see is swimming. after the precipitation, you suddenly have solid components that are no longer swimming. a decision is a solidification. before the decision, everything is still possible, afterwards it's solidified. it goes back and forth, but will the letters drop out or fall from the solution and be poured?

6.45 P.M. changed locations. went out to the small glass house by the pool. the screen is just barely legible. last week that resulted in the deletion of an entire file. an operating error caused by excessive brightness. the wind is blowing. sheltered by the glass walls. the west wall can be opened 3 m. you can see the mountains. you're connected to the mountains through the wind. you're much more connected to everything when you're not exposed to the weather's inconveniences. that's what you want: going in the water without getting wet, walking along a ridge without falling.

everything is arranged to be attractive, functional and varied. you see the mountains in front of you, the glass walls are covered with ivy, there is a sandy beach, etc., etc. there are also the plantings, roses, etc., like in stifter's indian summer: everything to measure. is this the way you want things? or do you not want things this way? you do everything to arrange things this way and they actually grow accordingly—then what?

further down, about 200 m northwest of here, they poured a foundation last week: 12 x 18 m. for a building surrounded by trees so that it can't be seen from the outside. it will house the lead plates from the cologne cathedral[53] along with the semen books: 20 years of solitude. in the morning they'll prepare the cement floor and then they can start building the walls. and then? then it will be almost too much. the first rows of stone will still be exciting. and then? the space is most beautiful when it's still an empty one, without walls. afterwards? a lot of buildings are planned along the path through the forest. different sizes, different heights. a few will be glass houses. is this a weakness— wanting to keep things you've made in houses nearby? instead of generously squandering them?

very seductive: building houses. a house, the walls entirely covered with lead books. a house with a pool: sea battles according to khlebnikov.[54] a house with a locomotive coming out of the wall. a house with fallen stars: the stars' names in a bed of water and above it a black sky with stars. a house lined with lead over water, which would be the source of the danube.[55] a glass house with a ruined concrete staircase, impassable, crumpled, with clothing hung from the ceiling: jacob's ladder.[56] there would be places in which the houses are clustered together and others

where they are more widely scattered. it would be nice to create this, but the question remains: what for?

8.20 P.M. too dark to read. night is falling. you can still see the mountains. the wind whistles softly—it's more of a whisper— around the glass house. strange music. when the ribotte was being rebuilt (1992), there was wonderful music one night coming from the pipes in one of the frameworks near the office. peruvian pipes.

outside it's very inhospitable. heavy clouds have rolled in. it must be beautiful to be in the glasshouse in stormy weather.

read entries from 1987, that was the exhibition in chicago. everything written there is easy to recall. the snow over newfoundland, the buildings in the city. the ideas for future pictures. it all measures up. eleven years since then.

13/9/98 sunday

12.45 P.M. read entries from 1965 to 66 this morning, with excerpts from bonjour tristesse,[57] words with annotations, words unknown at the time that had to be looked up and learnt. strange: some of them are still or are once again familiar, some not at all, as if they'd never been heard before. can clearly feel that the meanings of a few of the words have shifted a bit, probably because they've been used in the years since then. it's always like that with a foreign language: you'll never know some words, others remain pallid, and all these words always seem to come from a dark tunnel or a cave, whose size and depth you'll never know. they emerge as familiar words and disappear back in. at other times they seem unfamiliar and stay out a bit longer, some even stay out for ever (what is for ever?)

WORDS

it's a bit like with the laptop: the words (letters) that all sink down into it and are stored. you can't see them if you don't know the word (the file) and if you don't conform exactly. but don't they ever change? they also take on different contours with time.

15/9/98 tuesday

1 P.M. rib

2.20 P.M. chest x-ray in montpelier yesterday. left seventh rib is broken. it happened in the fall on the terrace last monday. it was raining and the metal on the small ramp to the flat door was slippery. at first there was no serious effect, but on sunday the pain increased and now you know it's a broken rib.

BROKEN RIB

the feeling this incident has triggered is one of ambivalence. on the one hand, of course it's a bother—the pain, the limited freedom of movement—but on the other it's a welcome excuse for more weeks, if not months, of inactivity, especially now, when things should have picked up again at the end of summer.

in the time when you can't paint because of the broken rib, the time in which you not only won't be painting but will be writing, draws closer. an advent season. actually, the time isn't drawing closer, we're passing from one particular time into another (one that will be filled will something else). nevertheless, you still say, the time will come when . . . or: hard times are coming. in such phrases, the word 'time' is always burdened with contents. you see yourself at a fixed point towards which something is approaching. 'hard times are coming' or, if it's in the past, 'those were times'. although it's more the case that you go through time and encounter something. that's not quite right either, because it would mean that the harder times had already come, although to be encountered in a later space. how is it really? do harder

times come to you or do you go to meet them? the nibelungs went towards harder times. they could have stayed home and even reversed course after it had become clear that things would be difficult (the water-maidens didn't rise from the waters for nothing). yet this example shows perfectly that it doesn't matter if times come to you or if you go towards them. because it makes no difference with regard to the particular destiny being fulfilled. the nibelungs' actions (or you could say: interference) didn't change anything. you could also say that when you go towards harder times, you take the initiative (for example, you could turn back or change direction), but it's not the case with them. they could have stayed home and waited until hard times came to them instead of setting forth to meet them.

HARDER TIMES. SONG OF THE NIBELUNGS

therefore: wait until the seventh rib has healed. then you can see if the time has come when painting is done with. or seen differently: if you've gone so far that there's no more painting.

in the meantime they're digging ditches in the forest for power lines to the future buildings to house prospective sculptures and paintings. or will they be future empty spaces with only a chair and a laptop? because things always turn out differently.

paradox: at a time when you seem to have reached a turning point (painting instead of writing, no: writing instead of painting), you suddenly undertake things that call the turn completely into question: the construction of buildings to house new paintings. the time is right for it: since the broken rib makes painting impossible, you have time for to plan and oversee the construction of new buildings.

maybe the new buildings are also meant for a time when, after a period of writing, you've begun painting again. then they would-n't be new buildings but old ones, and it's easier to work in old buildings anyway as they don't place the responsibility for the architecture on you. then there's the associated question: just as, in times when you're not painting, you prepare for times when you will paint again, can you prepare in times when you are paint-ing for later periods of writing? no.

because then you're complete. you saw that last year when noth-ing was written. nothing remains. does anything remain when you write? yes. activities don't interfere with writing, but does writing interfere with painting? yes. because reflections on a painting are bound to the hand.

HAND-BOUND REFLECTIONS

and if you take your hand from a painting and place it on the key-board, it's no longer with the painting. and when it's no longer with the painting, there's a disturbance. of course, there are always disturbances when you're painting, even without writing. then it's good to write because that disturbance has already come. writing doesn't eliminate the disturbance but it lets the painting and, with it, the disturbance, fall. fallen paintings.

FALLEN PAINTINGS

you let the painting fall. you could also say: you let it rest. and you can best let the painting fall by moving the hand that was working on the painting to the keyboard. if you give up painting completely and only write, is it a constantly falling painting? and

where do the paintings rise again? because everything let fall like that rises again.

it's not a decision, therefore (if there ever is one except in the military and even that should be examined, see alexander, but that's going too far off track), it's therefore not a decision between painting or writing but a cycle that can be briefly summarized:

disturbance while painting

reflections via letters

the painting falls

apparent final abandonment of painting

constant falling of the painting (or paintings)

the painting rises

disturbance and it all begins again

there is a small and a large rhythm in which all this takes place: the entire cycle plays out over years and within the extensive rhythm, it plays out again within the span of a day or even an hour.

7.35 P.M. while meditating, had the idea of tearing the new buildings' foundations out of the ground again and loading them on beams or pallets, then pouring lead on the corners to weigh them down so they don't rise any higher.

then a house for a lead tongue, about 6 m high with a floor area of c.5 x 7 m. the tongue should almost touch the floor. the floor should be poured with a declivity so that water will collect in a puddle, a small sea in which almost the entire length of the tongue is reflected. possibly covering the concrete with a layer of sand or round pebbles like a riverbed. it's also worth considering if you couldn't build a glass house around the tongue. title: the indigene.

THE INDIGENE

another house: with a pool and above it the table and chairs. khlebnikov's new doctrine of war, of time, of the dimension of the world, etc.

should all this be made? something that has existed for a long time as an idea? we'll see.

17/9/98 thursday

10.45 A.M. underground cables are being laid on the property again. this time from the office down to the gate. for the new building at the edge of the property. water pipes are also being laid in the ditches, for fresh water as well as for sewage. a ditch almost 80 cm deep, then a bed of sand and all the cables, at least eight pipes, then two concrete pillars will be torn down that had supported the cameras and projectors along with the electric and telephone wires above the property. because the pillars ruined the view of the cévennes. did they really? yes, because the relationship between the cables and the poles wasn't right. if there had been a lot of cables as there were in pittsburgh, for example, a web of cables, of tangles, if there had been tangles in the sky, then the poles wouldn't have seemed so important and you'd have enjoyed the tangles in the sky. but these poles are pathetic since there's almost nothing hanging from them. so the cables will be buried. there are already quite a few cables in the ground, some of them already forgotten, there are also sewage pipes and some intersected by the new ditches. so on the property there's always something being built and something else being taken apart.

11.55 A.M. read in the history of great revolutions, especially about those that involved regicide. it's interesting to see what sophistry was used to decapitate the king. it wasn't easy, so people had to put in some mental effort to reach the desired conclusion. the intellectual processes are marvellous, like the purely intellectual motions in paul valéry's monsieur teste.[58] it's just that these beautiful movements of mind caused blood to be shed. are they even more beautiful for that?

what's particularly interesting is how things are turned around with effective sophistry: the king's defendant de sèze pointed to the exceptional status of the king, the immunity guaranteed in the constitution.[59] sacredness of the king.

SACREDNESS OF THE KING, from which follows: SACREDNESS OF THE REVOLUTION

GUILLOTINE

yet exactly this, the king's sanctity, is used as an argument for sending him to the guillotine. because when the revolution replaces an absolute king through regicide, it itself becomes an absolute (the highest being).

robespierre: through his inviolability, the king had removed himself from the register of the citizens. he therefore cannot be tried in an ordinary court of law. his very crimes make it impossible for him to be considered an ordinary citizen.

once again robespierre on 3/12/1792. the king denounced the people of france as rebels. but victory and the people of france have determined that the king is the rebel and from this it follows that the king need not be tried, he has already been condemned. for as long as the king was not condemned, the republic could not be absolved. someone must be the rebel and that is the king. it is not necessary to render a verdict for or against a person, but to act in the public's interest.

all these deliberations can be read as purely intellectual operations, as hair-splitting sophistry. and those are always the most

real, the deepest and wisest deliberations. one must simply examine whether or not they are more wonderful when seen in connection with their actual consequences. it's probably the case that, in absence of the guillotine, this hair-splitting would lose its importance. does the guillotine make these deliberations more beautiful or more ugly? one thing is certain: that no one would have taken any notice of them, they probably wouldn't have been recorded if they hadn't had 'ultimate' consequences for someone. human blood makes thoughts more permanent. heroes, stars, mythical figures are more easily created when the ultimate 'finality' is involved. see evita, diana, james dean . . . if human blood is at risk, the outcome is different. it also has to do with the tradition of sacrifice. in some places, there is still the custom of burying at least a dog or a cat in the foundation of a house when laying the cornerstone. the sacrifice of a living crea-ture is meant to assist the successful building of the house. the jews then replaced such sacrifice, human sacrifice, with intellec-tualized sacrifice. men initially used an animal then later said that wine represented blood. and so completely intellectualized or not? after all, wars were fought over the meaning of the words 'represent' and 'is', so here, too, blood is central. just as the great revolution believed blood had to play a central role, even the most purely intellectual constructs are bound to the more primitive, to the full-blooded, despite the fact that the guillotine was meant to introduce a more humane and faster method of execution, one as fast as the speed of thought, if you will.

18/9/98

12.25 P.M. still on the great revolution, the transference of sanc-
tity from the king to the people, to the revolution.

louis XVI: in france, the nation does not constitute a separate
body, it is represented only in the person of the king. that is, the
phantasmagoric identification of an abstraction with a person.
the king not only represents the state symbolically, the king is
the state. state and king are identical.

KING = STATE. MONARCH = INCARNATION OF THE NATION

EUCHARIST

the monarch represents an incarnation of the nation. and this
earthly presence makes the monarchical mystery appear inti-
mately related to the eucharist. the execution of the king is
meant to annul this.

louis must die because the fatherland must live.

the king's power was invested with a supernatural legitimization.
that in turn legitimized the destruction of his body.

this body attains monstrous dimensions at the moment when
the regenerated nation casts it out of its community.

the execution of the king is a ceremonial sacrifice, a baptismal
ceremony.

on this republicans and royalists agree.

pope pius VI on 17/6/1793: we are confident that he has exchanged the fragile fleur-de-lis for the lily crown of eternity that the angels have woven for him.

LILIES LILY CROWN

because the king was not put to death by an executioner but by a machine—the guillotine—two things happened: on the one hand, the sanctity of the king was transferred to the machine; on the other, the two polarities were unbound, namely, sovereignty and sentence. for executioners and kings were always associated. the transfer of the terror to a machine enacted the spectacle of reason made law.

GUILLOTINE = REASON

the guillotine is a simple device, built out of simple geometric forms: rectangle, triangle, circle. instruments of torture, by contrast, are complicated. execution as enacting the law of gravity and geometry, i.e. symbolizing reason.

the brothers goncourt: the scientific observer sees the guillotine as a horizontal plane raised several feet above the ground on which have been erected two perpendiculars separated by a right-angled triangle that falls through a circle onto a sphere and gives it a secant.

d.f.: universal application of an abstract law that ensures an ordered and orderly society.

marat: the head of the tyrant has fallen under the sword of the law . . . the people seemed filled with a serene joy: as though they were taking part in a religious ceremony.[60]

TRANSFER OF THE SACRED

as an instrument of mob justice, the guillotine claims the sovereignty it stripped from the king when the blade dropped. this reversal of power (the blade's fall) is all the more striking in that it occurs in an instant imperceptible to the eye. the secrecy inherent in the sacred. (pp. 76–7 in daniel arasse: the guillotine and the terror.)[61]

p. 79: report of the execution with exact timing.

p. 83: the execution of the king gave rise to a new ideology: the body of the people.

THE BODY OF THE PEOPLE

the behaviour of the people should therefore determine the theory's truth.

THE KING'S BLOOD

p. 84: the assembly and the place de la révolution are two different planes.

the metaphor: the sword of law and the guillotine are not the same because, in that moment, when the king's blood not only waters 'the furrows' but is actually shed on the place of execu-

tion, it changes its nature. as soon as the king's head has fallen, the crowds push forward, dip their hands, pikes, sabres and bits of cloth in his blood. some even hawk locks of his hair and pieces of his clothing. an englishman sends a handkerchief dipped in the king's blood to london, where it is hoisted on the tower as a flag. others dip envelopes in his blood and skewer them onto their sabres.

recollection of a lecture on the 'logical second' in criminal law: the priest gives the executioner the signal to proceed immediately after absolution has been given, so that the condemned could not sin in the instant between absolution and execution. d.j. a sequence of events that happen so close to one another that there is no question of intervening time, although they do, theoretically, occur one after the other. assuming then that the condemned has an understandable desire for revenge against his executioner, which he doesn't abandon even in the face of death, the absolution must therefore be granted in the very last moment so that there is no time between the absolution and the fall of the blade. the blade's fall must also happen in a 'logical second'

LOGICAL SECOND

because as the blade falls (after the confessor has given the executioner the signal), there is still enough time, even if only a fraction of a second, to think of revenge. not enough for an entire thought, but the incipient thought could be sufficiently formed in the time it takes for the blade to speed down. the prisoner may not have ended his vengeful thought while the priest grants absolution, but could have sustained it through the sacrament

and up until his head was severed. and even a severed head could think of revenge, as the head is apparently still alive for a certain time after it has been cut off. that's why they had the heads drop into baskets filled with sawdust, to lessen the pain caused by the drop onto the hard surface. whether or not a severed head is still capable of sinning is, therefore, a theological question to be settled.

SEVERED HEAD CAPABLE OF SIN?

19/9/98

10 A.M. continued with daniel arasse's guillotine.

12.25 P.M. roosters crowing (there must be a new rooster in the neighbourhood). there's a charlotte von stein biography by doris maurer[62] that I started reading about an hour ago.

both of them, the rooster and goethe in weimar: from olden days. strange how two very different things can project similar longings into the past and the future.

6.25 P.M. greek lesson the day before yesterday: the melody of the language. why melody? it's more than melody, its sound awakens something. it calls up a longing that is difficult to express and is also associated with very different things like black pine and martin heidegger or the cuckoo's cry, something distant yet intimate.

GREEK LANGUAGE

went to bâtiment C yesterday and thought about the proportions of the new building on the way there through the forest. strange, delight in the imagined building set in, delight in the imagined space. whereby the finished, filled room in bâtiment C will be emptied, returned to an unfinished state, to help in determining the proportions of the future space.

EMPTY SPACE

yesterday, had the idea for the women of the revolution, that is, to install beds in various houses in the forest and fit them with water pipes and an underground network, through which the water, the fluid, flows. the simultaneity of the salons. the source could be in one house, from which you could see a little water flow, very gently. the water would then be piped underground to the other houses.

THE WOMEN OF THE REVOLUTION[63]

another idea: a blood pump, dialysis = cleansing blood with the guillotine (represented with a knife, perhaps lying on a table). otherwise a dialysis machine cleansing the 'people's body'.

DIALYSIS GUILLOTINE CLEANSING THE PEOPLE'S BODY

a house with electrolysis basins = the dead sea. a lead picture, covered with salt, leaning against the wall as the dead sea lifted into the third dimension. a dead sea turned into a picture

THE DEAD SEA

21/9/98 monday

flew to laguiole yesterday, over the once lonely valleys of the cévennes, back before any roads had been built. back then, the distance from one valley to another could be an entire journey. back then, the next valley existed only in the imagination. the road from one valley to another was an adventure, a story, the beginning of a mythology, maybe even: *mary wandered through a thorny wood making her way to anna . . .*[64]

MARY'S WAY TO ANNA

that's how it should be with the paths and buildings on the property: paths should be suggested, implied or created so as to signify or mean something, they should allude to something specific. like the labels on the pictures, with a model in each house to provide the context. joseph is taken to egypt, the exodus, etc. . . .

see the girl's diary found in the attic in Ho when we moved into the house, the way she referred to trips of only 10 km to the next small town as undertakings. completely different senses of space and experience.

3.50 P.M. rib is healing. part of it will grow together again, part never will. the period of 'inactivity' has been extended. wonderful feeling of suspension in the uncertain. luxury.

there's no need to make any decisions. everything is possible. like the beginning of a construction project, moving into a new, still-unfurnished home. it's all projection. at some point the

projection becomes stale, the dreaming empty. now and then you need to find a foothold, stability, a cornerstone.

and thus it's no longer so much an image of systole and diastole but an image of fluidity and solidity.

FLUIDITY—SOLIDITY

letter to daniel arasse[65]

thank you very much for your book about the guillotine. i've just read it and it was an enormous inspiration for me.

i particularly admire how you were able to gather a multitude of ideas around a single object (the guillotine) thus creating a symbol that is at once simple and infinitely complex, which is what artists attempt to do in their work. that is why i found quite a few thoughts profoundly related to my way of working. reading your book, i became even more convinced that we will work well together on our future book.[66]

especially where the boundary between thought and action (you could also say between art and life) begins to waver (begins to melt), where it's no longer clear if the decapitations are executed as theatre or if the decapitations, intended or not, have become theatre. or where it's no longer clear if the arguments advanced by robespierre (for guillotining the king) and saint-just are more beautiful when no blood is shed or when blood is shed. besides, a few days ago i found a text I'd written more than 10 years ago reflecting the arguments of robespierre and saint-just. they are so sophisticated, so 'art for art's sake', that they reminded me of monsieur teste's pure movements of intellect. and that

prompts the question of whether or not these intellectual acrobatics become even more beautiful if they lead to reality, whether these thoughts are embellished by blood??? more on these subjects when we meet!

until then, thank you once again for such inspiring reading.

26/9/98 Amalfi

4.40 P.M. Staying with M. and T., about 1 or 2 km from Amalfi. You see the houses of Amalfi in the late afternoon sunlight, affixed to the steep cliff face about 10 metres above sea level. Almost without volume, like a backdrop, since they are built one on top of the other. In the next bay, of which you can only see a very small part, is Atrani, a wonderful spot we visited at night several years ago. You can see the road to Salerno, scratched into the cliff, ascending gradually until it's no longer visible as it rounds the cliff and disappears into the next bay. There are still more fine scratches leading up the cliffs: other roads that access very small houses barely visible from here. Then, at a distance of about 20 km (or 15 km as the crow flies), you see Salerno as a subtle hint on the horizon. In late afternoon, the sea and the sky are the same colour, so this soft line would float in the air if there weren't a rock spur to the left by which it appears to have been shifted upward a bit (1 mm). Amalfi was once one of the four maritime republics of Italy, along with Genoa, Venice and Pisa. Strange: the steepness of the cliffs doesn't give an impression of arduousness or toil (as it does in Naples or in the Cévennes), nor of poverty. Because of the attractively shaped houses that are so wonderfully suspended one over the other, the impression is instead one of a continuous performance (stage scenery). Representations of variations on beauty, yes, a growing awareness of luxury, of something, in any case, that sets in only once the other—hardship, worry—is overcome. Or is it in fact the case that here hardship is simply bypassed? In contrast, those meagre, badly proportioned, gloomy houses in the valleys of the Cévennes: inhospitable, isolated, neglected. Also there's no helpful, warming, counterbalancing sea

there. Here, the sea, the surface of the sea, is the parquet from which you can see the structures (artifices, edifices), because even if you're not on a boat, it's always as if your view-point were the sea because there are so many peninsulas, like giant oriels from which you can look at the cultures, the cliff faces, the white bands of houses, perforated with small window holes, that nestle against the rock.— A bus drives along the road above and honks before every curve. This gives rise to a sequence of noises (the alternating honk that only Italian buses have) as if strung along a timeline with several directions, because the road is constantly winding along the mountainside, into the bays and back out again and circumscribing every peninsula. This creates a strange space formed by this sound.— Not far from here is the Villa Rufulo where Goethe stayed; odd that I'm currently reading the biography of Charlotte von Stein.

From another time (1963 or 1964). Why, after a length of time, you didn't leave a place (Ho) which had probably lasted much too long as a condition. Such comparisons are nonsense, of course, but doesn't the fact that they are drawn signify something? The incompleteness (openness—like an open wound) of the person who draws them. You could also say: peering up at a higher level that is probably not (or certainly not) yours. Because there are different levels, not one that could be objectified.

5.50 P.M. It's already evening. The bands of houses are as bright as usual, but the window holes have grown deeper (like Rembrandt's eyes in his self-portraits). This transformation is strange, but actually also logical, since the cubical houses have also grown bigger. You can't actually talk about bands of houses any more. The buildings are no longer suspended one over the

other but, rather, next to one another. You can see the dimensions of the individual houses in the different light, now changing rapidly. (Writing, you can hardly keep pace . . .) And so the window holes have naturally also grown deeper, empty but deep, deep voids.

28/9/98 Amalfi

4 P.M. On a plane from Amalfi to Salerno. All the houses in the valley seen from above: Salerno, Herculaneum, the industrial district of Naples, etc. Buildings scattered everywhere without any plan. Wherever they landed. Anywhere and everywhere. Fewer higher up the mountain and almost none on the peaks. But wherever there was space, level ground from which nothing could roll down, something was built. Motorways winding between them. You can see all of it from the mountains and it doesn't stop as far as the eye can see, from one shore to the next because you can see part of the two gulfs, the Gulf of Naples and the Gulf of Salerno.

Housing density and spirit level

There is nothing left, so to speak. Something was sown wherever there was level ground. And so the measure of housing density can be seen as a contour line, like the line on a spirit level → just as the line drawn along the shore of a reservoir is always horizontal because of the nature of water (spirit level) or as a snow line. There, above a certain altitude there's snow; here, above a certain altitude there are fewer houses.— Then we took the motorway to the airport.— In the plane, the centre of Naples seen from above: the hotel we always stayed in, Capodi-monte where the woodcuts were hung, Pozzuoli . . . On the beach, white waves rolled in in rows of three. The three white lines, grouped irregularly over a span of 100–150 m, form a very narrow band compared to the length of the entire sea all the way to the African coast: 0.1–2,000 km.

2 P.M. Over Corsica. The white band of waves around the island, more in the north than in the south. Again and again, you feel something close to astonishment at the amount of water in the seas, even though you were already aware of it.— The whitecaps on the open sea below appear static, they don't seem to move. And yet, you know that's where the greatest movement is, there's no stillness. The waves are terribly violent. From up here, they're white dots a naive painter has set on the blue surface with a fine paintbrush. When you're standing on the beach, you never know where they come from. They could be coming from far away, from the centre of a distant storm.— Stayed at M. and T.'s house on the water. Fri., Sat., Sun., left today, Mon., Sat. and Sun. were family days with their parents and new baby (seven people). It's strange to see something that you no longer have (never had). They visit one another, eat, watch television, talk loudly. Understand one another (?), share (what exactly?). Most of all it's the matter of factness with which all the family members belong regardless of their particular characteristics. A belonging independent of merit. An actuality without justification. Apparently, the mother's authority is not necessary (although strongly present) as surety for this 'system' of unequivocal identification. A constellation that the expression 'blood ties' does not quite capture.

29/9/98 St Émilion

Last night, took a walk through the city. The illuminated lime-
stone facades were marvellous. There were beautiful chateaux
with lovely proportions everywhere on the drive in from the air-
port, and they're here in this small city too. Situated in a narrow
basin, houses climb the hillsides and the larger houses (like our
hotel) lie on the basin's edge. So, along the edge of the basin,
you see the houses rising up the hillsides, their roofs as dark as
the night sky—like enormous sleeping animals. Strange unre-
ality of this wonderful image. The mysteriously illuminated
facades, like houses stacked on a slanting stage, the lack of any
modern additions (neon, billboard . . .). The profound stillness,
not a window to be seen. Desolation. When you looked out
from the edge of the basin, you saw countryside, rarely a farm.
This increased the impression of a backdrop: the presentation
of the city stopped abruptly at the limit of the lighting, it was
not as elsewhere, an old core surrounded by growth. Here there
were only as many buildings as were necessary to create the
'desired' effect. Now, by daylight—it's 10.45—from the hotel-
room balcony, you can see the light fixtures attached to the sides
of the houses. It's a truly skilled job, finding the particular inten-
sity for each spotlight and setting it at the proper angle to the
wall to get an exact amount of illumination, not too much and
not too little. By day it really does look like an abandoned set.
Illusion and disenchantment.

6.55 P.M. Saw the vineyards and the wine press with the cuvées.
Saint Émilion: Magdelaine, Moulin du Cadet, Cheval blanc; then
Pomerol: La Fleur-Pétrus, La Fleur-Gazin, Lagrange; then Canon
Fronsac: Canon, Milary. Each section of land corresponds to a

cuvée. Some cuvées, e.g. with Pétrus, don't meet the expected level of quality and so have to be released, which means they become wines without a cuvée classée. The wine is harvested, then pumped into vats. They wait until fermentation begins (after one to three days) and the marc (skins of the grapes) rises and builds a crust that is doused twice a day with the juice from the grapes so that the marc doesn't begin to rot.

The temperature must be controlled at this critical time (not higher than 82°F, not lower than 68). The winemaker can tell by tasting the grape juice whether it will be a good wine or a very good wine. It's a matter of long experience, intuition and modern measuring techniques. The timing of the harvest is very important. Too late and the wine will be too fruity, too early and it won't have any taste. If it rains just before or during the harvest, there won't be any wine of the highest quality. Then the goal is missed, that is, you've got a wine no one talks about. It will be combined with other locations for a *vin simple*, i.e. a loss.—

The cellars are all extremely clean because bacteria can interrupt the process of fermentation, after which it's extraordinarily difficult to get it started again. In the worst case, the sugars that have not yet turned into alcohol are consumed by bacteria. The result is vinegar, but this rarely happens. Just as rarely, someone might fall into the vat, which means immediate death due to the pure CO_2 created by the fermentation. Rescuing him is not possible because the CO_2 works at once. SO_2 is added to the juice right when it's being moved (pumped) into the vat to stabilize it. The amount is precisely calculated according to the condition of the grapes. If a few are overripe and beginning to

rot, you need more SO_2. There are steel vats and concrete vats. The concrete ones are better because the rough interior helps prevent the marc (crust) from slipping down. Also there's less ionic migration (electro-lysis) that could harm the wine slightly. After the primary fermentation (10 days), the wine is transferred to barrels for 18 months. There it ferments a second time. After this it is poured into bottles.—

Everything involved—buildings, the wine press, the instruments—are very solid. Everything has its place, is taken care of, is kept in the best possible condition (even the (new) roof timbering, for example), and emits, you could say, a sense of order, of rightness, of impassivity, of practicality. In short, what is called bourgeois, although there are also aristocratic vineyards, of course. You can admire this, but it's difficult to learn all the rules and conventions because the strongest agreements are not immediately visible. And this state of contingency covers the entire country. You can feel it even before your plane lands. This is an extremely refined culture that revolves around itself, like Chinese high culture. Who else knows the differences between the different years, the individual domaines, the various cuvées? The comparison with China is clumsy because today there's international attention. The Americans and the English are greater connoisseurs than the French. And in many countries, in Japan, in Germany, people adopt the high culture of Bordeaux to take part in something they don't really have. You can't improve the soil, and the wine can only be as good as the soil. That has something aristocratic about, this aspect of being born with a quality that can't be changed. To be sure, you can produce a merely simple wine from good soil, for example, when you harvest too early or too late, but you can never produce a

good wine from mediocre soil. To test the soil, Christian puts some in his mouth and chews. That, too, is an attribute of nobility: you can be born into a certain class, but you are also obliged to do something not for it but because of it. So, when you have good soil, you must do something because of it, but there is nothing that can be done for good soil.

30/9/98

9.50 A.M. In the plane, just before landing in Montpellier. The towns and cities down below: the core with interlocking houses all crowded together and in the suburbs, loosely spaced houses surrounded with land: isolated. The historical development: ever more isolation up to TV and TT.

2/10/98

3.55 P.M. back from a short trip to milan, amalfi, bordeaux. in
milan, houses are big, solid, sometimes threatening. tall and
heavy like the nearby alps, you could say. in amalfi, the houses
are sewn right onto the mountainsides or else they'd tumble
down. perforated with windows. in bordeaux, the houses are
bourgeois. st émilion, a well-designed wine label.

in the small glasshouse until evening. shifting rainclouds over
the mountains. at one point the cloud bank stopped exactly over
the second row of mountains so that their sides were lit up by
the sun. and because no light made it through the clouds in front
of them, the mountains further back became especially momen
tous. hallowed (promised). at that place another world began, a
stage, elevated by the special illumination.

ILLUMINATION

on the one hand, the illumination restricted the view. on the
other, the light made the mountains extend into the distance.

3/10/98 saturday

11.35 A.M. blue sky, just a few clouds over the mountains. the heat is returning. the birds are singing early again, as if it were six in the morning in high summer. a time when there are signs of the heat's approach, but it hasn't yet arrived. but you know spring won't turn to summer today. the shadows are too long. the light is not summer's light.

the fourth row of mountains is blue (almost as blue as the sky), from there the blue turns greener, each row of mountains has a bit more green to it, the closer it is, right up to this little glass house, where it's completely green. although a few trees already have colourful autumn leaves. there's no turning back. summer isn't completely over, it will return, but there's no way to know if you'll still be here. so this seasonal 'over' always carries the potential of being an absolute ending. that makes it so precious and that's why you don't want to miss a single one of its various hues.

OVER

fall colours, like all colours, actually first develop through their connection to this 'over'. oddly, the colours of blossoms (as, for example, in the poppy fields) don't evoke in your conscious as strong a sense of a final 'over', although blossoms themselves and particularly poppies in bloom should remind you of this finality because they bloom for such a short time. they don't. why? this brief blooming is not a passing as much as an explosion, a blaze, a transformation you can see when you look at the blossom: you can see the seeds form, seeds that already contain

new life. and each flower, as is well known, corresponds to a particular star (robert fludd). and when you see the stars, do you first think of the 'finally over'? no, you don't think of 'over' or of 'past', but 'into', into a completely different times which defy such categories.

ROBERT FLUDD PLANTS FLOWERS STARS

NOON. in the small glass house is a thick book with reproductions of the paintings in the prado. always more interested in these 'old' paintings. always more frequently perceiving their connection to what is present in the world (nature). physis—techne.

the solutions for the different worlds in one painting. especially beautiful in el greco, tiepolo, tintoretto. in their paintings, it's mostly the worlds from below and above. now you can no longer say below and above as easily. cf. ottersdorf, when a woman from the village explained during a thunderstorm, that it was god . . . didn't believe it even back then.

how can you represent the world on different levels in a painting today without lapsing into the no-longer-comprehensible division of above and below, and without painting an abstract picture?

7 P.M. in the glass house after a sauna. what a marvellous sky! there's a rising wedge-shaped cloud over the valley, so that you can see the sunset over the mountains where the cloud tapers. evening in october.

OCTOBER EVENING

just read a nice aperçu about ernst jünger: in the wink of an eye, he transforms chronological time into geometric orders, into a system of writing, an ordering of butterflies, of the day, of life, of history. for him writing was an autopsy of the moment.

ernst jünger: there is no more history, only homesickness for it. a mourning like that of achilles over the corpse of patrocles. in the end, the hero must wear jeans like the rest of the world.

when the entire future is already the past, there is no defeat. even a lost election is history. this in a comparison of kohl with ernst jünger.[67]

7.35 P.M. it's still red above the mountain. better red than dead. the green in the foreground turns to night. the leaves of the aspen that otherwise flutter lightly, rise up beautifully towards the red sky. the screen grows ever brighter. the birds are still chirping.

4/10/98 sunday

7.15 P.M. the light is different every evening. dense layers of clouds above the mountains, so thin that the red light of the setting sun pierces it and again, lights a fire behind the mountains. the sun itself only visible as a red scrap. the flap of a wound. the mountains are violet and the green in front of the glass house has darkened. did yoga earlier, saw the sky and noted it down. but what does 'noted down' mean? there's nothing left of what was. it was only 'noted down' because it was so strong. and what does 'because it was so strong' mean? it means that there was no correlation between natural beauty and you. what is your role in this? you're the one who would like to grasp it, to preserve it, otherwise it doesn't seem bearable. and that in turn means that there's no correlation between natural beauty and you because you are flawed. flawed in the sense of being open to an impossible correlation. a gaping wound.

NATURAL BEAUTY. IMPOSSIBLE CORRELATION OR GRASPING IT

odd that the beauty of art seems to satisfy this longing. you can linger over a figure by manet or munch or keep returning to it. it's there. this evening's sky is gone. now, at 7.30, it's gone. in order for it to be gone, it must have been here? no, it was never here. it was an occurrence. when something occurs, isn't it present? no, it passes and you were (by chance) there when it passed. the occurrences flee. and when sunsets occur, you'd like to run after them. you'd like to absorb them, to come to agreement with them.

AGREEMENT IMPOSSIBLE, THE OUTCOME: LONGING

but that won't work and you know it from the beginning. and because you know it, you're addicted.

7.45 P.M. tomorrow the concrete steps that were poured two weeks ago were stripped, then raised with a crane and let drop until they could no longer be climbed. jacob's ladder. a glass house is being built around it. perhaps with one or more glass display cases, for clothing, etc. . . . why, it's easy to ask, have the stairs been destroyed? if they weren't destroyed, they'd be point-less. you could do that, too, of course: make stairs that rise up to the glass ceiling and then stop. but that would surely be too simple. what, then, is a staircase lying on the ground? a staircase that's broken into pieces? a staircase in fragments is no longer obvious. you could also gather the pieces of the staircase into a pile.

tomorrow we'll see what was poured in with the concrete. con-crete is also used to isolate radioactive material. you seal it in. there's a correlation with lead as far as radiation absorption is concerned.

it wouldn't be surprising if tomorrow's result had almost nothing to do with stairs.

of course, angels are also associated with jacob's ladder. and so the clothing, you could you lay them between the blocks of concrete (layers, that is). piled up. as in the painting of the lost ones. but that would be a work of its own.

what you could combine with the pieces of stairs are the coat racks, filled with coats. this would be the angels' camp.

or you could set the individual pieces of concrete on trestles, as if in preparation for further work. a preparation for departure, so to speak.

but everything depends on how it turns out tomorrow.

5/10/98 monday

7.35 P.M. as every evening in the glass house with my laptop, facing the mountains, about which there's nothing to say today. you'd like to say every evening, although there's only been three or four such evenings so far. every evening—that catches you in a net, every habit, every possible habit, you turn everything you possibly can into a habit, just as in each strange city you start to take certain paths after a very short period of time, you follow only the tiniest fraction of the possible ways, and then you think you know the city. and now it's the glass house you're sitting in with your laptop, writing something after having done yoga.

the concrete stairs are lifted from the slope, torn from the earth, so to speak, and the pieces are piled one on top of the other. it looks quite beautiful. if something is fun, then there are naturally also doubts—whether or not it's not for the wrong reasons. for example, the joy of this action could originate from the memory of a work of art you'd seen earlier, one made by another artist, and it's the memory that enchants. you're confusing yourself with another, in other words.

you could also place the pieces of stairs on shelves as you'd tried to do with the waves back then, but nothing came of it.

the idea of putting stairs on shelves is not without its attractions. creating a pile. that creates height. you're putting the stairs to unusual use.

you could also place two pieces of stairs across from each other and let the stairs lead ad absurdum. because the stairs don't actually lead anywhere. once you get to the top, you have to come back down immediately. it would be best to leave the rein-forcing bars sticking out sideways with a small sign on each of them, valentinus' 31 steps, for example.[68]

6/10/98 tuesday

6.40 P.M. the sun is shining so brightly that hardly anything is visible on the screen. you write blindly, of course, still . . .

new stairs were planked and reinforced with iron. they'll be poured tomorrow. the foundation thinner this time, all of it more delicate. until it breaks. it will be easier to bend after the break because it will have more reinforcement. Structural plans for a building.

STRUCTURAL PLANS

the sun hidden by the clouds again, and so it's easier to read the screen.

SCREEN

while doing yoga, the sun was in front of the aspen (with leaves lightly rattling in the wind), hiding the leaves in its glare.

the pool is still heated. as if you were still going to go in the water this autumn. that amount of water can't be adequately heated any more. the heater is still on. it would be easy to turn it off, but you don't like to admit that it's over. you think that with that amount of water flowing, heated, into large pools, you're still a bit close to summer.

7/10/98 wednesday

6.20 P.M. read about george forster's trip to the south pole with walter scott.[69] meagre descriptions that still offer benchmarks for imagining the unimaginable.

the broken cameras in the closed-circuit system have been repaired. two new ones to observe the enlarged platform were tested. the oddly easy joy of these games. you like to see a reproduction of something you already know well from close observation. just as you like to fly in a helicopter over an area you know 'from the ground up'. you go for an abstraction of something you know when you fly. with cameras, you go for a picture of something you know in real life.

printed a letter. for a while now, things have been printed differently: the characters look different and the line spacing is greater. this means that the page breaks don't match. until now you started a new page each day. now the characters are completely different. because you can choose a new font each time, there's no more fetishizing the written. it has to be called up each time and printed anew.

what else happened today? continued work on the large painting of constellation with the waterbed, the fallen stars and the alkahest.

9/10/98 friday

11.05 A.M. yesterday the habit was broken. better: the habit was interrupted, but today, you fell into it again.

you fell back into an interrupted habit.

what happened yesterday? first in general and then specifically what caused the interruption of the habit? the foundation for a house was excavated in the forest, a foundation that is to be dug out of the ground later. next week, the foundation will be poured and, about a week later, this square concrete frame will be lifted out of the earth. then you'll decide what to do with it. one possibility is to set the concrete frame on beams about 50 cm above the ground, at a slight slant, and then build walls and a roof on it. you can keep in mind tiepolo's painting in which angels carry a house from one place to another.[70]

pouring the foundation in the ground has several connotations: the old song, negative and positive, the theme of the sculptor. also the theme of uncovering or exposing or revealing secrets. what lies hidden in the ground is dug up, brought to light. cf. mining. the earth as shaping force. contour flight.

the aspen rattle in the wind. even in the morning. early this morning, it was 7 degrees. cold.

painted constellation on the painting of the arch that was left outside all summer, in the wind and rain, 265 x 800 cm. wrote the labels yesterday. when this star painting is finished, it will be leant against a wall and in front of it will be a moat with fallen stars or

163

even a strip with the names of all the stars, lightly spinning in the water, the wandering of the stars,[71] or their disintegration and reconstitution out of the liquid, rays can't be obviously depicted because they're invisible. the moat should be as long as the painting is wide, so that none of the stars will fall outside it. the entire thing should be covered with a glass ceiling or contained in a glass house, that should be about 10 m wide but not deeper than 2 m. you can see all of it through the pane of glass, if you stand at a bit of a distance.

12.25 P.M. did yoga. started the pool's pump and turned on the heat. just to see if it's possible to go in the water again. the sky is cloudy, so no warmth from the sun.

6.20 P.M. edith piaf on tv. why is it so moving? as otherwise not possible. with reactions such as tears, goosebumps. strange. it's so other, so removed from me. would never be able to speak with her (the complete opposite with ingeborg bachmann, for example).

what causes this agitation? it's the poverty. the sensed poverty of such reckless, self-immolating extravagance (an explosion of life). memories are simply consumed and not repealed, served up, realized, reworked, expanded . . . the art of profligacy as truth. as the lack of concealment (aletheia). just as lava is uncon-cealed when it erupts from the earth's core and flows out of the crater and down, scorching and burning, until it sizzles in the sea. died in paris in 1963. probably saw her without realizing it. edith piaf: a distant country, a distant time, the complete oppo-site of an insufficient life force. every word, every tone paid for with blood. sentimentalities hammered into the hardness of

steel, no, there were no sentimentalities. that is art—where sentimentality tips into truth.

7.40 P.M. after the sauna. it's night. lighter up in the mountains. there's still a red strip of sunset glow. if there were no clouds, it would be little brighter. so you can say it's night. how is it in new mexico right now? the vast, almost uninhabited land. snow-capped mountains in the distance, a landscape without wrinkles, so to speak. here, in contrast, you have the carefully cultivated land with heights and depths. variously developed, convoluted. there the 'eternal' truths, the distant line of the horizon, sunrise and sunset, each and every day like nothing else. an expanse that has nothing luxurious about it, rather an expanse of neglect, a careless expanse.

10/10/98 saturday

10.20 A.M. fog. to get to the laptop, you have to go the following way (since you fell into and took on the habit of writing in the glass house): from bâtiment B, across the sand and up the slight rise where the glass house stands.

EDITH PIAF

about the song 'je ne regrette rien': when someone is able to say that he doesn't regret anything, there can be several explanations. because of a promethean defiance, perhaps, with a refusal to submit to any rules whatsoever, an insistence on always doing what one wants (although the concept of 'will' should be examined here).

or: because of a fundamentally different concept of time, with no chronological stages one can look back on and say one shouldn't have done it or that you missed this or that. seen from a synchronous, cyclical point of view, everything that occurred was necessary. then you no longer say as often 'it was' but, instead, 'it is': what has become, is. and it is to such an extent that changes aren't possible, not even virtual, retrospective changes. this would, of course, also lead to reflection on the concept of free will. because when you're focused on chronological time, you also give up responsibility. don't you? to be explored later.

or: because one sees oneself as part of a larger text and sees mistakes, good, evil, simply everything interwoven with life itself. or could you say: with being? that would be an eastern attitude.

no, that's not it either, because one doesn't immerse oneself in the bustle as much, one resists being pulled along, instead one holds one's ground and sees events come and go, but only sees them come and go, without being a part of them. so what does it mean, then, when she says, i don't regret a thing?

it's a worshiping of the will itself. pure will, without negation, without idealization, dilution or sublimation. the will as world spirit. pure vitality. without thought? without thought's pallor? without pallor, yes, but without thought? because later the lyrics say that she lit the fire with her memories. that means that she doesn't deign to 'master' the past or to cling sentimentally to anything. she's always moving towards the consuming passion, the next irrationality, the next current that pulls her away.

11.10 A.M. drank from the water bottle. the water was as cold as it was here last night. the water in the tank is not as cold. because of its capacity, it retained some of the day's heat. even if it's not the heat of summer. that would require a much larger volume of water. a sea. the water bottle that retained the night's cold has become an indicator of what happened in my absence. like a time probe.

TIME PROBE DILDO NOVICES OF SAIS[72]

there are all kinds of probes. a dildo is also a kind of probe. hence its wonderful effect on the observer. with that belong the speculations you pursue when a cat returns after being gone for several days. you ask yourself what it could have experienced. you ask this because you can't ask the cat, the animal itself. just as you can't ask the dildo what it experienced in there. and the

novices of sais could no longer be asked what they experienced inside the sanctuary since they went insane there.

and so the water bottle betrays something about changes in temperature at night. when no one was in the glass house. today there are all kinds of technological achievements that can reveal changes inside the body. computed tomography, ultrasound . . .

there's an additional aspect to the dildo that overshadows its particular character. it's not only in a place where you are not (because even if your body part is in there, you're not there yourself because this body part can't see and is completely dumb.) the dildo, then, is not only where you are not, it is at the same time a surrogate. it's a surrogate that can't speak. it's not a herald and yet it's still interesting because it keeps the secret. nevertheless, you project onto it, although naturally nothing will come of it. an extremely pure form of projection.

back to the edith piaf phenomenon:

the extreme effect she has on you comes from this: she is a probe that dives into the pit, into the whirlpool, into the abyss, into the typhoon of passions, into danger, risk, endless profligacy, in other words, she goes where you don't for reasons of proportion and calculation. and she sends messages from places you've never set foot.

you hear a woodpecker some distance away but still on the property and how he drills a hole in the tree.

7.15 P.M. the computer is turned off.

11/10/98 sunday

by chance (?) opened and read the file from november '93 on
the laptop. it's about mountains. yes, the same mountains that
are in front of you now. Naturally, they're not the same ones since
five years have passed. a lot can change in five years, why not
mountains too. above all, the view of the mountains. in autumn
of '93, the question was whether the mountains would remain
foreign mountains. the question remains. on the one hand, the
mountains seem less foreign since you frequently hiked through
them, flew over them, climbed down them and walked in them
between different localities. you only know them from the inside,
so to speak. on the other hand, they will never become moun-
tains like those from olden days. zion, for example, or hebron,
the black forest, the caucasus. because they're associated with
an irretrievable time (from childhood). these mountains are
familiar mountains (even the caucasus, where you've never
been). they're recognized, recurring mountains.

RECURRING MOUNTAINS AS OPPOSED TO FOREIGN MOUNTAINS

in contrast, the cévennes cannot recur because they had no time
to become heavy (that means filled with the emptiness of time,
back when there were still empty spaces).

now you can go into them once or repeatedly and come out
again, but that does not make them recurring mountains.

and that is, in fact, the way it is: you see the mountains and that
pleases you, especially today when they're particularly blue, but
they will never be among those (and in the last five years there

169

would have actually been more than enough time) that you recognize as places you've been before.

11 A.M. was in the forest, there where the foundation was being excavated for the floating house. looked at the negative space one more time and photographed it. they'll do the pouring on monday. then the earth will be closed until it's reopened to extract the foundation. that will destroy the negative space, however, because you can't lift the weight without first exposing the foundation. how, then, can you make it float once the walls and roof have been built, once the house is finished, that is? you can suspend it on an iron girder supported by two pillars. you can place beams or pieces of iron or thick stones under the foundation and set the house upon them. then it won't float but will be ready to be lifted.

you could also just turn it, lay it on its side. that would be enough to present the house as being torn from the earth. like antaeus.[73]

ANTAEUS

establish associations between this house and antaeus

the association of a house with something anthropomorphic?

you could say antaeus lives in this house and is lifted from the ground with his house. with all that's in it.

the form fired from clay is securely walled into the earth.

moving mountains. moving houses.

but in the tiepolo painting, the house was carried by angels. angels like photons, then: attach high-powered floodlights on the corners of the house like angels. or use the welder to create an electric arc, an arc that makes it difficult to get a clear view of the technique used to raise the house and is simultaneously a synonym for angel.

or, and this would be a clumsier but more obvious solution, you could attach leaden wings to the corners. of course, that would be much less intellectual. it would be like a motif and you have to ask yourself if you still want that after all that's happened.

but why not?

we'll see. the best part is you'll see everything at some point.

6.10 P.M. off to paris tomorrow. so had to get the laptop from the glass house and set it up elsewhere. before leaving tomorrow (9.15 a.m.) the concrete stairs that were poured lying flat need to be removed from their forms to decide whether the beads can be mixed into the concrete (as was done with the steps when lying on their side), in order to make the mass 50 per cent lighter. because it should merely have an appearance of heaviness, not be heavy. other-wise we'd have to find an even bigger crane to handle the entire work. the stairs should be usable. we have to be able to turn them, put them upside down, lay them flat and lean them against one another. they should no longer be just stairs, but what? objects that can be newly arranged with other objects. that's why you have to free them from their 'usual' con-text by raising them with a crane, like a pale unconscious woman. the flag, the flag is missing. cornet! and once more, cornet!:

cornet, the flag, the flag is missing . . . but there he is and he's carrying the flag like a pale unconscious woman.

THE FLAG: HE CARRIES IT LIKE A PALE UNCONSCIOUS WOMAN[74]

what must be done to the unshapely concrete stairs to turn them into a white unconscious woman? you could picture them as a flag: by fastening the stairs to a strong iron girder overhead, so that the steps are like folds.

the stairs fastened to an iron girder overhead, with the steps perpendicular to the ground. like the folds of a flag in the wind. what is that? an arcimboldo. there are also flags at half-mast. and the so-called stair rods with which the carpet is secured to each step. that's now become confused with flag poles. stair rails haven't been considered yet. they would bend when the sections of the staircase were piled on top of one another. in a different way than the protruding rebars. what should the railing look like? instead of a railing, you could add a (thin) section of wall, that is, cast it with the steps. because the wall and the stairs are usually one piece. but these are ideas to explore later. another thing to think about later is the bridge on the way from here to alès, about buying the narrow old concrete bridge and using it in fragments. it will surely be replaced soon in any case since it's old. it is cast concrete with steel reinforcing bars and in some spots the steel is showing.

6.45 P.M. now the laptop has to be turned off and moved from the glass house to a secure room because of tomorrow's trip to paris. so then:

16/10/98 Friday

Here since Monday for the fashion show, extraordinarily extravagant. Anticipation (at least feigned), exclusivity (alleged), particular character, uniqueness, the public (flashbulbs popping). Values in the class in which fashion has moved. What is this about? Clothes are presented, clothes for the next six months. They're worn by models chosen especially for them. Then there are reviews in the newspapers. To keep the articles interesting, they help the journalists with more or less eccentric stagings. These productions resemble art. Dance happenings, *tableaux vivants*. But most are like bad stage sets, too much variety. Issey Miyake is an exception. But what about it interests you? Its fleetingness, in 10–15 minutes it's done (actually it's not done—there are private viewings for clients). Its artificiality: the girls don't really look like that, they're fashioned for the moment (τελνμ).[75]

Are these personae in the sense of tragedy? No. There are no roles for them. On the contrary. Some will become celebrities (even without roles). Then eyes will be drawn to them. And people will turn around to look at them. Why? Because many others turn to look at them and turn around again.

18/10/98 Flight Paris → Munich

8.55 A.M. before landing: the orderliness below. The small houses, one next to the other, the fields with precisely delineated hedges. Clear borders. Earlier, on arrival in F: the motorway. Deep grief that it was all starting again: the solidity of the crash barriers, life in Buchen. Today there's something touching, exhilarating about this order that you no longer take as seriously, which is perhaps a mistake, but everything consists of mistakes. The landing gear is already out: a motorway intersection, ant trails. What if the plane were to land on the motorway this time, for a change?

22/10/98 friday

6.15 P.M. it gets dark early, now that the end of october will soon be here. the trees turned colourful as they do every year. and still you write it down, even though it happens every year. there are places that don't have seasons, just think of the equator. or other planets. because there are no seasons at the equator, it's not seasons that differentiate those planets from the earth. it is, rather, the presence of water. but they also have things in common. they all rotate on their own axes and revolve round something else. why can't they stand still? because there is no fixed point. everything within us also spins. electrons round nuclei, and they have a lot of space to spin. a enormous amount of space. the dimensions of a football field compared to the football. and so almost everything is empty, you could say. that means, among other things, that the football must be tremendously heavy. if it weren't so heavy, there couldn't be as much empty space around it. if you assume a personal weight of 70 kg, then the compact mass must be the size of a pinhead. in other words, the 'compact' mass of a pinhead would weigh 70 kg.

A 70 KG PINHEAD

if you were to think about it the other way round, you would calculate a man's weight at several thousand tons. that is, if you were to fill the spaces between electrons. in other words: if you filled the football field with balls, leaving no room for anything else.

all these thoughts are probably nonsense. like those thoughts a few pages earlier about letting the stars drop from the picture into the waterbed.

FALLEN STARS

all of them nonsense. now, after the stay in paris, it's become clear that the star painting, in itself, isn't bad, but the idea with water-filled bed won't work. why should the stars fall in the water? yesterday, placed a small pile of these glass star labels on the floor in front of the picture. some of them broken. that works. water doesn't. the water has nothing to do with the stars. the issue was the dissolution of matter, etc. alkahest. but it doesn't work.

water is different. you have to associate water with something else. for 'the women of the revolution' it was good. it was also good for 'the source of the danube'. a possible new title: 'the unborn'.[76] 'alaric's grave' (old).[77]

7 P.M. fleur jaeggy: we retreat into our room, we've got life through the window, through books. watching strollers pass by. only ever in reflection. a mirror image that seems to have solidified on the window ledge.

very strange, this conception of time. something passes by and becomes a picture. so you can ask yourself what it was with 20a lower mühlenweg. less passed you by, rather, it all collected in a well, like millennial layers of cultural refuse. all still there. nothing reflected. all of it still right in front of you.

23/10/98 saturday

6.40 P.M. fleur jaeggy: 'sweet days of discipline'.[78]

p. 28: a shadow fell over the pastry shop in teufen, as if even the snow were a curtain of shade. outside, wintry gloom. outside, the icy air accompanied us home. the boarding school is our home.

p. 45: frédérique spoke to herself. i saw her moving her lips and staring at something like the void. but how can you picture the void? maybe it's an after-image of that first place.

p. 51: at table i sometimes heard her laugh for no reason, a laugh that haunted me at night. i turned around and saw that everyone's faces were serious.

p. 70: it's enough for a fleeting thought to flash past for it to become your own, but if you don't grab it you feel even more alone than before.

p. 78: the landscape seemed to protect us. the small white appenzell houses. the fountain. the sign *töchterinstitut.* it seemed like a place untouched by human distortion. is it possible to feel lost in such an idyll? the irretrievable hit me on one of the clearest, most beautiful days of the year. i had lost frédérique.

p. 79: the ink faded . . . fréderique's words were headed for burial. we can mark some words with a cross and file them in our minds on index cards.

p. 82: sometimes i would go to the little train station in teufen . . . farewells have distant descendants and the countryside covers them with brushwood and dust.

p. 90: the shadow of age lurks in the faces of the young and exhaustion hides in cheerfulness the way a recently deceased grandparent can sometimes be seen in a newborn's face.

p. 91: i saw her pick yellow flowers and carry them, wilted and sluggish, in her arms . . . then she threw them on the ground. she buried them. she was the tiny courier of a scattered army.

p. 94: the rooms are empty, the windows abandoned to the landscape . . . the beds unmade, the bars of soap still wet and covered in suds.

p. 96: childhood has grown old . . . there's something inert in our speech too.

28/10/98 thursday

7.10 A.M. to NY in a few days, on 2 november. haven't painted anything for a long time. spent the past few days glancing over photographs and looking at what they say. strange that the most eloquent photos are the ones that were already taken, the ones that resemble the photographs of buchen. large, slightly warped, empty fields, paths, dirt roads, in m.r.'s company, for example, or in the fields of auvergne. why did you leave there? you're constantly asking yourself these questions. the problem of mistakes. mistakes in life. life mistakes.

LIFE MISTAKES

you can't use the word 'mistake' in this context. in the context of life considered in the light of the finally OVER, you can't really speak of 'mistakes'. there is an order that we can't comprehend as easily as all that. a delay, a hesitation, an enduring, also a sudden break . . . that make it impossible for us to judge. that's why, at any point in our history (our personal history) we can say: this is where you are now (with all your 'mistakes'), and the supposed mistakes can all be transformed. all the empty spaces from much earlier times can now be filled. one or another earlier 'wrong decision' that led to this or that.

last night, around 11, on our way home from the lake, we came across the cat who followed us back to the house. it's strange to meet someone familiar when out walking, who then accompanies you on your way home.

29/10/98

5.45 P.M. didn't notice that the laptop was still on last night, so it ran all night, no, it didn't run, since nothing runs if you're not typing anything in, but it's still warm because it was hidden under a bucket, because of the cats, who like to run over it and cause problems. you couldn't see it was still on, on all night. no one will claim that it was necessary to write all that down.

30/10/98

7.40 A.M. nothing was ever written on this laptop out of discipline but out of a spontaneous decision, an experience or even out of boredom or habit. when you exert discipline, you end up with 'works', you get results. yet discipline was exerted because something odd happened the night before last that needed to be written down (not spontaneously, though, since it happened many hours ago). so the decision was made to write down that two nights ago, the air outside was unusually warm. like in spring. air filled with the possibility of growth, filled with distance, with promise, swollen. incredible at this time of the year. last night it was completely gone. it was cold again. and because it was cold again last night and this morning, distinctly cold, decidedly cold, the decision was made to write about this exceptional occurrence. but what have you written down? that it was warmer than usual for this time of year. a parched observation. the taste, the expanse, the promise of the air that night is not depicted. can anything be depicted, after all? is what you do depiction? what is it, really? it's more creation. there aren't really any depictions, just creations.

DEPICTION—CREATION

because everything you create becomes something else. with regard to the night before last: when you went down to the lake in the middle of the night because the air was especially balmy and significant, that experience can't be depicted, it resists being fixed, but it still has an unfathomable effect on what develops when you undertake the impossible task of describing the indescribable.

and so this page came out of the decision, through discipline, to depict the experience of the night before last. or, you could also say, to react to the experience of the night before last. or: the experience of the night before last has raised questions.

RAISING QUESTIONS

also went on a bike ride late two nights ago, after the walk to the lake. the circle of light on the ground in front of the bicycle. getting on the bike is an almost automatic movement. the bicycle as a form suited to olden times (existing then), answering the waves of warm air with the 'wave-like' motion of riding on the undulating street. the air's motion towards the infinite accords with the bicycle's aimless route (motion). the bicycle as the romantic's tool.

THE BICYCLE—ROMANTIC'S TOOL

11.35 P.M. painting: a long wall of sunflowers, 280 tall and endlessly long, 20 m, say. based on the series of photographs taken a month or two ago. you could walk along it like you would along a wall because the field in front of it had already been harvested and so offered open sightlines for the photographs. again, it had the appearance of an empty reservoir since it offered a view that had previously been hidden. also, the field of sunflowers stood a step higher than the harvested field from which the photographs were taken. so it all looked as if it were on a stage. but why such a long wall of sunflowers that has almost the same dimensions as the field itself? to get beyond panel painting? hasn't it been left behind for a long time now? through its lateral expanse a painting that long reaches into geological eras. a frieze.

THE FRIEZE, TIME CABLE, CABLE TUNNEL

in contrast to panel painting, a frieze is not self-contained. like the vendôme column, it extends into future times and comes from equally distant past times. a frieze, therefore, does not resolve the problem of the subject because the subject is time. if you bend a frieze, it becomes a circular painting.

when you paint a frieze, you clip yourself onto the cable of time as if onto a ski lift. you keep painting, drawn by the time cable. cable tunnel.

7/11/98 tuesday

letter to the frankfurter rundschau

many thanks for the invitation. i am very interested in the topic of time as a malleable medium that does not advance towards a specific goal but flows both forward and backward. and where are we in all this? how can you perceive a threshold in this? long before einstein, the rosicrucian robert fludd tried to unify the macrocosm with the microcosm in a marvellous vision. he believed that every plant on earth corresponded to a star in the heavens. if the mathematical formula for that correspondence were found today, it would lift the threshold between what is past and what is to come . . . and so: i would like to think more on this topic, but i could not complete it by the end of december because over the summer i had a herniated disc that was pressing on a nerve (another kind of threshold crossing). so i was unable to do any work until now and have to catch up on a few things. if, however, you could give me more time, i would gladly participate.

8/11/98 Saturday (Sunday) NY Four Seasons NY 2612

12.45 A.M. There are fewer lights in the skyscrapers and, because it's the weekend, there's also less traffic. → Holidays in NY East 20th Street. A few cars that fell into the holes. Noises dampened by the snow. It snowed there often. And it fell almost silently everywhere. What I raised my pen to write can't be written. Nothing can be noted down directly. It can only be described indirectly, when you set to work with discipline on another project.

9/11/98 Paris Orly

Waiting for the take off. Ninth in line. Eight white aeroplanes waiting. A mustering of aeroplanes as if for a distant celebration that will begin soon. As soon as one takes off, another lands on the same runway. Then another, parallel runway is closed. A large red cross of numerous lights flashes. It stands about 3–4 m high. Odd to have so simple a sign (visible from a distance) in an otherwise complicated system of air traffic whose rhythms are not easily grasped.

8.20 A.M. The show has been going on for 25 minutes already, one plane takes off, another lands, etc. It's very entertaining. The take off is different from the landing. It's not the reverse of landing. It begins with a gradual transition from the second to the third dimension. When the plane has driven far enough, it finally lifts off. The one comes from the other. The rumbling and juddering of the wheels finally stops and then they're pulled in, stored in the belly (\rightarrow Jonah in the whale).— Something is lost. Something fades, disappears, you leave something behind. Something has been decided (you can no longer turn back, you can no longer be reached). The aeroplane too can no longer abort a take off once it has begun.

Start \neq landing.

The landing, in contrast, is hard. The wheels bang against the ground, smoke rises. Everything is applied at a single point, extremely concentrated (it's not a movement outward but a constriction, utterly focused). Angina. The angina of landing. The flight, the expanse is disrupted. For a time the process seems

suspended in ambivalence. The wings are still swaying. Usually one side comes up at first. The initial contact with the ground is an attempt. The machine briefly lifts off the ground again before finally settling on the ground. But the momentum is still great, the plane still speeds forward before the brakes set in. The whole thing, the hard landing, the sense of heaviness as the machine steadies itself on the ground, the braking, it all evokes a feeling of regret, of sorrow. Even the tentativeness, the wheels' first attempt to make contact with the ground, then to establish 'distance' again, it has a sense of hesitation before the inevitable, a logical second before finality. There is, after all, a finality to every landing. You know that it can't be launched again very easily. Certain procedures are necessary, the fuel is out, etc. Landing is like collapsing. You can see it in the landing gear. The wheels hang down at first, seeking contact, like feelers, and then when the weight bears down on them they are crushed under the burden that's too heavy (can the extension of the feelers, the wheels, be compared to Noah's sending doves out from the ark?).

Smoke rises on first contact. In itself smoke is usually a sign of catastrophe, something is burning, a fire is lit. Smoke as a sign. Smoke signals used by the Indians and in a papal election. The feelers have been burnt in the initial contact. And yet the plane lands. You get a bad feeling when the plane is 'coasting'. It seems the course can only be held with great effort. You truly feel caught between heaven and earth (even though you are in fact already on the ground), 'between heaven and earth' is probably not quite right, better: between driving and flying. Not completely two dimensional yet. The third dimension, earlier the expression of becoming, of infinity, of breaking free, is now the

possibility of catastrophe (as with a birth, birth as catastrophe). The limbo between the virtual (everything is possible in infinite space) and the contingent (there are parameters that must be adhered to) suddenly becomes a state of utmost contingency. The air currents above as a game that rocks plane ≠ a mortal danger down here (shearing, timing), because the course set down to the millimetre.— This morning you can see five aeroplanes in front of you and five behind. All of them white, a small assembly.

Aeroplane assembly

One took off after another. And you had the impression (why, exactly?) that they were all flying towards a common destination, even if setting off in different directions, the community of aeroplanes was not abolished. How is that? When there are no more roads (of course there are 'airways'), then everything is bound together through the medium of the air.— All this, all these remarks are only of metaphysical importance, because in reality, as every one knows, the entire airspace has been measured and there too there are roads, etc. But seen from below, it looks like they are heading off into the collectively indeterminate, into the common expanse. And you can stick with this image, because the airways aren't visible. The image consists of this: Air France's white aeroplane waiting, each in its own spot, until they can set off in different directions towards a gathering point in the sky, as souls meet without any location.

13/11/98 Return flight Munich → Paris

Needles in the morning. Between the individual vertebrae to the spinal cord. The needles are inserted until just before the spinal cord.

Probe

The spinal cord swims in a fluid so that it doesn't collide → the long row of vertebrae like the dinosaur's in the entrance to the Natural History museum in NY.

3.50 P.M. View of the landing strips. The green grass. Very light fog. Along the sides, rows of trees. And straight ahead, where you can't see the end of the runway, a row of blue-grey trees.

3.52 P.M. Turbines accelerating.

3.55 P.M. Still a thin veil of clouds over the machine. The land below seems to have been abandoned by the sun, now a thick layer of clouds under the aeroplane.

Backbone

The gaps between the vertebrae compared to the gaps between latitudinal lines.

15/11/98 Paris → Montpellier over the Cévennes

Some of the trees are rust red (from autumn), but it looks like a serious illness is spreading. As if the earth has begun to rust.

24/XII/98

What kind of a date this is. It's just a date. Just a few numbers and yet so strange: this date, this day contains an (illogical) concentration and an emptiness. This day is the sum of all days on this date and at the same time, it's empty. The hollowness of all the days on this date. A movement opposite to that of empty spaces from past times. In those times there was an emptiness that is now beginning to be filled. For a long time, the days before this date were very dense, full of expectation and were thus lengthened and extended days (here you could also speak of another kind of emptiness, because when days are lengthened, they become thinner, emptier . . .).

And now this day is empty. Is that true? Looked at closely, the word 'empty' doesn't seem the right one. Why? It's an abstraction. Because the longing that had been directed towards something nameable now seems to have no object. No longer any telos, any end.[9]

The laptop isn't working, a shame when there are still two days here at the Ribotte before leaving for India. Two more days to write. It's 10 to 11. There's a fire in the chimney. Outside it's grey. Now and then the sound of hammering comes from the buildings under construction.

Back to the date: 24/XII/98. What a lovely emptiness there is to today's date. Date? It's an emptiness of disillusion (dis-illusion as a more 'positive' process of no longer being deluded, that is, being on the path to the real). There had been some desired goals but they dissipated once they'd been reached, and so

thoroughly that when some of the goals happened to resurface later, they were caught in a current of disappointment. I have no more of these goals, and that is made all the more striking through the complementary experience. On the very day of the arrival that changed everything, you're unable to feel any sense of arrival.

Lift up your heads, O ye gates; and be ye lift up, ye everlasting doors; . . .[80] Of course we open the gates but not in expectation 'of', not even in movement 'towards something', simply in motion.

It's Sunday, just before three o'clock. It has gotten very dark, almost night, and it's raining. I'm sitting by the fire which glows like a setting sun compared to the fog outside. This morning the sky was marvellously red in the west and east. The fog over the Auvergne was ignited by the morning rays. Later, a few snowflakes fell and I thought, there's a celebration. It's as warm as summertime where I'm sitting and I'm not wearing any clothes. If you move away a bit, you immediately feel colder. So the fire is like a planet in space, and it's all transient. Because it won't burn for ever. I threw two pages, two written pages, in the fire. Can you, can anyone, with utmost concentration, decipher what was written in the smoke that is carried away on the wind? The two written pages, you would first have to separate their smoke from the other smoke in the chimney, the smoke from the embers and the wood.

3.30 P.M. Once again a shovelful or two of small pieces of wood thrown on the embers. And so it has become a fire once again and its triangular blaze reaches into the flue, above the chimney

opening. This is the last bit of wood to be consumed. The last of the wood that could be found in the house. The last before the departure for India. The chimney will keep its warmth for a while. Then it will cool. In the early morning two days from now, it will be cold. Right now, completely different reactors are burning in outer space. They will also go out. It's just a matter of time.

NOON. Ate breakfast. Worked from 10 to 11.30 in my pyjamas. Why do you like keeping your nightclothes on? No break. Letting yourself glide from one state to the next, letting yourself be pulled along. It was also a luxury earlier, the unnoticeable transition from night to day, from sleep to waking . . . from concentration to distraction and back again.— The mountains are covered in snow.

12.15 P.M. Still in my pyjamas. The sun throws shadows and the trees, the trunks, the branches seem to glow all the more, stronger than in summer when the sun stands high. It's a celebration. And then you don't want to leave. But you go anyway and the still flashing time on the festival ground seems the more precious, the closer the end nears. It's like a curve always nearing the maximal value.

26/XII/98 Nimes airport → Paris → India

The studio floors are still warm. Ashes threaten the embers in the chimney. As long as it's not final (the flight is delayed, in other words, waiting), it's difficult. Everything can still change, can turn out differently. There are lots of children in the terminal. A strange abundance of children, otherwise invisible. It's like looking into someone's home through walls grown transparent. New means of transportation have made the intimate visible.

How will it be to encounter everything again after being away for six weeks?

27/XII/98 Paris

A double departure. Once from France to India, early in the morning. And from my current location, 74 rue des Saints-Pères, to the rue Michel-le-Comte where there is the *hôtel particulier* built by Ledoux, in which we bought two floors. Spent the entire afternoon there, thinking about the renovation. To some extent, in my mind I've already moved in, that is, I've already moved out. Double departure. This is now an intermediate stop from which I will leave tomorrow. I wish I could divide myself in two, so that I could work at the Ribotte for six weeks without assistants. Alone. And travel to India at the same time. It's odd, knowing that everything here and at the Ribotte will disappear with distance. Just as thoughts will change with the passing kilometres and the rest there. Also: just as nothing is completely gone from consciousness, you can't even say it has been fogged over, just as it is . . . what? As behind a door? Not immediately graspable? Does something change in one's consciousness, the further away it is? You can't say that either, because it will come back when you return. You can say that it's always different, that it certainly can't 'be', in the sense of something permanent, something well defined.

29/XII/98 in Delhi at the airport

3.30 P.M. The flight to Ahmedabad leaves at 7 p.m. Arrived from Paris at 1 p.m. The flight was supposed to leave Paris at 9.45 a.m. Arrived at the airport and the flight had a 13-hour delay. Back to Paris, rue des Saints-Pères. Then visited the new flat one more time, spoke with the architect and bought an additional section so that the upper floor will be symmetrical with the 'oriels' facing the park. It's strange and irritating to have to return from one's point of departure and spend in Paris the time you were supposed to be sitting in the aeroplane.

Ahmedabad 6.50 p.m.

30/XII/98 Ahmedabad, in Amandi Shewabi's house, built by le Corbusier

7.50 P.M. Night is falling, the high park looks almost like a jungle, nowhere but in a half-overgrown park like this can you say: darkness is breaking in or night is falling. It's loud. Lots of birdcalls. Crickets. Shrieking. And the car alarms behind it all. Through the closer 'jungle noises', the car alarms—although rather near—(100–300 m) sound like the vague, interwoven hum of a city one looks down on from a high mountain. The bird cries make the city noises more abstract, part of a larger, more distant context.

Yesterday, in the airport lounge: old sofas and tables, everything arranged precisely and symmetrically, cream and ochre colours (a Hitchcock film set in the East), old-fashioned, dusty, with large plate-glass windows which faced the concourse downstairs and were partly covered by curtains. A placelessness, an intermediate station. A place that feels pleasant, familiar, contented precisely because it is 'in-between'. A contented place, even though there was no real arrival and no departure, but, rather, the opposite: a passage full of uncertainty.

Corresponds to: → hitchhiking. Once you end up in a car, a sense of calm, enjoyment, even though you know it's only for a short time, just a segment of the trip. As if glad that the trip were divided into segments. A kind of satisfaction with this chance to divide something unfathomable into parts, whereby, of course, separating the segments, forming discreet sections, does not make the individual parts any more comprehensible than the whole. Another correspondence: in a helicopter, for example,

from Buchen to Stuttgart. The joy of being raised so high (suspended), even though you know the fuel, the kerosene, will last two hours at most and worry sets in about finding a fuelling station, etc. Strange that in such conditions anxiety keeps silent. Yes, in such interims, it's practically imperceptible, but grows in 'permanent' conditions, at home, when you're at rest.

It also keeps silent, for example, when you're working on a painting. It always seems silent (or is it not even present?) when you can tap into the flow? Into which flow? Which movement? Perhaps the movement of molecules or atoms in general?

παντας ει. Doesn't anxiety come in the first place from the discrepancy between the common motion of all these things in space and 'being', i.e. consciousness?

The most beautiful is the most indeterminate, the weak and the empty spaces, is the decision, is the morning.

6.20 P.M. It's now almost too dark to write. Has everything been written down until now? That's a strange expression: 'until now'. Because if everything that was meant to be written hasn't yet been written down, then you can easily cross the 'now' line and continue on and on. . . . When do you stop writing? When it gets dark. Grandmother always turned the light on only after it had been dark for a while. Her reason was of the economical variety, but there was something else behind it. The notion that with advancing age decisions are no longer as important. Whether in Göttingen, Bavaria or Berlin. . . . It's not so much a question of deciding on a particular place, what is meant to happen will happen.

1/1/99 The landing strip in the morning in Ahmedabad. Its end shrouded in mist. At the point after which you were supposed to have lifted off, the tarred surface blurred into the sky. There the solid runway merged with the sky.

NOON in Bombay, a few hours' layover. Slums next to the runway. The low huts with roofs that look like they've been sewn together and are wonderfully constructed, multiplicity condensed in the idea of a roof. You could also say: a protective cloak without Mary.[81] What must it be like, to hear hellish noise every three minutes, coming from a wonderful machine you'll probably only ever see from the outside. The consolidated dreams of all children still open to everything. Building a noise barrier here would be a real luxury. A noise barrier would easily clear several levels.— We're crossing over a desert-like landscape. Along with that, the idea of abundance in Kerala.—

Other considerations in light of the aesthetically worthy huts. A surfeit of time and worry. Because it takes them time, e.g. the way cats sit by a mouse hole, to get food or a piece of lead to improve the roof through means that are not at all officially recognized. You don't get the two regularities here: meals and before them, work in a business, in a system. Or do you? You don't know much about this, the way you know little about other systems. Is it better to govern as a Keynesian or a radical liberal?— Nonetheless, those irregularities down there along the runways offer enormous potential when directed towards one thing (goal, idea). For that, you need someone obsessed.

The people living near the runway are not obsessed. They have no room within (not yet) for preoccupation, poverty is all.

Textbooks teach that no revolutions will come from these conditions.— Competition does not result in enhancement, accomplishes nothing. Take, for example, the surplus of porters at the train station. There's no distinction of the 'better' porters. Although there are so many porters in a single station, not one of them carries suitcases better than another. There are only a few who distinguish themselves with a faster grab.

In the meantime, small green rugs have appeared below, grouped around rivers. Seen from this altitude, they're as small as the roofs just before take off. Naturally, the fields are clearer and less multifarious than the roofs on the huts next to the runway. They are patches of earth with crops and not fields of recycled material. Plants naturally return to earth in the form of compost, just as sheets of lead and other remains return to constructions, but these fragments of civilization are different. They are not yet homogenized, not yet returned to their raw materials, but are at an intermediate station, held in an intermediate phase, and that makes them beautiful because it's a state of being *in-between.* Like other instances in-between: between heaven and earth, between birth and death, etc. These fragments out of which the slums are built aren't digested like food, they haven't been transformed but are held up once more before they rot, are made to shine once again, like the Host before it is placed in the tabernacle.[82] Many fragments in their ∞ multifariousness glow once again in a marvellous fashion, one which their previous makers would have been unable to conceive of or bring about or even appreciate.

What does the poor's very rich culture of patching have to do with the patchwork rug of fields?

Naturally, proper people will immediately object that this risks ignoring the fate of the very poor. The plane rises and you see it all from above. But writing about the patchwork of roofs in this perverse way is no more reprehensible than thinking in economic models. Where is the individual then? They will counter: But thinking about economics serves the individual. What good does it do the poor if several (few) people think their huts are beautiful, more beautiful than most palaces? Did anyone ever benefit from someone saying: Peace be to the huts? You could say yes. And did anyone ever benefit from someone saying they're beautiful? The other question: Does the lover of beauty require the huts? Does he need them? Does he depend on them or will another object serve his 'perversion' just as well, an object of Natural Beauty, say? Or history? Or still lifes? It's not the same just because it has to do with the same thing. But these huts are not just patches sewn together, they have an added value, that is, of people. Can something be considered beautiful that should be abolished in the view of the right-thinking? Perhaps one element of their beauty is that they actually shouldn't exist or, more exactly, that the surrounding circumstances—what is there in the form of the beautiful structures—shouldn't exist.

2/1/99 11.45 A.M. Bangalore → Mysore by train

The noise of diesel locomotives and the boats on the Rhine. On the train platform (waited ¾ of an hour) they were mixing concrete in a small mound. A cone of sand and cement. A lake in the middle, then the mixture is lifted from the edges into the lake with a trowel. Then the finished concrete is carried on their shoulders in metal containers ≈ 20 m to fill holes that have been pounded into the cracked concrete with hammers. Small repairs executed in the smallest units by small groups (→ workers making gravel on the roadside). The train has been travelling for a ¼ hour past houses, large and small, randomly arranged, with no recognizable order. Roads like paths in the reddish yellow sand. In one place, construction material for a road was unloaded and lots of men were digging a ditch (a future sewage system). Odd that a reinforced road is being built on that particular spot. The new, untouched, light-coloured material (kerbstones, pipes) looked strange. Like imports from another world or remains from a larger project. Drops on the hot stone. But there are many such drops here. The many drops slowly, very slowly, hollow out the hot world-stone. It's like the ancient mythologies in which bodily fluids like tears and blood (Cronus) gave rise to worlds[83] (→ ≈ when a leaf falls in Tokyo, a skyscraper in NY shakes).

NOON. Passed settlements. Tundra, the landscape in India most devoid of sensation (apart from the deserts).

Back to the drops mentioned above: with divisions into such small parts, one immediately thinks of an animistic process, an acting-as-if, a virtuality, of something religious. And, indeed,

the women breaking rocks into gravel on the side of the road are meditation artists. Even the sound of the hammers on the rocks contributes to this impression. It's hard to write because of the rocking of the train.—

Why do you feel good when your head comes up with clear thoughts (as it did yesterday comparing the roofs in the slum with the patchwork of fields)? You create something, you bring things together. You show connections (one doesn't create anything oneself, but brings ideas from elsewhere together in one's head), and this seems diverting. Does this distract you from existence? Does it create a web of illusion? Or is it connected to the fact that, when formulating such clear thoughts, you open yourself up to the impersonal and are freed from your own self for a time? You play along. You don't speak to something, you simply speak with. You join in. But it is *not* your own self that you join.

12.15 P.M. There are often pits, holes in the fields outside. That's probably where they dug up the clay to make bricks. The bricks themselves create the structure in which the bricks will be fired. Once they've been made and shipped off, the brickworks are completely dismantled. Then a new place is found from which the material will be gathered.

12.55 P.M. On the edges: mounds of gravel for the rail bed shaped like table mountains. Some of them active. The material is carried away in baskets. Lots of men around a gravel mound. You get the impression that there's always an equal balance of men and material. So many pieces of gravel, so many men. Set theory.[84]

3/1/99

In the jungle with the animals. Arrived at night. Full moon. When you arrive at night, you only see parts as the whole. Whatever the headlights illuminate. You can feel the jungle. You see individual plants. And you wait for morning, when you can see it all. It's not like that in cities: they are more complete at night. The jungle is night. In the jungle, light already has its shadows. It already is the secret.

The 32-year-old Ulrich in *The Man Without Qualities*.[85] Where were you at 32? Far from such thoughts. Far from those who think, far from development, still in empty space (but also in a badly furnished space?). And this distance from everything that one usually thinks of in association with this claim, what does it signify? Is it just apathy? Is it a *not* or a *not yet*?

The rice paddies. The dams have to be rebuilt each season (twice a year), or at least repaired ≈ the brickworks are also rebuilt for each firing. Constant attention. At the moment, many of the paddies are still without water. Stubble fields (→ at home: autumn) that must be ploughed and fertilized. Then the water is let in and the seedlings planted. Thus it's a concealment (with the waterline as border). Secretiveness alternates with revelation (draining the water and harvesting). Is it really revelation that occurs when the water is drained? For us it's more of a defamiliarizing. The familiar (stubble field).

Water level

There are no more inclined surfaces or scarps, that's why there are terraces. The fields as water level. This produces a very natural principle like coordinates or an absolute through the absolutely horizontal. An inclined surface is divided into levels. A partitioning or also a *stage-by-stage plan*. Introibo ad altare dei. Then I will go unto the altar of God.[86]—

The small huts on the fields. Holy houses for the gods. Such beautiful proportions between a little hut like that and the vast fields of water. An idea: home of the rice gods. The home of the gods above the waters.

3 P.M. Falling asleep in the room. How different it is in such an environment: outside sun, quiet, few birds. For a while, you leave behind the new, the strange in your surroundings and go who knows where. You fall asleep differently because you're leaving something different behind. At home, you leave the familiar behind for a while. When you wake up here, you don't return to familiar surroundings but to unfamiliar ones. And that's what gives this sleep its charm: you take a break from the foreign for a different kind of foreign-ness (sleep).

4.50 P.M. 'Go where pepper grows,' back then it meant go very far away. Pepper hangs down on thin strings like currants. Coffee is being harvested now and sits in huge piles on the concrete in front of the farmhouse.

Evening walk through the rice paddies. The gurgling (an unattractive word), the plashing of the water. It flows from one field to another. A kind of physical entropy. You can control the flow through holes in the dams and, where more is needed, with gaps

in the dams (as with a dam break). → Weirs in the Brigach in Donaueschingen—but there water flowed over the top edge of the weir. Here in the rice paddies it shouldn't overflow, just flow moderately.

5/1/99

It's the same for the variously shaped ricks of rice straw as for the brickworks. They're constructed and then used up, as are the dams in the rice paddies. They're rebuilt after every season, i.e. the means of production are renewed after each production. You start fresh every time. → ≈ Charcoal clamps. However, here it's still somewhat different than with bricks because there it's about building material (you don't build with charcoal), about building blocks that are used exactly as they were made. Or: that don't need to change their purpose to become buildings. That don't undergo any conversion and so remain as they are, that don't have to adapt to another usage.

The building was made from dried bricks. Then fire went through it and the now the fired bricks are reused. The bricks' usage does not change.— Why do I find this so important? It seems to indicate something. What? It's the rhythm. In a production facility, there is an output, day and night in some. Here they always have to start from scratch. The rice straw is stacked, used, planted, harvested, stacked . . . according to the rhythm of the seasons. It's exactly the same with bricks. The clay is dug from the ground, shaped, built, fired . . . there's an additional nomadic element to this because you move from one clay pit to another.— There are no distinct seasons any more. Products leave production halls without interruption. And there are no distinct seasons for produce either: they're flown in throughout the year. It's the same with festivals.

1.30 P.M. Alone in the room (R. and J. have driven to the coast). The noises of a hot day penetrate the room. A few household

activities. Conversations with the staff. They come in looking like they've made journeys through long spaces. It has little to do with you. Detached. But differently than in a hotel, where noises also sound in a room. But those mostly don't interest you because they're noises made by mundane, standardized activities. Here there are lines, lines connecting to the sounds because you know what they're doing. But the lines have grown so long, that they only touch you very lightly, something has inserted itself between you and them. And this 'in-between' makes the situation and your condition special. You could also say that, from your point of view, the shore has moved far away (though it's still there), you are as if in a rocking boat, far out on the waves, which you know are beating on the distant shore. It's also the particular state of being half awake. Things happen next to you, you could chime in but you won't. It's similar to being lonely when surrounded by many others. And it's also the lovely memory of childhood's lack of responsibility, where everything happens, not quite next to you but still without you, without call. The windows are made of wood on the bottom and glass on top. Only a little light comes in. Everything is designed to protect from the sun. And this shadiness creates a particular relationship of inside to outside, where the cries of the birds suggest the space. Outside you know about the hot sun, the water flowing in the rice paddies, the waiting seedlings.

2.25 P.M. Marked parallel to Villingen with the snow melting on the fir trees. There, too. The desire to lie on the plants like dew or to trickle into the earth with the melted snow. Here: time trickling away outside. The sound of a tiny shift in time wafts in on the air.

6/1/99

4.45 P.M. Warm sun. Warm, caressing wind. Sitting on a deck chair next to a bush in which butterflies danced. At noon. The butterflies' dance made you take up your pen, but there's nothing more to say other than it was beautiful and the colours were remarkable. You almost said something about it to the person sitting next to you at lunch, but didn't in the end. After all, what is there to say about it? Look how beautiful it is, or similar platitudes. If you can't connect the butterflies' flight to something else, if you can't offer some idea about it . . . what is there to say → ≈ it has been the same with painting for many years. If you have nothing to say about them, nothing to write, they stay in the containers. So many paintings begun that remain without ideas.— Now a late butterfly has returned, two, even, and they fly around the bush in that fluttery non-flight, showing different colours in quick succession.

Naturally, it's not only about ideas but also about associations, associations that don't come from you but from your brain. Different areas, words, fields brought together by chance. Before there were many butterflies, now there's only one. That's something to think about. No one knows why they flutter around in their exotic jungle garb (glory). If you knew the names of the species, you could say something about their families, their evolution, their metamorphoses, etc. But that isn't thinking. Many people like butterflies. They're so easy to like. And they move and they're colourful, some with an Arab Muslim density of decoration. Yes, perhaps so: that they complete some teaching, like the carved plates of some desert tribes. And that such a chiselled and geometrically restrained pattern achieves a sense of

motion that has nothing to do with strict patterns, perhaps, that, too.

5.10 P.M. There won't be daylight much longer. Tea has been served. Soon the sun will set behind the mountain and the sky will turn red. And you will walk through the rice paddies and hear the water run.

7/1/99

1 P.M. The butterflies are back, lots of them. To all appearances, this type of bush and this butterfly species belong together. Just as every plant corresponds to a star in the sky. They open their wings and display their wonderful pattern that recalls Moorish signs.— In the courtyard, coffee beans are spread out to dry. Men go through them in rows to turn them.— When the rice plants are ≈ 15 days old, the water is drained for two days and then channelled back in. It's left there again for another ~ four weeks.— A keeper watches over 40 cows in the jungle, protecting them from tigers. The manure the cows drop at night is channelled into a container, from where it emits gas that is used for cooking. After the manure is rid of the gas, it's used on the rice paddies.— Once a season (≈ 15 days after the seedlings are planted), the weeds need to be removed. A few women (8–15) make their way through the flooded rice paddies, pulling up weeds. Their backs are perfectly horizontal, their legs slightly bent (like quadripeds). They sink into the muddy ground up to their ankles. They come from the surrounding villages, they don't plant anything themselves, they live as day labourers.

3 P.M. Followed the path past the houses and a shop with all kinds of small wares. Marvellous red colours of the earth and the houses in the evening light, past the police station, a long, long overgrown wall, everything untended. The building itself is made of concrete, looks abandoned, shabby. Is the length of this pointless wall, the measure of the state's authority? The bamboo with its tender fronds chisels its delicate structure against the red evening sky. The plants bloom every 60 years, bear fruit and then die. There's also a variety of palm tree that bears fruit once after ≈ 120 years and then dies. You find it peculiar and tell others about it, because you see it from a human point of view. In itself, it's just a fact. Do facts interest you? The stars' distances, cosmic time—it amazes you and amazement is a feeling. Does it come only from one's relation to oneself, to sensuous experience? Can you marvel at something without comparing it to something else? That is: Is there science without emotion? Or is emotion, the sense of amazement, necessary only for the initial stages of scientific inquiry, as motivation? Like starting an engine? But where is the sense of marvel when you spend your life researching DNA sequences? Or solving equations? There are other motivations for that. You replicate nature or are satisfied that you can manipulate it. Or you figure out how it functions, how it works. Or you discover mathematical laws, in which case it's less about marvelling than appreciating beauty. Being amazed or marvelling at something, on the other hand, always has a very vague aspect, just as being deeply moved has something vague and dangerous about it, because being moved can be addictive. Some are easily moved, others are more sober. Totalitarian states (governments) exploit this feeling and are themselves no doubt also under the sway of strong emotion. Only those who allow themselves to be swayed can sway others,

although you have to distinguish various ways of being swayed, by the cosmos, by Edith Piaf, by the Nuremberg rallies, by a human fate (→ Zweig's biography of Balzac),[87] by an experience (moon landing), a human birth. Being deeply moved renders you speechless and a space is created in which many things are possible, for deep emotion can change people, when you extract the substance, so to speak, and put it to use (→ IIIrd Reich). What does being moved have to do with exaggeration? You take something so far that it no longer accords with human measures, is beyond measure, becomes speechless, brooks no answer, no discussion. Were you moved when you saw that here gravel is produced by hand using a very small hammer? A feeling of being moved comparable to the cosmos 10^{14} and the correlative, 10^{-14} in the field of subatomic particles.[88]

8/1/99

12.35 P.M. Visited the village past the gardener's house one more time. Houses built of clay and covered with straw. Everything neatly swept. (‡ the police station yesterday). In simple accomplishments, women clean the containers with ashes at the fountain. Scoop water, clean the rice. The men split the bamboo stalks to weave walls and bridges with them later. One built a hut for the goats in monsoon season. All these activities as if in a movie in which the speed has been altered. ∞ To us, seeming very slow, aimless. These activities went on all day long, without stopping, without end, so that life merged with maintaining life. There's no obvious concern, so you're constantly tempted to intervene, to organize things differently to make them more efficient. At the same time, you naturally back off because this aimless (meaningless, meaningful?) activity is what we do in a free space, like the one who's always pressing with his brushes or creating those white paintings, his entire life long at that (R. Ryman).[89] You've 'elevated' this slow, unconsciously meditative activity to culture. There are, of course, several biases in that sentences. It's very doubtful that this activity is meditative, even if only unconsciously so. In that case, a chicken scratching and clucking is also meditative.— And it's worth considering whether these minimal expressions of culture came from observation or arose in parallel and by chance and now are merely comparisons. After all, cleaning rice is necessary for survival. Paintings, whoever makes them, are not. Maybe it could be put this way: As soon as basic needs are met (to all appearances, they don't have serious worries), necessities are satisfied, one turns backward, imitating one's childhood thought processes, or, better, one thinks of a universal childhood.

4.30 P.M. The sun that was so scorching (outside, next to the bush with the butterflies since 3.30) is now losing some of its strength. In a half hour, it will become cool, at which point the sun will have almost sunk behind the hills and will etch out the trees on the hilltop.

9/1/99

9.55 A.M. The day after tomorrow already we leave for Nagpur. Yesterday, on my evening walk, I briefly noted:

Again and again, on the paths, in the paddies, you see the ashy remains of small fires. Again and again. This corresponds to the phenomenon of the *small and smallest* units → breaking stones → mixing the cement on the train platform described in another entry. These smallest units in an entity as large as India (almost a billion inhabitants), are they a sign of anarchy?

In the freshly ploughed paddies now full of water, there are piles of leaves from a tree used as a support structure for the pepper plants. These leaves serve as nitrate fertilizer for the rice paddies. The workers carry them into the paddies in large baskets on their heads and the leaves stay there until they're ploughed under.

Yesterday, found a snake skin, a cobra.

Thought about my spine, about the problem with the left nerve and back pain I've had since September, and remembered the Museum of Natural History in New York, with the enormous dinosaurs, their backbones, from the most massive vertebrae to the most delicate tail vertebrae and wondered about their possible back problems. And then, of course, about snakes themselves, who consist only of vertebrae, lacking limbs, which the Bible presents as a handicap, a punishment. They, the snakes, can rise vertically to only one third of their length. Thank God, you might say. Because of this, you can lift them by the tail and

they're defenceless (→ Antaeus).[90] They need contact with the ground even more than we do. They're always on the ground or on something fixed to the ground (trees). They can come out of the earth and when they're also the same colour as the earth, it's as sinister as the existence of viruses that you also can't see. Strange that such a fuss is made about snakes in all cultures. Even creeping is strange, especially when it's fast. With boa constrictors, there's the captivating aspect as well, and merely the paralysing sight Medusa has an aspect that captivates the mind.[91] A blow, a bite (of a predatory cat, for example) is a misfortune, but being strangled is something else. It's not a misfortune but a nightmare become reality, that seems not to come only from the outside but feels as if something threatening within us had been set free, a kind of auto-aggression.

Then: leaving the clay yesterday, I thought of the cellar floor in Villingen. This permanently damp mud floor, walked on barefoot. Here you're always walking on solid-spongy ground. Recalled the cellar in Villingen particularly when walking along new paths, formed the day before yesterday in a straight line across the paddy fields to the gardener's house. Part of the paths are still soft clay, not yet compressed from being walked on. Associations with the cellar in the house. This cellar has all the levels of the familiar-frightening. The lower you descended the concrete stairs, the less visible the steps' otherwise clear lines became. The swamp began before you even set foot on the compacted mud floor. And then you had to cross a damp, threatening, unsteady, engulfing surface to get to the laundry room that had a concrete floor and was, therefore, barred or, you could also say: the ghosts were locked up.

Another note from last night: end of the workday noises. There were conversations in the huts. In the larger huts there were small gatherings of people. On one of the fields they were playing ball in the twilight. The end of the workday as a literary theme. Hölderlin: When he rests of an evening and the man sees the finished work and . . .[92] The end of the workday, when the noises imperceptibly change into completely different sounds. As in Villingen. When the blue SARA display started to glow and the sounds of the radios and shouts of the children at play echoed off the walls of the housing development.

Strange how entire pages can come from such a paltry note as last night's; how in an instant a network of connections and feelings are concentrated in one concept and then spread out again over the pages.

11.35 A.M. Where the butterfly bush is, in the same meadow are also various trees, including three tall palm trees. Seen from here, they're arranged in a way that, between them, you get an open view of the mountain ridge on the other side of the valley. You also see tall trees on top of the ridge standing outlined in shadow against the sky. And their similar structure, just on a different scale, seems to consume the distance between them. The similarity, if not almost identical aspect, reduces the space between them, no matter how vast it is.

10/1/99

10.30 A.M. R. has left → Mysore, what's strange is that you're
still here. On call? Unreal, because you're actually already gone.
≈ → Venice when the luggage had already been collected and
we stayed on a few days in the rented palace. Naturally, this is
a completely different situation from when only the luggage was
gone. How exactly? It's a split that offers a promises of reunion
(tomorrow, after lunch, is the departure for Mysore), but, still,
it's a virtual split because there are ways you don't know, at least
experiences that aren't predictable in a foreign land. In any case,
the grounding here has now grown very weak. It's as if you're
already on your way but without the suspension you feel when
you really are travelling, like in a train. It's a different kind of
in-between state than being in a train-between one place and
another. It's the actual in-between due to a split. Can you go so
far as to speak of a single cell organism's feelings when it divides?
The division and the state before the new entities are created.

What do protozoa feel when they divide? It was a completely
different situation when R. left for the coast a day and a night
before I did, because then she returned to the same place. And
you stay here. Thus a movement after which the reverse move-
ment to a set place occurred. In contrast there is now one move-
ment and another, later movement and the two movements,
delayed in time, meet in one place.

10.45 A.M. Sitting by the pool, with the sun on my legs and a
gentle breeze that barely blows. It's not hot yet, but you can feel
the coming heat. Why is sitting outside so different from staying
in the room, even if the window is open? The skin's entire surface

is in contact with the outdoors. With the currents of heat and air. There are no interruptions. The exchange is unhindered. When the temperature is the same, there's no longer an exchange of heat. That's why it's nice when the temperature outside is a little cooler than you are. When you're not quite shivering. When you don't need to do anything against the cold, that is, when you don't have goose bumps and you're not sweating. When you can communicate through your skin, and thus become part of everything that flows and streams around you. What are you being told when the warm-cool air caresses you? When you caress another, the caresses are constantly repeated signs of closeness. Caresses from the air, the wind, these are not the same, they're not assurances, etc., but the repetition is there (albeit a different kind of repetition). Closeness? No: Distance. Distance that fills you, you're constantly being filled with distance. Living? Hardly: Can distance live inside you, once you're filled with it? Is distance something that can inhabit or, the reverse, can distance be inhabited? The moment you're caressed by the wind is the moment when the vastest distance pits itself against the most minute interior. Or: where the small circle surrounding you stretches out to the widest spiral. An expansion that explodes without a sound. A continual breaking of the sound barrier without any boom.

11.15 A.M. Written yesterday: the space between the palm trees here and the trees on the distant ridge is reduced by the trees' similarity, no matter to what scale the distant trees (added in) on the ridge are shrunk. . . . The varying proportions don't create depth. Now: hazy. The hill a similar shade of blue, if more compact than the sky above it. . . . Depth, distance clearly there. There, just far away, the other trees. What does that mean? That an exclusively calculating approach to emotional things

like distance or detachment leads to the suspension of these feelings. In contrast, unclear elements like fog, haze, smoke return things to their proportional relation. Fog creates an expansion of space, not a reduction. Because a reduction in size through distance (which is a mathematical reduction) can be repealed and suspended in a billionth of a second. The partial mantling in fog first creates the way = the experience. Without sound + smoke there is no way, no distance . . .

NOON. *credo ut intelligam.* I believe so that I may understand.

Ask God for a production loan.

Because you attain all understanding, love, etc., only through a special case of credit = faith.

When you go back, probably all the way to Karlsruhe, where you were first convinced you would be a great painter, no, you were more than convinced, you were certain, absolutely certain. That was faith and nothing but faith. At the same time, a limitation, a restriction to this goal which is a small goal compared to all other possible goals. (What is the most distant goal?) And that held for some time, even in the deadest, most suffocating situation, you had this faith. Then it ends at some point and you get physical signs, like illnesses. And even now, at this very moment, you're searching for a new room in space.

Hence the wavering last summer, reading back over the notebook entries—whether the decision to become a painter rather than a writer was the right one? whereby both, of course: a writer's room is as fragile as a painter's.

Last summer the credit you procured for yourself with the belief: you're the best painter. Curiously, when others (in the USA) said: 'The best painter on both sides of the Atlantic' the credit slowly disappeared, because when it's no longer a belief, but a plain fact (in the newspapers), the credit vanishes and you need a new 'higher' (?) belief. Where could that be?

It could be there, where you claimed you'd found the most comprehensive contextual formula for the world in a painting. Problem: Must it be a painting? Is the production loan tied to a profession or can it be freely applied where, according to its nature, there is constriction? ($\rightarrow \approx$ house in the cosmos).

11 P.M. Asleep. That's not right, because as long as the word 'asleep' is written, you're not asleep. Your head is sleepy and without edges, rounded in sleep, as it were. In the evening around 4.30, a walk in the jungle (2¼ hours). Coffee in the forest. Coffee plants climbing up the trees.

11/1/99

6.45 A.M. awake since 5. The birds started singing (warbling) a
few minutes ago. When a storm is building they stay quiet.
Then everything is silent. You can hear doves, too. → Rastatt[93]
on the tennis courts while waiting for S. Just as so many things
are tied together throughout one's life, so is the cooing of doves
and the non-synchronism between S. and you. So much
remained that was left behind and therefore still exists. That
which seemed so wonderful and accessible when you thought
back on it then, and does even now, but which, when it was
realized, seemed so remote to you. Nothing was actually realized
and that's probably why what didn't happen will be associated
your whole life long with the cooing of doves at dawn. And if
you had no other profession than being a painter, you could
work through it and build something solid and beautiful out of
it. The singing of birds at dawn draws you from the cave of sleep
and deposits you in the vast space of the forest, the meadows,
the world. Strange, why did you arrive a decade later than S.?
Does it have something to do with the empty spaces? Earlier
you engaged only on an external level, you travelled with her,
you painted her portrait, etc., . . . you went to concerts with
her, accompanied her home and said goodbye on her doorstep.
All these were actions empty at the core, as if for practice, but
still without content. Like a game, a rehearsal for later.—

For a long, long time I've written nothing on this laptop. Not
for months. And now what? Thoughts will come again on the
train. Will it all be used at some point? If things were to con-
tinue this way, it would be like playing the same note over and
over again on a violin. Building futility. Living within futility?

Futility is perhaps related to extravagance, or does futility closely precede extravagance?

7.30 A.M. There's been noise in the house for some time. The servants have arrived. They'll bring tea around 8. The lovely furnishings create the impression that you're receiving clients while still in bed. A curious sense of gratification when you're granted a delay, it's also a kind of non-synchronism. These instances of non-synchronism are much appreciated because they offer a chance to see things from a distance, as, for example, right now: through the servants, I can see how I'll get out of bed later.

8.15 A.M. The tea arrived a few minutes ago and warms me up because the air is still cold from the night. Reading Robert Musil is pushing me to think about what goes on during the initial stages of a painting's creation. First there's an emotion, something powerful, often triggered by an experience. Then it's 'actualized' and is then always followed by a collapse. Precision dissipates the emotion (there's still no idea present). Work, exactitude have a terrible sobering effect. What keeps you going? The hope that an idea will come, that some vast word will enter the painting and redeem it, so that the painting will move, will recover the variable, oscillating quality that inspired the initial enchantment. You can pursue this fluidity using various techniques, by atomizing a slight layer of colour over the painting laid horizontal, for example, or by strewing sand over the painting. The way a whirlwind of sand passes over it and, in obscuring the idea, gives birth to the word . . .

NOON. The last things have just been packed. 'The last things.' A short while ago, a snake wound its way from left to right

along the lawn's stone border. It was about a metre long and grey-green. Why did I even notice it? It was silent and fast. An imperceptible gait, its motion inexplicable. Sinister. They're everywhere but are only rarely visible. As soon as you notice them, they're already slipping away. Something intrinsic is externalized, a silent scandal. Although they could crop up anytime, anywhere, because they're legion, each appearance is an event that doesn't fit into a sequence. It is suited to give the year its meaning. Back then, when you saw the snake. A kind of epiphany. They're numerous and of a statistical size (as are their victims), but each appearance is accompanied by an immediate escalation, the incarnation of something almost spiritual. Spirit of the earth. It went past. Didn't pay any attention to you. You were 2½ m away on the lawn chair. Therefore: not an occurrence but an apparition. Its motion made it visible. Your eyes were caught by the movement. The brain reacts more forcefully to something moving because you were sitting there, reading. A physical constitution from a much earlier time. A snake— what elevates you more? Before it attacks, it coils up so that it can lash out. It condenses itself into a circle, secretly preparing its launch. Then it moves faster than the human eye can follow. Practiced for millions of years. So what it needs is a stable base, a spiral. From that point on, it's not possible to follow the operation with our senses. It has something of a silent detonation. The suppleness of its movement is ideal, just as the spine transitions exactly from the head to the finest vertebrae of the tail.

12/1/99

Bangalore airport. Took the train here this morning from Mysore. Two and a half hours. Saw: man with bicycle, over-loaded with grass (probably for cows at home). You could hardly see the bicycle. It was more of a cartload than a bicycleful. (Picture *The Last Cartload*.[94]) This single cartload fits into the system of the smallest unit, like the women breaking stones, the women carrying stones and those carrying concrete.

And the construction site in the afternoon in Bangalore: women carried away loads of dirt on their heads (excavated for the foun-dations) + the concrete for the foundations. Small fires built even on the train platforms, to burn garbage (as in the rice paddies). Seen while still on the train: brickworks on which grass was growing, i.e. they weren't 'harvested', dismantled. Maybe because it hadn't fired well. Strange to see brickworks 'left standing' like a girl no one invites to dance. Although means are scarce here and they usually make use of everything.

I stood by an open door the whole time and leant out to see the entire length of the train (12 cars) in the curves. It's always a particularly moving sight to see the locomotive much further forward than you yourself are. (≈ Rilke: Already my gaze is on the hill, the sunlit one, ahead of me on the path I have only just begun. So we are grasped by what we could not grasp, appearing to us, complete, in the distance—[95]) In the curves you can hear the pounding of the engine's pistons. And it's an extraordinary experience of time, something that is a part of you (part of the train) is already in a place where you are about to arrive. It pre-empts something, so to speak. What is taken away? Yet for that

part of you that pre-empts the distance to the locomotive in thought, for that part of you, the distance is already covered. The engine goes on ahead, like the railway cars that were hitched in front of the engine on Trotsky's train to pre-empt the mines laid on the track.[96] Everything that could happen between you and the car hitched to the front, should happen first, before you arrive at the spot. The head car should take on, as proxy, what is intended to happen later, should, therefore, slightly extend time for the travellers following right behind it. Prolong, expand the final opportunity. Later, in Mexico, there were no more extra front cars for Trotsky.[97]

6.08 P.M. The aeroplane rolls to the runway. The terminals fall away. Soon there will be no turning back. Planes can't abort a take off since it's too hard to land with full tanks. There is a 'point of no return'. Where is this point in life—e.g. when you marry? Or begin to practice a profession?— Nowhere is one so 'in-between' as in India.

6.15 P.M. During the ascent you can still catch a glimpse of the sun. Below, it's already night.

6.50 P.M. Arrival in Hyderabad. Again, women carrying concrete, rocks and dirt on their heads, their arms as if shackled, shackled to the stones they're carrying. Strange posture, surrender throughout the entire day—arms stretched upward until their baskets are emptied. Then they carry the empty baskets back, and on this 'return trip' they take the baskets from their heads and carry it in their hands. This upright gait, the 'exaggerated' form of this upright gait is the idea of the upright gait, the idea of the upright gait in its pure form. And even if they're not

balancing anything on their heads, there is still the pride, the idea of carrying something on the crown of one's head, one's highest point, and holding one's arm extended upward one's entire life. Like some sadhus who hold one of their arms up their entire life long, until it atrophies and can't be lowered again. An Eastern form of self-mortification.

14/1/99

4.25 P.M. First day of the ayurveda cure. The building is very small and shabby. Paint is peeling from all the walls. It puts you off, when you're still not used to it and have nothing to do with it. It gets a bit better after the first session. It has become part of you in a small way. You offer something to that which repels you.

Lots of kites flying outside. They're simply flat pieces of plastic that turn the sky into a kind of irregular sieve because they stay within a small perimeter.

Consultation with the doctor yesterday evening. The stress-induced pain in my large intestine should be taken seriously. Vata—air—movement—detachment—reconstruction.[98] Large intestine. Vata is in imbalance. Then in the evening, especially in the morning, the feeling that everything is slipping, the small house built near the abyss of the ∞ cosmos collapses, the final passing is palpable. This is produced by (1) my problem with stress that cannot be dismissed, affecting my lumbar spine and my large intestine and my liver; a stress that can only be eliminated by a change in lifestyle. And (2) my situation in the strange city. I'm no longer a traveller passing through, but an inhabitant, a resident, exposed. No more habits, but a plan to give up what has given me pleasure up to now. Would it be different in another landscape, i.e. by the sea or in the desert? Yes, because there wouldn't be this crowding, this proximity, this conglomeration of smallest units. Minute spaces.

Everything presses in, comes ever closer. And you resist taking it in.

5.40 P.M. Back from the oil treatment. It's already night. You can still see the kites in the sky, constantly changing sides, that is, sometimes they are flat against the sky, sometimes in profile so that they're momentarily invisible, like butterflies. They're always turning around a fixed point—the string. Of course, you can't see the string. So it gives a very strange impression, because you can't tell which point the butterfly kites are circling. There aren't any nectar-filled flowers in the sky, after all. With their fantastic way of flying, they also resemble snowflakes dancing outside a window.

The kites flash in the sky, perforate it. A hunger dance. They only climb as high as the string reaches. ≈ Flying a kite on Schauinsland Mountain. Then, when it has reached its highest point (the end of the string), 'mail' is sent up in the form of wet pages that slide up the string. When the kites are pulled in, you see the pages again. Reunion.

The third day. 10 a.m. Opened the door to the balcony. A beautiful, illuminated triangle, light yellow haze almost imperceptibly turning slightly blue towards the top. A beautiful colour, even if it consists of billions of particles of refuse, dust, excrement, emissions, exhaust fumes. . . . Raised to the light. And so all Villon's expectorations—pulverized, incinerated, desiccated, atomized, ground down under a thousand wheels and trampled by a thousand feet: 'in all this let those spiteful tongues be fried'—are elevated in their final disintegration to a large screen of light.[99] Seen as a section of the bright, muted sky by the balcony door, the haze produces a beautiful refined light. But down below: every day I have to make my way from the hotel to the clinic, c.700 m, where the expectorations are all still in their rough state. Yes, you can see them flying out of people's mouths in high arcs. And the garbage is all colours mixed with grey. It's as if everything has been upended. The individual life forms, people, houses, and the entire city too, for that matter. Overturned, that is, the digestion, the metabolism that occurs on the street. Indeed, there actually are small fires here and there on the street (Pitta). You protect yourself with clothing (spacesuits) and spacecrafts (cars). But here, in panchakarma therapy, you are also oriented towards expulsion, towards elimination in three ways.[100] So it's twice as unpleasant. On the street, on the way home, there's expulsion upon expulsion (your toxins also become part of the screen of light).

So many very early memories surface, from the distant past and the middle past. It's as if you were sitting in a large empty shell or in an enormous interior space with countless niches embedded

in the walls (floor-to-ceiling cells, like in a termite nest). And out of the niches, the cells, come noises, experiences, situations from all the phases of my life. And you can see it all simultaneously in this cell block (cell nest).

3 P.M. Could you also give paintings panchakarma therapy? Can they shed antiquated, scabby, superfluous elements and rejuvenate themselves? Perhaps you could call what is being done to them now such therapy: distilling, treating with alcohol, letting the alcohol be absorbed and then washing it away so that distinct, excessively hard layers are sloughed off, released. Something similar is achieved, paradoxically, when you scatter sand or ashes over your paintings. You don't distill them but take the purified end-product—'ash'—and introduce it into the painting. The alcohol penetrates the deepest layers and cleans the painting. The sand and the ash drift into the deepest valleys.

3.30 P.M. Agathe thinks or intuits things that Ulrich has thought far away from her,[101] which he now recounts for her and she sees that they are her own thoughts → strange, how it happens to you primarily with Ingeborg Bachmann's poems: you think you could have thought or felt them. Of course, that's nothing special. Every teenager identifies with something. And yet, there's a difference (this should be examined more closely). It's as if her poems could have come from you, supposing your life had been determined by other fortuitous circumstances.

17/1/99

9.05 A.M. In the bathtub. Sensation of being in a sieve. Not that
the tub's not watertight. It holds the water and the water is even
warm. But it's only the warm water you want to have anything
to do with. The tub itself is 'dubious'. Traces of previous uses,
since the tiles have collected dirt. Accumulated in layers. . . .
Still, this inhospitableness alone doesn't create the feeling, but
something broader, more spiritual, makes the receptacle you're
lying in seem like a sieve. Above all, it's the sound reaching you,
the sound of music, of cars, of voices. You feel as if run through
by it all, as if you had no second skin, no room, were directly
over an abyss of decay and music. It's not as dramatic as it
sounds, because at the same time it's a weightless, floating con-
dition, as if you'd been lifted up and not yet set down anywhere,
weightless and suspended. Suspended, but also disgusted,
repulsed by the filth. And so, actually, two contradictory feelings
at the same time. Can you take the one, sparked by the filth, as
material in order to perfect the other (the feeling of suspension)?
i.e. to complete within the transformation (digestion) that is
occurring outside you and so end up with a purified product?
You could also frame it chronologically: anticipating the later
state of transformation (digestion, metabolism). In other words,
to already be at the point where everything has become an end
product (earth). That ever-new refuse will come and there will
never be a point when everything has been digested does not
contradict this 'idea', because it's not about real digestion but
about metaphorical digestion. But could metaphors help later,
when you have to wade through the cloaca? No one can prevent
you from digesting the most remote, most alien things.

2.40 P.M. The many voices outside have united in an almost constant noise, barely varying in volume. Sometimes you think you can discern individual characteristics. Fewer trucks, because it's Sunday. The shops are closed. Instead, the street is full of market stalls, most of them selling clothing, cheap, mass-produced items in a country of extraordinary textiles, where fashion designers like Issey Miyake order their fabrics. There was an angry demonstration in Mysore protesting the introduction of silk from China. Chinese fabrics are the ugliest. This is becoming accepted, as if the long culture of creating textiles were a brief lapse.— It's not a babble of voices, rather it's a thick mesh a single voice could hardly cut through. It's also not the level of voices that you hear in the summer at open-air swimming pools. Because in those cases, the carpet consists for the most part of children's high, happy voices. Compressed exuberance. ‡ Now, there are elements of prayers, of the market criers' particular way of speaking, like every day, actually, but especially so today because of the street markets and because it's Sunday.

4.25 P.M. The noise level of the voices has remained the same ∞. Visited the construction site. They're building an elevated road. At the moment, they're laying the foundations for the columns that will support the road. Excavated shafts with concrete floors, from which iron bars protrude about 1 m. You can identity four different stages of completion: (1) Shafts with protruding iron bars. (2) Shafts filled to ground level with concrete, from which iron bars protrude in the shape of a column about 3 m high. (3) Rebar columns opening out at the top in a chalice or flowerlike form to receive the weight of the future roadway. They look beautiful against the sky, about 5 m high. (4) A few columns are already panelled. In one spot there were women

surrounded by plastic bags of crushed rock. They were stitching them shut or patching them as needed. Strange to see them on a Sunday, when there are otherwise no workers to be seen, these women with needle and thread—Norns, since there are so many individual fates here.[102] There doesn't seem to be any collective destiny. Even on workdays, you don't see any activity, except for a security guard in uniform with a truncheon. The truncheon as sole symbol of authority. A bit further off, there's a custodian, also with a truncheon, but a home-made one, roughly hewn from a branch. There were no allotted insignia. Instead, through a strange ritual, a piece of wood became an emblem of authority, underpinned by the standard uniform whose gravity coloured the truncheon.—

In a corner of the construction site, a man lay in the dust. Sleeping? Part of the dust. Already turned to dust in the heat. A sacrifice for the construction project's success? A man in a stalled or suspended 'work in progress', next to the bent rebars and a bit further off the columns of iron rods opening like flowers.— Such situations make you shudder: situations in which men are no longer part of the social structure, in which they behave differently, like lunatics, when one day they beat on buses with a stick and on the next stand in the middle of the street (like cows do) and do their exercises. Or when someone simply lays there as if dead (as in Benares three years ago). The lunatics who sleep in the dust and the dirt, they † are magicians who can create a space of unapproachability around themselves. As criminals do (→ Soho 1980 the black man in the restaurant who shot his gun at the floor and took off with the till). Still, that was a different kind of unapproachability. It's not so much an aura as an enforced extreme distance without any possibility of communication, as

when facing a cobra that is ready to fight. With the three kinds of aura named above, there was no danger, just a shudder.

5.20 P.M. The sky now a dirty blue-green. Over the city, a grey-pink meteorological inversion, the green above it rather poisonous. Not at all a screen of light but dust not yet turned to light.

7.30 P.M. Very loud in the house. There was a party recently and people were crowded into the corridor. When you opened your door, you had them all in front of you as if they were in your room. There was a presentation at the end of the corridor that ended at 2 a.m. Now children are running rampant a few floors below. There is no sphere to protect. Everything merges. At night, lorries drive through the city, horns blaring, like locomotives.

18/1/99

10.25 A.M. Eyes focused on the section of sky in the balcony door, without seeing anything definite, just light. Not perforated by the world's noises, just rising in the decay purified into light-dust.

19/1/99

9.15 A.M. Walked to the market. One street over, partly rural—goats, what do they feed on?—and at the same time 'skyscrapers' (six storeys) are being built. In one of the houses, the ceiling was in the process of being planked, an unusually high ceiling (more than three storeys), all of it with different kinds of wood, often bamboo, connected with nails and small pieces of wood. The planking on the floors with transverse connections ≈ dense young forest. Below, a crowd of people. Diesel (petroleum) was being dispensed from a 200 l tank mounted on a rickshaw. Little containers of all shapes and sizes (plastic) in a curved row. From so much use, the containers' original purpose (label) could no longer be determined. A boy (≈ nine years old) gave a child (≈ two years old) little boats made from folded scraps of newspaper (like the little boat in the Hans Christian Andersen fairy tale). Other children played in the construction sand (construction waste) with a brick. One after another, men washed with soap at the fountain and poured the cold water from the pipe over themselves. Next to them, the women washed clothing. The streets were still rather empty, where had the numerous people converged overnight? Because there seems to be less room in flats here than on the street. And the streets were packed until evening. They must have folded themselves up quite small or into layers as in immigrant ships. When the Muslims emigrated to Pakistan, many of the trains arrived filled with corpses.[103]

10.50 A.M. In 10 mins to panchakarma therapy, 7–8 mins walk through the city, the excrement, the sputum, the dust, the exhaust fumes, etc. Everything is divided up, the days have a

strict rhythm, as in a monastery. Nothing unforeseen happens, whereas in the studio, you make every possible effort, use all your discipline, your willpower, sometimes at great cost, *in order that* something unforeseen, something unprecedented happens.— Just as the small containers for the petroleum are filled one after the other and taken away one after the other; just as the stones are beaten to gravel with little hammers along the length of the road as it's being built, so the days proceed here, one activity, one treatment after the other. It's a state of being between two states: (1) in which you consider each activity, take a step back, then continue, and (2) in which you don't think, instead say to yourself that what is past is no longer important, is not worth examining; instead, you jump from one activity to the next and so have a rapid, unthinking, shallow course. Between the two is the time here, one after the other, and because the one is like the other (stone upon stone), you don't need to check (to look backward), but you also don't need to worry about what's coming.

5.30 P.M. It's already getting dark. Had my treatment earlier than usual today. Already at 4 p.m., they poured oil on my reclined head for 20 minutes to alter my consciousness. It's like floating over an abyss or, better, like dipping into an abyss, an abyss of sky. Having your head extended backward is a defence-less position, a desire to drink something that's being poured vertically. A thick, vertical stream. Each drop of oil draws something out of you and makes you lighter. A little like floating in the sea and the water's surface runs up the dome of the sky.— Outside, the beautiful evening colours again in the balcony's rectangle. Pink over the city (the sun, of course, sets behind the hotel). The wonderful pink from all the fine dust that shades

into a colder blue near the door's upper edge. Behind the hotel—I got up to see the sun from the balcony (which abuts the corner of the building). It's not burning very bright, although it's still above the city, because it's muted by the dust. Surfaces of houses and trees, arranged like a series of ruins, grow more and more misty with distance because of the strong aerial perspective. It's completely different than at the Ribotte, when the individual mountain ridges appear as surfaces in the evening. Why completely different? Because of the mountains' form. Here there is no form, the city has no form. The soft, transfiguring evening light otherwise helps every city. Here, it doesn't help at all.— Odd: solitude in a strange city compared to solitude in a familiar place (e.g. at home but without people, NY or Buchen). No matter where. The former is an uncontrolled solitude, at any time it can destroy you or make you panic. The latter is a gentle solitude that binds with soft chains. A self-affirming one. At New Year's, when there's noise everywhere and everything is very social—in the family or the community. And when you're standing there, alone, what is that? Or at Christmas, when you feel such a blatant, such an overwhelming sense of community out on the street, yet your solitude still doesn't feel claustrophobic. You absorb it like nourishment. You tap into something. It's no ordinary solitude but one that is nurtured a thousand-fold. How does the transmission happen? It's not a transmission, that sounds too medical-technical, it's a feeling, as if every one of them had agreed to do something for you, in a sort of reverse proxyship. Not one for many but many for one. Because if the streets and houses were empty, it wouldn't have any effect. You know that others are in the houses (as you once were) and have left the streets empty out of holy reverence.

For a week, they've been preparing a wedding next to the ayurveda centre. Large, openwork planks from boardwalks are set up and disguise the huts. For a few days, they will represent a palace. The material is brought in on those three-wheeled carts with supports, from the location of the wedding which took place elsewhere. It's all like a film set for a few days in the life of this couple. They're playing in a movie whose screenplay they haven't written. Few actors do, in any case.

6.05 P.M. Went to the balcony and looked towards the sun. It has set. There's a haze there, a fog like in the rainforest (from the exhaust fumes at rush hour). How the same pictures of these phenomena can be made from so many different kinds of material! Above the fog, the yellow street lights (few).

20/1/99

8.10 A.M. Stared at the rectangle (balcony), eyes wide open, without moving my lashes. The screen of light grew darker. Like a bright gloom. Then I closed my eyes and the triangle remained light in the dark, a yellow-green.

9.30 A.M. Walked a few blocks, a few hundred metres → north where the city ends, or at least is interrupted by a kind of forest. Again and again, this juxtaposition of smallest units. Sometimes just tiny front buildings in which families live and large shops, clean inside and lit up with lots of neon lights. It seems to be the same all through the city. But it's different from Bombay where people live, cook, etc., in a uniform way out on the street, the sidewalks. There's no mixing but, rather, an overlapping according to the time of day. To the north, the shops end and it becomes more rural. Cooking areas, goats, snug little wooden houses, the quiet life, so to speak. At the 'end', where the forest begins, there's a broad ring road. That's where the cowpats are dried. They look like pancakes in the dust. In the midst of it all, children everywhere. The rapid transition from rural 'idyll' to 'big city' is so attractive because in this case it fits the chronological transition from ancient times to the future. Thus spatial simultaneity of various stages of civilization is like a constant caving in of a thin sheet of dream ice. You could also say: a ford with deep holes. Or like a helicopter flight (e.g. over the desert in Israel) close to the ground when now and again there is a deep abyss in the form of a valley (the atom bomb next to the cow patty). What runs counter to the rural aspect is the poverty, the many residents in each hut. On top of that, the little houses are filled with amulets, little temples, blankets, curtains, wall

hangings, etc., as if they wanted to take the lack of space ad absurdum by overloading the small space. In the morning, the house, the bodies and the area in front of the house are cleaned with water. But there's no way to drain the water. It simply dries. Their dumping water is more of a ritual activity than one with a purpose. But it also stimulates for a time further digestion on the street. The decay can continue.— Then walked west along the edge of the forest to the main road where the overpass is planned. Saw a single column there, almost completely lined with concrete up to the spot where it opens to support the much wider track. Rebars were sticking out of it. A tall ladder was leant against it, as when it's being worked on. But that's not the case. Maybe the money trickled away somewhere else. It seems be the same as with the morning bath. Now and then a small shower of money seems to rain down on the construction site, as overflow, so to speak, from some source and then there's activity. However, the water soon dries up again. On the side of the main road there are strange cubes packed in plastic. Before them, stones in a particular order. They're sales stalls and the goods were packed in plastic overnight. One stall was already open, with books and magazines. Saw a milk-bicycle just before the hotel. A man went up to it. He had a wound on his hand. He spoke with the milkman, stuck his good hand deep in the canister and rubbed the milk onto his bad hand. Did this several times. The milk helps—it's from a holy donor. It's not clear whether the milk will heal the hand or the germs on the hand were mixed with the milk. So more of a spiritual healing through the interpenetration of everything with everything.— There's still a dream from yesterday to write down: you had become minister of culture (how wasn't clear) and were in a cabinet meeting. The other ministers were almost all (four or five)

women and were talking to one another. Parisians with proper make-up, well dressed, lithe and haughty. It was a real problem for you since you didn't know much about French politics. Not even about the electoral system. Whether they also have party lists like in Germany, etc., because you had to have been elected somehow, either directly or indirectly. You thought you could give a general philosophical talk if necessary but your lack of knowledge was unsettling. So you tried to engage your colleagues in conversation. In vain. Because the meeting was over and all of a sudden you were with the French women, the ministers, in the TGV.[104] There were comfortable upholstered benches as in an old house and there were several empty seats between your colleagues. You asked politely if you could sit down but they said it wasn't possible, they wanted to sleep later and needed the whole space. You gave up and considered resigning, because how could you be a minister if you didn't know anything about the country's politics? Then you asked where the train was headed. Hopefully → South. The conductor was as confused as you because he was travelling → North and the next station stop was in two hours. And you couldn't just stop the train. Then the dream that had something strangely marvellous, flamboyant about it at the beginning fell flat and the banal reality of sitting in the wrong train and urgently needing to get home (why urgently, actually?) suddenly took over.

21/1/99

10 A.M. Seven days have passed. It's 'already' the eighth day. It's Thursday. Once again noting the day of the week. It divides the whole better than writing only the numerical date. Next Wednesday we're 'already' flying to Calcutta. Then we'll be sitting down for lunch at the Oberoi. No more of these metal containers that need to be washed out after use. And yet you'd be better able to endure it all—the dirt, the unpleasantness, the noise at night—or wouldn't think about it at all if it were for a work, a visible work, which is of course something to think about. Because cleansing is also a kind of work. A 'work-in-itself'? Are you then dependent on something tangible? If this led to a book, it would also be something tangible. If it were directed towards a goal. And yet things here are supposed to occur independent of such a goal. Just as construction on the overpass has stopped. There are a few foundations, some holes now filled with water and columns in varying degrees of completion. And then the goal seems to have disappeared. Somewhat inspired by this general abandon with things left up in the air, you wonder why the elevated road should be finished at all? It's interesting to look at the construction site as in a technical museum. It's also clear with regard to the cowpats laid out to dry: in Ottersdorf, you gathered manure in an old perambulator, you scraped the soft cow manure from the street with a dustpan and loaded into the pram. Horse dung was easier to gather. You were paid 5 pfennigs for a full pram. It was the first time you experienced, albeit unconsciously, the connection between excrement and gold. (→ Octavio Paz: Quevedo).[105] Gathering manure was an activity with a goal. With two goals even: a full pram and the accumulation of capital. The unselfconscious way

of handling shit in the old country. In this context, also painting murals with shit. Then you wouldn't have noticed the dirt and filth in the ayurveda centre. It's scandalous how you can never get rid of such imprinting which doesn't come from the self or from nature. Marked for life.

In the trams after the war there were still those black and white enamel signs: No spitting in the car! There are no such signs here. People spit more or less energetically and with better or worse aim at what little unoccupied space there is. But you're always stepping in it and thinking you can feel it through your shoes. Even the hard ground is permeable for certain violets from infinity.

12.35 P.M. On the way from the hotel to the ayurveda centre there's a place strewn with little red and white bits of paper, like rather too large confetti that have been trampled underfoot. The red and white colouring is striking, otherwise they wouldn't be noticeable amid all the refuse. They're lottery tickets. Strange, this pattern made of so many hopes. You can't call them dashed hopes, because (Caspar David Friedrich) the word dashed doesn't apply to this.[106] Also, these are not noble hopes lying there. Maybe even the word hope is wrong.

4.05 P.M. Got a new shirt from a tailor in Bangalore. (After the train trip from Mysore → Bangalore, before the departure by aeroplane the same day → Nagpur, I went to the tailor and ordered 18 shirts.) Knee-length. Strange how one's feeling about what one is wearing affects one's thoughts. No more trousers. Nothing that is tight or confines. Like a hut with space in-between. Or something to wear in an interior space (wearing it to the office at the Ribotte would probably not be on).

(≈ Buchen: for a while I wore only a shirt from the time of the rubble women.[107] A limbo between being dressed and undressed. The air between the wide-cut frock and the body isn't outside air, but it's still air that has just been warmed by your body and that remains close to you for a time. Above all, it's not closed below like pants or stockings. So it's a cone opening towards the earth.)

6.45 P.M. On the way to the ayurveda station, they're laying new electric wires. You can hardly even say they're buried since they're not laid very deep (20 cm). In cities at home, these jobs are so fenced off, so clinically and operationally isolated, that there's no intersection between the area that remains intact and the one that's dug up. In the narrow ditches where the cables will be laid, wastewater always collects immediately and the cables become deep-sea cables to a certain extent. Then they're laid out next to the parked bicycles and heaved into the narrow ditch. From time to time, you can see the cable growing back out of the earth in places where a transformer or a distribution panel is mounted over the 'pavement'. There aren't many buried supply lines and waste pipes, as you can see in excavations like these. Most everything is visible, like the men's morning baths at the well.

More comments about the oil treatment. On a previous page there was a passage about an abyss and spreading filth, a flowing. . . . It's something else: you feel the joint that connects your head to your body. Then you think of a head continuing to live, of consciousness in a decapitated head (guillotine). After ≈ 20 mins, the flow of oil ends and the therapist lifts your head, dries it and gives it a brief massage. That's what it must be like for

newborns, when their heads are still to heavy for them to lift. It's nice to let your head hang back and have someone hold it (even if the therapist is not particularly likable, because it's something impersonal, transpersonal). Letting your head hang back contains much primordial experience. In the same way as many things from the old country surface during the oil treatment. Today, especially, Bad Boll,[108] etc. A very strange apparition. The landscape (Ölberg),[109] the schoolhouse, it's all there. But the question is why? It's there and exerts a powerful pull, one that can't be compared to anything else (as so often before), but what do you do with it? Can it be used for thought? Is it one of the empty places that must be filled? Make a list of such places like: the Louvre, dark facades at midnight 1963, Brigach and Breg, the Ottersdorf forest path, Rhine, arm of the Old Rhine,[110] reservoirs . . .

22/1/99

5.40 P.M. Pursued by two begging children on the way back from the ayurveda centre. They were completely naked and one of them kept grabbing my arm and pulling on my bag, making gestures of wanting to eat (he was well fed, which you could clearly see because of his nakedness). Strange: a naked child in the city (five, six years old). You see them often in baroque skies and in paintings of the Virgin Mary. Here, they're supposed to present utter poverty, not a single, small pair of pants to wear. It's like the washing and the digestion on the street: what we keep completely separate and hidden is on display here. It appears as a kind of violence: lepers on the street, naked children, also in São Paulo years ago, the sick and the crippled in the city centre. You immediately become angry, almost feeling attacked by the violation of distance. ≈ On the street, people often shake your hand and want to talk with you. The 'violence' in the pushiness of these children (who may be exploited by gangs) is strangely similar to the violence that comes from a completely opposite experience: when, for example, a person close to me, with whom I live, gives me the silent treatment as 'punishment' for a time, and so does the exact opposite of what the children are forced to do, namely, break off contact. You have both, then: the intentional interruption of an accustomed contact as well as 'making' contact, that is, forced contact with people you've never been in touch with before. The former feels like a subtler, greater, stronger violence, like a bare threat. Why? Because you not only have to suffer violence, you are also declared to be its cause. You give me nothing, therefore I have nothing. You hurt me, therefore I can no longer speak. A load of guilt is always being passed on. → Shunting yard

6 P.M. It's getting dark. In the morning, in the evening, always haze over the city. As if something were cooking everywhere (→ the belly of Paris). The square you have to cross twice a day is as full of advertisements as Times Square. They tower over the houses. Not much neon but walls of fibreboard or thin wood, illuminated by spotlights. It's as if everything were glued on, like the coloured plastic foil in the car windows. And there's nothing grandiose about it as there is to some of the giant billboards in empty landscapes in the USA. The billboards are rather mixed, as everything is here. There is no writing in the sky. At night, a man sits in the street not far from the hotel. He warms himself with a small fire he feeds with the garbage lying around him. The smoke rises like something coming from the bowels of the earth. Of course, this image was immediately dispelled when it abruptly went out and you could see him tearing up new pieces of paper or cardboard. The man sat in front of the fire like a snake charmer. It was his centre or, as we would say, his hearth and home (→ in Latin hearth = house). It was his own small centre, like the many centres next to each other here. Everything's always side by side, in Kerala the many little ash piles on the small dykes in the rice paddies. And on the roads, the rather larger ash piles from the elephant attendants. In the morning the fires were all swept away. It is the main shopping street, after all.— Another aspect of Kerala occurs to me in association with the digestion taking place on the street. (How will this digestion occur in the monsoon?) The morning shit piles on the beach. Countless fisherman came out of their huts down to the beach to have their morning bowel movement exactly at the drift line of the retreating waves. The feces were immediately swept into the sea and processed. Here too a succession of the individual excrements. No accumulation (neither

by individual persons nor by the collective. No sewage system, where everything is mixed in one flow. No flow of money, either. It's almost all subsistence economy. Only the fish are sold every morning on the beach for a small amount of money.)

5.15 P.M. Last night, cleansing cure. Now the pain is gone. Ate rice with a little salt because of the electrolysis that doesn't work if you cut too much out (\rightarrow electrolysis on the paintings). Tried to eat (rice milk) earlier (around noon). I couldn't keep it down. Digested like a worm, without the finer distinctions between stomach, liver, small intestine, large intestine, etc. After a few minutes it came out below. It had a different colour and smelled a bit differently but was just as liquid. The guarantors of metabolism have defaulted. There's nothing left to do but wait. Slept. It was over by four in the morning.

No treatments today. Strange. When you resurface (admittedly too dramatic a word in this case), it doesn't matter much what you're looking at, you'll find it attractive, whatever it is, as long as there's enough air around it (even if it's the worst air), you take it as an opportunity to welcome life. Maybe not even life but everything between the objects—the fact that there even is space between them. The flowerpot on the windowsill in Rosa Luxemburg's prison cell.[111]

6 P.M. The day is ending. The noise level rises. You might think it escalates like a turbine engine. The movement on the street is different here than at home. Each person walks or drives somewhere, and they all somehow pass one another. There's a lot of honking. Almost nowhere else is there so much honking. But no one turns or moves aside in response. Actually, the honking

is incomprehensible. Or not? In a way, you can't see? The many Vespas don't remind you of Italy—they're driven so elegantly, recklessly, as if in a dance.

24/1/99

3.10 P.M. People lying in the dirt on the street, some crippled, some just sick or poor. Always in the colours of the street. Covered with dust. The difficulty of transposition (Dilthey).[112] How much practice would it take to see the excrement, the dust on the street as one's garb or, better, not to have anything come between one and it. No boundary between one's self and the 'world'. A kind of dissolution (like cutting open one's veins in the bathtub?). It's also due to the climate. Only in the north could the stylites not gain acceptance.

25/1/99

Only tomorrow left. Then → Calcutta. It's been almost a month since leaving Paris. Exactly one month since leaving La Ribotte.

26/1/99

7.25 A.M. The day before departure. That's the hardest time. Once again the unwashed hand towels, the sloppily cleaned oil-treatment tables, the swollen wood of the steam bath. . . . It's like when you urgently have to go to the toilet, the last few metres before you get to safety are the most difficult. Eating too is most difficult on the last day. It becomes clear at the end: the pots (metal receptacles stacked one on top of the other in a separate trough) are not cleaned, much less sterilized. They're probably refilled just as they've come back from the patient. You could have figured it out earlier but didn't want to.

Yesterday evening (7 p.m.) went out to get something to eat in a cycle-rickshaw. You can sense the flow of traffic better when you're sitting in a Faraday cage, so to speak, protected by the rickshaw's meagre frame.[113] It's not a flow we're familiar with. It's the flow of a flat torrent with eddies, crosscurrents, blocked side currents, etc. . . . although 'torrent' is the wrong name because it's not wild. The current is ordered by means of transportation, with pedestrians amidst the cars, mopeds, motorcycles . . . some take a direction that runs counter to the whole. Then there's honking. But the honking doesn't change anything. There's no aggression in the traffic. Yet it's also not considerate, quite the opposite. People are neither particularly worried nor agitated. No one jumps aside at some danger. Every shot is a fate and an irrevocable one. So everything just flowed around the rickshaw when the driver rode through the intersection against the light. Some had to brake sharply. But you don't hear a single tire squeal. You get the feeling that they stop just before colliding (that's paradoxical of course, because how can you

prevent an impending collision simply by stopping?). But the traffic, composed of a mixture of the most varied vehicles, passed very close to our rickshaw as it gradually moved forward, perpendicularly to the flow, like a ferry crossing a river. Naturally he could have waited a minute and it would have been easier, but no one gets upset about this sort of 'nonsense'. And it isn't nonsense at all. The rickshaw driver had already waited a long time for a customer—why should he wait now? He got it into his head: two customers want to get somewhere. What's with that little light on the side of the road? It's like that documentary, in which young women said they couldn't imagine that the little pills actually can prevent pregnancy. The traffic light is also too small. The way people behave in this traffic is a metaphor for the abyss between the Indian and the Western ways of understanding the world. Even after a week, it's still not possible to slip into the flow of traffic without a problem, without 'stumbling', without malaise. There are always obstacles, crowding from behind, from the side (what only we would consider crowding, §1 of the traffic code). Nothing obstructs, nothing jams, nothing endangers. Things happen the way they happen. Could you say that the laws of nature are different here? That perhaps people here are able to pass through one another, immaterially, as it were? Or that they have a prodigious system in their heads, one comparable only to a supercomputer, that spots every gap in the traffic and exploits it? It's rather their 'lack' of emotion (a lack only from our point of view). Emotionality leads to accidents. It's like a science, i.e. the turning off of affect, a traffic science. Every one in traffic is a traffic scientist and this scientific (or philosophical) calm is achieved by observing traffic as an experiment. The possible consequences (†) are effects that

are a priori part of the system. A natural inevitability. That's why it wouldn't be fitting to ask about 'victims'.

8.10 A.M. Today is a holiday: Republic Day. Outside groups of students in uniform march past. This is an exception in the image of small, individual elements: the uniforms, the congregation at one spot, the gathering of many particulars into a whole. That's what the English brought and that's why the trains arrive (even though they don't always depart again right away). Another group of young soldiers or police officer trainees, also in clean, neat uniforms. Still children, actually. Their lockstep wasn't working quite right.

27/1/99

8.20 A.M. Bags packed since yesterday. The plane leaves at 11.30. There's still the luxury of being here for a while yet, although the bags have already been collected. An *interim time* that is connected to the entire state of being 'in-between', between heaven and earth, life and †, men and gods.

Nagpur

11.20 A.M. In the plane → Calcutta. Beforehand, walked through the city one more time ¾ hour towards the south. There were covered arcades for craftsmen and offices. In one (it was 9.30), someone was asleep on a sofa, covered with a shawl (like the woman on the construction site a few days earlier). There are also large schools there with children in uniform. And, right behind them, very small huts, sometimes right in the middle of the road, made from laths and scraps of sackcloth. Just big enough to fit a bed. There were people cleaning their teeth everywhere, each in his own way. You don't see any women washing themselves. They wash the laundry outside. Through the small alleys down to the river (it's hard to use the word 'river', because the water seems to have altered its material state: viscous, collapsing under the burden of carrying such quantities of digestion by-products. The train from Mysore → stopped in Bangalore, right near a water treatment plant).

Cowpats are dried on the 'quay wall'. Along the wall you see the process in various stages. The very fresh patties and those already dried out, leaning against one another in small pyramids.— When I returned to the hotel, there was a cow, calmly

crossing the major intersection despite the already heavy traffic. Calm and steady, a paragon of Kapha. A veil of rushing traffic spread in front and behind the cow. The mopeds, bicycles, rickshaws and occasional cars are, in their filigree way, in their movement, a wonderful counterpart to the cow's cubical body. Just as when the wings of a jumbo jet divide banks of fog or the sacrificial smoke surrounding the holy object streams by horizontally or like a dancer's veil (the cow dances amid the veils of the passing vehicles).

11.45 A.M. Below there's a river and many small fields. Smallest units. It's strange to be sitting in an aeroplane seat again—far from the digestive processes, in deliciously purified air without any smell or shape. The river below flows in a ribbon of sand (light yellow) about 300 m wide, sometimes it pushes up against one bank, sometimes against the other, often dividing into small- or medium-sized rivulets which later join up again. Like a highly calcified blood vessel, through which the blood can hardly make its way and that is about to suffer an infarction. Soon we'll be in an international, vaguely hideous hotel, in which every thing works well and we'll regret no longer being in a place where things are difficult (where we suffered something, where we were repulsed).

Building = living Overpass construction site

11.55 A.M. On the drive to the airport, we took the same road where the pictures were taken a few days ago, from the main street straight ahead. Only in sight of the airport did we turn right. There, saw that those columns were under construction in another location too, two of them even had workers. So it

does continue. Still, the project seems to be turning into a particularly long one. At this rate, we won't see its end. But f inishing it doesn't seem to be the point. The construction, the act of building is perhaps already an act of passing over. Building = living (Old High German: buan, like 'bauen', German for 'to build'.) Cutting the inaugural ribbon after only a few years, as politicians in the West like to do, would probably represent a kind of brutality here. Nothing is 'cut through'. No one here would say that the overpass is 'under construction' because the overpass is already passing. Another attempt to circle the phenomenon: the existence of the overpass is merely accidental. The building of it is what's essential. And it's so sad to see how quickly these building phases (scaffolding, etc.) are broken off at home. Here, the fabulous giant flowers remain standing in their full glory. Once again without the cement castings that will make them secretive, the strands rising first in a wonderful curve towards the sky and then bending horizontally, thus inclining towards the planned course but still resisting for now. Or the marvellous foundations with the curving rebar rising from the depths; rising straight up from the ground, from the concrete and then bending back down to the earth (reflection). There were about 10 workers busy with one of the columns, straightening the rods for that column. There are very many strong iron rods (between which there hardly seems to be any room left for the concrete) bound together with wire. One worker held a plumb line up to an iron rod. Wondrous, this modest plumb line in construction. This string with a small cone against an iron rod one hundred fingers thick. It was as if the string weren't directing the iron rod but were merely an accessory, a decoration, or, even better: a commentary on the construction (as the few workers seemed to be a commentary

on construction in general). Because the tools are never the framework itself, they're never powerful, they're always just the cherry on top, the name of the sculpture, so to speak (the land surveyors' plumb lines).

River

12.05 P.M. Another river, this one coral-green (\approx Great Barrier Reef) with the same ribbon of sand, but the river's movements are round and full, rather convulsive. Then a landscape like in Australia with lots of small black dots.

12.20 P.M. Several narrower loops of sand with reddish rivers in them. Reminded of the traffic flow that also doesn't run straight in Nagpur but winds here and there according to the laws governing the flow of rivers.

Li-theory-India

The way a 'report' about this trip should begin: with a declaration that you don't want to give any information, you can't give any, because all information contains its opposite. You can't say they're poor because they're rich; you can't say underdeveloped because they have rockets and atom bombs. . . . They are spiritual and materialistic, tolerant and aggressive. Best to say nothing at all, because when you mix up what you say, nothing is left. Then what do you do? You look up and look down and stay somewhere in-between.

12.40 P.M. Below, again, extremely small green areas and between them desert-like expanses. From up here you only see

the delicate green, not the dwellings. They're like grains of sand enclosed in the green. Descending (for the approach), you see the green areas are rice paddies with dams and the houses around them. And what looked like the desert are also fields further, just not rice fields. Because the rice paddies need constant care. They must constantly be built and maintained. Over Calcutta, an extreme atmospheric inversion. There's hardly any light left. The city is dissolving into the dust that forms a clear line against the blue sky at a height of about 3,000 m.

1 P.M. Landed.

27/1/99 Oberoi Grand Hotel, Calcutta

6.30 P.M. At the hotel since three o'clock. Solid wooden furniture, as in an old train, the Orient Express. Strange how distant the surroundings suddenly seem. No one enters the room when you hang the red sign outside. There's no noise from the street, everything padded, isolated. Thirteen million inhabitants in the Ganges Delta. Is there any difference reading Musil here or at the Ribotte? It makes a difference where you write, that's clear. Isn't it?—

For example: three, four years ago on the night train to Jaipur (Rajasthan) I read *Malina*.[114] The boring landscape outside, the narrow seat, no corridor, the Indians sleeping over, under and next to you. Drawing yourself together into the most compact space to create distance between yourself and others (which doesn't work, because they immediately fill it), to protect one's experience, no, to shape it.

28/1/99 in the train Calcutta →

10.45 A.M. Vast, vast rice paddies, harvested, without water (≈
Po Valley).[115] Faced with the fields' expanse (train trip 140 km),
indirect idea of a billion people; the grains of rice—people.

England: rolling fields of grain. India: flat fields of water (water
level) with men and animals everywhere in the fields. Banana
groves here and there. And all kinds of plants you don't recog-
nize. Some on stalks a metre high. Again and again the fresh
green of rice seedlings. The fields will soon be flooded with
water from the Himalaya glaciers. Stubble-fields everywhere
(barefoot on the stubble), the people in them bucolic. Like in
old paintings (Lorrain), people as decoration.[116] And in the dis-
tance, trees (→ Po Valley).

10.55 A.M. Gurap West, the lakes in the town partly covered
with algae. All of it from the Ganges Delta.— A few of the fields
here are already flooded. The colour green germinates. 'Germi-
nate' is wrong because these are not cereal plants but rice
seedlings. Rice school. Here and there, yellow flax. There are
no swathes of land, no areas without people. (They hang out of
the train's open doors and windows. The suburban trains with
partly barred windows like bee hives. Bees crowding around the
entrance hole.) How do they regulate the H_2O supply for the
fields? There is a rate of volume, a plan that must be followed.
It can't be left idle like the overpass in Nagpur. But worry about
the rice has been in their genes for thousands of years as when
sea turtles, barely hatched, turn towards the sea. Here there are
small machines that plough up the earth in the wet fields. Now

and again you see men scooping the water from one field to another. A human waterwheel.

11.15 P.M. Saktigarh West, India's breadbasket.[117] The enclosures were just set up with long bamboo poles. It looks like an animal slain with spears in an ancient land. Half an hour to get to the airport. You drive right up to the train tracks, even right up to the train car with your name posted on it. The conductor has a list with the numbers of the reserved seats. As always, went to the end of the train platform. There a group of workers were busy repairing a switch point with crowbars and spanners. A red cloth was spread over the relevant track (later a locomotive even stopped in front of the cloth). It's always wonderful to see work in its primal state here as on the first day. That's what's enchanting about this place (‡ airport, aeroplane).

11.25 P.M. When the train pulls in, the noise level rises suddenly because of the vendors who come in on the Bardhaman train. The sounds are similar to those made by the street vendors we heard in the hotel for 14 days.— The yellow fields aren't flax, they're mustard. The rice harvest was a month ago, so it's autumn now if you were to apply our seasonal divisions.

Back to the track repair. Some were pulling up weeds like farmers in a field, everything about the track was rustic. Suddenly a large crowd surged over the track, having disembarked from a train. Inundation of the tracks, a flood of people. You almost couldn't see the rails any more until another train arrived, for which they made room. Otherwise, the same distribution of people as in the fields, evenly distributed. Anyway: they're always peculiar places, the far ends of train platforms, like a

North Cape, the farthest extended point. Because the tracks don't form a border. They are crossed, flooded, absorbed . . . — Odd, seeing a 'sleeper class' carriage at noon.

Not long after Calcutta: a field with brickwork chimneys, staggered deep in the strip bordering the tracks.

A few construction sites along the way. A new railway line is being set up. First an embankment is raised with hoes and baskets. The dirt comes from the adjacent fields. Then sand, then gravel, then the prepared concrete ties and finally the tarred crossties to secure the track. All this observed against the direction of travel. And again the question (*our* question, they don't ask such questions here): When will it be finished?

And still: vast, vast rice paddies (although the individual paddies are small), the sum of the rice fields forms the expanse. The earth's vast crust is put to use. You'd think that so much rice could never be consumed. The saying goes: as far as the eye can see. But it extends much further than the eye's range. How far does the rice extend? Now we're in a strip of sand, 200 m wide with a riverbed, like the ones we saw from the plane. They're setting up a bridge for the railway. There's not much to see yet. They've just started with two or three columns, their reinforcement bars already lying flat. When did they start? Simultaneously (an odd word here), work on the dam has begun (also for the new railway line), and an old steamroller is here to compact layer on layer because naturally this dam must be higher than usual.

29/1/99

Santiniketan[118] 6.41 p.m. – 1.10 a.m. path along the canal raised with dams. A wide road once paved with bricks now for the most part returned to dust. Red dust mixed with sand and clay dust. Trees on both sides of the canal (eucalyptus). Frequently, lakes on the other side. In the distance, again, rows of trees as in an English park (→ Skibo Castle). The expanse of the canal water, in which the treetops are reflected, the lakes and the partly flooded rice fields extended even further by the haze (fog) rising over the plains and the lakes. The noises from the street also faded away. It has grown quiet. Only the soft crunching of a bicycle tyre now and again. Wonderful expanse for almost the entire walk. The trees and rows of trees in the distance are the only orientation points like the posts in the sea on the drive from the airport → Venice. Posts set underwater in the mud, indicating an invisible way. In the distance the train's horn, as in Nagpur at night when otherwise all was silent. What is so beautiful about this 'park'? The way this broad tract of land is rendered secretive here and there by expanses of water and the distant orientation of the trees that are themselves often dissolved by the same element—water—in the form of fog.

7 P.M. Flowers outside the guestroom glow particularly brightly in the evening (not at the moment, since it has been night for some time now). Red roses, yellow and purple asters, dahlia, chrysanthemums. Haven't seen these stars for a long time and deeply moved by them.

Visited a village with clay houses in the afternoon. The kitchens, inner courtyards and the rooms are clean. Every three days

watery cow dung is applied, which sterilizes and creates a particularly beautiful surface. Sometimes they mix manure and ashes into the clay. That creates a wonderful, dark plaster. Houses in a very attractive cubical form, thatched with rice straw. Odd: living in one of them wouldn't be disgusting as in all the huts and hotels seen in Nagpur. Saw looms in a government settlement. Various movements were executed by hands and feet. The feet go up and down. One hand speeds the shuttle back and forth, the other? ≈ helicopter: the feet for the small rear rotor, one hand for the control stick, the other for the levers that regulates the position of the rotor blades and controls the ascent. Four independent movements like in weaving—to weave in the air.

Yesterday evening (until 11) there were dances by the women from the village visited in the afternoon. Instrument: drum, one-sided noise . . . the women held hands and pressed the sides of their bodies tight against one another, giving the impression of a single long body. Complicated steps forwards and back, whereby the whole complex revolved round a centre. The women are very short, which you only notice when you stand next to them.

8 P.M. Walking through the 'park', thought of how it would be to have a house there (as I do almost everywhere special). It's a stupid thought, actually, that always recurs. Stupid because everything speaks against it: it's far away, in an unknown area, no opportunity, etc. In contrast, everything speaks for the (Ledoux) house in Paris, although there's nothing affecting about it, nothing at all. What is it? As in the New Testament: Let us build three shelters?[119] You want a house where it's beautiful so

you can repeat this experience as often as you want. But why do you want to repeat it, when you've already had it once? Why do you want to see this expanse again? Because you've left something there, something unresolved (longing is always the unresolved). Or would it be more accurate to say: something has been sunk within you? But in this case, mustn't you return to that place since you're carrying it with you? So is it best to say: 'You've left something behind that you would like to see again and therefore you'd like to settle there'? But what has been left behind is always what is unresolved, the puzzle. You'd like to settle only in places where you've left the solution to the puzzle. One could also say: where something has been deferred, where there's a 'not-yet'. Not to be confused with the 'not-yet' of childhood. That not-yet is like a turning upside down; it's completely free.

30/1/99

8.20 A.M. Sitting next to the roses, drinking tea alone, still without the hostess. Birds and pigeons. Music. So many people like roses. The intoxicating scent of flowers, lilac, lily of the valley in the village church in Ottersdorf in May during evening prayers ('Mary Open Wide your Cloak'). An entire month devoted to the blessed virgin. In complete contrast to the intellectuality of, for example, the Gospel of John.— Today, we continue by car and then two days in a government hotel. The chauffeur is standing next to the car outside the compound wall. He waits there the entire day. What kind of 'not-yet' is that? Or rather a 'later', as with the construction of the overpass in Nagpur? 'Not-yet' doesn't fit the construction site because you can't really say it's not finished when no one is waiting for it to be. They don't appear to want to add anything to it. Just as with the tendency to believe that there's nothing to be added to nature. The artist's diametrical opposition to this tendency. Admittedly, not completely opposed, since what distinguishes the true artist is that he works with the smallest possible quantities. He doesn't want to add anything (he also doesn't conform), and yet he feels appealed to, stimulated, called to solve puzzles. Why are roses so red? How are the smallest and the greatest interrelated?

In the car on the way to Bishnupur.[120] Rice is laid out on the road to dry (three years ago in S. the rice straw was still spread out on roads to be dried by the car tyres). A few metres of the road are used for something else. Misappropriation.

The building lots are delimited with stones, branches, etc. Thus no signals, just objects from daily life that take on the character of signals, like the truncheon in the police officer's hand, cut from a tree.

Large construction sites on the way. A highway to the north is planned. To keep the fresh concrete (when building bridges, for example) wet, small dams are created in the rice fields. Strange combination, like the sewing machines on the writing desk.
In some sections, where the new road was lower than the old one, stones were laid along the edges to mark the difference in levels. These stones are painted white by a man with a paintbrush.— Now and then there were gravel works; the gravel is not crushed by hand here but with a simple machine. Women carried the rocks up the hill where the crusher stood (a small machine with fly wheels on the right and left). Run by an old motor under a casing. Mechanical transmission through drive belts patched in several places. A drum with holes is attached to the crusher. The diameter of the holes gets wider, the further away they are from the machine so that the gravel is sorted by having the largest fall out of the end of the drum. Women holding baskets stood at every opening and carried the gravel to piles. Human conveyor belts. The dust was terrible and no one wore facemasks except for rags tied around over their mouths. A hellish situation. Again and again, these machines with the women. No concentration, just the same equipment all around the edges of the road project. And in the dust (smoke, fog), the strolling caryatids[121]—the menial work and their proud, upright posture.

It's always the same here: a city is not so much a city because of any characteristic that defines particular cities elsewhere. In the West, for example, a particular architecture, the city centre, special edifices, etc. Here, a city becomes a city when there's more, an excess of the same (the small parts of the whole are maintained). More small shops, more rubbish, more of everything lined up in a sequence. Often, millions of such sequences.

31/1/99

6 A.M. On the way to Bishnupur: Bankura. A midday picnic in an acacia forest. Tall, slender, gently curved trunks. The ground has been plucked clean. Not the slightest twig, not a leaf. (Donaueschingen: went into the forest to gather wood, brushwood, after the War.) From time to time the caryatids walked through the forest. It was wonderful to see the slender figures walking among the high trees. Lightly, without touching them, as upright as the trees, a few of which were moving—at least it looked like a few had actually set into motion. A mother with two naked children passed by. An intimate picture of earthly paradise. Strange: what we see, what you see, always ready to take a 'false' view of things because you don't take the time to be in them. The women's hard labour everywhere in the quarry, in the brickworks, in the fields and we who gaze at mere appearances, take photographs, are inspired to thoughts that have nothing to do with the objects we see. *Tristes Tropiques*.[122] But something else occurs, as when at home, also without the Romanticism of distance, we let ourselves be seduced into a sense of longing without object by pictures that brush only the surface (→ Sissi, Heimat movies[123]). We like the illusion, the processions, the brief moments that make us dream, palm trees against the deep blue sea, the warm yellow glow of a small church's windows at night in deep mountain snow. And so the proud, upright gait of the small Indian woman walking through the red eucalyptus forest with her two children remains a dream.

9 A.M. In Bishnupur for the brick-'temple'. Tomorrow we drive back to Calcutta, *c*.five hours to cover maybe 200 km. In the hotel bathroom, the water from the sink runs in an open runnel

along the wall and empties into a grilled drain in the corner (\rightarrow the water runnels in Freiburg). Strange: when you see the dirty water again, see it draining away, coloured with soap or toothpaste. It's a 'revelation' from which you recoil slightly. You'd rather not see the discharged, disgorged remains a second time. Because the wastewater first disappears down the sink drink, as you're used to seeing, and is hidden in the pipe that reaches down to the runnel. Only then does it reappear. The brief time it's hidden gives you the impression it's already been carried away from your body and so you're disgusted at the sight (many hotels have these runnels). It's as if something of yours that you'd already discarded is catching up with you. Earlier, we also used to have these runnels in our villages and, where the incline wasn't steep enough, the water collected and smelt of rot. Back to the bathroom. When you see and hear the wastewater a second time, you believe you're looking into your own digestive tract. On the drive here, lots of ponds, some green with algae, some viscous from evaporation, some completely dried up, just the bottom of the pond covered with a bit of water.

In all these ponds people washed themselves, their laundry, their pots. Therefore you had the impression that the water 'dirtied' more than it cleaned, that it was more of a ritual than a washing. You witness the conviction that concepts like clean or dirty don't apply to water, that holy substance.

11.30 A.M. Back after visiting a few temples. Their architectural form doesn't speak to me. There doesn't seem to be any all-inclusive, culturally comprehensive aesthetic. Otherwise you'd find these forms attractive as an expression of something. But there's no sense of recognition, only the details catch your

attention. There are thousands of bricks that have been imprinted using a clay mould with scenes of daily life, of hunting, of battle . . . along with the 10 incarnations of Vishnu, as fish, snake, etc.[124] Between them are decorative elements, each one different. The abundance and wealth of appearances. Voluptuous temple dancers. The background is covered with plaster and the quantity and diversity of the raised dark red figures is impressive. It's a bit like Arabic engraving, although the latter is more conducive to thinking because of its ban of the figurative, no evasions into epic narrative are possible. Script is its only signature melody. Yet the characters (sura[125]) also dissolve into abstraction. The web, the lines, the pattern as thick as outer space. (In some such patterns, stars are actually embedded as shards of mirrors → Amba Vilas Palace,[126] Jaipur in Rajasthan.) How did the Arabs draw the constellations, anyway? This lavish and not easily decipherable system of multiple octagons combined into a pattern that could continue endlessly also has a shimmer of infinity even without mirror shards. The excessive multiplicity creates the emptiness of outer space. That can also be experienced in these rooms (e.g. Morocco, Marrakesh): you cannot add anything to it. (In the embellishments of the Baroque or the Rococo, space is always saved for a picture.) They create an empty space that *cannot* be filled. Yet there's something else: the walls are permeable like structures that have become visible (have come to a standstill), after the meat has fallen away. Multilayered perforations, walls, then no more walls (here a counterpart to the Baroque, to the Rococo).

12.40 P.M. The fan is hung from the ceiling on a hook. Many of them together would create a turbine, an aeroplane motor.

9 P.M. The mosquito nets are already draped over the beds. An unattractive yellow, made of plastic. Tomorrow by train → Calcutta. In the afternoon, we travelled about 30 km to a village where they grow tomatoes. A particular kind of tree's leaves are dropping now because it will be dry and hot next month. Thus the leaves fall not before winter but before summer. The trees prepare for winter before summer arrives. Women were busy with brooms in the acacia forest. They swept the forest. The swept-up, oleaginous leaves serve as fuel for the pottery kilns. You have to feed the leaves into the oven constantly because, naturally, they're completely incinerated after a brief flare. The oven is made from a firebox left standing in the corner. In front of it there's a platform for the stoker. A clay grate is set over the fire (could not find out how it was reinforced), then the objects to be fired and over it all a dome, also made of clay, smoke pouring from the holes in the dome. According to the law of many small units, there are several such ovens in the village. A wonderful event on the drive home. The barriers had been lowered in one spot and we waited *c.*15 minutes. Then they were opened again, even though no train had passed. We got out of the car to watch the train thunder by from up close. Nothing came. No one found it amusing or annoying. The train could just as easily have come. It made no difference whether it came or not. After the barriers had been raised again, the cars drove on. Maybe the train had got lost on the way. Or the barriers were not just for the train. In the West, we always believe in the principle of sufficient reason. There has to be a reason to lower the barrier. Are they always lowered for a reason? If barriers can be lowered here for no reason at all, does it also mean that the barriers can be left open for a reason (that is, when a train is coming)? When you look for an explanation: why the barriers

are lowered for no reason, you can easily forget the real reason: the barriers are down. The context slips and the two parts of the causal chain are made independent of the other, that is, the train is once again truly dangerous and the barriers are pointless. However, the train is certainly only slightly dangerous because here you always have to reckon with such free radicals (broken parts of the causal chain). Everyone knows that barriers can't protect you from a train. And there are many train accidents, but there hasn't been the number of lives lost for a time now that would lead to the claim that breaking the causal chain has had catastrophic consequences. Of course, one can argue that there might be a reason that we're simply unaware of behind the false closing of the barrier. And you can go even further and say that it's better to lower the barriers one time too many than one time too few. But there are no such exaggerations here. You would never close it one time too many, it's enough not to close it one time too few.— Be that as it may, closing barriers for no reason is inherent to this place. It's an experience and there's nothing to prove about it. A liberating experience, like a profound joke.

1/2/99

7.55 A.M. On the train to Calcutta. First visited a locomotive. The driver showed us the insides. Damp cloths hung over the valves. Stones were wedged under one of the locomotive's wheels, one in front and one in back, so it didn't roll away. Like the small stones on the street when a truck is being repaired. They don't use a brake block but ballast stones that lay on the ties and below them. They take whatever resources are at hand. The relationship between input and outcome is like that of a water drop that hollows out rock and the rock itself. The little stone under the wheel of the several thousand horsepower engine is like the drop that hollows out rock. You can only understand this stone if you think of the time it takes for water drops to hollow out a rock.

8.15 A.M. There are already people out in the fields. The fields never seem to be left on their own. As in those old landscape paintings in which people serve as decoration. Garbeta. A ditch is being dug alongside the railroad embankment, for kilometres already. With pickaxes and shovels, to lay the wires. Again, the impertinent question: How long will it take to complete such a long stretch?

Salboni, before our departure we saw the railroad workers' breakfast. Mounds of white rice with a small bowl of spices. The rice was cooked in small basins at the train station where the platform is not longer attached. The fire was still hot. The rice stays on the ground, so to speak. From the hook over the fire to the meal trays of the workers seated on the ground. Midnapore, where many market women disembarked with large bundles on

their heads. They sell as much as they can carry. They carry on their heads a volume equal to that of their own bodies. It reminds you of the hairdos in the French court that were so high that the tops of the door frames had to be raised. Each person brings to market what she has harvested from her small field. (≈ gravel made by hand.) Gokulpur, Giri Moidan.

9.30 A.M. The system of levers for the switch points runs along the tracks. At first many are parallel. Then fewer and fewer, the more switch points have been crossed. Amazing that it functions over hundreds of kilometres?! Even when you don't see anything special, no switch points, signals or construction sites, it's nice to stand by the open door. The head wind lets you feel the trip, constantly stimulating your skin and your thoughts. Just as when you're sitting at home, not moving, the wind carries (brings) something in. (*Vistula, Vistula . . . you carry with you many a girl's tears from Silesia's silent mountains.*)[127]

Bhogpur 10 A.M. Here they're planting rice everywhere. On the edges of the fields you see little motorized pumps that pull water up from a deep canal, about 2 m. Mecheda, Bagnan. Train stations: drowsiness, lethargy. Expecting porters, waiting. Because nothing happens that hasn't already been rehearsed thousands of times. And between the individual activities (exercises), e.g. raising a flag for a train speeding through the station, again, quiet and waiting. There weren't many activities and yet everything had to be geared around them. The periods between them could only be passed lethargically, no 'in-between' thoughts were to crop up that might endanger the activities by eliminating the reasons for them. People on the smooth water surfaces like ice-skaters before the start. There are no more motorized pumps

here, just simple buckets hanging from bamboo poles to scoop water from the canals onto the fields.

Uluberia 11.10 a.m. Bauria 11.30 a.m. Sankrail West 11.55 a.m. The stagnant pools extend into Calcutta. As it was in the country, so it is in the city somewhat, too, since everything here is muddled and the city character seldom evident. The smallest units remain small. Tikiapara. Everyone makes his own fire; everyone carries what he needs; everyone has a bed and over it, a roof hardly any bigger than the bed. Everyone cooks his own rice. Everyone sprinkles wash water in front of his house even if there's nothing there to collect the used water. If it were possible, everyone would make his own straw. Everyone prays at his own small altar, at home and in the rice fields.

1/2/99 Calcutta Oberoi Hotel #458

5.45 P.M. I ate lunch and slept 1½ hours. Woke as if after a new day. From depths not as easily overcome as when one wakes into a new morning. Telephoned La Ribotte.

Being in this hotel is like being in a vacuum, as it always is in such rooms. And all the images pass through this empty inner space. The small units, the huts, the tools, the fire. Each one separate. Almost nothing collective is visible. (Even the streets which, after all, are collective undertakings look like they've been constructed and maintained separately by individual users.) And you wonder how all of it, all these countless particulars, holds together. Even in the train stations here, you have less a sense of massive movement towards goals than you do, for example, in the Gare de l'Est when you see the commuter trains arrive in the morning and everything flows in one direction.

‡ *volonté générale*. the will of the people.

Streams of people, crowds of people ‡ they walk much more slowly, at a different pace. You probably can't even speak of crowds but, instead, of a great many people living in a societal rather than a political order. But a societal order is not a social contract, and certainly not a *volonté générale*. Each person has his own destiny to fulfil. A maximum number of people and at the same time, a minimum of organization.

One more thing about the train station. The noise of the giant diesel locomotives, a strong, calm chugging, the word 'heart-beat' doesn't quite fit, although there is something soulful in the

sound. Mostly you hear the pistons, how they rise and fall in a steady rhythm, always with a few louder piston strokes now and again. When you hear this sound, you know you can rely on its power.

2/2/99

This year February only has 28 days, so this month will go by even faster than usual. Found the Robert Musil in the hotel again after four days, it had been left behind in Calcutta. All sorts of concepts, thoughts underlined (to be noted down later). Some of them flagged with a *c*. If a few of these concepts eventually end up on a canvas, what is that? Decorative arts and crafts? Abstract ideas once again made flesh? No, a concept set down in a space so that it can prove itself there. Or: concepts remain for me logical seconds of abstraction, they are barely conceived and already they're fused (overgrown, shot through) with emotion. In this process, then, the exactness of the emotion supplements, is appended to the concept's accuracy.

9.45 A.M. Calcutta airport, on the way there a roughly 3 km stretch of workers busy crushing bricks to use as fill under the layer of asphalt on the road. → China, the brick roads running through the Taklamakan Desert. Everywhere there are workers sitting on the side of the road, crushing bricks with hammers. We would call that a job creation programme.

11 A.M. On a plane to Bhubaneswar → Puri → Konark.[128] A flight is always the best place to read (and write). You're strapped into your seat and yet have a sense of motion that you often miss when you're sitting in a chair, reading.

3/2/99 Puri

1 P.M. went to the beach.

8 P.M. They sit on the beach wrapped in scarves. They always have scarves with them, like nomads, they carry their scarves around like their houses. In train stations at night, they lie wrapped in scarves. On the beach they sit enclosed in scarves. The hotel has a beach in the preserve about 2 km away (through the forest) where the locals hardly ever come. Only two were there: one with two small bottles offering massages and another who was selling something. When they are peremptorily sent away, they return a ½ hour later. Strange: the Indians with the beach massages. Walked ¾ of an hour to where a river empties into the sea.[129] The river flows at a right angle into the sea, but just before that it curves sharply and flows almost parallel to the shoreline. There's a place where small waves run into the river. The place where fresh water mixes with salt water, where minerals are carried into the sea. Points where a river runs into the sea or where two rivers converge are always interesting. (\rightarrow Brigach and Breg get the Donau underway).

Confluence

What is it about a confluence that sets one dreaming? Is it a certain feeling that's evoked? Or an idea? First of all, there's a change in dimension. A previously consistent current suddenly doubles in scale. Two have now joined together, fused. With especially large rivers (the Ganges, the Nile) you see the river's inestimable breadth before the ∞ expanse of the sea. A fantastic abundance that the ∞ sea needs. When a medium-sized river

flows into a larger current, the width of the former, once comprehensible suddenly expands into a much broader, vaster, immeasurable one (Murg → Rhein). A transition without clear boundaries, the first current, previously flowing so reliably, suddenly ends and blends into another. It's not transformed, just gone. Because it can't have its water, its own water back. (‡ the Rhein, which flows into Lake Constance and back out?)

Puri ≈ Ave. Foch[130]

9.20 P.M. A very wide road runs through Puri. Arriving on the road from Bhubaneshwar, it's surprising to end up on this road which is as broad as the Avenue Foch. It's also similarly structured: in the middle a 'traffic channel'. To the right and left are broad strips of sand with several rows of market stall running parallel to the road. It's like the confluence of a stream into a large river. Suddenly there's a breadth, an extreme expansion that is hard to grasp. First you think of a large square rather than a road. You can hardly see the houses. The sand between the stalls is as clean as the beach. Strange: this contrast, e.g. to Nagpur. As if a dry riverbed or the beach itself had been flooded with people. They all have the same lantern and the vendors mostly sit in the lotus position at the cash register (a wooden drawer they open by pulling it out from under themselves, whereby they remain seated on the case. Doing so, they seem to have become one with this drawer. And they seem to be reaching into themselves, a strange connection between excrement and gold → making money. The broad road gives all the more an impression of a river, because here too the current flowed most quickly in the middle (where the cars and mopeds drive), slowed near the edges (rickshaws, bicycles) and came to

a standstill at the banks, sometimes creating eddies of people circling the stands without paying attention to which direction they were headed.

4/2/99

8.30 A.M. In the garden, at breakfast, lots of clay pots, dahlias, poppies and others. Bees in every blossom. How do they know if there's anything left in the bud? If they've been there already? Do they have an agreement or do they act, like the majority of Indians, without any particular reason? Just seen, how the red petals had fallen from field poppies. Like a meteor shower, if you look at the right moment.

NOON. The rush of the ocean (as ever and always), a strange word: ever (a time indicator: before anything ever was, before you ever were, for ever: every single, every single wave, every single plash of millions of sounds united in one rushing noise). Can you bring together the many small units in India? Will it yield a wonderful noise made up of the many individual parts, like this combined rushing? (*Duel with Death*, Gulbranssen.[131]) And so we close the circle from Norway across the ocean to India. Ourobouros.

4.10 P.M. Back from the ocean. Strong wind in the afternoon. Sand intruded everywhere, into your ears, your nose, your books. After a only few minutes, the towel was covered in sand. A feeling of being exposed—which you get very quickly when the beach doesn't belong to the hotel. Then you're dropped off on the long, the seemingly ∞ long dirt road and don't know what is at either end (if there even are any ends) or what might be coming from either direction. Now and then, local inhabitants come to beg or they want to sell something. You say no, no, very clearly, but they won't leave. They stay there, looking at you and repeating themselves. Sending them away is disagreeable. They

come very close, which is normal in cities where there's no room. But here with the open sea and the broad beach, it seems slightly obscene. Though we're the obscene ones, of course, lying there wearing only underpants. Something fundamental falls out of joint. A constellation you hadn't anticipated. Centuries of colonization: a meeting of incongruities.

5.40 P.M. In a restaurant (Harvey's Bar). As you get older, it gets harder to accept inconveniences. For various reasons. At some point you have the means, through experience and money, to get rid of them, but then, and this is the essential reason, you no longer see the inconveniences, the unpleasantness as way stations on the path to something 'better'. You don't believe in way stations any more because the goal has changed (either because you've achieved it or you've realized that it's not achievable). There is no more goal that will follow hardship. The principle of rationalization seems to get weaker or to disappear altogether with age. *Per aspera ad astra*, through adversity to the stars, no longer applies, perhaps it never should have.—

The tables in the restaurant are painted with oil colour. Thatched roof, flower garden. A small room is set off with simple, wooden boards that have been painted green. Window facing the street, a small window onto the restaurant, glass door, hermetically sealing the dining room. E-mail access, fax machine, computer, word programme—the juxtaposition is fantastic. The kitchen as it was five thousand years ago and then email and Internet. Strange that they can call up your paintings and books about you here.

6 P.M. Backache, nerve pain in my left leg, noticeable again since 24/1/99. Barely felt it before then, except when climbing the stairs. Now it's back again, even when seated on the wooden bench at the table. It's a strange sensation, like a sign of disintegration. The individual vertebrae seem to detach themselves from the group—strangely, it's of a rather comforting interest. Where will they be detached to, if they are no longer held together? → The vertebrae of fired clay in the zinc box in the studio.

5/2/99

8.45 A.M. This morning at breakfast on the terrace a woman, who swept the paths and the lawn. It's the same kind of broom everywhere, from the north to the south. They're short and you can only sweep with them bending over, that is with legs perpendicular to the torso. The same posture when planting rice seedlings. These women have two postures: one as caryatids (when carrying burdens on their heads) and one in a right angle facing the ground. Strange that nowhere are there any brooms with handles. Just the short brooms that prevent the upright human posture. Only outcasts are destined to sweep and they're treated like animals. Not acknowledged by the others. They're very numerous. Such sweepers are everywhere, even in places where there isn't anything to sweep up (≈ the same bent posture when you pass through the low doors in the palaces).

When you hang the note ordering breakfast on your door, nothing happens. If you give them the order verbally, they remember it all (it can be an entire list of things) and bring it at the right time, even if the order was made 20 hours earlier. The level of abstraction brought by the note on the door doesn't work, even though the waiters can read. It's a form of organization that can't be applied. Because: What is this note hung on the door? Let's think as an Indian waiter: a longish note hangs on a doorknob. First, there isn't one on every door; second, it's rather small; and third, what can it possibly say. He's already seen the people in the room, several times, and at any time they could have told him what they want. The procedure that should be followed with this note has surely been explained to him but it has nothing to do with him. The procedure would be for him

to take it to the kitchen, to read it there and record the time room service is ordered. There, they would order all the notes chronologically and then begin. But the Indian waiter can't take the note and bring it down to the kitchen, because that would leave a hole, would be illogical. He sees the conveyance of a wish as interrupted by the note which for him remains just a piece of paper.

5/2/99

In the afternoon, we drove back from the beach at 3.30. Before that, we first headed east → then back → west. It was low tide and the wet surface between the choppy seas and the sand was unusually broad because the slope was very slight. The sun shone rather low and very strong. The sea and the broad section of wet sand gleamed, glistened. Idea: walking in an endlessly long hall of mirrors, brightly lit as for a celebration. The many white waves outside in the distance and the strong foam just before the beach glowed with the wet sand like a sea of chandeliers. The dry sand and the adjacent forest, about 100–200 m back, appeared sunk in darkness, although it was still broad daylight. In the east, too, the beach and the sea seemed lost, as if at the end of the world. Here, in contrast . . . a cataract of light. The excess of light has the peculiarity that it no longer illuminates any paths, it becomes aimless. It's almost unnecessary to say that this impression disappears when you leave the wet part of the sand. Then it was a 'normal' beach with retreating waves, etc. From the boulevard, as well, somewhat more elevated than the beach, from which we looked back when leaving, you no longer perceive the festival of light.

In the evening, a man came out of the forest on a bicycle laden with pieces of wood. The skids sank into the sand (in Ottersdorf, they transported canisters of milk this way; in icy conditions, they pushed the bicycles). He had come in the morning and we had turned him away harshly. We thought he was begging. This evening it was clear that he only wanted a drink of water. Water offered or refused: mythic.[132] How shocking it is to realize you've refused someone this basic need.

9 P.M. Time to sleep. Outside the watchmen pass (the song of the nightwatchmen in medieval times, when they've shut the gates at dusk → curfew). They have whistles like the traffic police and blow them constantly: sometimes near, sometimes further off. Puzzling, who they're whistling at the entire time. Like an unidentifiable jungle noise. Another suspension of the principle of sufficient reason. It's preoccupying (and annoying) when something happens and you can't discern the reason for it or its pointlessness seems crystal clear. But what do we know?

2.55 P.M. From a passage in Bonsel's *Travels in India*,[133] it occurred to me that the entire water complex—water in reservoirs (which are then drained), water in rice fields (water level)—can be differently conceived: raising entire seas that drain away and turn to land. This happens constantly; after all, you see the petrified mussels and other sea-animals fossils.

Then drove to Bhubaneswar, ate lunch in the Oberoi and have now boarded the plane. Very nervous, like before the final acceleration over the last few metres. A flight might be cancelled, or overbooked, more passengers than seats, etc. . . . It's ridiculous, of course, to be so agitated. You want to avoid staying here longer, at least any longer than planned. Why is that, since you came here in the first place? Why wouldn't you want to enjoy it to the last drop? It's a flight reflex. Stretched out in the Ambassador's back seat, feet against the door.[134] Strange: the nerve ends (you can locate all organs in the feet) touching the door, in an unusual direction. Nerves directed outward, the spine disjointed, free, in the passenger compartment. Passed oxcarts being laden with straw on the way. One man stood on top and took the sheaves lifted up to him. In one street just before the hotel in Bhubaneswar: little brick houses. Without mortar. Bricks just stacked one on top of the other the way you piled up stones from the ruins in Donaueschingen as a child.

3.35 P.M. in flight → Delhi (two hours), hay ricks on the harvested rice fields. Gathering the sheaves. A kind of system, gathering up the many small piles. Following the law of smallest units, you could also thresh them individually right where they're standing.

Turbine ≈ rice seedlings

Combing out the grains individually and only then cutting the stalks. Also trussing the young seedlings shows a system. → ≈ the turbine's many parts, all working together according to an exact plan.

There was no business class per se on this flight. When we boarded, we saw there were the wider seats. They'd switched aeroplanes just before departure. We sat in that area. They told us the flight was completely booked because they were still waiting on another flight. But no one else sat in the wider seats. We stayed there. Strange: information here. It seems to be spread with no relation to facts. To what are they related then? The mystery of India.

4.55 P.M. The aeroplane lavatory looks like a latrine on the ground. It suddenly makes the plane seem heavy, unable to fly (or able to fly only in dreams, where everything is possible), because you associate latrines with concrete walls, stolid buildings that don't rise into the air.—

In the morning, the temple of Kanakkan: beggars on the street leading to the temple, some of them without hands (leprosy?). Strange, conflicting emotions: revulsion—you don't dare look and yet you do, as if drawn by some irresistible force—and affection, yes, love (not pity), the way these emotions come over you at the sight of horrifically disfigured people (as back in the 60s, the pictures of faces eaten away by napalm). It's the most impersonal, most gratuitous, most unfathomable love. Concepts like beauty and ugliness are irrelevant.

5.05 P.M. The atmospheric inversion over Delhi, as straight as if carved with a knife. Amazing that the plane can land.

6.30 P.M. Arrived in the hotel, 35-minute taxi ride on streets as big as highways that have nothing Indian about them at all. The flight to Paris leaves at 1.20 a.m. So, a five-hour stay. The room is like a junk room, chock full of hideous furniture. It's strange, flying out in the middle of the night. Finally finished reading Robert Musil. At any rate, the chapters he'd cut from the proofs. Now there are only variations, sketches, etc., left.

It's absurd, not yet in France but still on safe solid ground: already feeling regret about having to leave, although the greatest worry was not being able to leave (because of a few strikes). The stress that something might not work, the feeling of being trapped, and at the same time the regret (maybe even sorrow) at being freed from the trap just like that.

7/2/99

8 A.M. Paris, in the rue des Saints-Pères flat. Sometimes it's nice to find things exactly the way you left them. The white walls, the panelling, the stucco ornamentation where the walls meet the ceiling. The facades of the other houses. The morning light in the waking city. And the music you haven't heard for 40 days. Almost too many good things at once. Occasionally it's not so nice to find things the way you left them. We'll see what kind of surprises the Ribotte has in store. If the paintings are still the same. Hopefully not, since your point of view should be different after 40 days.

10/2/99

Still in Paris. Yesterday went to the new house (Ledoux), 28 rue Michel Le Comte to discuss the renovations.

Outside a few snowflakes were falling. The white light from the panelled walls and white flakes outside the window. The warm white rooms create a feeling of an interim.

13/2/99

11.50 A.M. Saturday. The mountains are here, as they were before, different every time. Snow on the mountains all around. The air is crystal clear. Icy cold.

Strange: read a few more articles from NY about the exhibit in the Metropolitan.[135] One from the *Donaueschinger Südkurier*. . . . In Villingen, we always passed the newspaper offices on the way to the train station. Strange: what the Met has to do with Donaueschingen . . . in the paper, it said: born in Donaueschingen on 8/3/45 in the hospital bunker during an air-raid . . . 22 Marie-Egon Street . . . The way to Donaueschingen via the Met. The present is perforated with holes open onto the old country.

11/2/99

10 A.M. back from india. flew there on 27/12/99, back in paris
on 7/2/99—in barjac since yesterday afternoon.

where is india now? the studio has been cleaned. the cats are
here. unfinished paintings are watching you. the office is busy.
the building for 20 years of solitude is almost finished. letters
must be answered. where is india in all this? nagpur, for example?

THE WOMEN OF ANTIQUITY[136]

ADA

in 344 went to meet alexander, who reinstated her as ruler of caria.

ADOBOGIONA

celtic princess, married to brogitarus, friend to the roman people.

AGRIPPINA

born 14 bce. married germanicus, nine children, one of whom was caligula. accompanied her husband to germania and later to the middle east, from whence she returned to rome with his ashes in 19 ce. banished to pandataria, where she died of hunger in 33. in 37, her son caligula had her ashes interred in the mausoleum of augustus.

AGRIPPINA

born 15 ce. daughter of germanicus, mother of nero. murdered her husband in 48 ce and married the emperor claudius. had seneca called back from exile to be a tutor to nero. in 54, poisoned the emperor claudius with mushrooms. nero tried to have her drowned on a sinking ship. the oracle was fulfilled: he became emperor and killed his mother. she said: let him kill me, as long as he becomes emperor. mushrooms, ship.

AMESTRIS

wife of xerxes. amestris wove a garment for her husband, which he gave to artayante in return for a fuck. amestris revenged herself by having artayante's mother's breasts cut off and thrown to dogs to eat. breasts, garment.

ANTHIA

one of xenophon's characters: child bride, captured by pirates, remains faithful despite her great beauty. her equally beautiful spouse searches for her throughout the mediterranean. the sea.

ANYTE OF TEGEA

poet 3rd century bce. five poems about objects, five about landscapes, five about men's tombs, five about animal tombs. book.

ARETE

philosopher. portrait.

ARISTARETE

painter. palette.

ARISTONIKE

pythia of apollo's oracle. when xerxes campaigned against greece, the oracle prophesied: the athenians will be able to protect themselves with wooden walls. the naval victory at salamis followed. ships.

ARRIA

wife of aulus caecina paetus. became famous through her death. in 42, her husband was brought to rome to be sentenced for taking part in a rebellion. she followed his ship in a small fishing boat. she stabbed herself in the chest with the dagger first, then handed it to her husband and said: paete, non dolet. it doesn't hurt, paetus. her daughter, also named arria, wanted to do the same when nero condemned her husband to death in 66. he told her, however, that she must stay alive for the sake of her children.

ARSINOE

daughter of ptolemy and sister to cleopatra. fought against caesar in egypt, was forced to appear in the triumphal procession and then was spared. in 41 assassinated by mark antony at cleopatra's wish. fetters.

ARTEMISIA I

halicarnassus 480 bce, with xerxes against the greeks. in salamis a price was put on her head: 10,000 drachmas.

ARTEMISIA II

sister and wife of the carian king, mausolus. sepulchre.

ASPASIA

pericles' second wife. portrait.

BOUDICA

wife of prasutagus, ruler of the iceni tribe. after being raped by the romans, led an uprising that cost the lives of 70,000 romans and 80,000 britons. killed herself after defeat. non humilis mulier.[137] no ordinary woman. many grave markers.

CALPURNIA

caesar's fourth wife, who warned him against going to the senate on the ides of march.

CALVIA CRISPINILLA

outlived a dozen emperors. first a playmate of nero. magistra libidinum. porn.

CANIDIA

preparer of poisons from naples, source: horace. vials.

CHIOMARA

wife of orgiagon, king of the tectosagis, 189 bce, raped when captive of the romans. cut off the centurion's head and threw it at her husband's feet when they were reunited. blood, head.

CHLOE

daphnis and chloe by longus.[138] pastoral novel, peaceful rural life. flowers.

CLAUDIA

caesar octavian married the 12-year-old as his soldiers wanted. yet did not touch her. the reasons for his abstinence have not been recorded. hymen.

CLAUDIA ACTE

nero's first great love and last follower.

CLAUDIA QUINTA

her chastity was called into question. trial by ordeal: in the second punic war, a ship became stuck fast in the low water of the nile. she was able to free it by hand (according to later sources: with her belt or her hair). boat with belt or hair.

CORNELIA

mother of the two plebian tribunes, tiberius and gaius gracchus. haec sunt ornamenta mea. these are my jewels. gems.

CORNELIA

chief vestal, falsely charged with unchastity, immured. wall.

ELEPHANTIS or ELEPHANTINE

author of medical manual about contraception, cosmetic hair care, sexual positions.

EPICHARIS

freedwoman, who took part in the pisonian conspiracy against nero in 65 ce. did not betray anyone despite torture. instruments of torture. résistance.

FAUSTINA

empress in 138, aunt of marcus aurelius. portrait.

HORATIA

murdered by her brother because she grieved for her fiancé who fell in the alban war with rome in the 7th ct bce. sword.

HYPATIA

greek philosopher and scientist, 370 to 415 ce. 1983 american feminist journal entitled hypatia. magazine.

IAIA LAIA MAIA

painter 100 bce. palette.

JULIA

daughter of augustus, married to agrippa, after whose death she married tiberius. accompanied her husband to rhodes in 6 bce, lovers from the best circles in rome flocked to her there. augustus exiled her. lascivious transparent linens. portrait at hand.

JULIA

daughter of aforementioned julia, granddaughter of augustus, 8 bce banned to the island of trimerus because of her dissolute life. ovid was involved in the scandal and was therefore exiled to the black sea.

JULIA DOMNA

married septimius severus because julia domna's horoscope stated that she would be the wife of a ruler. daughter of the high priest bassianus of emesa on the orontes river in syria. accompanied the emperor on all his military campaigns. the praetorian prefect was murdered because of her efforts. widowed in 211 ce, her two sons caracalla and geta, ruled jointly. enmity. the 22-year-old geta was murdered on caracalla's orders and died in his mother's arms. their mother had to show joy. when caracalla was assassinated in 217, she starved herself to death. blood. portrait.

LAIS

hetaera[139] who slept with diogenes for nothing.

LAIS

midwife, author of medical manuals, medicinal effects of menstrual blood.

LAVINIA

woman from pre-roman times. daughter of the king latinus and his wife amata, married to aeneas. after aeneas' death, guardian

of their son ascanius, female guardianship at the start of the roman empire.

LEAINA

hetaera. interrogated under torture about the tyrannicide. she remained steadfast, even bit off her own tongue to keep from speaking. on the acropolis, a bronze statue of a lion without a tongue. maybe the story arose later, to explain the puzzling memorial. 'leaina' means lioness. tongue, underclothes.

LEPIDA

married thrice. her last husband charged her with falsely claiming to have born a child, adultery, poisoning, consulting astrologers about the imperial family. she appeared in the theatre in pompeii and begged the people for pity. but afterwards her slaves gave evidence against her under torture. she was exiled and anathematized. vials, theatre, constellations.

LEUCONOE

horace's lover. the poem in which the phrase 'carpe diem' appears is addressed to her, nothing else is known about her. living more beautifully.

LIVIA

wife of augustus until his death. caligula called her 'odysseus in a roman petticoat'. underclothes. portrait.

LUCRETIA

resists tarquinius superbus. only when the latter threatens to lay her dead body next to the dead body of one of her slaves to destroy her good name, does she relent. after the deed, she gathers her relatives and kills herself. this gave rise to the roman republic after 244 years of kingship. roman eagle.

LYCORIS as dancer CYTHERIS as freedwoman VOLUMNIA

lover of caius cornelius gallus, previously a lover of mark antony's before he married fulvia, also of brutus and then of gallus, who introduced the subjective-erotic into latin literature. only frag-ments of these poems survive. remains of what was written.

MANDANE

daughter of the median king astyages. the king's two dreams: his daughter passed so much water that asia was flooded. the other dream: a vine grew from his daughter's womb and overtook asia. water, vines.

MARTINA

preparer of poisons, from syria. vials.

MELISSA

daughter of procles (tyrant of epidaurus), wife of periander (tyrant of corinth). died at her husband's hands. a guest had left a pledge with periander and the latter could no longer find it. he used the oracle of death on the acheron river to find out from his wife where she had hidden it. she appeared but refused to

speak because she was cold since no clothing had been burnt during her burial. periander summoned all the women of corinth to hera's temple, where they were forced to take off their clothes. these were then burnt and melissa revealed the secret. clothes with ashes.

MESSALINA VALERIA

claudius' third wife. blond wig, to hide her black hair. had 25 customers a night in the brothel, more than all her colleagues. opened a brothel in the palace. sent many people to death or into exile, seneca, too. finally was executed. wigs. portrait.

STATILIA MESSALINA

nero's third wife, after he had murdered her fourth husband. in her lifetime was venerated as a goddess in the eastern part of the empire.

NEAIRA

hetaera in athens.

NIKARETE

corinthian who bought young girls and made them work as hetaerae. among them neiara.

NITOKRIS

egyptian queen, the only women among 330 kings, in the 22nd ct bce. avenged her brother who was murdered during his reign

by drowning his murderers in an underground chamber by means of a secret canal. committed suicide to avoid further revenge through asphyxiation in a room filled with ashes.

NOSSIS

greek erotic poet of the 3rd ct bce.

OLYMPIAS

mother of alexander the great. had a dream before alexander was born: she heard thunder and was hit by a thunderbolt, a raging fire spread all around. and: a snake lay next to the sleeping olympia = embodiment of a god. after alexander's death, antipater kept olympias away from power. 316 bce cassander ordered olympia killed. snake, lightning.

OLYMPIAS

theban midwife, book on abortifacients, treatment of menstrual problems and sterility. Intrauterine device.

TIMARETE, EIRENE, KALYPSO, ARISTARETE

painters, mentioned by pliny.

PERSINNA

mother of chariclea in novel by heliodorus.[140]

CHARICLEA

white child of black parents. at the moment of conception, persinna was looking at a painting of andromeda in chains. same motif as in goethe's elective affinities.[141] united colours of benetton.

PHAIDIME

harem-wife of cambyses, then smerdis, then darius. she helped darius ascend to the throne by revealing that the true smerdis had been replaced by an imposter. she knew from her father that the false smerdis' ears had been cut off. when smerdis had fallen asleep after intercourse with her, phaidime took smerdis' head in her hands and confirmed that he had no ears. she relayed this to her father, otanes, who immediately instigated a conspiracy that cost the false smerdis his life and throne. ears.

PHERETIMA

mother of arcesilaus, king of cyrene, who started a civil war. mother and son were forced to flee, he to samos, from whence, with help, he was able to reconquer the throne, but he was later killed in barca. pheretime fled to egypt where she received an army with which she conquered barca. she had the guilty crucified and their wives' breasts cut off. she displayed the men's bodies and their wives' breasts along the city walls. when she returned to egypt after this revenge, her body was rife with maggots = the gods' punishment for zealous revenge. maggot-ridden breasts.

PHILAENIS

famous sex advisor of antiquity, lost manual on sexual positions, mentioned in goethe's roman elegies.[142]

therefore i bless your magnificent half-foot long rod,

may it always stand at your beloved's behest.

may your member not tire, until you've both enjoyed the dozen

figures philaenis devised.—

PHRYNE

hetaera in thebes. the artist praxiteles sculpted a marble statue of her for a sanctuary dedicated to eros. charged with impiety. she was defended by hypereides who won the trial by uncovering phryne's breasts before the judges. she made generous contributions to the reconstruction of thebes. plaster cast of a woman.

POMPEIA PAULINA

wife of seneca. wanted to commit joint suicide with seneca, but nero forbade it. her blood had already flowed, so her face was unnaturally white for the rest of her life which she dedicated to the memory of her husband. whitewashed portrait.

POPPAEA SABINA

nero's wife. after their marriage, nero became more and more of a performer. poppaea sabina died after nero kicked her stomach and she miscarried. nero himself gave the funeral oration. the greatest amount of incense ever was burnt at her funeral. she was very beautiful, strawberry blond, she bathed in donkey milk (when travelling, 500 she-donkeys were brought along) and

used special cosmetics, poppaea-unguent. portrait. incense smoke.

PORCIA

wife of brutus. at first, brutus did not want to tell her of the conspirators' plans against caesar, but to show her fortitude she gave herself a wound. after this, she took part in everything. she likely committed suicide following the defeat at the battle of philippi by swallowing live coals. gash-burning coals.

PRAXILLA

greek poet. a poetic meter was named after her: praxilleion. almost all her poetry has disappeared.

other greek poets:

MOERO, ANYTE, SAPPHO, ERINNA, TELESILLA, CORINNA, NOSSIS, MYRTIS

RHODOPIS = the pink-eyed one

thracian hetaera doricha (original name). slave on samos, then part of egypt. roses.

ROXANA

wife of alexander the great. married 327 bce, pregnant when alexander died 323. son called to the throne. she killed stateira (darius' daughter), alexander's other widow by luring her to babylon and murdering her along with her sister.

THE SABINE WOMEN

SEMIRAMIS

babylonian princess. her mother was a deity, half human, half fish, who abandoned semiramis at birth. doves fed her and saved her. doves.

SERVILIA

mother of brutus, in love with caesar. speculation that brutus was caesar's son. caesar gave servilia an extremely valuable pearl, it was the talk of the town. pearls.

THE SYBILS

at first there is only one according to heraclitus, later more and more: persian (also referred to as chaldean or jewish), libyan, delphic, cimmerian, erythraic, samian, cumaean, hellespontine, phrygian, tiburtine sybils. later references to thessalonian (manto), colophonian, thesprotian, sicilian, egyptian, median, sardinian and luccan sybils. seers of divine inspiration, who, unbidden, prophesy dismal futures. the 14 sibylline books, of which numbers 9 and 10 are lost, contain texts dating up to the 1st ct ce.

the books are first mentioned in the 6th ct bce. an old woman offered them for sale to tarquinius superbus. the price was too high for him thereupon the woman burnt three of them and demanded the same price. this happened again until only three books were left. these were bought and kept on the capitoline hill.

STATEIRA

daughter of darius. married to alexander in a mass wedding in 324 bce. later murdered by roxana.

SULPICIA

roman poet (love elegies) who lived during augustus' reign. dove?

TARPEIA cf tarpeian rock on the capitoline hill

tarpeia secretly let the sabines into the capitoline citadel. three possible reasons for her betrayal: love for the sabine leader, greed for the gold armbands worn by the sabine soldiers, patriotism.

THARGELIA

hetaera from miletus. 5th ct bce. 14 marriages. after the death of antiochos (king of thessaly), she ruled thessaly for 30 years. ignominious death by a vulture she brought with her into prison.

THUSNELDA

wife of arminius. in 15 ce, she was captured by the romans who had come to her father segestus' aid. displayed as trophy in germanicus' triumphant parade in 17 ce.

TUCCIA

vestal virgin. her chastity was questioned in 230 bce. trial by ordeal that proved her innocence: she carried water home from the tiber river in a sieve. sieve.

TULLIA

daughter of cicero.

VERGINIA

as with lucretia, a political system was changed because of a woman's role (although in this case a passive one, in contrast to lucretia's). appius claudius lusted after verginia while her father was away on a military campaign. verginia resisted, but he had a ruse. he claimed she was a runaway slave. the judge ruled in appius claudius' favour in front of her father. so her father stabbed his own daughter and cursed appius claudius.

VETURIA

coriolanus joined the volsci and besieged rome. his mother, veturia, and his wife, along with other women, went to the enemy camp and their entreaties were answered. coriolanus led the hostile army home and was murdered there as a traitor.

WIDOW FROM EPHESUS

a widow joined her dead husband in his grave, intending to starve there. a soldier guarding the corpses of crucified robbers nearby convinced her to eat and to sleep with him in her dead husband's grave. while they were busy, one of the robbers'

corpses was stolen. the soldier wanted to commit suicide, but the widow hung her husband's corpse on the cross in the robber's place. cross felicien rops.[143]

XANTHIPPE

when mykonos, her aged father, is left to die of starvation in prison, his daughter xanthippe visits him regularly and feeds him with her breast milk. caritas romana. milk milk-bottle.

ZENOBIA

wife of rhadamistus (her cousin), 1st ct ce. although late in her pregancy, she flees with her husband. it is too hard for her and she begs her husband to kill her so that she won't fall into enemy hands. he throws her into the aras river. shepherds find her still alive. river, la belle de la seine.[144]

ZENOBIA

queen of the palmyra from 267 to 272 ce, an oasis in syria between the persian gulf and the euphrates river, between rome and parthia. the king odaenathus was murdered in 266. the widowed zenobia takes over the throne. the first woman to rule in the arab world. she builds an empire, conquers egypt, ankara. in 271, she takes the title augusta. the emperor aurelian wages war against her. zenobia is caught escaping, displayed bound in gold chains in the triumphal parade. gold chains.

now all the ones who seem interesting are written down. who is interesting? probably only those for whom you have a painting in mind. not only. which others as well? those who stand out for their cruelty, for being particularly monstrous. not because of monstrosity per se, but because a particular quantity or a particular

brand of cruelty creates legends, sticks them in the memory like a flood or an earthquake.

something egregious must happen, something people will recount for a long time, and by force of repetition it solidifies into a myth that is carried through time without losing anything. such women must have done something inhuman, like climbing into a dead husband's grave, have placed more value on her honour than her life, have outlived several emperors, have been particularly skilled at mixing poison. or have worked a miracle, like the one who could carry water in a sieve. or have had a profession that was reserved for men at the time, like poet or painter. and of course women who were especially beautiful, but who did not use their beauty, i.e. were chaste or remained faithful, or, conversely, exploited their beauty ruthlessly like the hetaerae and most especially the one who surpassed her colleagues and could service 25 johns a night.

17/4/99 saturday

11.50 A.M. new laptop. problems at first, a few keys are arranged differently or have a different character. and even under the palms of your hands, this laptop extends further and requires a different hand position, a flatter one, the screen is bigger, the letters too, so you can read what you've written more easily. the colours are hideous, the last one was white, and the letters are black on white. no, white on black—it's going to take a while until I can write on this without difficulty.

bought lots of dresses, shirts, skirts, nightgowns at the flea market and dunked them in plaster, along with other pieces of old clothing, and then let them dry. the movement, the fall of the folds, was thus solidified. folds are always evidence that something has disappeared, vanished, the way the folds in sheets on a bed that's still warm in the morning hint at bodies now gone. the folds in the clothes of the vanished women of antiquity, they make you think of the pillar of salt too, of lot's wife. you could also dip the plaster clothes in salt or sprinkle salt over them, with the beautiful shades of green from electrolysis for the women from the sea.

18/4/99 sunday

10.50 A.M. now when you turn on your laptop, whatever you wrote last appears and you can start writing again right away or take up where you left off. not having to do anything to access the file and so forth does eliminate a certain inhibition and naturally you start writing, even if you have nothing to say, because the beginning is so effortless. on the other hand, it's also possible that if a bit more effort were required to start, you might not write down something from which you could later develop a few ideas precisely because you hadn't wanted to deal with the initial procedure.

now there's sand in the folds of a few of the pieces of clothing. the sand accentuates the folds and also triggers an emotion: the drifting, the scattering of ancient cultures, of nineveh, for example, evokes a feeling of transience, of constant change. the folds aren't formed like ripples in the sand on the seashore. they are, instead, in the cloth and the sand drops into them. a light trickling of snow. a sand-covered cloth like this hung against a large, reworked photograph of the desert, playing on the difference between the ripples (the folds) in the sand and the folds in the cloth sprinkled with sand. this play of differences didn't work. it happens. you write down something you've thought through, but when you create it, it doesn't work.

looking at the cloth hanging in the desert: it should be taken off the picture and hung on a coat tree and placed in front of the picture with other pieces of cloth. then it would be as if the desert had been skinned in various spots or as if frescos has been stripped from a wall. would you have come up with this idea

if you hadn't been sitting in front of your laptop? since the coat tree stands right next to the picture, it would have led you to the thought while you were still heading to the laptop. the idea simply came back to you as you wrote on the laptop. no: that's not the way it went. rather: the coat tree is standing right there because you wanted to hang clothing from it in view of the desert. hagar,[145] and so on . . . then another idea came from the laptop, as it were, to join the first: instead of laying (hanging) the sand-sprinkled cloth against the image of the desert, you could hang it on the coat tree as if parts of the desert had been skinned (desert pelts).

STRIPPED DESERT HIDE

1/5/99 sunday

9.25 P.M. if only there were a system, where each day you had something that told you later what you'd done that day (later how?). and if you knew it then? some people do that, make daily records. here that's never done, there are long gaps. there are probably years about which nothing was written. so what should you write today? that it's summer. the lilac is almost done blooming. the wisteria is in full bloom, the blossoms cascade down the eastern wall, the continuation of the first building, there where the hillside fell in a landslide right at the beginning, so that we had to have a retaining wall built. at first it looked terrible and now it's stunning. the ivy climbs up it and the wisteria falls down from above, it took four years to grow. a certain amount of time is always necessary. at Y's in montfavet, where we drove today, trees were planted when the house was built in the 18th ct. now they are very tall and very beautiful. two hundred years. you can't wait that long. how long can you wait? in five more years, the poplars will be real trees, the poplars that were planted two or three years ago. and the weeping willows by the lake. what else is there to write today? that the roses smell sweet. in the office building, up the stairs to the guest flat. but that's not so quickly done, because their scent has you under a spell, why? why can't you just leave them, why can't you ever get enough, as in an addiction??? should you only note down the fact that you've breathed in the roses' scent several times on the day in question and found it hard to leave them? and that it's no use, because your longing for the scent remains just as strong? and should you write that every day? because as long as it's summer, it won't stop, we've taken care of that since there are now roses everywhere. of course that creates a certain

322

rhythm over the days and years, because each day you express it slightly differently. that means that time would help create something structured from such entries. so, what else was there today? the drive to bagnols-sur-cèze, where you hadn't been for a long time. the first poppies and thoughts of the rhine. of the poplar forests, the wetlands, the water, the opposite shore. and that it will be a long time before you can think of the landscape here in the same way. that perhaps there's not all that much time left for it to happen at all. that the memory of the landscape here will grow as slowly as the trees. why did you come here if memory can no longer catch up to the trees?

what is there left to write? worked on the paintings of the 'women of antiquity' with J. earlier. was in paris and ghent then back in paris. a new museum in ghent where we set up the sculpture of the argonauts.[146] remembered the main square differently, for example. if not more beautiful, at least more impressive, how to describe it now? petty, divided into small parts, bull's-eye panes.

8/5/99 sunday

2.40 A.M. a whole week has passed. it's obvious that it's sunday again. the numerical date doesn't reveal much, because you could also get them wrong. what has happened since then?

at night the noises now are like in a jungle. the frogs, birds, owls and many other sounds, also human-like sounds. louder than in the daytime. night is full. the grass has grown this week, almost to full height. if you were still a child, you couldn't see over it. then it would be even more summer. the wedding dresses have been dipped in plaster and some are already hanging on hangers. when you turn them so they'll dry, bits of the floor are visible on them, bit of shellac, drops of paint, dust, etc. a wonderful layout, that inspires dreams of the great paintings of olden days. a shelf of lead books has been built in the new building. some of the books have bits of lead lying on them, like fallen meteors.

9–10/5/99 monday in the middle of the night

3.30 A.M. tired and yet can't fall asleep. turning on the laptop was a contrary action. you turned it on because of insomnia, but as soon as it was on, you fell asleep. so you turn it on to fall asleep and when you're asleep, you no longer think of the laptop. that's how it always is: that which causes an effect is in turn absorbed by the effect caused.

the brides stand, entwined with barbed wire (called razor wire). they're very beautiful because they're very meaningful: the iron maidens, the chastity belt, the vestal virgins, to name only the most obvious. you could also try working with thorns (brambles). mary wandered through a thorny wood. or mary in the rose bower. a lot going on tomorrow, new assistants. strange: some-times you'd just like to withdraw, without complications, or, better, without extra arms.

14/5/99 thursday, holiday

probably ascension day yesterday. the many caryatids today.
hung, laid the thorns over them. a forest of thorns.

16/5/99 saturday

10.10 P.M. no progress. no additional plaster figures because
there's no one here to stir the plaster on the weekend. yesterday
L. Y. and L. were here. they left today. can you use this informa-
tion to fix time and reconstruct it later? the field below is now
completely red because of the poppies. the second year that it's
so red. and it always draws you towards it. but you can't take
hundreds of pictures of it every year. there are always the same
shots. what should you do with them? what can you do in the
face of so much natural beauty? and why was it necessary to put
so much effort into creating this field on the property, when you
can see the same thing everywhere within a few minutes' drive?
it's the first step towards artificiality: to set it within a fence, to
frame it, as it were. it's singled out, deliberate. otherwise poppies
are not usually wanted, they're treated like weeds. not everything
you want is already art.

17/5/99 sunday

3.05 P.M. went to the poppy field this morning. what was there? as red as it was yesterday. that wonderful field makes you feel as lonely as a desert of ice. the wonderful world of glaciers, where there is nothing for you. where you are nothing. and whether it's the massive, most beautiful world of ice or this field of poppies. the iciness surrounding this poppy field.

FIELD OF POPPIES[147] ICINESS

let a thousand flowers bloom.[148] without such a phrase or a similarly cynical one, a painting of poppies isn't possible. the cynicism in this phrase is analogous to the iciness and to the marvellously beautiful poppy field. dulce et decorum est pro patria mori. how sweet to die for one's country.[149]

4.05 P.M. there's now a forest in the studio. pushed the painting tables aside yesterday and so the entire free space in building B, where the ceiling is highest, is filled with the clothes stands, the brides and the thorns. and the increasingly slanted light slides off the white of the wedding dresses, gets caught in the brambles, and what's left of it trickles onto the floor where it extinguishes the colours. it penetrates the barbed wire, as it does the brambles. in the spots where it goes through the barbed wire and where it goes through the thorny branches, it creates smaller and larger baroque spaces of staggered depth.

24/5/99 monday (pentecost)

NOON. again the long gap, when nothing was written. there are now two long dresses with long trains in bâtiment B. on one of the trains, there's a boat amid the waves in the sea of fabric. on the other, rolls of film have been unwound. the women with the thorns aren't good, too naturalistic. the barbed wire is both more abstract and more concrete. it should all be much more expansive. no anecdotes. suggestions rather than allusions.

THE WOMEN OF ANTIQUITY

phryne in thebes, for example. what is special about what has been handed down? that she was exonerated in court after her lawyer exposed her breasts. she did not corrupt the judges with her seductiveness, instead they saw that such beauty could not be unholy (she'd been charged with impiety). her absolute beauty thus stood for god. to put it differently, she stood outside human laws. she was immeasurably wealthy and had a plaque mounted in thebes: alexander destroyed it, phryne the hetaera rebuilt it. since most of the money for rebuilding the city came from her. and so she put herself on the same level as alexander. she undid his work. she is one half of the duality construction–destruction. from her donation, the stones were shaped to rebuild thebes. a kind of rubble woman.

RUBBLE WOMAN

pompeia paulina, for example, whose face was always unnaturally pale due to an interrupted suicide attempt. even alive, she was half-dead. romans loved dying in the bathtub, by letting their

blood flow into the bathwater, they lost the demarcation line between inner and outer. back to a protozoan state, in which the entire life form, still without its own circulatory system, is in contact with the outer world, the water, the sea. opening one's veins in the warm bathwater. self-destruction, like the fall of the roman empire not long after. pompeia paulina stopped half-way. the halted destruction, the suspended suicide, her pallor is like a whitewashed wall on which is written: you cannot forbid my death.

1 P.M. still sitting on the terrace over the pump for the pool. you can see the mountains and earlier there was a bird of prey high in the sky, carried by an updraught. circling and drawing lines that are not pre-determined and that can't be inscribed.

5.05 P.M. now, again, when there is hardly any wind, the very particular noise of the young poplars' leaves, that flutter with the slightest breath of wind.

what will remain of these cities: the one who passed through them, the wind!

memory of nelly sachs[150]
or the body will die
abandoned
in the lost face of the winds.

5.40 P.M. an autumn poem by trakl. strange how in the sun, in the heat of early summer, autumn is just as possible.[151]

30/5/99 sunday

3.15 P.M. the many 'enter' keys, until the new page appears. because you want to start a new day with a new page. why? because you want to see that a new day has begun. in case you read it later. if you ever do read it. you can also write something you'll never read, that no one will ever read. like the depictions in the lead books that will always remain closed, for example, or the women about whom you know nothing even though they've written books and painted pictures. that anyone has even a hint of all that is not known about them is due to men who mentioned them in the past, but too briefly, so that you only know that they existed and produced something but you'll never see it because it disappeared, was lost. or like most queens, who you know were married to this or that king, without ever gaining their own contours. would they have wanted to? that's always the question: did you ever truly want what you miss having or pretend you miss. what do you really want anyway? you didn't consciously want everything in your life that seems complete, that seems obvious. for example, a half an hour ago: DID YOU WANT TO WRITE THEN? it wasn't about writing—you wanted to eat some chocolate and it's hard to do that when you're painting with a brush in your hand. eating chocolate is part of writing just as before cigars were a part of writing. so you didn't, in fact, want to write but to eat chocolate. not that you were against writing, but it was the desire to eat chocolate that got you writing a half hour ago. it's a tricky thing, the will. did the queens of france want to be famous without their husbands? did they want to be something other than to be their husbands' wives?

THE WOMEN OF ANTIQUITY

it's interesting to see which women you chose. once the list is made, you can think about what determined the selection and what it signifies.

31/5/99 monday

6.45 A.M. swam in the morning for the first time this year. memory of having written something about water, warm currents, etc. above all the memories—the ones that reach far into the past and seem like something beautiful. the beauty in the matter that formed the basis for the memories was often not apparent at the time, that is, not even there. the beauty arose with the passage of time, through the intersecting of past and present. beauty can't be fixed onto a specific recollected incident, but it flashes when something remembered overlaps with something in the present that has no objective relation to what is recalled— only you perceive the relation. just as the beauty of the mount of olives overcame you when you were in jerusalem 10 years ago. you were remembering another place, in the black forest, where you spent time as child more than 40 years earlier and where there was a hillside also called 'mount of olives'. the two mounts of olives have nothing in common geographically or aesthetically but it was this interaction, this coincidence of present and past, it was the space in-between, between the two mounts of olives that triggered the shock that then produced many paintings.

3/6 or 4/6/99 friday

7.10 P.M. is all this, the sand, the heat, the plashing water outside near the pool, a false conclusion, an illusion, a HOLIDAY SEASON?

the strong scents of lilac, of lily of the valley. the roses are gone. now it's summer, the colours have changed, the sage, the blue of the sage is gone. soon the blue of the lavender will appear. the dark violet of the iris is also gone. everything is still green, soon it will be withered. in the forest there are two new sets of stairs, one from the path to the large forest lake and then from the large forest lake up to the smaller one, where the tree ferns grow. the small pond was silted up.

SILTING

completely overgrown with reeds. how will it look when you're gone, when gradually (though rather quickly here) the vegetation gets the upper hand? you'll have to look for any traces of culti-vation, the rose houses, the terraces, the olive trees, etc., under the scrub.

many new women with many different applications. the clothes, the crinolines become the support.

4/6/99 saturday

7.05 P.M. if you're a painter, you go to the studio every day. if you're a writer, you take your laptop and turn it on every day. that's why the laptop here isn't turned on every day, although that resolution was made. there are always reasons why people don't keep their resolutions. either they're not well conceived or there's not enough willpower to stick to them. mostly they're simply not intelligently conceived. after all, where can you turn for help in formulating resolutions? everything usually ends up very differently than planned. then you're happy that you were wary of keeping your resolutions. the resolution to write came about because you thought it would be useful to know later what you had done in the past. today: painted the white plaster women to give their clothing some character. then tried out various dedications. laid large, heavy, lead stones on the heads of two women. instead of heads, lead stones. they carry.

CARYATID

then laid a rat trap on a dress, also used one as a head for one of the women of antiquity, as a trap, honey trap. then drilled small holes in other dresses and stuck roses in them. then drilled larger holes in others and stuck tomato plants covered with shellac in those holes.

DAPHNE

made some of the women's busts watertight and then filled them with water. container, vessel, particularly odd effect in the woman with the long train carrying the boat behind her. the folds

of the train are the swells, but the water is the woman. that was the unhappy CLAUDIA QUINTA, who was falsely accused of impropriety and had to defend her honour through a trial by ordeal, in which she used her hair to pull a ship out of shallow waters in a river. you could say of both sculptures that the woman brings the water and the ship back in the swim, brings them with her, as otherwise only rivers channel water.

CLAUDIA QUINTA the woman who is the water for the rivers.

it's always particularly interesting when you can exaggerate to the point where the results are completely different. if you pour a half litre of water in the busts and say it's enough to raise the river's water level enough for the ships to be able to sail again.

the snakes' skins. mary crushing the snake's head is just such an exaggeration.[152] in doing so, she creates the possibility of conquering the world's evil.

one must not forget, of course, that mary is also a woman of antiquity, and because she is composed from isis, aristarte, etc., she is completely of the ancient world.

why are these wedding dresses so suitable for carrying all these stories, objects, points of view, perspectives? they're white, they're all alike, they have nothing behind them (as is appropriate for a bride), they're vessels for almost everything.

strange: the poppy painting with sand on it peeks out from behind the plaster gown, behind the paintings, and the entire time it's saying something indecipherable. it's now in a new context, but

what is that context? this painting has nothing, absolutely noth-
ing to do with what has been done over the past days and weeks.
and yet, for an hour now, something is being revealed as—as
what? maybe something will happen if you leave the studio right
now. usually something occurs in the very last instant when you
leave the studio. usually the past takes shape during a depar-
ture. like winter, now in the process of leaving.

10/6/99 friday

10.05 A.M. what happened? in paris from monday to thursday afternoon. back to the ribotte. from paris went to germany for a day. from düsseldorf (airport) to duisburg and from there to bonn with the autobahn. what happened there? wondered if it had been a mistake not to continue in essen in the 40,000 square metre locomotive hall. desert cities in general and especially with regard to essen, duisburg, etc. the desert and all those questions discarded as pointless. focus on how it will be, not on how it might have been. or should be or actually should have been. must something be this way or that? is this way or another better? are there wrong decisions? are there even decisions at all?

the women are now on the shelves. one on top of the other. with various significations, now the iron maiden, now daphne, now mary in the rose bower. now another one. there are mannequins also (bought in paris). strange: when you stand before one of them, your heads all on the same level, all the other body parts on the same level too. an odd counterpart, if you will. they don't want anything from you, but they're there in a strange way.

and when you get close enough to them, you're surprised that they're not breathing. that you're not exchanging breath. and you'd like to dress them, that's what you bought them for. but you can't dress them because they don't move. the essential element of clothing is that the body can move in it, otherwise it's not clothing, it's packaging or armour. they also reveal a kind of frozen movement, so you should design 'clothing' for that particular position. the torsos that were also bought in paris last week are just stands shaped like a standard upper body without limbs. a lay

figure was also bought, it's on its way. in the old days, in villingen, you marvelled at the expression of the male and female mannequins in the shop windows. back then they were carved from wood and rather realistic, but not so realistic that a child wouldn't have noticed. and further back, in donaueschingen, the dolls you brought to bed—you were astonished by the abrupt change from the wood, out of which their upper bodies were made, to the softer material (rags and such) used for the bodies from the waist down and legs. time and again, astonishment at this break without transition, this change without transition. the doll was a counterpart, a being—almost or fully? in any event, something to which energy flowed or better: towards which energy was directed. or did it release the energy? because the doll gave nothing of itself. it couldn't even close its eyes or make a sound. but it was there. it was a reference point.

13/6/99 sunday

POPULATING (the studio)

3.05 P.M. how is it with clothing in books? clothes hardened in plaster as book pages. cardboard covered in a thin layer of plaster, on which the wet plastered clothes are laid? that's probably the best way, will have to try it tomorrow. you could also write on it later. you could also work barbed wire into it. as with françois villon, put all sorts of things into a mixer to create a particularly revolting brew.

24/7/99 saturday, new file

6.45 P.M. it has actually been a month since anything was written. also nothing or next to nothing in the notebooks. it's difficult to create a new file on this new laptop. but now it's done. it's as if the laptop were your sphere, a heavenly sphere, under which you're standing. as if you had returned once again, beneath your heavenly sphere.

outside it's summer. heavy gales for a few days. at night the sand drifts like snow. under the cold illumination of the flood lights, it is snow.

the studio is filled with these plaster women.

8.50 P.M. now there are books with plaster pages. these plaster walls that are empty. strangely emptier than blank pages. why? stood before them for a long time, leafed through them as if look- ing for a particular page since each page is different. depending on how the liquid plaster ran. depending on its consistency when applied. but they're empty and that is their quality. each empty in its own way. empty walls. walls in rooms that have yet to be occupied. the walls are covered with plaster, smooth but not slip- pery. graphite makes wonderful lines on that surface.

it's a sensation to run your fingers over the pages of the plaster books, to see them disappear into the white. and longing, as it is behind the mountains, under the stars, by the sea. the insis- tent, endless, insatiable longing that accumulates in the face of emptiness. you have to take a pencil, take graphite to these white pages. should you do it without direction, without an idea, just listening to the sound the graphite makes on the plaster?

30/7/99 saturday[153]

5 A.M. a few minutes after the laptop was turned on, a ventilator started up and created a microclimate in the building, its own sphere. you can feel a slight draught. when the secretary was given the laptop yesterday, so she could print out what was written before the holidays, access to the file was briefly lost. things like this happen time and again. when the astronauts were just about to land on the moon, they noticed they were going to miss their intended landing site and the red warning light on the computer flashed, indicating that they were carrying too much weight and would crash. just now the batteries flashed, showing they're almost empty. so time to stop. searching for the programme the day before yesterday probably used up the entire battery.

3/8/99 monday[154]

10.10 A.M. the month in which the grain is harvested in some paintings (breugel).[155] here it was harvested a long time ago because there's no rain after june. winter wheat is being planted on the field in front of the property and will be harvested in july at the latest. now everything is at rest. cracks are opening in the earth, the lake is receding and the worry is that the lake might drop so low that the trees around it, especially the weeping willows and their roots, won't be able to reach the water level. they need a lot of water. it rained last night, not much but enough that the sand no longer looks like snow. no more drifting.

what happened during the time nothing was written? looked for names of women of antiquity in the world history of prostitution as well as in the book secrets of women.[156] some names appear in all the sources, like rhodopis and phryne . . . those who created new associations through a peculiar story. for example, with phryne, the association between beauty and blasphemy, between jurisdiction and beauty.

THE WOMEN OF ANTIQUITY PHRYNE RHODOPIS (DORICHA)

and that should now be written on all the white panels (330 x 190 cm). there are 18 of them. always two together, like book pages. the plaster walls are a good surface to write on. but is that a reason? it could become one. when something is added, when there's a conjunction. and your hand, the fingers on your hand are constantly brushing over it and it's wonderful but still without the wonder.

9/8/99 monday

6.30 P.M. cloudy the last few days. early end to summer after being very hot and dry. on thursday was up in laguiole and flew with the helicopter again over the valleys from another time. it's always a straight line, sometimes mende is on the left side of the helicopter, sometimes on the right. the other air 'up there', cooler, completely different consistency. the coolness, the unexpectedness, this other kind of air, forgotten after such a long heat wave, makes another land appear that is only superficially connected with the place reached after a 30-minute flight. it's a land composed by the currents of air. coolness at the height of summer, mountain air. place of air, grave in the air.

PLACES OF AIR

there were also the flowers. the small violets, turning blue, like the ones found in poor but mostly wet earth, often in heavy winds.

if you could describe it exactly. the difference between the air there and here, then you would have described the world.

what else happened in that time. read heliogabalus again.[157] the mood, the essence, the bloody core of the book was exactly the same as you'd experienced it back then. the scaffold in the river of mucus, vomit and semen was still clear after 24 years. the description of anarchy as an order, as the only principle that runs through disorder, through absolutely pointless horror and war. and something that was self-evident then but was not analysed: artaud's proximity to what the fascists used as fertile ground:

politics as art. myths as guidelines for political acts. for example, the night on which the 14-year-old heliogabalus was proclaimed emperor: lit with torches that were multiplied in enormous mirrors they'd made = speer's cathedral of light,[158] etc. a wealth of equivalents that were not clear to you at the time, strangely enough. but you probably sensed it all.

what else happened. the lines along the edge of the pool that indicate the number of lengths swum every day are photographed daily. for later: i hold all india in my hand. the lines are strange, they become significant in the photo. become a memory. when you know that a memory is something intentionally ripped from its context which doesn't even actually exist. because nothing stands still. you bring individual things to a stop and then remember them that way. a mental and almost physical act of violence. the way these lines stand on the smooth grey wall.

now what? constantly passing the plaster books. what do they hold?

you could put the lines along the pool on them. lines of charcoal on the plaster wall. day after day. and to the lines, to the meaningless lines add the telling phrase: i hold all india in my hand.

l'écorce du monde: title for a new book.[159] the earth's crust: book with pages of cut-up pyramids, outside the cover and inside the rust red of earth on a deep red shellac.

10/8/99 tuesday

8.05 P.M. slanting light from the west, from the mountains, that lights up the new poplar shoots so brightly that they lose their green in the glare.

what happened today. photographed the lines on pool's concrete walls in colour and in black and white, several rolls of film. especially the ones washed out in the rain, now just faint lines. and the other, darker lines over them. summer seen via the lines. it's now growing cooler, the sun is setting behind the little glass house. you shouldn't look directly into the sun. there are rays you can't see that burn the retina. all the rays you can't observe. and there is the abundance of rays given off when a star explodes, a supernova occurs. the mountains appear in clearly distinguished shades of blue, one ridge behind the other. the arrangement is very striking: the still blue sky, beneath it the ridges, each taking on a tinge of green from the next and the green then continues along the horizon across groups of trees extending into the distance, over the vineyards, hills, hamlets, ending in the full green here and the silver of the olive trees in the garden at the entrance. and in front of the laptop, the young poplars' new leaves twist in the wind.

what else was there? edmond jabès: when there's nothing left, there will still be sand. there will still be the desert to conjugate the nothing.[160] strange: opened the book at random and this line with sand was the first thing seen.

in the heart of what no longer is moved nor takes root, in the heart of the self-contained that defies reason and the seasons

(the keys of the desert surrender the five continents), in the heart of these arid stretches which repelled the sea as slowness overcame them . . . what can you do against wall? you tear it down. what can you do against bars? . . . bars which are shadows on sand?

8.35 P.M. now the air is filled with reverberations. a gramophone is playing upstairs. the crickets' chirping rises from beneath the ground. all the sounds, even those you can't hear, are isolated from one another and so hold their ground against the coming night. each night is like a snowfall, like a redeeming blanket spread over sleep. the sounds are isolated from one another, that is, they keep their distance from one another, like the stars in outer space that extends ever farther.

11/8/99 wednesday

10.45 A.M. and so the pages are filled in. with earth, with shellac, the pages that were covered with chalk a year or two earlier. the layers accumulate. and that means: waiting, always waiting, until one edition is dry. like now, for example, you wait while waiting, you write. since it doesn't distract you from treating the pages. because it doesn't require any ideas, it anticipates ideas as it goes, the pages lead to an idea.

WAITING

so: you wait until the pages were dry and the idea waits until the pages come to it. that's how it is with a book.

a book is anticipation for the one who writes it as it is for the one who reads it.

11 A.M. it's time to look in on the waiting pages again. you say 'look', but you don't just look. although looking is the essential part. because what you see after it's dry is decisive for how you will continue. without looking, there's no doing. sometimes looking is stasis, namely, when what you seen is so interesting, you don't want to cover it with another layer. you just wait for it to dry. after it's dry, you wait again, to keep the dried page a bit longer. to keep it past the time it takes to dry. there are thus two kinds of waiting: waiting until a process (the drying) is finished, and waiting in the sense of lingering (because it is so beautiful). the former is potentially mixed with impatience, the latter with its opposite: waiting because you want to stop time. in the one case, you want to speed up time, in the other to detain it. in

reality you can't do either, at least not by the clock. yet in reality the clock doesn't count. in reality you make your own time. just as you make your own history, your own stories. has the drying time already been exceeded? i.e. were the pages already dry for some time, as these lines were being written. an empty time, from the point of view of the production process. Although it could have gone on, it didn't. but that's exactly what you're looking for now: empty time.

EMPTY TIME

what happens to time when you die? what occurs with the particular time of someone who has died? when you don't continue with the book, with the pages of the book (although they're dry), empty time is created and when you don't proceed at all, because you abandon it, because you move on to something else, the book remains, or better: the time you would have spent finishing it remains empty. empty. empty.

in other words, the book is dead.

DEATH OF VIRGIL

12/8/99 thursday

5.30 A.M. worked on a few pages in bâtiment C. the red is starting to glow, glowing heath. hermann löns,[161] the second face. sultry story, that keeps smouldering with no storm.

is that where you'll leave it, with this red earth and the crust all around it? *écorce de terre*. or mustn't there be a reference point after all, something swimming in the magma, In the lava? an olive branch, a fingernail, writing? letters? what usually swims in molten lava? bits of rock that have already cooled.

ÉCORCE DE TERRE

looking in the mao bible for a solution to problem of the book with the red earth. p. 116: the leading bodies of the party must give a correct line of guidance and find solutions when problems arise, in order to establish themselves as centres of leadership.[162]

p. 116: the higher bodies must be familiar with the situation in the lower bodies and with the life of the masses so as to have an objective basis for correct guidance.

p. 117: the lower bodies of the party and the party rank and file must discuss the higher bodies' directives in detail in order to understand their meaning thoroughly and decide on methods of carrying them out.

that is an excerpt from 'on correcting mistaken ideas in the party'.

the red book of quotations was often used before. for example, when a pipe burst, people didn't immediately try to stop the leak, instead they opened the book intuitively to the appropriate passage and started reading. the passage above with the excerpt from 'on correcting mistaken ideas' was intuitively not the most appropriate solution, unless you equate the various hierarchical divisions of the party cadre to the layers in the book, to the layers on each individual page in the book. or you take the entire stack of book—then you have three levels, almost like the angelic orders, where you have three times three. so, with the stack of books: the layers on the individual pages of the book, then the pages in each book, then the books piled on top of one another. a democratic life under centralized leadership. a nice title for a book.

on the next page, 118: the people, and the people alone, are the motive force in the making of world history. the masses are the real heroes.

MAO: THE MASS LINE THE PEOPLE

p. 122: for over twenty years our party has carried on mass work every day, and for the past dozen years it has talked about the mass line every day.

p. 123-4: education on the mass line. the following evils alienate us from the masses: dogmatism, empiricism, commandism, tailism, sectarianism, bureaucracy, and an arrogant attitude.

13/8/99 friday

12.40 P.M. the plaster shirts sway in the late summer wind and knock against one another. black bodies hanging from the poplar trees . . . the pages with the insides of the earth progress, the shellac cooks in the sun and bubbles form, ruby red on top of it, the dull earth that behaves differently. when the shellac hasn't hardened yet, for example, there are problems with the water in which the earth dissolves. zinc-grey colour like cinders.

otherwise it's above all the lines on the concrete walls of the pool that note the lengths swum with the date and time each session began. in morning, when the sun pierces the trees' foliage, particularly concentrated sinuous lines are created and drawn on the wall by the waves in the water. like curves in a studies of electromagnetic radiation. and that offers a fascinating image: the rigid lines from which the charcoal splintered off as they were being drawn, the rigid, immobile lines in the mesh of dancing lines. a mesh of sun. took lots of photographs. this morning, in the water up to my neck. you can also see the dancing mesh on the bottom of the pool. one more remark about the water and the wall that encloses it: when the water is agitated, is plays along the surface line, i.e. in a particular hand's breadth, the wall is continuously wet, dry, wet, as on the beach where the water licks the sand. the horizontal strand line is projected onto the vertical wall, as you can observe when swimming in the sea in the morning, when it's not clear where the water ends and the sky begins.

one more thing from the mao bible: p. 127: our comrades must not assume that the masses have no understanding of what they

themselves do not yet understand. it often happens that the masses outstrip us . . . i.e. applied to the politics of the painting: a specific surface on a painting still doesn't speak to you, you want to ignore it, but the painting is more intelligent than you and already one step ahead. that was an applicable mao-sentence, actually you can a apply them all, if you really want to. sophism.

14/8/99 saturday

1.10 P.M. photographed the lines as on every day. the poles in the water. the waterway from the airport to venice marked by poles like these. in a vast expanse of water, a row of poles. on the length of the concrete wall the row of lines, the way they rise or fall according to the depth of the water. the lines, the poles that signify the loops of the day, in the endless number of days, past and future, rammed in, charted by the date and the time. they are partly or completely washed away again by the rain and on the background that has been washed clean, you can start recording the days again afresh. they're never completely erased, you're always covering something else. and over it all flickers the mesh of waves reflected by the sun on the water.

three carts carrying open books are rolled out into the sun. you'd like to stay near them for a time because you've intervened, to see how the layer will dry, to see which rivulets, which streams will form. it looks just like, truly exactly like the confluence of rivers into the sea in australia seen from an aeroplane.

16/8/99

NOON. mist rises from the water's surface, vaporized mist. because the water is now warmer than the outside air. the climate is undecided. some rain in the morning and cool air, so that you opened the shutters that had been closed for two months because of the light. mist over the water. intimations of autumn, but, as mentioned, it's still undecided, other conditions can still come. what won't change this year is the constant decrease in the day's length. and so it's possible for you to end up eating your evening meal at night. it's one day past the middle of august and already fog whirls as if the summer had been too strong to last any longer. summer that has burnt itself out.

LATE SUMMER

5.20 P.M. the data had to be stored. and then there was the command: to save files to a disc, press *y*. but there was no disc in the device onto which you could save the data. tried everything possible, turned it off every possible way, ran the battery down and thought the command would be forgotten. nothing worked. in the end, pushed random keys and suddenly could enter a word to open the old program. by transferring, charging, F1, etc. relieved.

strong odours in the forest after the rain. the forest lakes are completely full again. an abundance of water. if only you could store the overflow. joseph's dream in egypt.[163] another kind of overflow in the vaults, in that case, an abundance due to purchases made at the flea market. is that an overflow? when you've got more than you need. is there more than you need in

the vaults? no, some of the things there, you don't yet know if you need them or not. so not an overflow at all, then. rather, the things down there denote something that's missing. namely, the idea to it. the idea for each thing is still missing. that's also not quite right. there already is an idea, or you wouldn't have noticed the things and carried them to the vault. each thing you carried from there to here had a pull, an attraction, something waiting for a concept.

18/8/99 wednesday

10.40 A.M. it takes about 25 seconds for the computer to load the most recent document after you turn it on. as long as an earthquake lasts, sometimes they go on longer. the one in istanbul yesterday was about 50 seconds long.[164]

it's cold in the mornings. even though there's sun and you can already sense its afternoon warmth, mornings have a temporary chill or a deferred warmth.

yesterday drew a few panels with the women surrounding heliogablus, the four julias, julia domna, julia maesa, julia mamaea, julia soaemias . . . then brought heliogabalus and che guevara together. And with tamara bunke, ulrike meinhof, because the anarchists helio-gabalus and che oppose the latin rational world, for order through disorder, for one conviction against many convictions, for the one god (the black phallus) against the many gods of rome, etc. thus wild women.

6.07 P.M. stillness. one or two crickets, otherwise nothing this evening. saw a film from '58. callas in the paris opera.[165] through technical means (still very primitive back then), through very poor transmission, despite the bluntest instruments: a direct effect, as if these technical means weren't at all required.

21/8/99 saturday

9.50 A.M. it's cold in the shade. the damp sand and the wind, you can't sit naked in the shade any more. it's ok in the sun. the shadow from your head and hat falls over the screen so that you can read the letters. otherwise, you'd have to write without any letters at all. of course, you're writing without letters now, too, since no letters fall on paper. there is no paper any more. if the sunlight were shining directly onto the screen, you'd have to write without seeing the image of the letters. it would be possible, since one can write blind. but it's like flying into a snowstorm in a helicopter and not being able to tell what is up and what is down. and so you crash, although there's an artificial horizon. but you don't believe in it.

there are now 14 panels describing the women of the revolution, each ordered in pairs. one with the whores from egypt, one with the victims of moral systems determined by men (like immuring the vestal virgins who have been accused of impropriety), one pair of panels with shining examples of virtuous roman matrons, among them the name of a woman cato had leant to his old friend for five years so that the latter would have a successor. this last example as a touch of spice, as a sort of question mark.

23/8/99 monday

11.55 A.M. the books in the courtyard, page by page, sometimes the liquid dirt flows onto the pages below and you have to lift them and insert something so that they don't stick together when dry. like watering plants every morning.

now additional layers of shellac and earth will be spread on them. each time a page is reworked, something is lost, only a little is preserved. in the end, there is very little left of each layer. the rest is absorbed. yet it's precisely this largesse, this luxury that seems to allow for beauty. knowledge of what is concealed, covered up, of the underground.

LAYERS UNDERGROUND DISGUISE

secretiveness. it will be six days before all the assistants return. soon you'll go out to the courtyard to see what's dry. the water added to the dirt first has to be absorbed into the air, then you can turn a page. because no wind reaches between the closed pages. closed coffin. the books' pages never sit completely straight, they curve in various directions and so there are trickles, rivulets that combine into larger streams, into glacial valleys. the runoff flows out where the book is lowest. there the draining dirt returns to the ground, into the earth. only a small part of it stays on the books' pages. so part of the dirt does stay on the book, takes part in a virtuous earth cycle, a section of the earth become a symbol of something. but the materiality of the symbol has the same composition as the represented earth. looked at from another point of view . . . a part of the whole, a part of the earth becomes a symbol. or: when you pipe liquid earth over the book, when you pour earth dissolved in water over the book, a

remnant is left behind, which, although still matter, becomes a symbol, a representation of the earth.

MATTER FOR BOOKS—EARTH SYMBOL—REPRESENTATION

25/8/99 tuesday[166]

12.05 P.M. the pages, the red pages like the photographs of mars are coming along. no direct sun today, but very warm, so that the pages dry quickly, even if not quite as quickly as on other days. but they're becoming more ambiguous. now they're left outside overnight as well, sediment on the seabed.

now a new procedure. when you're occupied with something for a certain length of time, there's always a new procedure, a new handle, that inspires a new idea. so it is now: shellac is applied to the thick, damp earth, when it dries it turns a sulfurous shade of yellow.

27/8/99 friday

6.40 A.M. yesterday evening it was already dark. took a few more
pictures of the lines on the pool's cement walls. it starts at nine,
night falls. it was after ten, after dinner in the small greenhouse
over the pumps. a full moon hung in the eastern sky, not quite
as high as bâtiment B. as was written earlier: the sand looked
like snow in the floodlights. a few weeks ago, when the wind was
so strong, the resemblance was even stronger, then the drifts
were of sand or snow. this time, because of the rain and the
many footprints, the dogs' paw prints too, everything was tram-
pled, and yet there was an interchangeability of sand and snow
and seasons. it was cool, as it is at night now. the water, however,
was warm. went in up to my knees, to get the proper angle for
the pictures. an unusual experience: the warm water and the
cold outside air. the water became a refuge (like a hut in the
snow). water as house, as hearth. a strangely intimate, almost
bashful return.

RETURN WARM WATER—COLD AIR

of course, you get this sensation in the bathtub too, especially
in winter. but unlike the bathtub, the pool is so large that an
enveloping warmth expands, spreads far. you are part of a bigger
whole. all the more so because of the simultaneity of the ele-
ments: wind, air and water. you also get this sensation on a smaller
scale when you're sitting in the bathtub and a draft of air passes
over the water when the bathroom door is opened. this warm
water on your legs at night was a promise of your own warm infin-
ity. where warmth and infinity are otherwise separated. people
talk about the cold of outer space. here, in contrast, refuge in

openness. the water's warmth in the cold night air is also: the extension of summer through the heat reservoir that is the water. a postponement.

POSTPONEMENT

the day before yesterday, on the sand, breathing: had this sensation after about 20 minutes: still only present in a negative way on the sand. and the contents of the husk had drained away into the vastness.

28/8/99 saturday

7.30 A.M. the sun has just risen over the hill in the east. outside, on the beach. it's already rather blinding. the pumps have been turned off, so the sound of falling water will have faded away. then you'll hear other sounds. three of the already bound books, of which every day a page was made with red mars dirt throughout august, are full and they've been set up in a circle with their pages open in order to dry. the place names are still missing. the leaves of the young poplar trees growing along the beach are hit by the first rays of the sun. the edges are translucent like marble. the marble angel in the donaueschingen cemetery. from the notch through which the water drains when the pumps are working, you hear only splashing. the water is flowing out. flow is a word for futility. ending. irretrievability. worry. also permeability (even if only in one direction, since nothing flows back). say to the still earth: i flow.[167]

FLOWING

face turned towards the sun in the east. it's not blinding, because the sun was hidden behind a cloud shortly after it rose over the hills.

29/8/99 sunday

7.35 A.M. the last day of summer. maybe not the last summer day, since it could get hot again. but the last day without the staff here, the last day of the summer holidays. yesterday only five lines on the edge of the pool. always difficulties at the end of a phase. for example, when gathering algae in the algarve, the last two days there. something ending, more than just the four weeks spent there. a season. a lifetime.

SEASON LIFETIME VACATION TIME

you make a break, although you go back to your previous life. saved the book pages from the rain yesterday. now they're all inside and drying. rivers, valleys, rifts, great syrian-african rift. from the small to the large, from one's lifetime (dates of the lines and here the date describing the progress with the book pages), from one's lifetime, then, to geological time. and if you add mars as a theme, to cosmic time. where time begins to wobble, it warps. time in the black holes.

TIME LIFETIME, GEOLOGICAL TIME, COSMIC TIME

5.30 P.M. gathered the book pages out in the courtyard, looked at them and saw that it was good. but breath was still missing over the clay-dirt layers. a few are still outside in the hot afternoon sun. they'll return later. the book pages' return. it's extremely astonishing how different the pages become every day and how much australia's ancient geology, yes, even the geology of other planets, like mars, they contain.[168] they're movements solidified by the sun's warmth in the courtyard. and there is

literally liquid lava underneath if you think of the thick layer of shellac below that will become liquid again in the strong heat.

MARS

a concept, as it has been used since the early 80s: the coincidence of virtual and literal meanings: the pages made of actual earth, with which, at the same time, the surface area of a planet is described (cf. sand of the brandenburg march).[169]

the pages with the earth structures can be looked at for a long time because they are the world. they are infinite, containing a considerable number of possibilities. the wealth of possibilities determines the length of time, because when enough time is available, as in geological periods, then what can happen does happen, even in actuality. up here, it would be the opposite conclusion: because so many possibilities are depicted in the books with earth and shellac, they must have taken a lot of time. that is the virtual aspect of the books: in truth, they didn't take much time, because everything happened in august and tomorrow something else will be created. so time was accelerated, cf. alchemical theory: what happens in the oven (athanor)[170] would have happened anyway, just faster.

BOOK MATERIAL—VIRTUALITY

ACCELERATION OF TIME ATHANOR

30/8/99 monday

11.45 A.M.

MAO

p. 126: if we tried to go on the offensive when the masses are
not yet awakened, that would be adventurism. . . . if we did not
advance when the masses demand advance that would be right
opportunism.

ADVENTURISM RIGHT OPPORTUNISM

we should go to the masses and learn from them, synthesize their
experience . . . then do propaganda among the masses, and call
upon them to put these principles and methods into practice so
as to solve their problems and help them achieve liberation and
happiness.

HAPPINESS OF THE MASSES

applying mao's teaching to the production of art: we use the
material, whatever it is, paint, sand, shellac, lead, straw, etc.,
etc., etc., . . . as an artist you have to listen closely to the material
because it has a spirit inside it. you have to leave the material on
its own for a time. the paint drips, for example, the sun dries, the
lead ages outside, etc. but then, before it's too late, the artist
must consider where the future painting, the not-yet-defined
painting is headed, must redefine it and determine a method to
continue work on it, must apply these methods found in reflection
to the material and see what comes of it, see how the material

interacts with the new methods. after a certain period of time, and more reflection, he must distill what has been achieved and, in turn, apply this distillation to the material again—and so the spiral continues . . .

p. 59: . . . politics is war without bloodshed while war is politics with bloodshed.

p. 59: history shows that wars are divided into two kinds, just and unjust. all wars that are progressive are just, and all wars that impede progress are unjust. . . . as for unjust wars, the first world war is an instance . . . to oppose a war of this kind is to do everything possible to prevent it before it breaks out and, once it breaks out, to oppose war with war, to oppose unjust war with just war, whenever possible.

PROTRACTED WAR

p. 60: revolutionary war is an antitoxin which not only eliminates the enemy's poison but also purges us of our own filth.

p. 61: political power grows out of the barrel of a gun. . . . [the] marxist-leninist principle of revolution holds good universally for china and for all other countries.

p. 63: theory of the 'omnipotence of war'.

p. 63: only with guns can the whole world be transformed. . . . war can only be abolished through war, and in order to get rid of the gun it is necessary to take up the gun.

p. 70: the world is progressing, the future is bright and no one can change this general trend of history.

p. 72: all reactionaries are paper tigers.

PAPER TIGERS

just as there is not a single thing in the world without a dual nature . . . so imperialism and all reactionaries have a dual nature—they are real tigers and paper tigers at the same time. . . . from a long term point of view, from a strategic point of view, [they] must be seen for what they are—paper tigers. . . . [from a tactical point of view, they are] real tigers which can devour people.

US imperialism has not yet been overthrown and it has the atom bomb. . . . it will also be overthrown. it too is a paper tiger.

p. 79: strategically we should despise all our enemies but, tactically, we should take them all seriously. this also means that we must despise the enemy with respect to the whole, but that we must take him seriously with respect to each and every concrete question. if we do not despite the enemy with respect to the whole, we shall be committing the error of opportunism. . . . but in dealing with concrete problems and particular enemies, we shall be committing the error of adventurism unless we take them seriously. . . . the peasant can only plough the land plot by plot.

pp. 80–1: either the east wind prevails over the west wind or the west wind prevails over the east wind.

EAST WIND AND WEST WIND

velimir khlebnikov: wave of the east against the west.

if mao had only stepped back after the first great leap forward! had become the artist, the poet he always was. then many millions of people would have remained alive. in the 60s, students in the west read his red book of quotations as a set of guidelines. you always thought it wrong. you took the theories and turned them upside down, i.e. read them as aesthetic theories. not as an aestheticization of politics, but introduced this literature into the house of art as an aesthetic harvest before it could become politics. speer's cathedral of light as art. does that work? can you consider an image (imago) removed from its intended purpose (propaganda) as beautiful? can you declare it art? an artist can do anything, there are no restrictions.

what about the mao bible appealed to you? that you could read it against the grain. (artists generally stroke cats—tigers—against the grain). you merely need to shift his theory of the omnipotence of war to speak of the war in the artist's head.

WAR IN THE HEAD

then you have a wonderful aesthetic theory, then you have a representation of an art work's genesis. when the first layer is painted on the canvas, the artist is faced with endless possibilities. he has to decide how he will continue. and such a decision means war, many possible paintings must be abandoned, eliminated. and it's clear that the best possible, the monad-painting won't be made. it will always be THE picture that you carry inside

you and that will never materialize, in favour of the other possible paintings. at first you seem to be a match for the paper tigers facing you. you develop a tactic, a method, a procedure to skirt the shallows—for example, the danger that you'll create something that already exists. because of increasing intelligence and experience, you no longer fear the war in your head. but at the end of every process, whenever you declare a painting finished, you have to realize that what you're battling is not a paper tiger. because you won't reach the essence, the painting-in-itself. (frenhofer in balzac's unknown masterpiece.[171])

PAPER TIGER

now you see the difference: mao speaks of the tiger's dual nature. imperialists are real tigers and paper tigers. from a long-term point of view, from a strategic point of view, they're all paper tigers, but from a tactical point of view, they are real tigers. with you it's the opposite: from a tactical point of view, the obstacles that arise when you're painting are real, but opposable tigers, but from a long term point of view and faced with the impossibility of creating the painting-in-itself, that is, of creating infinity with finite and material means, these obstacles are invincible opponents.

11/9/99 saturday

12.15 P.M. was unsure for a moment if a new quarter had already begun.

12/9/99 sunday

4.40 A.M. yesterday, wrote only that one sentence because com-
pany came. strange word 'company', as if you'd only recorded
the date. the way the lines on the pool record the lengths swum,
so what has been written over the years is made up almost
entirely of dates. and that which 'is' lies between the 'lines' that
resemble runes on the photographs. in an extreme way, it's all
about what lies in-between.

in-between

what is in-between is not what has been designated, because
no one asks who the company was who interrupted the writing.
it's also not the time in the interval, because no one asks
(though it would be more likely), what happened on those days
when nothing was written. no one asks that either. but you see
the dates and it lies in the space between these lines (runes).
does that mean you don't even need to read it? you do, but you
should take it for something else. for what, then? for that which
lies in-between. you shouldn't take what has been written for
what it says, but for what is in-between and isn't specified any
more than that. so you should always turn to or arrive at that
which can not be specified. you should always end up with the
unanswerable question. it could also be put it this way. you
should always seek the unrealizable. or always 'achieve' the
unachievable? you never settle for less. but that doesn't mean
you're dissatisfied. you can be satisfied when you don't settle
for less. between what you long for and the longing, there is an
irreducible space. the object of your desire travels the same path
that leads you to your desire, always ahead of you. when you set

out to reach what you desire, the object of your desire sets out too. it sets out both in the sense of opening up and in the sense of moving forward. and it moves away from you, though in the same direction. there is a space between you and what you desire.

DESIRE ON THE PATH TOWARDS BEING

the battery will soon be dead. then the laptop will shut down, so nothing more will be written. no one knows what might have been written. where is that which might have been written? some believe that humans should be altered with the new possibilities created by genetic engineering. prenatal selection. no philosopher had said it before, now there is one who says it. however, it's completely absurd, since the imperfections of humans today can't be improved by the same humans. but: one morning, someone has the feeling that it would be good for the media landscape to make such a comment. and there is a reaction. and this philosopher can write. and because he can write, because he can issue inflammatory aperçus, at some point people become convinced, and at some point they do it, too.[172]

17/9/99 friday

4.25 A.M. awake since 1.30. awake with what? with that which lies between here and the promised land. arms held up until you can't take it any more, the 'not yet' still right in front of your eyes.

NOT YET

even he didn't see it any more. but his people did. the people are his paintings. they will see it, you won't. they will move in to the place you can no longer reach. not because of time, which grows shorter, but because it's impossible by definition. because there can't be any such thing as that which you must reach. because as you make your way towards it, it moves further off ahead of you. tortoise and hare.

p. 86: all views that overestimate the strength of the enemy and underestimate the strength of the people are wrong.

p. 88: what is a true bastion of iron? it is the masses, the millions upon millions of people . . . rallying millions upon millions upon millions of people round the revolutionary government . . . we shall . . . take over the whole of china.

p. 91: the stage of action for a military strategist is built on objective material conditions, but on that stage he can direct the performance of many a drama, full of sound and colour, power and grandeur.

p. 93: in actual warfare the chief role is played by defence much of the time and by attack for the rest of the time, but if war is taken as a whole, attack remains primary.

p. 97: our army's main sources of manpower and *matériel* are at the front.

p. 99: without a people's army the people have nothing.

strange, these sayings. they were learnt by heart and the little red books were held up during assemblies and demonstrations the way you wave a handkerchief. there are pictures of it: a sea of red books. fields of poppies. the red cover was most important, since what was there inside, between the pages? almost nothing. that a battle must lead to victory, that dark clouds pass, that you must rally the millions to take over china . . . all of it self-evident. it must have all sounded different in mao's language, more poetic, ritualistic, perhaps like prayer. (strange associations with samson, another exceptionally strong one, whose sayings, like mao's, are full of poetry.)

when you read it in german, it sounds like a parody. empty. why read it? it lies on the unfinished canvases like an insulating layer between the various strata of colour. instead of shellac. the old masters used shellac to isolate vermilion from layers of other colours, because, without it, an unwelcome chemical reaction would have occurred.

18/9/99 saturday

7.45 A.M. the cats are circling, prowling the studio. through the arched doorway on the west side, you can see the silhouette of a parasol on the veranda and the rising staircase. it's light out. soon, it won't be light any more at this time of day. or not yet light. there's a black hole in the studio where the painting destined for the national gallery stands (280 x 760 cm). it's meant to be a milky way when it's finished.[173]

had the continents swim yesterday. they were set on wood in such a way that they were just barely floating and were partly covered with water. in this way they were very well integrated into the pool. it's nice when continents swim, especially when you know that they swim in real life, too.

CONTINENTAL DRIFT. I HOLD ALL OF INDIA IN MY HAND

then set them out on the beach, propped up with the chairs. to rest. they're still there. continents in the water, then stranded at the edges of the pool. the tracks on the beach leading into the water. so that they gradually become invisible, all traces disappear. oodnadatta track in australia.

OODNADATTA TRACK

19/9/99 sunday

8.15 A.M. brought in the red painting. it's raining. the shellac fused with the red earth into a sulfur-yellow tone. it got wet from top to bottom. now it's no longer possible to use the sun's strength to depict mars. it's no longer burning, soon it will be time to light a fire in the fireplace. and you need to light the gas heater to make the surface dry faster. time is tight. they've already started to eat inside. if only you had walls around you again.

6 P.M. a lead boat swims in front of a starry sky. the boat that had fallen from a great height. one less vilified could not be suitably placed in front of the sky. why? because it would be too boat-like. through the fall, it has become an abstract vehicle. the boat has already been through something. a boat that brings something with it. otherwise, the stars would be banal on both paintings, on the one for the national gallery as well as the one for NY.[174] on the one for NY, the blackness has been applied to the mayan pyramid. the combination of the mayans, who were experts in astronomy, with the starry skies.[175]

I HOLD ALL OF INDIA IN MY HAND

the lines on the pool are gone. almost completely washed away by the rain. no photograph was taken on the last day. if it warms up again, new lines will be drawn with other dates.

22/9/99 wednesday

10.50 A.M. on the star paintings for the national gallery in london
and for NY. tough. idea for a rat trap in the middle of the painting
that would pull in the labels.[176] a black hole. such a literary idea
again.

STAR TRAP

naturally with such a wide format, you need a magnetic point.
now it doesn't look like a trap but more like a nice bouquet. the
trap needs to be larger and not made of rusted wire. something
lighter. zinc, for example. star trap, or you could say: light trap.

LIGHT TRAP

light trap is more abstract. the light is diverted by the black holes.
even time is no longer the same near the black holes. when you
see something especially beautiful, it seems easy to die. con-
sider the japanese who commit suicide in sites of natural beauty.
the gallows were always set up were the landscape was espe-
cially enchanting, at vantage points. what do the eyes preserve
in the last moment, the final instance.

THE FINAL INSTANCE

earlier people said that the eyes carried something over. you
can't take anything with you otherwise. the last glance, the final
thought.

cloudy for days now. the water in the pool has grown colder. as you swim across the pool, you notice that it's warmer where the heated water comes in. you notice it only fleetingly because you're passing through it, but, even when you try to stay in that spot, the warmth doesn't stay put because it spreads unevenly. you swim, you pass through the spot and it's already over. it was barely even there.

BILLOWS OF WARMTH STAGES OF EVOLUTION

you only ever have a memory of something. once it's over, you remember what sparked the memory. you only ever touch a fraction of any reservoir that doesn't exist as material. it always leads past you to something that once seemed to be a part of you. after moving through all possible evolutionary stages (from single-cell amoeba through amphibians to humans) there is a return. that is the beginning of a way that will become lost. you are not the end product of evolution, instead, you pass through it.

take the ideas of the masses and concentrate them, then go to the masses, persevere in the ideas and carry them through, so as to form correct ideas of leadership—such is the basic method of leadership.[177]

why did you write down that sentence from the red book? because you can transplant it, move it to the studio. the sentence deals with the relationship of the masses to leadership. the masses are always right, they proceed, but their ideas must be collected, i.e. formulated and concentrated so that they can be returned to the masses. leader-ship then learns from this in turn. now the analogy: the artist begins a painting, is at first

completely immersed in the paint, the material, has a vague idea of what it could become but doesn't know it yet. after a certain time, he pauses, observes the picture as a counterpart. it has been reified, he can interrogate it, find out what it wants to say. then, after this 'rationalization', he bends over the painting again and begins the process anew. that is the essential process of producing a painting. why do you need mao's red book in addition? i don't need it, it's superfluous.

4/10/99 monday

11.45 A.M. yesterday the studios were filled with people. strange. a large number of people were walking in places where you usually have to step very carefully because things are spread out all over the floor. the innermost is turned outermost.

12.15 P.M. the photographs of the pool are being bound together as a book. i hold all india in my hand. with the reflections of the rippling waves on the concrete.

6/10/99 wednesday

10.20 A.M. there's nothing in particular to write. the greenhouses are being built. the exhibition in paris on 6th november is now in limbo. it's not being worked on, but it's not finished yet. it needs some improvements.

it's now very cold. it could almost be a freeze. the water in the pool has dropped to 19.5 degrees, despite the heating. the photos taken this summer are being blown up. with the reflections of the rippling waves on the wall. water, a wall and the lines, that's the entire work.

8/10/99 friday

7.15 A.M. the heating is on in all the buildings. it's already the 8th of october. then comes november. and then it's not long until the longest night. after that, the women of the revolution will be painted. and all the accessories of actual women will be nothing more than a way into the paintings. as so often before. and what are the paintings a way into? where do the paintings lead? what's the use of paintings in hard times?

construction on the greenhouses is continuing today.[178] ground is being levelled for the two on which work has not yet begun. they will be outside the fence. where the land rises to meet the forest. that's why they have to bulldoze. and so you can already see the place where they'll stand. through the cut into the slanting earth, you can already imagine the future buildings. and that, actually, is the best moment.

8.40 P.M. brought the cats in. every evening.

the painting in which the sheep are rowed across the lake every night. a swiss painting.[179]

the last sentence hasn't yet come. maybe the last sentence of this evening will occur to you early tomorrow morning.

9/10/99 saturday

7.40 A.M. read poetry this morning just before seven. for example, 'welcome and farewell', some of which you still know by heart.[180] then something else happens: it marks a time like a scent, it's omnipresent, but it also goes back in the sense that it's associated with a certain time. with the time in which you learnt things by heart. it must have really have affected you for you to still remember it. maybe it even replaced your life, that is your possible life. or did it just prompt something that was already within you as a possibility that wasn't lived because there was no horse.[181]

10/10/99 sunday

11.20 A.M. the women of antiquity were painted two days ago. why?

because after their foray into three-dimensionality, they probably should return to a flat surface.

because it's a constraint and constraints often lead somewhere. when, suddenly, everything is no longer at hand, culture begins. after all, nature wastes so much sperm, so many seedlings, there are so many newborns and only a few survive. in art, on the other hand: a hair, a staff, a poem, a word.

the difference in the process of painting, compared with 30 or more years ago: then there were always beginnings that led nowhere, that didn't advance beyond the beginning. so many paintings were begun and abandoned because the beginnings were so discouraging. in most cases, there wasn't enough motivation to get past the beginning. now, in contrast: even when the beginning is not at all promising, as this one with the women, you've learnt in the meantime that if you just keep at it, something surprising is sure to come. maybe not today, maybe not in a week either but it will at some point. that is an experience.

PAINTING

there were also a few other cases, of course, as in 1974, for example, the paintings with the scorched earth.[182] in that case and a few others, there was no interruption in motivation, no hesitation in or obstacle to continuing. this lasted for several

paintings. you could see the outcome in your progress and it was fulfilled. there were no intermediate stations between the outcome and its implementation. the effect (the painting) followed the causal shock (the photos of the fog-covered fields in Buchen) without any stumbling.[183]

it's warming up again, the water has reached 20 degrees. late summer.

11/10/99 monday

3.55 P.M. the platforms for two greenhouses are finished. in the end, there were two slightly raised areas in front of both greenhouses, from which you could look southwards and see the scenery around the lake as well as the other, almost-finished greenhouse on the lake. you delight in every change to the surroundings, however small. from one almost-completed greenhouse, you moved directly to planning the next and, when the frame for one is built, the foundation for another is already being laid. you've barely moved into one room and you're already headed towards the next. from each space that was only imagined until now, you hurry to the next place, the next vision.

16/10/99 saturday

5.15 P.M. the leaves are turning yellow. the tree in front of the small glass house is already completely yellow. and it's very warm. birdsong. the water is 23 degrees. the earth is dry again. it rained a few days ago and the trucks couldn't drive in the spots where the ground had been levelled. in the northeast, new land has been created. part of a farmer's field was acquired and the section to the north was levelled where two new glass houses will be built. a road was added that leads over the new land towards the south. it then turns west and ends at the greenhouse in front of bâtiment A. from this road you can look towards the lake, over the field the farmer still ploughs. strange, such a new road. so inspiring. now you can drive back and forth as often as you'd like, where there had previously been an impassable field. like when you drain a reservoir and suddenly see the ground and everything else that had been hidden under water. cf. the draft of the lecture 'on germany', the passage where you talk the reservoir and mean the GDR.

22/10/99

7 P.M. leaving for japan in two days. for a few days.

when you step out of the studio into the courtyard, you smell the smoke from the chimney. an autumn smell. burning the potato fields in the rhine plain. the fog over the fields that mixes with the smoke from the potato fields. rising into the fog and getting lost there. the harvested fields. the gentle melancholy that can mutate into a endless fall when other parameters are applied. there are no potato fires here, here the trees are never bare, just the structure of the fields, the lines appear earlier.

AUTUMN POTATO FIRE SMOKE

the foundations for the two additional greenhouses have been laid. the terrain is completely rutted because it has rained for several days. deep tyre tracks filled with water. the mud season. the stalled attack.

Tokyo flight

24/10/99

4.05 A.M. Paris time. Twenty minutes ago you could still see
Siberia. Without human habitation, just rivers, silhouetted in
black against the snow when they're not frozen over. On the
horizon, mountains completely covered in white. That must
have been the central Siberian plateau. Back to Japan. The first
time, seven–eight years ago, during the move - France a transi-
tion. Was it a transition from one point to another? Or an enor-
mous effort for more of the same? Could you have stayed there
too, or anywhere for that matter? What are decisions? How
would it have been in Essen? Do you think of the uninteresting
bare fields in Buchen that you had to charge with everything
and of the hostility of the people there, what the concern about
the snow that covers everything produced. Outside, clouds that
prevent you from seeing the landscape. Just one week in Japan.
How was it there? The new land on the ocean must be now be
completely built up. Cherry blossoms.

5.35 A.M. No more snow. You can't see the rivers as clearly any
more. They meander the way they did an hour ago, as if they
didn't know where they should go, they divide and merge again.
Sandbars. A few mountains, peaks dusted with white, rise from
the mass of ochre, gray and beige, shades of colour difficult to
differentiate. Clouds again. Where are the people down below?
And the natural resources?

29/10/99

12.50 P.M. Flight to Paris. In the hotel, forgot to draw the room's floor plan (Okura Hotel, #1080). The first time in more than 15 years. In Benjar, couldn't find the preceding notebook. Passing soon over Siberia, the North Pole, maybe the Bering Straights. Strange, addressing oneself as 'you'. Started a few years ago here, when the 'I' stopped. A view of oneself without the naive 'I'. No longer a dialogue with another as in Greece, but with oneself. But what, after all, is the 'self'—the same?

7.25 P.M. Tokyo → Paris

Flying long distance, the curious feeling of suspension (if too many other people aren't disturbing you). Everything is in its place, like in a cave. Everything is provided for. You don't have to get up. Actually, nothing unexpected can happen. You can keep to yourself. The vessel that contains you is in motion. And you don't have to contribute to this motion in the slightest. →
= Uterus.

10.15 A.M. Tokyo time, 1½ hours from Paris

Probably somewhere between Denmark and Sweden. Earlier you could see a small airport down below. Strange, these straight lines as if drawn by gods. Do they also appear as signs of the connection between what is above and what is below to someone who has never flown, who doesn't see them as runways, who therefore doesn't see them from an aeroplane?

4/XI/99

7.30 P.M. Only a few, three days left in the flat at 74 rue des Saints-Pères. Strange: the building is the same (→ floor plan still to be drawn), but time has become concentrated, has condensed. You see the room, you walk through it and know that it's the last time. And you believe you've missed, forgotten something.

Omission

And it's not the only place you're leaving. There are many places full of things you've missed → the fire in Australia (photos), in the morning the fire's ashes in the storage facilities.

Afterglow of a previous state in your current one.

8/XI/99

12.05 P.M. on the flight Paris—Montpellier. The flat at 74 rue des Saints-Pères has been vacated. No more key.

14/11/99 sunday

5.30 P.M. arrived from paris on monday, there the exhibition at
lambert. on the 18th, flight to london, NY, caribbean. return to
barjac on 17/12/99, because there's no flat in paris. it was nice,
having a room there you could always go to, where you could
leave things. it's raining non-stop. where the large wall is going
to be built, only a few reinforcements have been set up and the
earth has flowed over it. concern that it won't be finished by
march. we'll need a new space then for the paintings now in the
salpêtrière.

looked over all the books in the library to bring to the ocean. only
a very vague memory of como of them. bove and many others.
what has remained? you've spent a certain amount of time with
several books and a few of those were even inspiring.

17/11/99 wednesday

got up at six this morning, to have a bit of time before leaving.
hopefully the construction (living) will continue here while you're
away. it's nice coming back when something has been changed.
you also like coming back, hoping that everything has stayed the
same. you'd like both: the cabins and the starry firmament.

19/XI/99 London in the hotel

This is how it must have been in the generals' tents, like this spacious, comfortable room: on the move. It's all here, temporarily, because there are lots of people who procure it, because there's an organization that doesn't allow disorder. Comfort in extreme uncertainty. Also the calm, comparable only to the calm before battle. A bomb can fall at any moment, a bullet can pierce the wall and go for your head. It's said that Frederick the Great slept outside with his soldiers (he had gout). Alexander slept two hours before the great battle (333 Issus). Napoleon's tent in the Musée des Invalides along with a portfolio, razor and other luxury travelling items. You can get used to being on the move.

26/XI/99 New York

10.45 A.M. The last few days there's been fog that glazes the buildings and fills the spaces between them with lightness, that finally properly paints the buildings and makes the last-row houses disappear in a soft and gradual transition. They're not the last ones, since with the fog you can't tell how many more there are on the other side of the hazy 'boundary'. It is, in fact, so that you could imagine there's something coming at you from there. A cloud, a pillar of cloud that contains something. Went to Broome Street yesterday. Couldn't find Claes' house, where I stayed in 1980.

1 P.M. View of the East River and Park Avenue, houses on the distant horizon are illuminated.

3.10 P.M. Changing colours when the sun emerges from the clouds, like they do at sea.

4.35 P.M. Looking out the window (to the North), the building facades are very bright. Bone coloured. Lit by a late afternoon sun, the brightness very brief. Already gone five minutes later.

4.40 P.M. It was just a cloud that dimmed the colours of the facades. Now they're glowing again.

27/XI/99 Barbuda, West Indies

10 A.M. On the beach there's hardly anything that disrupts the horizon. Reduced to this line of deep blue (turquoise). The wind. The sound of the waves, sometimes so weak that you think they've stopped altogether. The house below you is spacious, bright, with wooden blinds. A few steps away is the wooden shelter with beach chairs, a few steps further on, the changing line of the waves rolling onto land. And one more step or ∞ steps to the clearly drawn horizon. The most wonderful line because it actually has no end, but is an abyss. And, further away, they're building new rooms at the Ribotte. In the morning (9 a.m.), the sand is swept from the entrance of the house down to the waves.

12.55 P.M. At night by the ocean. Half-moon, bright sand. The sand turns to snow and the rush of the waves grows distant. Now the ocean lies there, abandoned in the midday heat. No one disturbs it.

1.30 P.M. The wind blows through the blinds, sweeps over you. Porous walls. Membrane. With a handle, you can change the direction of the blinds' wooden slats and close the openings completely. In front of the wooden slats, metal sieves (fine meshed screens) are attached to keep out the insects. It has no effect on the flow of air. The placenta that allows nothing harmful into the umbilical cord. The blinds with screens a placenta.

5.10 P.M. Heavy clouds close to the surface of the water. On the horizon, they fall into the abyss. And you don't know if they're

quickly blown away and disappear at some point or if they fall as a whole, as liquid.

Parasol—strange that such a small structure can stop the rays that have travelled through such vast spaces.

6 P.M. Returned very soon to the room enclosed by the insect screens and blinds because the midges come out at sunset. Swam in the ocean earlier. The water drips from your head and your body so that your earlier swim and now your sweat flow together in one flow, dissolution, exuding, so that the ocean still covers you even in this closed room.

29/XI/99 Monday

10.15 A.M. Lying 40 cm above the ground. Under the umbrella between the house and the beach. Rush of waves is soft. Now and then it seems to stop, as if the waves only rolled in occasionally. Each one could be the last. Continuous, rhythmic thought on the edge, leaving its course open, postponing it, suspending it. At night you hear the dotted line of the edge, the dotted, interrupted pattern.

1/XII/99

12.30 A.M. Yesterday evening. Special breathing exercises. After ¾ hour, after heavy unconsciousness, great anxiety. Enormous turmoil. Urge to yell, suppressed nevertheless. Extreme distress. First thought: could you even find your way back. The fear of not returning to your senses. Knowledge of the adjacent room with R. But it wasn't clear if you got away from the room at the speed of light or if dropped away and was still accessible in this case. Deep fear, anxiety, constriction and finality. The 'return' happened quickly. Light behind your eyelids, animated by the sparse light that fell through the slats. Left arm as if shattered by a cramp. Continued with the breathing for about 20 mins. Came to and found it all mostly hollow and ridiculous like the sculptures in the exhibit at Y's.

Separating the wheat from the chaff. As if the paintings were no longer on the level of your lived experience. As if it were about something else altogether. As if what it was about never showed in such paintings.

NOON. Which books were brought to the island? And what shows up here? Or is it decided by something? It takes a long time to read Martin Heidegger's *Being and Time*. Is that the best use of your time? Or is that an irrelevant question because you can read, can do whatever you like, it's all the same as long as you do it. So there are no real decisions (e.g. nor in choosing books).

Read the Latin prayers in the Schott missal. Strange how a few scraps of Latin evoke something, inspire you to take from the Rite and pour it into something. 'Accipite et manducate ex hoc omnes: hoc est enim Corpus meum . . . Accipite et bibite ex eo omnes: hic est enim calix Sanguinis mei, novi et aeterni testamenti, qui pro vobis et pro multis effundetur in remissionem peccatorum. . . . Mysterium fidei.'

'Take this, all of you and eat it: this is my body . . . Take this all of you and drink from it: this is the cup of my blood of the new and everlasting covenant. It will be shed for you and for all so that sins may be forgiven Let us proclaim the mystery of faith.'[184]

The Latin is much more awkward and pricklier than you remember, counteracted, so to speak, by the ardency required between the Accipients and the One Whose blood was poured. How different in the Greek. Latin is not an ardent language. You can't imagine Caesar speaking any other language . . . magnis itineribus[185] . . . restituit rem[186] . . .

7.25 P.M. There is no longer anything else. The rush of the small waves, crickets, body temperature in the room, no clothes, no irritants, easy access to the water, to the moon, to the stars, even if only at night.

3/XII/99

Completely overcast, no blue sky, so that the clouds, illuminated from behind by the sun, take on a sandy colour and the bluish ocean lies between the yellow of the sand and that of the sky. A band sharply cut, sharpest along the horizon, while in the foreground the band is bordered by the breaking waves.

How would it be in a house on the water instead of the Ribotte? Always the straight line, always this reference point, always the noise and the storms, the weather.

Strange, the palm trees growing out of the sand. They're not like trees with their fans. Sunday is the entry into Jerusalem, Palm Sunday.[187] Every time a wave breaks over another: like thunder. The 'noise' comes then, too, louder and ebbing away, and sometimes it happens very close in front of (over) you, sometimes further away. As if someone were directing it. Especially now, because the strong offshore wind 'filters' the sound waves. Only the strongest reach the house. So the 'claps of thunder' are also heard individually, although in reality there is no separation between the rolling waves and they're not lined up on a string either. Now they're here, now they're there, sometimes bigger and sometimes stronger.

Have been here a week. Arrived last Friday from NY. On the terrace railing are spread the coral gathered on the beach and strange trees that grow under water and on which calcium deposits gather and in time encrust them completely. Strange, how these little 'trees' grow. Differently than trees in forests.

4/XII/99

9.40 A.M. Rain. The sky an even grey. The rain is falling. But when you're on the largest body of water (the Pacific), the rain has a different quality. To a certain extent it becomes trivial and almost absurd. Because all water on land comes from evaporated seawater. And so it goes, so it falls, not long risen, back into its origins. You can also go into the ocean to be 'protected' from the rain. Then, at the most, your face gets wet. Read in Grillparzer's Medea[188] this morning. You know why you always reread certain books and 'collect' a few passages. On the other hand, with the mussels and coral that you gather on the beach, it's arbitrary—why this one and why not the others?

5/XII/99

2.40 P.M. The waves always seem to bring something in, but after a time you no longer expect anything.

NOON. The ocean glitters like Valentinus' sparks.[189] It's the first time the sky is so blue. A throng of clouds along the entire horizon: to the right, dark clouds over the ocean dropping small curtains of rain. To the left, too, clouds pile up over the land.— It's a big difference from when the ocean is all blue and there's no rain. It takes on an eternal aspect (because very little changes or because it's so familiar to you from earlier times?). Eternal, mercilessly vast, inexhaustible. Far away like the clear line on the horizon, when you want to take hold of it, there's nothing to grab because it's actually a broad surface that bends at the far end. You can't approach the line. At the most, something might surface, might distinguish itself (a boat's sail, for example). Hit songs like 'Your Ship Will Come In'[190] reduce the ocean to something we expect things from, see the ocean as a medium of promise. The ocean—the starry firmament. Here it's one direction, above all directions. Both are impassable. Both are providers: the ocean, food, H_2O, the first life forms, the flotsam and jetsam; the starry firmament, the meteors, the rays of light There was no blue all day. And when it's not blue, but grey, when the horizon dissolves and all sorts of baroque drama is staged, very dramatic, full of contrasts and structures, abysses from which light shines or vast, distant prospects in which a bit of extremely bright sky is cleared or dark, threatening curtains that fall down to the water, black clouds that want to press against the ocean because they didn't take the time to empty themselves but, instead, wanted, as a whole, as a totality, to merge with the ocean immediately. If that is the case, then you don't speak of the ocean but of all its aspects that are bewilderingly entertaining, multifarious, but are not what it is: the

ocean. That can often only be seen as a fraction, from afar. But this blue, these lines are the whole ocean. You like to look at it. It is determinant of everything else that is still there, olive groves, even hillsides, like a water level because of this objectively straight line. And so it sets the absolute point of reference, sea level. It has no colour, it comes from the depths and the colour of the sky, which are both difficult to grasp. When you see blue, even only from a distance, you know where you are: by the ocean. It has no definite shape. It merely sets the line. It absorbs everything and yields many things. mountains from the water's lime.

7/XII/99

2.30 P.M. *Advent, advent, ein Lichtlein brennt* . . . a little light is burning.[191] Prayers in the snow. Snowfall. Shower of gold falling on Danaë.[192]

The selection of books you brought from Barjac isn't the right one. There aren't any here that enchant you. Not like in India when you read the *Man Without Qualities* breathlessly for the third time on your travels.

It's not like at home at the Ribotte when you blindly pass the bookshelves in the morning to find the 'right one'. You take it from the shelf and it pulls you in. (The way people in your paintings are pulled in.) What would you do in a library much bigger than yours? Would you also scan the shelves to find the one that's right for the moment? In a sea of books . . .

The collection of coral trees is particularly beautiful and varied. The selection is unconsciously clear-sighted. Casually, as you pass, and now they're all set out on the veranda railing in a different proximity than in the depths of the ocean or in the flotsam on the beach. They could just as well have grown out of the lead pages as they did out of the ocean floor. Above all: a lead bookshelf under water on which coral grows.

8/XII/99

9.25 A.M. The ocean's deep blue, hardly any clouds. It lies there and barely moves. An unadulterated being. Because the horizon is sharp and where the waves come in, it's distinct. The sand still under the water, the water still over the sand. And it stays blue right up to a narrow band on the oscillating border. Now this blue is the counterpart, not the way it is on a rainy or on a grey day when the clouds rise to the heavens and you can barely see it any longer. Here it lies as if poured out, where is the vessel? You can't see it. It doesn't run or flow away. It sticks to itself. It is one. It doesn't rise at any point, doesn't stand up. As mysterious as the Holy Trinity, just as surreal. In the afternoon, the locomotives return from the ocean. When you're on the ocean, you look up at the stars to figure out where you are, because you are surrounded by water. Without the stars, you are nowhere. Knowing that there is more ocean than land on the earth makes it seem even larger (vaster) and that all the rivers lead there, large rivers.

10 A.M. 'Drawn' right up to the ocean in the beach chair. To see the entire length of the line. And at the end of the 'line' is the abyss. Behind the sea-line is the abyss, behind the horizon, another horizon. The abyss is always moved back to the next horizon. There is always only *one* horizon for each specific location (standpoint). It is not generally binding.

11.45 A.M. When you swim and see the coral branches beneath you, the algae, the forested cliffs, the valleys . . . then you no longer think of the sliced line, the other, completely different blue. Once again, you're there, with the things that you see,

marvel at and leave behind. You have descended into the other world (the frog king's daughter), but still in a world, whereas the deep ∞ blue is above. It's glittering again. Sparks that burn up the blue expanse.

3 P.M. Time and again, one or two sentences. Will anything ever let itself be glimpsed through such a meagre web?

More clouds now. Way out on the farthest horizon, there are two bands of very brightly burning concentrated sparks where the sun burns down from a cloudless sky and ignites the ocean with white flames. The last light, so to speak, the last illumination, the light barrier before the abyss. Now the flashing is spreading towards the beach. Burning right through your sunglasses into your eyes. And beneath it are the calcified coastal trees.— Is that still a rushing noise that the ocean is making? So little fervour. More a series of noises from right to left and from left to right like lethargic Sunday traffic on a country road. Off and on, almost constantly, the noise moves from one side to the other, ebbs to make room for the next one. You can't look at the ocean any longer. It burns your eyes too much.

9.30 P.M. Returned from the restaurant along the ocean. The sand like snow, stamping, the lights of the houses through the palms. On the other side, the ocean is audible and, as a dark space, more felt than seen. Stars where the sand forms steep surfaces and above, the ocean. The ocean's depth thus starting right at the front. Should you swim out? Hero and Leander.[193] To Antigua, for example, visible as a bright glow on the horizon . . . 25 mins by plane. Swimming at night at the Ribotte, even where the water is deep. Walking along the beach, lights to the

right, darkness to the left, where there are no paths, where the borderless all is where you can lose your footing (*glisser dans l'infinie, l'indéfini*, sliding into infinity, into the indefinite), slip away. And the stars above among which you can't slip, from which you can seek out, choose a particular star and associate with it. The abyss and the single star. The stars and the abyss.

9/XII/99

1 P.M. Strange what piles up, when you pick something up every day and add to the other objects. Thirteen days have now passed. When time is at play, things happen that were not previously imaginable, before they could be seen together in a sequence made obvious and clear. As, for example, in a book which you've spent a year, perhaps an entire lifetime writing.— Not quite valid for the paintings, since they don't accumulate in the same way (although, in this case, it is a bit true), they are made in intervals and take more or less time to be completed, but each one is a singular instance. When you work on something everyday, e.g. on this collection of coral branches, at some point the whole takes on a whole new quality, a geological one. Then everything occurs eventually, because in such a long span of time whatever can happen will happen. As with these daily lines, when you have them in front of you as a whole (maybe??), they will yield something.

1.15 P.M. Sky ¾ overcast with white clouds. As a result, the sea is grey from the clouds above, even if also glitteringly bright. They're even the same colour, only the surface is different, made rough by the glittering, as it were, while you know how the clouds are: diffuse, glazing, soft. And so, once again, the ocean is not facing you as a counterpart but, because of the celestial camouflage, as a gentle sliding into the indefinite. In any case, as something completely different, to which you should assign another name: watery.

3.15 P.M. Blue ocean. And so it is again, as if you were the tip of an antenna measuring the distance to a great counterpart.

The blue lies before you and you're almost touching it like an antenna, while your body, as land, lies behind you. There where the Other begins, the one that had once enclosed you and, according to ancient scripture, had receded from land (the division of water and land). Your entire collection is on the terrace railing. A colourful collection of things tossed up (fallen) that usually move under water like trees in the wind. And the curious seashells, ears with the funnels turned inward (your first meeting in Donaueschingen with the ocean as sound, someone had put a shell up to your ear and said that's the sound of the ocean. The rushing of the ocean has been recorded inside it). The grain of ice in its beak, it will survive the summer.[194] This sentence of Paul Celan's expresses a similar phenomenon: being the keeper of something that cannot be contained.— As if the sound of the ocean were removed and carried like a tiny grain of ice, like a breadcrumb in a beak through the summer.

3.35 P.M. It happened again (a few hours ago, in fact): The ocean has recovered its shade of blue.

It's a mistake to paint all the little swimming pools blue. You can't take anything from it. It's kitsch, cutting something small off of something large. How is it with relics? That's something else: they are fetishes. And always carrying a bag of dirt from the 'homeland', that's something else, too. That's real. Whereas the blue of the swimming pools is a ridiculous allusion, meant as a reminder of the blue of the ocean.

These vivid blue swimming pools, especially seen from the helicopter on the flight to Languiole. A mosaic assembled from shards of the ocean, like the ridiculously touching sound of the

ocean. You think of Gulbranssen: *The Forests Sing Eternally*.[195] It's addressed in a similar-different way: taking the rushing noise made by bringing together the individual rustling of the many leaves on the trees in a forest and projecting it into the time-lessness of the cosmos. What does the swimming pools' blue have to do with the forests' eternal singing? The blue of the swimming pools repels you, while the shallow, kitschy title attracts you, has accompanied you since childhood like the slogans from the little red book that are at once too easily understood and incomprehensible.

Gulbranssen tries to bring human fates into the realm of the unchangeable (eternal). To portray the turbulent lifeline of a cathode and anode. Can you also say that of this horizon, from this straight line at the end of the blue? Is that why you thought of this comical (kitschy) title just now? Another such title: *Gone With the Wind*. Lines are drawn and blown away by the wind: gone with the wind, as fleeting as the wind. Or, perhaps, this one too: *For Whom the Bell Tolls*. That sounds less blue and not as windy, more Greek.

10/XII/99

8.20 A.M. Swam in the ocean. Looked down at the trees and the fish. Large, flat, light green fronds that slowly sway back and forth. Colourful fish, light blue, green, yellow or even camouflaged, matching the pale ground in both structure and colour. If you took a section of the whole and set it on a table, you'd have an aquarium. When you are in the water with it, it's something else. And yet, you can't claim that you're there with it, within it. You're on the border, on the surface of the water, looking down. You taste the water, but you don't breathe it.

11/XII/99 Saturday

1.25 P.M. Clouds, light curtain of rain on the horizon. Yet there's glittering too, where the sun shines down through a hole in the clouds.— In the right corner near the beach, they've dug ditches with a large machine, all the way down to the flooded fields behind the houses. So the water flowed down to the ocean in four different ditches. But the flooding still hasn't receded. It dropped a little overnight but the water still covers the paths, it may be even deeper now. It seems almost as if the surface of the ocean is now at the same level as the lakes to the east, because, this morning, very little water drained towards the ocean. Strange to hear for so many hours machines that are used at the Ribotte. You don't want to hear them at the beach because they're busy building little water features. Compared with the wide ocean, they have an effect similar to that of the little blue swimming pools in the south of France. Because the fresh water in the flooded areas flows, streams and pours itself, as it were, into the ocean, which is as powerful as ever and subsumes the inflowing water the moment it arrives. And when the waves withdraw, the fresh water can keep flowing from the land. Estuaries.

12/XII/99 Sunday

10 A.M. This morning, swam to the small underwater forest. Ten minutes out. Recognized the valleys there, the 'big' trees, that sway gently.

But the water was murky, mixed with sand, so that it all looked foggy. Now the ocean is again dependably blue.

13/XII/99

2.05 P.M. Packed up the coral branches so they could be shipped. Fitted them together, intertwined in the empty spaces between them, so they would protect one another. What was growing on the bottom of the ocean now lies in a box. And where will they end up one day? (the fairy tale of the fir tree by Andersen.) Shellfish have attached themselves to some of the dead branches, nesting in the forks like birds' nests.

2.45 P.M. Divided the day—as has become the routine here—with a midday nap, when all is quiet, the sand, your thoughts, and even a walk (30 m) to the beach umbrella is not ventured. The ocean glitters across a broad expanse and you don't dare turn your eyes towards it.

7.25 P.M. Only three days left. Departure is Thursday at 6 p.m. And yet, three days is a lot, especially when it's the last three days on the ocean. The ocean has rolled sand (many m³) at the mouths of the canals that were dug two days ago. And now no fresh water is mixing with the salt water. Incessantly heaving the sand (→ ball mill in the Clara cottage in the Schwarzwald). There the rocks are ground into pigment by steel balls in a large, rapidly spinning cylinder. Hellish noise and the floor trembles from the imbalance in the cylinder. An alchemical metaphor for the continuous and ceaseless revolving of the material. You should get yourself such a ball mill.

A ship has stopped out on the ocean directly in front of our house. Three lights on the mast. Trinity: sulphur, mercury, salt.

The water turquoise blue, even though no clouds. Without clouds it's 'normally' Prussian blue or indigo. It is glittering heavily. Waves breaking on the coral reefs (*c.*200–300 m out) and waves breaking here on the beach. When they rise and roll out from right to left, they're strewn with sparks. As in a half-tone picture, where three-dimensionality is created through a mass of dots (black or white), the swells are made very bright by the even more numerous glitters in the hollows that are itself in shadow and lent a metallic sheen, so that the most intimate, most secret, most transient part of a wave shines brightest. A kind of negative is created, as when developing photographs, you can reverse the tones → solarization. Only the spray from the crashing of the risen wave remains 'normal'. Normally, the spray is white with a sponge-like structure, but with this extreme glittering, it looks like dirty, melting snow. You've never seen foam on waves look so dirty before.— The ship that had anchored in front of the hotel last night has sailed farther out and is now on the horizon, which never designates a (precise) location. The tall mast irritates the dark, flat ocean like a per-pendicular thorn. But why can't you look beyond it? What is there to say about it? Does it bother you? It (the mast) turns the wonderful line into a thing by giving it a handle. The ocean without verticals, just as the air has no beams. When you come from land, where there were still trees and bushes and then sud-denly see the wide-open ocean, it's a shock.— The mast on the horizon. You don't want anything to trouble it, don't want any 'impurity', however negligible to intrude. (→ production of chips. Elimination of the finest dust particles.)

15/XII/99 Sunday

3.10 A.M. Sitting on the floor in the changing room. From one side, you can hear the wind howling faintly. It gets caught in the window slats and makes a noise that sounds like a storm. From the side facing the sea, you hear the waves, although the sound is a bit altered after crossing the various rooms (veranda, bath, hall). Some, only slightly changed, sound like a footstep, a clap, or like someone turning over in bed. With the distance from the point of origin (beach), the sounds turn into those that we expect to hear in the middle of the night. Facts turn into beliefs, become independent and no longer have anything to do with their origin (in this case, the ocean).—

Does something systematic disappear more easily than something random? This question immediately makes you wonder if it would be possible for all these notebook entries to disappear through the author's †, or if there's the chance that a † is more likely to be deferred when something is still unsorted, i.e. unfinished. The question is absurd, because you yourself don't know what has been ordered and what is still undone. (→ Michelangelo's Pietà) The pointless question is an example of how a wish can seamlessly become an illusion. With the claim that everything that has been started must be finished before it or its creator can die, the wish not to † becomes portrayed as a wish that can be fulfilled. But you never know if something is finished or not. Maybe a so-called unfinished thing is only a part of some finished thing without our being able to recognize it. One sees so little. That's why most people like watching sports—there you always have results.

16/XII/99

8.15 A.M. Rain. Day of departure. Still, today H., C. and Cy will visit. Strange having a visit in the midst of departure. The packages with the flotsam and jetsam are sealed. (\approx 100–130 kg). The maximum weight you can bring with you on the plane. Beautiful packages. Light-coloured tape and the grey fabric reinforced wrapping with the light twine around it. Lying there like sleeping dogs. Four packages. It's raining. The ocean has disappeared in grey (taken the veil).

4.20 P.M. After the nap. Still an hour and a half. Then it will be cold after the time in the plane. It's snowing in Paris. The greenhouses in the Ribotte must be finished by now. What will be put in there?

17/12/99

9.10 P.M. back from the island. the tall canvas is in the studio
(950 x 500 cm). for the salpétrière.[196] rounded at the top, it
should fit in the arches there. there will be five such canvases.
it's a rather simple 'idea', painting pictures in there. something
that's possible.

not reluctant to leave the island. as opposed to earlier, when it
seemed like you were leaving forever. but now: and here's the
canvas, here are the greenhouses, now completely finished.

how it changes. the way you return, different from returns in
earlier years. at some point you'll have to reread it all, what was
written about the ocean. there are entries on different places,
lanzarote, crete, algarve, mauritius, etc.

upstairs there are a lot of newspapers from the past five weeks.
in case you wanted to read them, and you see what gathers
when you stay where you are. all that happened and all that you
don't even want to know, you read it, but after two weeks you
start to think that you don't need to read it any more. it's enough
that it happened. on the island, there were faxed summaries
from the new york times. of course, that's reported from a dif-
ferent sphere than the german newspapers.

23/XII/99

3.30 A.M. Radetzky March.[197] Weary sadness. Greetings from beyond. Below the water is running in the greenhouse. Is it already full? The day after tomorrow is Christmas. When it got dark, the tree was lit.

25/12/99

9.50 A.M. in the house in front of the burning fireplace. outside, fog. the light is on. alone. yesterday was christmas eve. strange, how it passed. as if you had to preserve something enormously valuable, solitude namely, from various threats. memories of NY. there it was easiest, so to speak, because the city, distant as it was (and you always remained the latecomer there), became the best stage on which to rescue solitude. how would it have been in paris? rue faubourg st honoré. paris, however, is spoilt because frequented.

there you walked all night through the silent, empty streets, past the warmly lit windows, through various spheres familiar to you from earlier times, with the wonderful feeling of having been saved from, of having escaped, the small warmth. without these many, many lit windows, without this critical mass of small spheres, groups, each clustered round a warm, familiar hearth and without the memory that you too were once at home in such a bubble, your exposure to the wind between the east river and the hudson river—actually a current of air that circles the entire world, a cold solar wind—your exposedness, your solitude, would not have been have been such a malleable existential one. without the activities you intuited in the houses that night, activities you remembered, recreated in your mind, then the walk along the wall around the frozen lake would not have been as wonderful as it was.

10.30 A.M. the fire in the chimney projects its warmth across the 5.5 m distance between us. it blazes. a directed warmth, whose beams bridge this gap like the other, greater distance between

the sun and the earth. fire that is also still nourished by the sun, as a repository, since the trees from which the wood comes once stood in a forest. and so, just as the wood feeds on a sphere that used to exist, the happily solitary man also feeds off a sphere that once existed. and similarly, even if it's something completely different: your skin, still tanned from the beach, brown, sandalled feet in the studio. but only for a short time yet, because the colour will adapt back to the foggy air. the thin layer of skin will be shed. will disappear. and it will be as it was before. hardly any remains from the oceanside.

26/12/99 sunday

10.25 A.M. boxing day. in the old days it was a space protected by a special sphere. it lasted for several days and then began to crumble. noise, the sound of arguments, mundane sounds intruded more and more. until the 6th, when the three kings arrived, things went back to how they were.

portuguese music coming from the loudspeakers: fado.[198] those sweet, melancholy, laments. in the late eighties, on the algarve, the locals' dancing in the hotel. how it was, how it should be described—gone, but a certain mood, more than that: a continuous philosophical shading with many small roots in the earth. a determined sadness, the way one of the dancers (and she is the only dancer you remember) lifted her knee and wrapped her bent leg around her partner's behind. a strange, isolated move since the dance didn't otherwise have any ostensible eroticism to it. also it wasn't lascivious, but more of a decision to make a sign independent of what was to be signified. as if what was to be signified went astray on its melancholy journey. the bent leg remained, like caspar david friedrich's cross in the mountains.[199] the singer remained in a certain corridor, not raised very far above the ground. the beginning of this pain has been lost and it's therefore no longer curable. when the record has finished playing, the sound continues because there's no reason for it to end or to change into something else. like an endless holding pattern at the height of the corridor.

27/12/99 monday

9.40 P.M. work day today. cleaned the studio. took the plastic off the floor. it was covered with paint drips, plaster spills and other hardened things. rolled it up and put it with the garbage. now the concrete floor is as it was when you moved in. rolling out the plastic sheets when you start fresh. or have just started, because beginnings are harder now, even if you were going to burn everything. if you were going to pour lead into everything and let it sink back into the earth. because the future is contracting? radetzky march. everyone perceives the decline in their own way. that the practiced gestures continue even though they've lost their meaning, even though they extend into a future that no longer exists. can anything be done against the slide into old age? can you come to understand it more clearly? clear everything out? but the external activities, the decisions, the ruptures, the leaps, they're no longer any help. at one point it was still possible, to say, to announce, for example: stop painting. a radical stop. possible only because you really believed at that moment that you were stopping. forever. back then it was still possible to say forever, because there was enough time for this 'forever'. you could say it and allow time for it—what you said—to happen. the time that you had at your disposal for afterwards (after stopping) lent the statement (the intention) its weight. when there is less time left, the luxury of being able to say 'i'm stopping' becomes necessity.

1.15 A.M. storm. the storm can lift the roof off the containers, between which the paintings are kept. it wouldn't be all that upsetting, since what is being painted right now is no longer considered special, considered especially worth protecting. in any

case, you never know what is worth keeping and what isn't. chance preserves some things and not others. besides: what is 'preserving' . . .

in buchen there were times when you considered everything special and if a storm had blown it away, you would have mourned it. and now? it's not as concentrated on a single painting. on a discovery. on a success. on a revelation. now it's more of a river in which things are swimming. has the river become murky? without a radical attitude. without the desperate desire to overcome something. because at the time you always had the desire to rise. and now? the long ladder is still there, but now it lies horizontally. things lie next to one another, no longer one on top of one another. and so it's no longer important if this or that piece is carried away by a storm.

12/28/99 saturday[200]

12.25 P.M. strange, it's as if there were no island. here it's cold in the morning, the sand frozen and then warmth when the chimney is lit. fire. ice. the morning filled with cold air that thins out when it warms. noticed on waking that the waves breaking on the sand were gone. when you wake up next to the ocean, you hear nothing at first, but then, a second after you regain consciousness, your sense of hearing returns and you hear the rush of the waves that had been masked while you slept.

Most of the artworks referred to in this section may be located at the following:

- The Metropolitan Museum of Art, New York (available at: http://goo.gl/oenpQw)

- Tate, London (available at: http://goo.gl/DnMEbD)

- White Cube, London (available at: http://goo.gl/o9PABY)

- Guggenheim Bilbao Museoa (available at: http://goo.gl/aOc60Q)

- Galerie Thaddaeus Ropac, Paris and Salzburg (available at: http://goo.gl/FxYdn7)

- Gagosian Galllery, New York (available at: http://goo.gl/BKYDkg)

For a more comprehensive list of websites featuring Anselm Kiefer's works, see http://www.artcyclopedia.com/artists/kiefer_anselm.html

1 See Anselm Kiefer, *Les Reines de France* (1995, three panels—emulsion, acrylic, sunflower seeds, photographs, woodcut, goldleaf and cardboard on canvas, 560.1 x 737.9 cm overall. Collection of Solomon R. Guggenheim Museum, New York). 'In 1991, the year of Germany's reunification, Kiefer left his homeland to travel the world; he eventually settled in the South of France. This change had a marked effect on the artist's style and themes, which ranged from the sunflowers of Arles to the queens of France. [. . .] In *Les Reines de France*, the women are rendered like Byzantine icons against a background of distressed gold-leaf mosaic. This new iconography, while still engaged with the weight of history, indicates that Kiefer now approached his subject matter with admiration, even joy'—Nancy Spector, Guggenheim Collection Online (http://www.guggenheim.org/new-york/collections/collection-online/artwork/ 4434; last accessed on 13 July 2015).

2 See, among others, Anselm Kiefer, *Wege: Märkischer Sand* (1980, oil, emulsion, shellac, sand photograph on projection paper, on canvas, 280 x 380 cm, http://www.saatchigallery.com/artists/artpages/anselm_-kiefer_20.htm, last accessed on 13 July 2015).

3 Lilith is a figure in Jewish mythology, developed earliest in the Babylonian Talmud and generally thought to be in part derived from an earlier class of female demons in Mesopotamian religion. The Hebrew term *lilith* or *lilit* is translated as 'night creatures', 'night monster', 'night hag' or 'screech owl'. A vampire-like creature rumoured to haunt wildernesses in stormy weather, she is said to be especially dangerous to children. In rabbinical writings, she is supposed to to have been the first wife of Adam. See, among others, Anselm Kiefer, *Lilith* (1987–89, oil paint, ash and copper wire on canvas, support: 381.5 x 561.2 x 50 cm, Tate Collection, London); *Lilith* (1987–90, oil, emulsion, shellac, plumb, poppy, hair and clay on canvas, 380 x 560 cm, Stiftung für Kunst und Kultur e.V., Bonn); *Lilith* (1990, oil, emulsion, shellac, charcoal and ash on canvas, with clay, women's hair, lead bands and poppy seeds, 380 x 560 cm). See Daniel Arasse, *Anselm Kiefer* (Munich: Shirmer / Mosel, 2007), pp. 283–4).

The Codex Juris Canonici is the official code of canon law in force in the Roman Catholic Church, introduced in 1918 and revised in 1983. The Church's stand against contraception is well known.

Tannhäuser (*c*.1200–*c*.1270). Enticed to the court of Venus in Venusberg, a magical land, Tannhäuser—a professional *minnesinger* or lyric poet—lives a life of voluptuous pleasure until, overcome by remorse, he makes a pilgrimage to Rome to seek remission of his sins. But the pope tells him that just as his pilgrim's staff will never put out leaf again, so too his sins can never be forgiven. In despair, Tannhäuser returns to the court of Venus. But, shortly afterward, the discarded staff does begin to put forth green leaves. The pope sends forth messengers to search for Tannhäuser but he is nowhere to be found. The most famous presentation of the Tannhäuser legend is in Richard Wagner's opera, *Tannhäuser und der Sängerkrieg auf der Wartburg* (Tannhäuser and the Singing Contest at Wartburg). See Anselm

Kiefer, *Tannhäuser* (1991, sculpture with lead books and branches, approx. 120 x 120 x 120 cm, Collection Würth).

4 The first few lines of the Polish national anthem, or the 'Dabrowski Mazurka' (Poland Is Not Yet Lost), may be roughly translated as follows: 'Poland has not yet succumbed. / As long as we remain, / What the foe by force has seized, / Sword in hand we'll gain.'

5 Kiefer alternates between Ribotte and Ribaute while referring to his 'studio', his 200-acre estate near Barjac in the Cévennes, at whose heart is a stone manor, once the headquarters of a silk factory, surrounded by a series of barns where the manufacturing processes took place. Kiefer moved there in 1992, and turned it into 'a Brobdingnagian *Gesamtkunstwerk*, surely one of the most extraordinary artworks of the last century [. . .] The grounds are dotted with teetering towers made from the stacked concrete casts of shipping containers [. . .] Kew Gardens-size greenhouses that are used as immense vitrines, containing a 12-foot lead battleship washed up on a choppy sea of broken concrete or a full-scale lead aeroplane sprouting sunflowers [. . .] a cathedral-like barn [. . .] and an underground temple of Karnak [. . .] tunnels and subterranean hospital wards, a lead-lined room full of water and a series of pavilions, each bigger than a squash court [. . . it] is the site for what Kiefer calls "reverse architecture"— putting artefacts back into the landscape.'—Michael Prodger, 'Inside Anselm Kiefer's Astonishing 200-Acre Art Studio', *Guardian*, 14 September 2014 (http://www.theguardian.com/artanddesign/2014/-sep/12/-anselm-kiefer-royal-academy-retrospective-german-painter-s culptor, last accessed on 13 July 2015).

See also Sophie Fiennes, *Over Your Cities Grass Will Grow* (documentary film, 105 min., France, Netherlands, Great Britain, 2010), which recorded both the environment and the artist at work. Around 2008, Kiefer moved to Paris and 'left behind the great work of Barjac—the art and buildings. A caretaker looks after it. Uninhabited, it quietly waits for nature to take over, because, as we know, over our cities grass will grow.'—Brian Appleyard, 'Over Our Cities Grass Will Grow', *Sunday Times* (9 May 2010).

Also available: Danièle Cohn, *Anselm Kiefer Studios* (London: Thames and Hudson, 2013).

6 Located to the west of Dornoch in the Highland county of Suther-land, Scotland, overlooking Dornoch Firth. Although the castle dates back to the twelfth century, the present structure is largely of the nineteenth and early twentieth centuries when it was the home of industrialist Andrew Carnegie. Now operated as the Carnegie Club, a members-only hotel and country club.

7 The ouroboros or uroboros is an ancient symbol depicting a serpent or dragon eating its own tail. See, for example, Anselm Kiefer, *Astral Snake* (1980–85, torn and pasted photographs, shellac and water-colour on photograph, 59.4 x 74 cm, The Metropolitan Museum of Art, New York).

Behemoth is a beast mentioned in Job 40:15–24. Suggested identities range from a mythological creature to an elephant, hippopotamus, rhinoceros or buffalo.

8 The Ophites are a Gnostic sect dating back to the second century CE. The name was derived from the Greek *ophis*, meaning 'serpent', and relates to the reverence demonstrated by the Ophites towards the reptile. According to the theologians Origen, Irenaeus and others, the essence of the Ophitic doctrine was that Jehovah of the Old Tes-tament was merely a demiurge who had created the material world. Special importance was granted to the serpent because he had enabled men to obtain the all-important knowledge of good and evil that Jehovah had withheld from them. Accordingly, the serpent was the true liberator of mankind since he first taught men to rebel against Jehovah and seek knowledge of the true, unknown God.

9 Jakob Boehme (1575–1624), a German Christian mystic and the-ologian. According to his *Aurora* (1612), the seven qualities, planets and humoral-elemental associations are as follows:

(i) Dry–Saturn–melancholy, power of death

(ii) Sweet–Jupiter–sanguine, gentle source of life

(iii) Bitter–Mars–choleric, destructive source of life

(iv) Fire–Sun/Moon–night/day; evil/good; sin/virtue. Later, Moon–phlegmatic, watery

(v) Love–Venus–love of life, spiritual rebirth

(vi) Sound–Mercury–keen spirit, illumination, expression

(vii) Corpus–Earth–totality of forces awaiting rebirth.

'The understanding of the thing here called "quality" is the foundation of that whole revelation of Jacob Behme, and of all Mysteries of which his writings are only a description. For all along, the seven qualities are called sometimes seven sources, seven species, kinds, manners, circumstances, conditions, powers, operations or faculties of a thing. Also the qualifying or fountain spirits, which give model, image or frame the power, virtue, colour, taste, figure, shape, constitution, substance, essence and distinct being of all things, whichever were, are, shall be or can be, in, from and to all eternity, in God and in all creatures, in heaven, in hell or in this world; also the forms or properties of nature, which is the [. . .] power of God.'—Jacob Boehme, *The Aurora. That is, the Day Spring. Or Dawning of the Day in the Orient Or Morning Redness in the Rising of the SUN. That is The Root or Mother of Philosophy, Astrology & Theology from the True Ground. Or a Description of Nature* (John Sparrow trans., C. J. Barker and D. S. Hehner eds) (London: Printed by John Streater, for Giles Calvert, 1656) (http://meuser.awardspace.com/Boehme/Jacob-Boehme-Aurora-electronic-text.pdf; last accessed on 15 July 2015).

10 Kiefer's *Karfunkelfee* (2009, gold paint, cloak, brambles, acrylic, oil, emulsion, ash and shellac on canvas in steel and glass frame, 382 x 576 x 35 cm; White Cube, London) is a series of diptychs and triptychs enclosed in glass vitrines, depicting dark forests filled with thorn bushes. The word has its antecedents in German Romanticism and refers to the fairy in 'Das Spiel ist aus' (The Game Is Over), a poem by the postwar Austrian writer Ingeborg Bachmann: 'On the golden bridge, only he who might know / the fairy's secret word can win. / I'm sorry to say, along with our last snow, / it melted in the garden.' The associations, for Kiefer, are mythical, geological, alchemical and profoundly ambiguous: 'The interesting thing about the Karfunkelfee or "Karfunkelfaerie" [. . .] is her ambiguous appearance. She can be a fairy godmother as well as the evil one.'—White Cube website.

11 In the mid-1990s, Kiefer created several cycles of paintings that rein-
 terpreted derelict structures no longer serving their original function.
 One such cycle focused on representations of Egyptian pyramids with
 evocations of poems by Paul Celan and Ingeborg Bachmann.
 Another was based on photographs Kiefer had taken of brickwork
 structures in India. Works from these cycles were shown at Gagosian
 Gallery in New York in 1998 in an exhibition entitled *Dein und mein
 Alter und das Alter der Welt / Your Age and Mine and the Age of the
 World*. (see website). See also, among others, Anselm Kiefer, *The
 Sand from the Urns* (1997, acrylic, emulsion, shellac, clay and sand
 on canvas, 280 x 560 cm) in Arasse, *Anselm Kiefer*, pp. 294–5.

12 '89' in original.

13 cf. note 5.

14 This is a thought that Kiefer comes back to, time and again, revealing
 his fascination with the ideas of Robert Fludd (1574–1637), a promi-
 nent English Paracelsian physician, astrologer, mathematician, cos-
 mologist, Qabalist and Rosicrucian apologist.

 On Fludd and his influence on Kiefer: '[O]ne of Kiefer's] giant
 books, made from lead and cardboard [. . .] 2 m high and weighing
 around 300 kg [. . .] on which he has etched the outlines of the con-
 stellations, with numbers corresponding to the numerical system
 applied by Nasa to identify the stars [. . .] is called *The Secret Life of
 Plants* [. . . and] is inspired by one of Kiefer's heroes, Robert Fludd,
 an obscure and eccentric seventeenth-century English thinker and
 writer who believed that every plant on earth, and indeed every
 human being, had a corresponding star in the heavens. ' "His writing
 is just extraordinary," enthuses Kiefer. "He combines the macrocosm
 and the microcosm. It is what Einstein wanted to do in a way: com-
 bine the laws of the vast cosmos with the most tiniest things in life:
 a bud, a leaf, a blade of grass. It is Blake's way, too, and the quest of
 the wheelchair man today." The wheelchair man [. . .] turns out to
 be Stephen Hawking, another more recent inspiration. "He is saying
 what Fludd said, that we belong to the cosmos, that we are all con-
 nected to the cosmos." '—Sean O' Hagan, 'When I Was Four I
 Wanted to Be Jesus. It Was Only a Short Step to Becoming an Artist',

Guardian, 27 April 2008 (http://www.theguardian.com/artanddesign/2008/apr/27/art; last accessed on 15 July 2015).

Kiefer began to make books and paintings with underlying themes devoted to Fludd in the early 1990s. See also, among others, Anselm Kiefer, *For Robert Fludd* (1995–96, 16 spreads—acrylic, emulsion and sunflower seeds on woodcut mounted on photocollage, 103.5 x 81 x 10.6 cm, Guggenheim Bilbao Museoa).

15 'Bachmann follows a woman who escapes from a sanatorium and, after years of silence, sends her brother a cryptic telegram. Rightly suspecting that she has fled her sadistic husband—a renowned Austrian psychiatrist whose intimate relations have merged with his studies of concentration camps—her brother finds her in their childhood home. Together they travel to Egypt, where Franza slowly begins to regain her bearings. But Franza's desire to cleanse herself by journeying into the heart of the desert's void ends in tragedy, as she becomes the victim of a horrible act of violence.'—Jacket text, *The Book of Franza and Requiem for Fanny Goldmann* (Peter Filkins trans.) (Evanston, IL: Northwestern University Press, 2010). Written in 1966, it was first published in 1978 in *Ingeborg Bachmann. Werke. Dritter Band: Todesarten: Malina und unvollendete Romane* (Munich: Piper). The desert scene in *The Book of Franza* was an important inspiration for Kiefer's 'Desert Paintings' cycle.

16 Tzimtzum is Hebrew for contraction/construction/condensation. A term used in the Lurianic Kabbalah to explain its theory of creation—that God began the process of creation by 'contracting' his *ein sof* or infinite light in order to allow for a 'conceptual space' in which finite and seemingly independent realms could exist.

See Anselm Kiefer, *Zim Zum* (1990, oil, emulsion, shellac, chalk and ash on canvas on lead, 380 x 560 cm) in Arasse, *Anselm Kiefer*, p. 206.

See also, among others, these two later works: Anselm Kiefer, *Ein Sof* (2008, oil, acrylic, shellac, glass, plaster and clothes on canvas, 190 x 140 cm, private collection); *En Sof* (2006, titled and variously inscribed; paint, chemise, chalk, charcoal and glass in steel frame, 190.3 x 140.5 cm, artist's collection).

17 Robert Musil's concept of 'Seinesgleichen geschieht', literally 'likeness repeats', developed in *The Man Without Qualities* (1930–43), which refers to the alienation of subjective and objective experience. 'Pseudoreality Prevails' is from Burton Pike's masterful 1996 retranslation of Musil's novel.

18 Probably the Ardhamatsyendrasana or the Half Lord of the Fishes pose.

19 A quotation from a sonnet by Francesco de Quevedo in which he writes of a man holding a ring bearing the portrait of his beloved. The image acts as a focus for meditation, and with the poet's contemplation of it comes a consciousness of the universe and his place within it. 'I hold the starry plains of heaven,' he writes. 'I hold all Indias in my hand.'

I Hold All the Indias in My Hand was the title of Kiefer's exhibition (4 December 1996–9 February 1997) at the South London Gallery, UK.

See also Anselm Kiefer, *I Hold All the Indias in My Hand* (1995, pencil, watercolour on photograph, 46 x 69.3 cm); *I Hold All the Indias in My Hand* (1996, woodcut, shellac and acrylic on canvas, 275 x 192 cm), in Arasse, *Anselm Kiefer*, pp. 266–7.

20 At the time of Kiefer's birth, his mother was living in the Black Forest town of Donaueschingen, where the rivers Breg and Brigach converge to form the Danube. After 1951, they moved to Ottersdorf, on the Rhine.

21 Ripuaria Freiburg is the local branch of the German Catholic Student Association and their house is still located at 15 Schlierbergstrasse. In 1966, Kiefer studied law at the University of Freiburg before diverting his studies to painting, first at the Freiburg School of Fine Arts and then at the Fine Arts Academy in Karlsruhe (see https://de.wikipedia.org/wiki/KDStV_Ripuaria_ Freiburg _im_Breisgau; last accessed on 15 July 2015).

22 The opening lines of Goethe's poem, 'Welcome and Farewell'. See Johann Wolfgang von Goethe, *Selected Poems*, VOL 1 (Christopher Middleton trans. and ed.) (Princeton: Princeton University Press), p. 9

23 Adalbert Stifter, *Abdias* (1842). Available in English in *Brigitta and Other Tales* (Helen Watanabe-O'Kelly trans. and introd.) (Harmondsworth: Penguin Classics, 1995). Kiefer retains a slightly confused version of the story in which the girl is born blind, then regains her sight after a lightning flash, then dies a few years later of a second lightning flash.

See also Anselm Kiefer, *For Adalbert Stifter* (2014, acrylic, emulsion, oil, shellac, gold leaf and sediment of electrolysis on photograph mounted on canvas, 280 x 380 x 8 cm, White Cube, London).

24 The story is known as 'The Ring of Amasis'. Herodotus narrates (*Histories*, III, 4; 5th century BC) that Polycrates, tyrant of Samos, was so fortunate in everything that Amasis, king of Egypt, fearing such unprecedented luck boded ill, advised him to part with something he highly prized. Polycrates, accordingly, threw an extremely valuable ring into the sea. A few days afterwards, a fish was presented to him, in which the ring was found. Amasis now renounced friendship with Polycrates as a man doomed by the gods. Not long after, Polycrates was crucified by his host, the satrap Oroetes.

25 The moor's last sigh. Referring to Boabdil, the last sultan of Andalusia who, after many battles and a long siege, surrendered Granada to Ferdinand and Isabella in 1492. The spot from which Boabdil looked upon Granada, upon that which he had lost, before going into exile, is known as Puerto del Suspiro del Moro (Pass of the Moor's Sigh).

26 Adalbert Stifter, *Indian Summer* (Wendell Frye trans.) (New York: Peter Lang, 1985). Originally published in 1857 as *Der Nachsommer*. The book traces the maturing process of a young man from the Viennese merchant middle class whose parents' hard work allow him to live a life of leisure if he chooses. The turning point in the young man's life comes when he meets the mysterious owner of 'the Rose House'—one side of it is covered in roses of all types and colours—an estate in the mountains.

27 Alkahest is a hypothetical universal solvent, having the power to dissolve every other substance, including gold. It was much sought after by alchemists for what they thought would be its invaluable medicinal qualities. A sham Arabic word, attributed to Paracelsus.

Also the title of Kiefer's exhibition between 28 July and 24 September 2011 at Salzburg Halle. See, among others, Anselm Kiefer, *Alkahest* (2011, oil, emulsion, acrylic, shellac, chalk, lead and glass on canvas, 280 x 380 x 19 cm. Galerie Thaddaeus Ropac, Salzburg).

'The term Alkahest signifies that there is a solution which can dilute any substance. This idea comes from the alchemists. Dilution is of course something very important for me. I often lay pictures on the floor and pour water over them, or pour on water that has paint dissolved in it. So I'm exposing them to dilution.'—Anselm Kiefer, 2009. From 'Press Release' for the Alkahest exhibition, Galerie Thaddeus Ropac (see website).

28 Here Kiefer seems to be adapting Heidegger's concepts of 'being' and 'beings' ('Sein' and 'Seiendes') to Bachmann's poetry.

29 Martin Heidegger, *Nietzsche, Volume 1: The Will to Power as Art* (David Farrell Krell trans.) (New York: HarperCollins, 1999), p. 74. [Kiefer often misquotes or misremembers passages. Here, the passage he quotes continues differently from Krell's translation, so the second half is my translation of Kiefer's adaptation of Heidegger.—Trans.]

30 Ibid., p. 144.

31 Ibid., p.145. The first half of the passage Kiefer quotes is different from Krell's translation.

32 'The sunflowers are over for another year: the confident golden heads have drooped, their sunny countenances giving way to a black scowl. It feels like a metaphor for the end of summer. But for the artist Anselm Kiefer, this is when sunflowers get interesting. Like his hero Van Gogh, he revisits the sunflower time and again, not for its buttery radiance, but for its blackened seeds. Sunflowers, in Kiefer's work, are embedded into paintings, apparently dead, but bearing the potential for life.'—Claudia Pritchard, 'Anselm Kiefer, Royal Academy, Preview: Is He Our Greatest Living Artist?', *Independent*, 14 September 2014 (http://www.independent.co.uk/arts-entertainment/-art/reviews/anselm-kiefer-royal-academy-preview-is-he-our-greatest-living-artist-9729789. html; last accessed on 15 July 2015).

See, among others, Anselm Kiefer, *Sunflowers* (1996, woodcut, shellac and acrylic on canvas, 435 x 349 cm. Guggenheim Bilbao Museoa);

and Anselm Kiefer, *The Orders of the Night* (1996, emulsion, acrylic and shellac on canvas, 356 x 463 cm, Seattle Art Museum, Gift of Mr and Mrs Richard C. Hedreen. Available at: https://www.royal academy.org.uk/article/anselm-kiefer-a-beginners-guide; last accessed on 15 July 2015).

33 In fact, it was a Tuesday.

34 It was a Friday.

35 The *Donaueschinger Nibelungenlied*, or *Manuscript C*, is one of the three main thirteenth-century manuscripts of the medieval epic poem *Song of the Nibelungen*, an important source of inspiration for Kiefer who was born in Donaueschingen. The other two manuscripts are in Munich (A) and in St Gallen (B, widely accepted as the most reliable).

36 When the aged Cimon was forced to starve in prison before his execution, his devoted daughter Pero secretly visited her father to nourish him at her own breast. In his *Memorable Acts and Sayings of the Ancient Romans* (*c.*30 CE), the ancient Roman historian Valerius Maximus presents Pero's selfless devotion as the highest example of honouring one's parent. See Peter Paul Rubens, *Cimon and Pero* (*Roman Charity, c.*1630); and Jean-Baptiste Greuze, *Cimon and Pero: 'Roman Charity'* (*c.*1767).

37 It was a Saturday.

38 Hermann Broch, *Der Tod des Vergil* (Zürich: Rhein, 1947). 'It is the reign of the Emperor Augustus, and Publius Vergilius Maro, the poet of the Aeneid and Caesar's enchanter, has been summoned to the palace, where he will shortly die. Out of the last hours of Virgil's life and the final stirrings of his consciousness, the Austrian writer Hermann Broch [has] fashioned [. . .] a book that embraces an entire world and renders it with an immediacy that is at once sensual and profound. Begun while Broch was imprisoned in a German concentration camp, *The Death of Virgil* is part historical novel and part prose poem.'—Jacket text, *The Death of Virgil* (Jean Starr Untermeyer trans.) (New York: Grosset & Dunlap, 1995).

39 It was a Sunday.

40 On Kiefer's use of snow, see, among others, Anselm Kiefer, *Winter Landscape* (1970, watercolour, gouache and graphite on paper, 43.2 x 35.9 cm, The Metropolitan Museum of Art, New York), 'depicting a frozen, barren landscape in which the ploughed earth is blanketed with snow, while spare trees in the background add to the bleakness of the work'; *For Paul Celan, Ash Flower* (2006, oil, emulsion, acrylic and shellac on canvas with burnt books, 330 × 760 cm, http://www.-apollo-magazine.com/12-days-kathleen-soriano/; last accessed on 15 July 2015); and *Black Flakes* (2006, oil, emulsion, acrylic, charcoal, lead books, branches and plaster on canvas, 330 x 570 cm, private collection, Museum Küppersmühle für Moderne Kunst, Duisburg), both featuring barren, snow-covered landscapes and 'both inspired by Celan's poems, where snow and ice often refer to the landscape of the Holocaust, symbolizing the oblivion and silence that descended over Europe at that time. [. . .] In *Ash Flower*, a bleak landscape [. . .] stretches to the horizon where there is a glimmer of light in the dark sky, just visible through bare trees. The words of the poem are written across the canvas upon which stand piles of burnt books made from lead. In *Black Flakes*, we see the same bleak landscape, with snow-covered furrows, from which protrude stalks like cuneiform or Hebrew characters. Words from the poem, written by Kiefer in charcoal, recede into the painting's horizon.'—Victoria Sadler, 'Stunning Anselm Kiefer Exhibition at Royal Academy', *Huff Post Entertainment*, 26 September 2014 (http://www.huffingtonpost.co.uk/victoria-sadler/royal-academy-anselm-kiefer_ b_5886700. html; last accessed on 15 July 2015).

41 It was a Monday.

42 A reference to the sea that was crossed by the Israelites (see Exodus 15:4 and Deuteronomy 11:4). Also known as Yam Suph in several other Old Testament texts (see Joshua 2:10; 4:23; 24:6; Nehemiah 9:9; Psalm 106:7, 9, 22; 136:15). The word *yam* means 'sea' (Francis Brown, S. R. Driver and Charles A. Briggs, *The Brown–Driver–Briggs Hebrew and English Lexicon*, Oxford: Clarendon, 1907, p. 410) and the word *suph* means 'reeds' or 'rushes' (ibid., p. 693), which explains why some versions of the Bible call it 'Sea of Reeds' or 'Reed Sea'

instead of the Red Sea (see Exodus 15:4 in the Revised Standard Version, New American Bible and Jerusalem Bible).

43 Hartmut Böhme's critique of the Anselm Kiefer exhibit at Gagosian Gallery in New York City was published in the *Neue Zürcher Zeitung* on 6 June 1998. The title of the exhibit, *Mein Alter und das Alter der Welt* (Your Age and Mine and the Age of the World), is taken from Ingeborg Bachmann's poem 'Das Spiel ist aus' (The Game Is Up). The passage Kiefer refers to in his notebooks reads: '[T]he fusion [of Kiefer's work] with motifs from Ingeborg Bachmann and Paul Celan is irritating, even obscene. This is not [Celan's] "house of forgetting" or his remembrance of the dead. This is not [Bachmann's] Egypt. Nor is it the world of the poem from which the quote, "your age and mine and the age of the world" is taken. Bachmann's Egypt is the site of a catharsis that ends in death [. . .]. What in Bachmann's work remains, not without reason, fragmentary and piecework is gathered [in Kiefer's painting] into a powerful totality. The tender and severe myth of Isis and Osiris, which Bachmann adapted from Robert Musil in her work with wistfulness and melancholy, that myth of love, sacrifice and death certainly contains a mythical curriculum which the poet attains in moments: yet never are her words—formed and let loose as they are from the vulnerable substance of the human body—suited to the all-surpassing metaphysics of painting that Kiefer celebrates here with inimitable grandiosity The contrast between literature and art will never be more clearly "visible" than it is in these pictures, in which Kiefer, in a gesture of devotion and dedication to the poet, suffocates Ingeborg Bachmann writing in a monumental cult.'—Hartmut Böhme, ' "Mit einem Steingefühl, alterslos" Anselm Kiefers Zyklus für Ingeborg Bachmann' (http://www-alt.culture.hu-berlin. de/hb/static/archiv/ volltexte/pdf/steingefuehl.pdf; last accessed on 17 July 2015).

44 A religious hermit, and considered the founder and father of organized Christian monasticism, Anthony withdrew for absolute solitude to a moun-tain by the Nile. During the course of this retreat, he began his legendary combat against the Devil, withstanding a series of temptations in the form of visions, either seductive or horrible. So

exotic were the visions and so steadfast was Anthony's endurance that the subject of his temptations has often been used in literature and art, notably in the paintings of Hiëronymus Bosch, Matthias Grünewald, Max Ernst, Paul Cezanne and Salvador Dalí as well as in the novel *The Temptation of Saint Anthony* (1874) by Gustave Flaubert. For more details, see http://www.britannica.com/biography/Saint-Anthony-of-Egypt (last accessed on 17 July 2015).

45 Stylites or 'pillar-saints' refers to Christian solitaries who, taking up their abode upon the tops of a pillar (*stylos*), chose to spend their days amid the restraints thus entailed and in the exercise of other forms of asceticism. Stylites believe that the mortification of their bodies will help ensure the salvation of their souls, and were common in the early days of the Byzantine Empire. From Herbert Thurston, 'Stylites (Pillar Saints)' in *The Catholic Encyclopedia*, VOL. 14 (New York: Robert Appleton Company, 1912) (http://www.new advent.org/cathen/14317b.htm; last accessed on 17 July 2015).

46 'Simply open your eyes and ignore what you cannot understand, and you will see that a labourer whose mind and knowledge extend no further than the edges of his furrow is no different essentially from the greatest genius, as would have been proved by dissecting the brains of Descartes and Newton; you will be convinced that the imbecile or the idiot are animals in human form, in the same way as the clever ape is a little man in another form; and that, since everything depends absolutely on differences in organisation, a well-constructed animal who has learnt astronomy can predict an eclipse, as he can predict recovery or death when his genius and good eyesight have benefited from some time at the school of Hippocrates and at patients' bedsides.'—[Julien Offray de] la Mettrie, *Man a Machine* (1748). Available in English as *Machine Man and Other Writings* (Ann Thomson ed.) (Melbourne: Cambridge University Press, 1996), p. 38.

47 See, for example, Anselm Kiefer, *Sun-Ship* (1984–95, sunflowers, lead, ash, asparagus and emulsion on canvas, 330 x 560 cm, Guggenheim Bilbao Museoa). 'The monumental *Sun-Ship* depicts an expansive tilled field, over which is set a large airplane made of lead, shaped

like a paper plane [. . .] The highly scarred and ash-covered surface [. . .] also refers to the devastation incurred by aerial bombing during the Second World War. The sunflowers borne by the plane, however, might suggest the potential for regeneration' (for image, and more details, see website).

48 German: *Der Fangschuss*. A 1976 West German film directed by Volker Schlöndorff, adapted from the novel (1939) by the same name by French author Marguerite Yourcenar.

49 Lingueglietta is a village in Liguaria, Italy, fairly close to the French border.

50 In the Book of Daniel, Chapter 5, a disembodied hand was witnessed at Belshazzar's feast, writing on the palace wall of Babylon, while those at the feast profaned the sacred vessels pillaged from the Jerusalem Temple. The words that appeared on the wall were: 'Mene, Mene, Tekel, Upharsin'. The visionary Daniel, summoned to interpret the message, explained that it meant the imminent end of the Babylonian kingdom. That night, Belshazzar was killed and the Medo-Persians sacked the capital city. See also Remdrandt, *Belshazzar's Feast* (*c*.1635–38, oil on canvas, 167.6 cm x 209.2 cm, National Gallery, London) (image available at Wikimedia Commons; last accessed on 17 July 2015).

51 See *Götterdämmerung* (1874, Twilight of the Gods) in Richard Wagner's *Der Ring des Nibelungen* (The Ring of the Nibelung, or the Ring cycle).

52 Adam Elsheimer (1578–1610) was a German painter, etcher and draughtsman, active mainly in Italy. Although he died young and his output was small, he played a key role in the development of seventeenth-century landscape painting and had a great impact on artists such as Rubens, Rembrandt and Lorrain. His nocturnal scenes are particularly original and he is credited with being the first artist to represent the constellations of the night sky accurately (see *Flight into Egypt*, 1609). For a slideshow of his paintings, see http://www.-bbc.co.uk/arts/ yourpaintings/artists/adam-elsheimer (last accessed on 17 July 2015).

53 'In alchemy, base metals are transformed into gold. The base metal, lead, is used extensively by Kiefer to suggest creativity and spiritual transcendence, much of which has come from the roof of Cologne Cathedral, the tallest Gothic structure in Germany: "I feel close to lead because it is like us. It is in flux. It's changeable and has the potential to achieve a higher state of gold. You can see this when it is heated. It sweats white and gold. But it is only a potential. The secrets are lost, as the secrets of our ability to achieve higher states seem lost or obscured." He continues, "For me, lead is a very important material. It is, of course, a symbolic material, but also the colour is very important. You cannot say that it is light or dark. It is a colour or non-colour that I identify with. I don't believe in absolutes. The truth is always grey." '—Michael Auping (ed.), *Anselm Kiefer: Heaven and Earth* (London: Prestel, 2005), pp. 37–9.

54 Futurist poet Velimir Khlebnikov (1885–1922) and his fellow poet Vladimir Mayakovsky were active in the Russian avant-garde before and after the 1917 revolution. An avant-garde writer, mystical theorist and absurdist, among his many odd ideas was the notion that climactic naval battles occurred every 317 years and had a cosmic significance for the course of human affairs. For more on and by Khlebnikov, see: *Collected Works of Velimir Khlebnikov*, 3 VOLS (Charlotte Douglas ed. and Paul Schmidt trans.) (Cambridge, MA: Harvard University Press, 1987).

Although Kiefer is aware that Khlebnikov's ideas are nonsensical, he has, over the years, dedicated a number of works to him. See, for example, pp. 98–100 in Nan Rosenthal, *Anselm Kiefer: Works on Paper in the Metropolitan Museum of Modern Art* (New York: Metropolitan Museum of Modern Art, 1998), for a discussion on this topic, as well as images of the following: *Big Iron Fist* (*c*.1980–81, gouache and acrylic on photograph, 83.8 x 59.1 cm); and *Little Tank Fist Germany for Khlebnikov* (1980, painted photograph, 82.6 x 58.4 cm).

For images of the large rectangular shed, made of grey corrugated steel and measuring about 140 square metres, as well as some of the 30 paintings (*Part I Anselm Kiefer Für Chlebnikov*, 30 June–30 July 2005) and a half-painting, half-sculpture incorporating a full-scale,

cast-concrete staircase (*Part II Anselm Kiefer Für Chlebnikov*, 3–27 August 2005) exhibited at the White Cube, London, see the White Cube website.

A detailed review of this work (Grace Glueck, 'Paintings by Anselm Kiefer, Inspired by the Poet Velimir Chlebnikov', *New York Times*, 16 June 2006) as viewed at the Aldritch Contemporary Museum in Ridgefield, Connecticut, is available at http://www. nytimes.com/-2006/06/16/arts/design/16kief.html (last accessed on 18 July 2015).

And, more recently, during Kiefer's 2014 retrospective at the Royal Academy, London, the Academy's Annenberg Courtyard was used to display *Velimir Khlebnikov: Fates of Nations: The New Theory of War. Time, Dimension of the World, Battles at Sea Occur Every 317 Years or Multiples Thereof, Namely 317 x 1, 2, 3, 4, 5, 6* (2011–14): 'Measuring almost 17 metres in total and consisting of two large glass vitrines, [. . .] a transparent, reflective sea-scape in three dimensions that calls to mind the Romantic sublime of painters from JMW Turner to Caspar David Friedrich. [. . . T]he frames of the vitrines [. . .] stage a mysterious drama, in which viewers, seeing each other and their own reflections, become participants' (https://www.royal-academy.org.uk/exhi-bition/anselm-kiefer; last accessed on 18 July 2015).

55 See, for example, Anselm Kiefer, *The Source of the Danube* (1978, oil, wood and mixed media on artist's book, closed book, 30 x 21 cm; https://www.phillips.com/detail/ANSELM-KIEFER/UK 010514/150; last accessed on 16 July 2015); and *The Source of the Danube* (1988, oil, sand and burlap on canvas mounted on front and back of book, 30.4 x 20.3 x 5 cm; http://www.christies.com/lotfinder/paintings/-anselm-kiefer-die-donauquelle-5459770-details.aspx; last accessed on 16 July 2015).

56 A reference to Genesis 28:12: '[Jacob . . .] had a dream, and behold, a ladder was set on the earth with its top reaching to heaven; and behold, the angels of God were ascending and descending on it . . .' The ladder may be regarded as the link between heaven and earth; in Christian iconography, it anticipates the role of Jesus as the mediator between the two realms. The ladder, and the 'clothing' mentioned in

the notebook entry, recur in Kiefer's art. See, for example, Anselm Kiefer, *Jacob's Dream* (2004, paint, shellac and charcoal on cut, torn and pasted photographs, 107 x 58 cm); and Anselm Kiefer, *Jacob's Dream* (2010, paint, clay, ash and chalk on board with iron, resin ferns, cotton and linen dresses and ceramic ladder, 280 x 140 cm)— both at Galleria Lorcan O'Neill, Rome (http://www.lorcan-oneill.com; last accessed on 18 July 2015).

57 See Françoise Sagan, *Bonjour Tristesse* (Irene Ash trans.) (New Harmondsworth: Penguin, 2011). See also the 1958 film with the same name, directed by Otto Preminger and starring Deborah Kerr and David Niven.

58 See Paul Valéry, *Collected Works of Paul Valéry, Volume 6: Monsieur Teste* (Jackson Matthews ed. and trans.) (Princeton: Princeton University Press, 1989).

59 Raymond Romain, Comte de Sèze or Desèze (1750–1828) was a French advocate. Together with François Tronchet and Malesherbes, he defended Louis XVI, when the king was brought before the Convention for trial. The case was lost and the king was sent to the guillotine; de Sèze himself was also imprisoned although he managed to elude the scaffold. After his release upon the fall of Robespierre, he disappeared from public life, serving neither the Directory nor the Napoleonic government, both of which he saw as illegitimate. Upon the return of the Bourbons he was made a peer, as well as a judge and a member of the French Academy.

On the sacredness of the king with reference to de Sèze and Louis XVI: 'Although the century of the Age of Enlightenment had already modified the monarchical concept of divine right, as well as the sacred powers with which the body of the king could be invested, the prestige of the sovereign still remains extremely imposing, even in the constitution of 1791, which, from its second paragraph forward, advances the principle of the inviolability of the royal person. [. . .] de Sèze clearly makes allusion to it in the text of his speech for the defense: "In our present ideas of equality, we want to see in a king nothing but an ordinary individual, but a king is not at all an individual; he is a privileged being, a moral being and a sacred body

[. . .]"'.—Antoine de Baecque, *Glory and Terror: Seven Deaths under the French Revolution* (Charlotte Mandell trans.) (New York: Routledge, 2001), p. 90.

See also David P. Jordan, *The King's Trial (Louis XVI vs The French Revolution)* (Oakland: University of California Press, 2004[1979]).

60 From Jean-Paul Marat, 'The Execution of the Tyrant' (Mitchell Abidor trans.), *Journal de la République Francaise* 105 (23 January 1793) (https://www.marxists. org/history/france/revolution/marat/-1793/tyrant.htm; last accessed on 16 July 2015). [Translation modified.—Trans.]

61 From Daniel Arasse, *La guillotine et l'imaginaire de la Terreur* (Paris: Flammarion, 1993). Translated here by Tess Lewis. Available in English as *The Guillotine and the Terror* (Christopher Miller trans.) (New Harmondsworth: Penguin, 1987).

62 Doris Maurer, *Charlotte von Stein, Eine Biographie* (Frankfurt am Main and Leipzig: Insel, 2009[1997]). Charlotte von Stein (1742–1827) was a German writer and the inspiration for Iphigenie in Goethe's *Iphigenie auf Tauris* (1779–87) and Natalie in his *Wilhelm Meister* (1795–96). Eldest daughter of the Weimar master of the court ceremonies, she became lady in waiting to the duchess Anna Amalia (1758), subsequently marrying Friedrich, Freiherr von Stein (1764), equerry to Duke Charles Augustus (Karl August) of Saxe-Weimar. Following Goethe's arrival in Weimar (1775), there arose between them a 'union of souls' which, as his letters to Stein demonstrate, went on to wield considerable influence on his life and work. After his return from Italy, his relations with Christiane Vulpius, whom he later married, caused a break in the friendship. By 1801, however, Stein and Goethe had achieved some reconciliation. Stein wrote several plays, including *Rino* (1776), a small humorous piece on Goethe and ladies of the court, and the prose tragedy *Dido* (1792; published 1867), a work containing many allusions to her break with him.— http://www.britannica.com/biography/Charlotte-von-Stein (last accessed on 16 July 2015.)

63 See Anselm Kiefer, *Women of the Revolution* (1987, lead pages with dried plants, mounted on board with bound canvas, 69.85 cm x

50.17 cm x 3.81 cm, San Francisco Museum of Modern Art, http://www.sfmoma.org/explore/collection/artwork/172#ixzz3go7O JJNV; last accessed on 16 July 2015); *The Women of the Revolution* (1992/2013, lead beds: dimensions variable, photograph on lead, 350 x 442 cm, MASS MoCA, Hall Art Foundation, New York [on view Spring/Summer/Fall till 2028], http://www.hallartfound-ation.org/exhibition/ anselm-kiefer/ artworks/thumbnails; last accessed on 16 July 2015).

64 Refers to an old German Christmas carol that was popular for the better part of the twentieth century. Also refers to a cycle of roughly 30 paintings and one sculpture, begun in the 1970s and completed in 2007–08, that deal with the biblical figure of the Virgin Mary. See Anselm Kiefer, *Maria Walks amid the Thorn* (interview by Klaus Dermutz) (Salzburg and Paris: Galerie Thaddaeus Ropac, 2009). For more details about the first exhibition of this body of work, see the website for 'Press Release', Galerie Thaddaeus Ropac.

65 This letter is written in French in the original.

66 *Anselm Kiefer* by Daniel Arasse (2007) already referred to. Also published by Thames and Hudson in English translation in 2014.

67 Kiefer is quoting from, 'Der Riss in der Zeitmauer' (The Rift in Time's Wall), an article by Thomas Assheuer in *Die Zeit*, 1 October 1998 (http://www.zeit.de/ 1998/41/Der_Riss_in_der_Zeitmauer; last accessed on 16 July 2015). Assheuer reflects on Helmut Kohl's major defeat after his 16-year tenure as the chancellor of Germany as well as his admiration for Ernst Jünger, two men who could only see the present distorted by their particular versions of history. Jünger remained the 'paleontogist of the present' and Kohl the 'historicizer of the political moment'.

68 The most prominent and influential of the historical Christian Gnostic, Valentinus (*c*.100–*c*.160 CE) assumed as the beginning of all things the Primal Being or Bythos who, after ages of silence and contemplation, gave rise to other beings by a process of emanation. The first series of beings, the Aeons, were 30 in number, representing 15 Syzygies or sexually complementary pairs. The totality of all 30 Aeons was termed the Plêrôma (fullness) and considered to be in per-

fect balance. Perhaps Kiefer is referring to these 30 Aeons when he writes of Valentinus' 31 steps.

Kiefer has a work entitled *Valentinus*, which was displayed as part of his exhibition *Next Year in Jerusalem* (6 November–18 December 2010, Gagosian Gallery, New York). According to the Glossary that the gallery circulated at the time (and that is now available on its website) as an iconographical guide to his works, in *Valentinus*: 'lead buckets are juxtaposed with diamonds, a paradox of clarity and sensation as lead is one of the softest and most dense metals which does not allow light to pass through while diamonds are the hardest known materials that occur in nature that are capable of transmitting visible light'.

69 See George Forster, *A Voyage Round the World*, 2 VOLS (Nicholas Thomas and Oliver Berghof eds) (Honolulu: University of Hawaii Press, 2000); and Captain Robert F. Scott, *The Voyage of the Discovery: Scott's First Antarctic Expedition, 1901–1904*, 2 VOLS (New York: Cooper Square Press, 2001). Kiefer may be remembering both accounts.

70 Giovanni Battista Tiepolo, *The Miracle of the Holy House of Loreto* (1743, oil on canvas, 122.9 x 77.8 cm, The J. Paul Getty Museum, New York).

71 'Kiefer is fascinated by the night sky and its different interpretations throughout history, particularly those describing it as a divine, mysterious kingdom recalling our origins and fate. Spirituality, observes the artist, consists of "connecting with an older knowledge and trying to find continuity in the reasons why we search for heaven. The sky is an idea, a part of . . . an older knowledge. Heaven is an idea, a piece of ancient internal Knowledge. It is not a physical construction".'—Auping, *Anselm Kiefer*, p. 166.

See also, among others, his *Falling Stars* (1998, mixed media on canvas, Blanton Museum of Art, Austin); and *The Renowned Orders of the Night* (1997, acrylic and emulsion on canvas, 510 x 500 cm, Guggenheim Bilbao Museoa).

72 See Novalis, *The Novices of Sais: With Illustrations by Paul Klee* (Ralph Mannheim trans.) (New York: Archipelago Books, 2009).

73 In Greek mythology, Antaeus was the son of Poseidon and Earth. A giant, he could not be overpowered as long as he was touching the earth. Hercules finally defeated him by lifting him off the ground and crushing him to death.

74 See Rainer Maria Rilke, *The Lay of the Love and Death of Christoph Cornet Rilke* (Stephen Mitchell trans.) (1985). [Translation modified.—Trans.] Full text available at: http://stephenmitchell-books.com/translations-adaptations/thelay-of-the-love-and-death-of-christoph-cornet-rilke/ (last accessed on 16 July 2015).

75 This word does not exist. Nor does the other Greek word on p. 190.

76 See Anselm Kiefer, *Unborn*—exhibition at Gallerie Thaddeus Ropac, Paris Pantin, from 14 October 2012 to 23 February 2013. 'It's the other aspect of the unborn, the desire of not wanting to be born. Cry of the prophets, the revolt of Job. It would have been better if you had never been born! Everything happens as if it would have been preferable to not be born. The retrograde movement of creation. Theodicy, the accident of creation, God's regret to have fathered this ungrateful being, this outlaw, who does not abide to the contract.' —see the website for 'Press Release', *The Unborn*, Galerie Thaddeus Ropac.

A slideshow of some of the works in the exhibition is available at the website.

See also Anselm Kiefer, *The Unborn* (2001, oil, acrylic and plaster on lead on canvas, 193 x 309.9 cm, Yale University Art Gallery, http://artgallery.yale. edu/collections/objects/100898; last accessed on 16 July 2015).

77 See, among others, *Alarich's Grab* (1969–89, mixed media on treated lead mounted on original photograph in glazed steel frame, 170 x 240 cm, The Ely and Edythe L. Broad Collection, Los Angeles, http://www.broadartfoundation. org/artist_41.html; last accessed on 16 July 2015).

78 Fleur Jaeggy, *Sweet Days of Discipline* (Tim Parks trans.) (New York: New Directions, 1993). [This, and the following quotes are in my translation.—Trans.]

79 In Greek in the original.

80 King James Bible, Psalm 24:7.

81 Perhaps a reference to the sheets of blue plastic which are used to waterproof the roofs of the huts, and which make the entire area, when viewed from the air, seem like a blue cloak spread on the ground.

82 A tabernacle is a box-like vessel, made of metal, stone or wood, for the exclusive reservation of the consecrated Eucharist or 'Host' which has the appearance of Bread but is the true Body of Jesus, in fulfillment of God's promise during the days of the Old Testament to come and make His dwelling among His people.

83 'Cronus was the son of Uranus and Ge (Gaia), and the youngest among the Titans. [. . .] At the instigation of his mother, Cronus unmanned his father for having thrown the Cyclopes, who were likewise Uranus' children by Ge, into Tartarus. Out of the blood thus shed sprang up the Erinnyes.'—William Smith (ed.), *Dictionary of Greek and Roman Biography and Mythology*, VOL. 1 (London: Taylor and Walton, 1844), p. 898. The castration is regarded by many as the moment of separation of Heaven from Earth.

84 Set theory is the branch of mathematics that studies the properties of well-defined collections of objects or 'sets' which may or may not be of a mathematical nature, such as numbers or functions.

85 See Robert Musil, *The Man Without Qualities*, 2 VOLS (Burton Pike ed. and Sophie Wilkins trans.) (New York: Alfred A. Knopf, 1995).

86 The opening words of the Holy Mass. Psalms 43:4.

87 See Stefan Zweig, *Balzac* (William and Dorothy Rose trans). Ebook available at Amazon.com

88 Subatomic particles, one of the basic units of which atoms and all matter are made, include electrons, protons and neutrons, all of which are themselves made up of elementary particles called quarks. The field of subatomic particles has expanded dramatically with the construction of powerful particle accelerators ('atom-smashers') to study high-energy collisions of electrons, protons and other particles with matter. As particles collide at high energy, the collision energy

becomes available for the creation of subatomic particles (for more details, see http://www.britannica.com/science/subatomic-particle; last accessed on 21 July 2015). Kiefer is here perhaps comparing the act of hand-hammering gravel to the action, and results of, collisions in a particle accelerator.

89 Robert Ryman (born 1930). American painter and printmaker who reduced his painting to the strict minimum: the square format and the colour white. He permutated and varied these constants by manipulating scale and texture. Small and large formats were arranged on the same wall and all sorts of media were applied to a variety of supports so that the results were always different. Close to Minimal art, Ryman's work may be distinguished from it by the importance he gave to the painted surface and to the painter's touch, using these as essential elements in his highly refined examination of the optical and material properties of the painting discipline.—From Alfred Pacquement, 'Robert Ryman', Grove Art Online. Please see the Guggenheim website for some of Ryman's paintings; and 'Robert Ryman: Color, Surface, and Seeing', available at http://www.art21.-org/texts/ robert-ryman/interview-robert-ryman-color-surface-and-seeing (last accessed on 21 July 2015), for an interview with the artist, especially on his use of white.

90 On Antaeus, see note 73.

91 In Greek mythology, Medusa and her sisters Stheno and Euryale were known as the Gorgons, female monsters whose heads were crowned with poisonous snakes instead of hair and whose faces were so hideous that those who gazed upon them were turned to stone. See, among others, Caravaggio, *Medusa* (*c*.1595/96, oil on canvas mounted on wood, Uffizi Gallery, Florence).

92 See, for example, 'The Rhine': 'And to rise from the sacrament of sleep / How good that is, waking / From the cool of the woods, at evening then / To approach the milder light / When he who built the mountains / And drew the rivers their paths / Has filled the sails of our busy lives / So poor in breath / And steered us, smiling, with his breezes / When he too rests and towards / His pupil now the maker / Finding more good than bad / Towards this present earth. /

The day inclines.'—Friedrich Hölderlin, *Selected Poems* (David Constantine trans.) (Newcastle upon Tyne: Bloodaxe Books, 1996), p. 52.

93 A town and baroque residence in Rastatt, Baden-Württemberg, Germany.

94 See, among others, Anselm Kiefer, *The Last Cartload* (2014, acrylic, emulsion, oil, shellac, chalk and sediment of electrolysis on photograph mounted on canvas, 280 × 380 cm, Galerie Thaddaeus Ropac).

95 See Rainer Maria Rilke, 'A Walk' in *Uncollected Poems* (Edward Snow trans.) (New York: Farrar, Straus and Giroux, 1996), p. 183. [My translation.—Trans.]

96 None of the public-domain accounts of Leon Trotsky's train have any mention of such an attack or attempted attack. They do mention, however, that the two extra railcars had to be attached to the train at Stalin's insistence in order to accommodate his two automobiles. See Leon Trotsky, 'Chapter 34: The Train' in *My Life* (New York: Scribner's Sons, 1930; https://www.marxists.org/archive/trotsky/1930/mylife/1930-lif.pdf; last accessed on 22 July 2015), for a fascinating account of the role played by the train in the Russian Civil War.

97 An ironic comment on the manner of Trotsky's death in exile, shorn of the security of his armoured train: on 20 August 1940, Ramon Mercader, a Stalinist agent of Spanish origin, infiltrating Trotsky's household, fatally wounded the former Bolshevik leader by striking his head with an ice pick.

98 In the ayurvedic system, the totality of the transformations undergone by the seven organic substances (*dhatu*) is governed by the combined play and balance of wind (Vata), fire (Pitta) and water (Kapha), present and active in the body in the form of three vital principles or *tridoshas*. It is these three that are responsible for all the physiological and psychological processes within the body and mind. Every physical characteristic, mental capacity and emotional tendency of a human being can therefore be explained in terms of the *tridoshas*.— From Guy Mazars, 'Medicine in India: Ayurveda' in Helaine Selin (ed.), *Encylopaedia of the History of Science, Technology and Medicine in Non-Western Cultures* (Springer Science & Business Media, 1997), pp. 1535–41.

99 A reference to, and a quotation from, a ballad in François Villon's (1431–63) *The Testament* in which there is 'an extraordinary display of word-play [. . .] given over to outrageous recipes (from a ragout of soot, pitch, piss and turds to water polluted by rats, frogs, toads and assorted reptiles) for frying the vicious tongues of nasty people'.— Michael Freeman, *François Villon and His Works: The Villain's Tale* (Atlanta, GA: Editions Rodopi, 2000), p. 12. *The Testament* is a collection of more than 20 poems, composed in 1461 and first published in French in 1489. Available in English in *Francois Villon: Complete Poems* (Barbara Nelson Sargent-Baur trans. and ed.) (Toronto: University of Toronto Press, 1994).

100 'Considered the method par excellence for restoring the balance of the three vital principles, and includes five procedures [hence, panchakarma]: the administration of emetics (vamana), purgatives (virecana), enemas (basti), errhines (nasya) and bloodletting (raktamokshasana).'—Mazars, 'Medicine in India', pp. 1539.

101 See Musil, *The Man Without Qualities*.

102 Dispensers of destiny in Norse mythology, who lived at the foot of the ash tree Yggdrasil which they watered daily from the fountain called Urd. Sisters, they eventually became three in number in the manner of the three Fates of classical legend. See also Anselm Kiefer, *Urd, Verdandi, Skuld (The Norns)* (1983, oil paint, shellac, emulsion and fibre on canvas, 420.5 x 280.5 x 6 cm, Tate Collection); and *Yggdrasil* (*c*.1980, gouache and acrylic on photograph, 82.6 x 58.7 cm, The Metropolitan Museum of Art, New York).

103 During the Partition of India in August 1947, that resulted in the sovereign territories of Pakistan and (later) Bangladesh, UNHCR estimates that 14 million Hindus, Sikhs and Muslims were displaced and there were attacks by huge crowds upon villages, trains and refugee camps. For example, '1947; August 13 to 19: Violence peaked during this week. In addition to derailment—the first case being the one of a "Pakistani Special" train carrying Pakistani government employees and their families from Delhi to Karachi, next to Patiala State in East Punjab, killing one woman and one child—attacks on train and stabbing of the passengers began. Lahore train station also became the

scene of bloody carnages. On August 13, 43 non-Muslims were stabbed in the Mughalpura Railway Workshops. On August 14, 35 Sikhs were stabbed in Lahore station.' —From Swarna Aiyar, 'August Anarchy: The Partition Massacres in Punjab, 1947' in D. Low (ed.), *Freedom, Trauma, Continuities: Northern India and Independence* (New Delhi: Sage Publications, 1998); and Anders Bjorn Hansen, 'The Punjab 1937–47—A Case of Genocide?', *International Journal of Punjab Studies* (2002) 9(1).

104 The TGV is France's high-speed rail service.

105 For connections between excrement and gold, and for Paz's discussion of Quevedo's metaphor equating the face and the arse, see Octavio Paz, *Conjunctions and Disjunctions* (Helen Lane trans.) (New York: Arcade Publishing, 2011[1974]).

106 Caspar David Friedrich (1774–1840) was a German Romantic landscape painter, best known for his allegorical landscapes which typically feature contemplative figures silhouetted against night skies, morning mists, barren trees or Gothic ruins. Primarily interested in the contemplation of nature, his often symbolic and anti-classical work seeks to convey a subjective, emotional response to the natural world and to this end set a human presence in a diminished perspective amid expansive landscapes.—From William Vaughan, *Caspar David Friedrich, 1774–1840: Romantic Landscape Painting in Dresden. Catalogue of an Exhibition Held at the Tate Gallery, London, 6 September–16 October 1972* (London: Tate Gallery, 1972). See also, among many others, Jost Hermand, 'Dashed Hopes: On the Painting of the Wars of Liberation' (James D. Steakley trans.) in George Lachmann Mosse, Seymour Drescher, David Warren Sabean, Allan Sharlin (eds), *Political Symbolism in Modern Europe: Essays in Honor of George L. Mosse* (New Brunswick, NJ: Transaction, Inc., 1982), pp. 217–38.

107 A reference to the Trümmerfrauen, 'the rubble women': 'With their men dead or prisoners of war, these women are the ones who set about clearing up the ragged ruins of Germany's cities. They worked in improvised lines, passing along buckets of bricks, knocking them clean of mortar and piling them up for reuse. Historians estimate

that they cleared 500 million cubic metres of rubble from around Germany's cities. In Berlin alone it was about 75 million cubic metres, enough rubble to build a 600 km wall to Cologne 5 metres high and 30 metres thick.' Derek Scally, 'Berlin's Rubble Women Did Much of the Post-War Work', *The Irish Times*, 22 July 2015 (http://www.irishtimes.com/news/world/europe/berlin-s-rubble-women-did-much-of-the-post-war-work-1.2205344; last accessed on 22 July 2015).

See also Leonie Treber, 'Dismantling the German Myth of "Trümmerfrauen"', *Deutsche Wella*, 24 November 2014 (dw.com/p/1DsOz; last accessed on 22 July 2015).

See also Anselm Kiefer, *Man in the Forest* (1971, oil on canvas, 174 x 189 cm, http://www.studiointernational.com/index.php/anselm-kiefer-heaven-and-earth; last accessed on 22 July 2015), featuring Kiefer in a night shirt in the middle of the forest, holding a burning branch.

108 A municipality in the district of Göppingen in Baden-Württemberg in southern Germany. Site of a thermal spa since the Middle Ages. Acquired in the nineteenth century by Pastor Johann Christoph Blumhardt, it was used as a 'healing centre' until 1919. In 1921, it was handed over to the Moravian Church. Following the Second World War, Bad Boll became its western European headquarters and continued as such until the reunification of Germany in 1989.

109 See, for example, Anselm Kiefer, *Ölberg (Engel)* (1978, pencil and gouache on paper, 44 x 31 cm); *Der Ölberg* (1978, graphite on paper, 43 x 31 cm)—drawings from the Sonnabend Collection, Craig. F. Starr Gallery (http://www.starr-art.com/exhibits/anselm-kiefer-drawings/; last accessed on 22 July 2015). Ölberg is also the German name for the Mount of Olives, east of the old town of Jerusalem: 'From the window of my house in the Black Forest where I grew up Catholic, we saw a mountain, which we called the Mount of Olives [. . .] When I came to Jerusalem, it was like a recognition.'—Kolja Reichert, 'Schon im Schwarzwald sah er den Ölberg' (He Saw the Mount of Olives even in the Black Forest), *Die Welt*, 30 October

2011 (http://www.welt.de/print/wams/ kultur/article13687940/ Schon-im-Schwarzwald-sah-er-den-Oelberg. html (last accessed on 22 July 2015). [My translation.—Trans.]

110 On Kiefer's fascination with the Rhine, see, among others, Anselm Kiefer, *The Rhine* (1981, metal lectern, perspex and book of wood-cuts on paper laid on 25 pages of cardboard, 118 x 42 x 9.5 cm, Tate Collection).

See also Anselm Kiefer, *The Rhine* (*Melancholia*, 1982–2013, collage of woodcut on canvas with acrylic and shellac, 374 x 330 cm, private collection, http:// painters-table.com/link/ra-magazine/anselm-kiefers-alchemy; last accessed on 22 July 2015) 'various gigantic canvases [. . .] arranged as interlocking screens, so that the viewer enters a maze-like forest with the waters of the Rhine visible in the distance. In between the tree trunks stand the touchstones of Kiefer's imagination: wartime bunkers, a blaze of fire, the polyhedron from Dürer's famous print *Melancholia*. It is as if one of Kiefer's lead books has come to life and is embracing us within its pages.'—Alastair Sooke, 'Anselm Kiefer at Royal Academy of Arts: "Images of Elegiac Power"', *Telegraph*, 22 September 2014.

'Even water, plain and simple, is ambiguous. When the Rhine, which forms a geographical border between Germany and France, flooded the basement of his childhood home, Kiefer wondered where the boundary lay then—in the midst of the swollen waters or in his cellar?'—John-Paul Stonard's review of Anselm Kiefer's (27 September–14 December) 2014 retrospective at the Royal Academy, London, *London Review of Books* 36(26) (6 November 2014): 32.

111 Specific mention of the flowerpot on the windowsill does not seem to be available but there is enough about her fondness for flowers and gardens. See, for example, Helen Scott's review of Peter Hudis (ed.), *The Letters of Rosa Luxemburg* (London: Verso, 2011) in 'Rosa Luxemburg: In the Storm of Struggle', *International Socialist Review* 81: '[In prison] She occupied herself with writing and reading, and with her correspondence with friends and comrades. But she also drew comfort and pleasure wherever she could find them: in tending a small garden that she was able to grow for a time, or feeding birds

that she trained to come to the window of her cell, or even, at one point, in studying a swarm of wasps' (http://isreview.org/issue/81/rosa-luxemburg-storm-struggle; last accessed on 22 July 2015).

112 'Because of this "real transposition" which can take place through objects that embody inner experience, man can achieve a degree and depth of understanding impossible in relation to any other kind of object. Obviously, such a transposition can only take place because a likeness exists between the facts of our own mental experience and those of another person. This phenomenon brings with it the possibility of finding in another person the profoundest depths of our own experience; from the encounter can come the discovery of a fuller inner world. Dilthey [. . .] sees this transposition as a reconstruction and re-experiencing of another person's inner world of experience. The interest is not in the other person, however, but in the world itself, a world seen as a "social-historical" world; it is the world of inner moral imperatives, a shared community of feelings and reactions, a common experience of beauty. We are able to penetrate this inner human world not through introspection but through interpretation, the understanding of expressions of life; that is, through deciphering the imprint of man on phenomena.'—Richard E. Palmer, *Hermeneutics: Interpretation Theory in Schleiermacher, Dilthey, Heidegger and Gadamer* (Evanston, IL: Northwestern University Press, 1969), p. 104.

Later, Wilhelm Dilthey confessed that the 'result reached in interpretation can never have demonstrative certitude'.—B. H. McLean, 'The Crisis of Historical Meaning' in *Biblical Interpretation and Philosophical Hermeneutics* (New York: Cambridge University Press, 2012), p. 71.

See, for Dilthey's thoughts, *W. Dilthey: Selected Writings* (H. P. Rickman trans. and ed.) (Cambridge: Cambridge University Press, 1976).

113 An enclosure formed by conductive material or a mesh of such material, capable of blocking external static and non-static electric fields by channelling electricity along and around it but not through it. Named after the English scientist Michael Faraday who invented them in 1836.

114 Ingeborg Bachmann, *Malina: A Novel* (Philip Boehm trans.) (Teaneck, NJ: Holmes & Meier Pub, 1990).

115 The Po River Valley is the heart of the Piedmont region in Italy. Occupying more than 70,000 square kilometres, the plains comprise some of the best farmlands in the country and extend from the Western Alps to the Adriatic Sea.

116 A reference to staffage, the term applied to small figures and animals in a painting that are not essential to the subject but are used to animate the composition. Before its adoption into the visual arts in the late eighteenth and early nineteenth centuries, the word in German meant 'accessory' or 'decoration'. In the Baroque period, artists such as Nicolas Poussin and Claude Lorrain made great use of staffage.

117 The north Indian states of Punjab and Haryana are considered the bread baskets of India as they produce large quantities of wheat. West Bengal, where Saktigarh is located, is called the rice bowl of India for it is the largest producer of rice in the country.

118 A small town near Bolpur in the Birbhum District of West Bengal; home to Rabindranath Tagore's Visva-Bharati University.

119 King James Bible, Matthew 17:4. 'Then answered Peter, and said unto Jesus, Lord, it is good for us to be here: if thou wilt, let us make here three tabernacles; one for thee, and one for Moses, and one for Elias.'

120 A town and a municipality in Bankura District in West Bengal, India, famous for its terracotta temples built by the Malla kings during the seventeenth and eighteenth centuries.

121 In classical architecture, a caryatid is a standing female figure, clad in long robes, serving as a column. According to a story related by the 1st-century-BCE Roman architectural writer Vitruvius, caryatids represented the women of Caryae, who were doomed to hard labour because the town had sided with the Persians in 480 BCE during their second invasion of Greece. Other opinions suggest that the device may derive from the postures assumed in the local folk dances at the annual festival of Artemis Caryatis. The most famous caryatids are found in the south porch of the Erechtheion on the acropolis of Athens.

122 Available in English as Claude Lévi-Strauss, *Tristes Tropiques* (John Weightman and Doris Weightman trans.) (New York: Penguin, 1992).

123 Ernst Marischka's Sissi films of the 1950s—*Sissi* (1955), *Sissi: Die junge Kaiserin* / *Sissi: the Young Empress* (1956) and *Schicksalsjahre einer Kaiserin* / *The Fateful Years of an Empress* (1957)—'offer melodramatic renderings of the courtship and marriage between the Princess Elisabeth of Bavaria (1837–98) and Franz Joseph (1830–1916), the Habsburg Emperor. [. . . G]enerally viewed as being symptomatic of the kind of regressive politics one associates with the *Heimat* (homeland) films of the 1950s, films that represent a pastoral Germanic homeland as an antidote to burdensome national histories. Shot in glossy Agfacolor, the *Sissi* films are usually read as representing a hybrid genre of *Heimatfilm*, historical drama, melodrama and even fairytale: the innocent princess marries the Emperor, and their union signifies a liaison between Germany and Austria that reimagines the unsuccessful "marriage" between the two countries following Hitler's annexation of Austria.'—Heidi Schlipphacke, 'Melancholy Empress: Queering Empire in Ernst Marischka's *Sissi* Films', *Screen* 51(3) (Autumn 2010): 232–55; here, p. 232.

124 Known as the Dashavatar or 'ten descendants' or incarnations of Vishnu, each of whom has been responsible for preserving the cosmos in a time of crisis. The generally accepted list is as follows: Matsya or Fish, Kurma or Tortoise, Varaha or Boar, Narasimha or Man-Lion, Vamana or Dwarf, Parashuram, Rama, Krishna, Buddha and Kalki.

125 Any of the 114 chapters of the Koran. Arthur Jeffrey believes that it has a common origin with a Syriac word that means 'writing' (see his *The Foreign Vocabulary of the Qur'ān*, LaVergne: Woods Press, 2007, p. 181).

126 Also known as the Palace of Mysore, or Mysore Palace, situated in Karnataka, India. The official seat and residence of the Wodeyars, the royal family of Mysore who ruled the princely state from 1350 to 1950. Kiefer may be confusing it with Amber or Amer Palace in Jaipur, built by Raja Man Singh I in 1592, and in the third courtyard of which is located the Jai Mandir or Sheesh Mahal ('mirror palace'),

decorated from floor to ceiling with patterned mosaics made out of coloured glass and mirrors.

127 See, among others, Anselm Kiefer, *Ride to the Vistula* (1980, watercolour, gouache and acrylic on paper, 49.5 x 63.8 cm, Metropolitan Museum of Modern Art, New York).

In one of the Vistula paintings (Kiefer made quite a few between 1976 and 1981), 'an inscription along the bottom reads: Weichsel, Weichsel, weisse Weichsel' (Vistula, Vistula, white Vistula). The words are from a song popular during the Third Reich, which Kiefer found in a secondhand bookshop. The song trolls on: "Vistula, what are you whispering? You come from the quiet mountains of Silesia and bring the tears of beautiful young women with you." Kiefer describes it as "sentimental kitsch. But you know it means the Vistula *has* to be German."'—Rosenthal, *Anselm Kiefer: Works on Paper in the Metropolitan Museum of Art*, p. 67.

The song may have been unfortunately inspired by the Red Army's mass rapes in Germany: 'Domination and humiliation permeated most soldiers' treatment of women in East Prussia. The victims not only bore the brunt of revenge for Wehrmacht crimes, they also represented an atavistic target as old as war itself. [. . .] Estimates of rape victims from [Berlin's] two main hospitals ranged from 95,000 to 130,000. One doctor deduced that out of approximately 100,000 women raped in the city, some 10,000 died as a result, mostly from suicide. The death rate was thought to have been much higher among the 1.4 million estimated victims in East Prussia, Pomerania and Silesia. Altogether at least two million German women are thought to have been raped, and a substantial minority, if not a majority, appear to have suffered multiple rape.'—Antony Beevor, 'They Raped Every German Female from Eight to 80', *Guardian*, 1 May 2002 (http://www.theguardian.com/books/ 2002/may/01/news.features11; last accessed on 23 July 2015).

128 Bhubaneshwar is the capital city of Odisha. With its many Hindu temples, which span the entire spectrum of Kalinga architecture, it is often referred to one of India's temple cities. Together with Puri and Konark, it forms the Swarna Tribhuja or Golden Triangle, one

of eastern India's most visited destinations. Puri is a seaside town in Odisha, famous for its Jagannath temple, one of the essential, and original, Hindu pilgrimage sites. Konark is a small town in Puri District and is home to the thirteenth-century Sun Temple, designed as a chariot for the sun god Surya.

129 The Nuanai River Confluence, where the Nuanai flows into the Bay of Bengal.

130 A street in Paris, France, named after Marechal Ferdinand Foch, the French hero of the First World War. The widest avenue in Paris, it is located in the 16th arrondissement and runs from the Arc de Triomphe southwest to the Porte Dauphine at the edge of the Bois de Boulogne city park.

131 The film (*Und ewig singen die Wälder*) by Paul May in 1959, adapted from a novel by Trygve Gulbranssen.

132 One of the primary ways of upholding the divisions of the caste system in India has been to share, or not share, water. So, for example, high-caste brahmans will neither give nor accept water—the basis of life—to anyone from a lower caste for fear of being polluted.

133 Waldemar Bonsels, *An Indian Journey* (Harry Brown illus.) (New York: Kessinger Publishing, 2010[1928]).

134 The first car to be made in India, the Hindustan Ambassador was manufactured by Hindustan Motors from 1958 to 2014.

135 The exhibit titled *Anselm Kiefer: Works on Paper, 1969–1993* at The Metropolitan Museum of Modern Art, New York, 15 December 1998–21 March 1999.

136 'Another of [Kiefer's] recurring interests has been the unfair treatment many mythologies have handed out to women, particularly strong women whose intellectual questioning has been seen as unruly and cause for demonisation: for example, Pandora and Lilith. In *Women of Antiquity* [2002], Kiefer uses attributes to identify individual characters from history: a lead book identifies Myrtis, a Greek poet blamed for competing with Pindar; a glass "melancholia cube" represents Hypatia, an Alexandrine philosopher who was brutally murdered in sectarian unrest in 415 CE; and a rusting mass of razor

wire signifies Candidia, a Roman witch who wove vipers through her dishevelled hair.'—Anthony Bond, *Contemporary Collection Handbook* (Sydney: Art Gallery of New South Wales, 2006). For images of the series, and more details, please visit, http://www.artgallery.nsw.gov.au/collection/ works/324.2005.a-c/ (last accessed on 23 July 2015).

See also Anselm Kiefer, *The Woman of Antiquity* (1999–2000, oil, shellac, emulsion, sand, ash and pastel on photographic paper laid down on paper, 280.5 x 190.5cm, http://www.christies.com/lotfinder/sculptures-statues-figures/anselm-kiefer-die-frauen-der-antike-5533763-details.aspx; last accessed on 23 July 2015).

On this subject: 'On the one hand, *Women of Antiquity* deals with the "death" of the body in the sense understood by Barthes [who, in *Erte*, or *A la Lettre* says that the garment "without head or limbs" is "death", not the neutral absence of the body but the body "mutilated, decapitated"], on the other, it suggests, paradoxically, the body's renewal; a type of metaphoric double-dealing that uses and subverts the the signifier. Thus, in the case of [Candidia], the wild foliage of barbed wire takes us back to Medusa, the young girl who had the cheek to believe that her hair was as beautiful as Minerva's, but was then punished for her presumption by having it turned into spitting snakes. Killed by Perseus, Kiefer's "Medusa" moves (figuratively) forward to the death camps, to what has been the artist's ongoing preoccupation with Germany's (until recently) unarticulated memory of past atrocities. In this process, *Women of Antiquity* conflates past and present, nameless and the names, those killed literally and figuratively by history.'—Alan Krell, *The Devil's Rope: A Cultural History of Barbed Wire* (London: Reaktion Books, 2002), pp. 145–6.

137 Recalling Horace's use of these words (*non humilis mulier triumpho*) to describe Cleopatra whose death did not seem to him to diminish her pride and courage in life. See Horace, Odes 1.37, *Nunc est bibendum* . . . (Now there must be drinking!).

138 See Longus, *Daphne and Chloe* (Paul Turner trans.) (New Harmondsworth: Penguin, 1989).

139 'Hetairai ("companions") is an Attic euphemism for those women, slave, freed, or foreign, who were paid for sexual favours. [. . .] There was a class and semantic distinction, but not a legal one, between the hetaira and the *porne* ("buyable woman"). [. . .] Membership of the category hetaira implied beauty, education, and the ability to inspire ruinous infatuation both in foolish young men and those presumably older and wiser.'—Simon Hornblower and Antony Spawforth (eds), *The Oxford Classical Dictionary*, 3rd EDN (New York: Oxford University Press, 1999), p. 702.

140 See Heliodorus, *An Ethiopian Romance* (Moses Hadas trans.) (Philadelphia: University of Pennsylvania Press, 1999).

141 See Johann Wolfgang von Goethe, *Elective Affinities* (David Constantine trans.) (New York: Oxford University Press, 1999).

142 Available in the public domain as Johann Wolfgang von Goethe, *Erotica Romana*.

143 Félicien Rops (1833–98). Belgian graphic artist and painter, active mainly in Paris. Primarily a printmaker, his work is highly distinctive 'because of his vividly licentious imagination, which took delight in the morbid, perverse, and erotic'. From Ian Chilvers, Harold Osborne and Dennis Farr (eds), *The Oxford Dictionary of Art* (New York: Oxford University Press, 1988), p. 432. For his depiction of the cross, see his *The Temptation of St Anthony* (1878).

144 See, among others, Anselm Kiefer, *La Belle de la Seine* (2014, acrylic, emulsion, oil, shellac sediment of electrolysis on canvas, 280 x 280 cm, Galleria Lia Rumma, Milan and Naples, http://www.liarumma. it/artists/anselm-kiefer/; last accessed on 24 July 2015).

145 The Egyptian servant of Sarah, Abraham's first wife (Genesis 16 and 21). When Sarah continues to be barren, she encourages Abraham to sleep with Hagar. Mother of Ishmael.

146 SMAK (Stedelijk Museum voor Actuele Kunst), Ghent, Belgium. See Anselm Kiefer, *Die Argonauten* (Elena Ochoa Foster ed.) (Madrid: Ivory Press, 2011). See also, among others, Anselm Kiefer, *The Argonauts* (1990/2010, 27 works of pencil on photographs); *The Argonauts* (1990, acrylic, ashes, lead, wire holder, glass, chalk, plastic

figures, loam, oil, porcelain, snakeskin, straw, textiles and teeth on canvas, 280 x 500 cm, Städel Museum, Frankfurt, http://www.staedelmuseum.de/en/collection/argonauts-1990; last accessed on 24 July 2015); *The Argonauts* (2014, a series of lead sculptures).

147 See, for example, Anselm Kiefer, *Bohemia Lies by the Sea* (1996, oil, emulsion, shellac, charcoal and powdered paint on burlap, 2 panels: 191 x 280.7 cm each, The Metropolitan Museum of Art, New York).

Part of the text accompanying the image on the Metropolitan Museum of Art's website reads: 'Along the center ridge and on either side of the rutted country road bloom an abundance of pink-orange poppies, a flower associated since antiquity with dreams, sleep, and death. The poppy is also the emblem of military veterans, whose presence is evoked here by occasional drips of paint the color of dried blood. [. . .] Kiefer took the words from the title of a well-known poem by the Austrian writer Ingeborg Bachmann that concerns longing for utopia while recognizing that it can never be found, just as the former kingdom of Bohemia, landlocked in central Europe, can never lie by the sea.'

148 See, for example, Anselm Kiefer, *Let a Thousand Flowers Bloom* (2000, gouache, sand, ash and charcoal on two torn and pasted photographs, 127.6 x 76.8 cm, The Metropolitan Museum of Art, New York); and *Let a Thousand Flowers Bloom* (2000, oil paint, shellac resin, wood, metal string and screws on canvas, 380.3 x 280.5 x 5.4 cm, Tate Collection).

It is also the title of exhibitions held at Anthony d'Offay Gallery, London (2000) and White Cube Gallery, Hong Kong (2012), among others: 'The exhibition's title [. . .] is knowingly ironic [and] refers both to the epic, blooming landscapes of these pictures but also to a common misquotation in the West of a well-known phrase pronounced by Chairman Mao in 1957 ["Letting a hundred flowers bloom and a hundred schools of thought contend is the policy of promoting the progress of the arts and sciences."] which, while ostensibly encouraging cultural plurality, led to the deaths of millions and the final curtailment of any and all forms of dissent. The paintings [. . .] relate to a series that Kiefer began in 2000, using landscapes

from the photographs that he had taken on his travels through China in 1993. These works, however, are more generic since the landscapes are based on a trip the artist made to the Auvergne region of France during springtime.' For more about the series, and for some images of the works, please visit the White Cube website.

For a review of the 2000 exhibition in London, please see Jonathan Jones, 'Mao and the Magic Realist', *Guardian*, 9 November 2000 (http://www.theguardian.com/culture/2000/nov/09/artsfeatures; last accessed on 24 July 2015).

Also available is Alex Danchev, *Anselm Kiefer: Let a Thousand Flowers Bloom* (Honey Luard ed.) (London: White Cube, 2013).

149 The line may be roughly translated as 'It is sweet and fitting to die for one's country'. See Horace, *Odes* III.2.13. Among the numerous references to this phrase, see also Wilfred Owen's poem 'Dulce Et Decorum Est', written during the First World War, where the sentiment has been described as 'the old lie'.

150 Jewish German poet and playwright, who escaped Nazi Germany and fled to Sweden, from where she wrote her poems as a 'mute outcry' against the Holocaust. She was awarded the Nobel Prize in Literature in 1966. Nelly Sachs and Paul Celan developed a close friendship after the War. Kindred spirits, both poets felt the German language was their only homeland. Their correspondence was profoundly important to both of them. See, among others, Nelly Sachs, *Collected Poems 1944–49* (Michael Hamburger, Ruth and Matthew Mead and Michael Roloff trans; Hans Magnus Enzensberger introd.) (Loas Angeles: Green Integer, 2011); and Barbara Wiedemann (ed.), *Paul Celan, Nelly Sachs: Correspondence* (Christopher Clark trans.) (New York: Sheep Meadow, 1998).

151 Georg Trakl, Austrian Expressionist poet who served with the Austrian army during the first three months of the First World War before committing suicide on 3/4 November 1914. For his works in English, see, among others, Georg Trakl, *Collected Poems* (James Reidel trans.) (London: Seagull Books, 2019).

152 King James Bible, Genesis 3:15: 'And I will put enmity between thee and the woman, and between thy seed and her seed; [she] shall bruise thy head, and thou shalt bruise his heel.'

153 It was a Friday.

154 It was a Tuesday.

155 See Pieter Breugel the Elder, *The Harvesters* (*c*.1525–69, oil on wood, 119 × 162 cm, Metropolitan Museum of Modern Art, New York).

156 See Nils Johan Ringdal, *Love For Sale: A World History of Prostitution* (New York: Grove Press, 2005); Katahrine Park, *Secrets of Women: Gender, Generation, and the Origins of Human Dissection* (New York: Zone Books, 2010).

157 See Antonin Artaud, *Heliogabalus; or, the Crowned Anarchist* (Alexis Lykiard trans.) (Chicago: Solar Books, 2006[1934]).

158 Created by Albert Speer, a German architect and for a while Minister of Armaments and War Production in the Third Reich. Commissioned by Hitler to design and organize the Zeppelinfeld stadium, he created the 'cathedral of light' for the 1937 Nuremberg Rallies: 'The hundred and thirty sharply defined beams [of the anti-aircraft searchlights], placed around the field at intervals of forty feet, were visible to a height of twenty- to twenty-five-thousand feet, after which they merged into a general glow. The feeling was of a vast room, with the beams serving as mighty pillars of infinitely high outer walls. [. . .] I imagine that this "cathedral of light" was the first luminescent architecture of this type, and for me it remains not only my most beautiful architecture but, after its fashion, the only one which has survived the passage of time.'—Albert Speer, 'Architectural Megalomania' in *Inside the Third Reich: Memoirs* (Richard and Clara Winston trans) (New York: Simon and Schuster, 2003[1970]), pp. 50–70; here, pp. 58–9.

159 Edmond Jabès, *L'Ecorce du monde* (The Earth's Crust) (Paris: Seghers, 1955).

160 See Edmond Jabès, 'And You Shall Be in the Book' in *The Book of Questions*. Reproduced in *From the Book to the Book: An Edmond Jabès*

Reader (Rosmarie Waldrop trans., Richard Stamelman introd.) (Hanover, NH: Wesleyan University Press, 1991), p. 38.

161 Hermann Löns (1866–1914) was a German journalist and writer. He is most famous as 'The Poet of the Heath', for his novels and poems celebrate the people and landscape of the North German moors, particularly the Lüneburg Heath in Lower Saxony. His most successful novels were *The Warwolf* (1910), about farmers in Lower Saxony retaliating against rapacious soldiers in the Thirty Years War, and *Dahinten in der Haide* (Out on the Heath, 1910).

162 *Quotations from Chairman Mao Tse-Tung* (Peking: Foreign Language Press, 1966). All subsequent quotations are also from this volume.

163 King James Bible, Matthew 2:13. 'And when they were departed, behold, the angel of the Lord appeareth to Joseph in a dream, saying, Arise, and take the young child and his mother, and flee into Egypt, and be thou there until I bring thee word: for Herod will seek the young child to destroy him.'

164 The İzmit earthquake occurred on 17 August 1999 at 3.01 a.m. (local time) in northwestern Turkey. With a magnitude of 6.7 on the Richter Scale, it lasted for 37 seconds, killed around 17,000 people and rendered homeless approximately half a million more (http://news.bbc.co.uk/onthisday/hi/dates/stories/august/17/newsid_2534000/2534245.stm; last accessed on 24 July 2015).

165 See *Toujours Paris* (1958, remastered DVD released in 2001).

166 It was a Wednesday.

167 Rainer Maria Rilke, *Sonnets to Orpheus: Second Series*, 29.12–14 in *Duino Elegies and The Sonnets to Orpheus* (A. Poulin, Jr, trans) (New York: Mariner Books, 2005), p. 195.

168 From the Wayne Tunnicliff (ed.), *Art Gallery of New South Wales Contemporary Collection Handbook* (Sidney: Art Gallery of New South Wales, 2006): 'While living in Germany, Kiefer seldom left his home village even to attend his own openings. Since moving to France, however, he has taken to spending up to three months of each year exploring remote locations around the world, including a period spent in Australia in 1992. These travels are times of research

into ancient traditions and opportunities for gathering materials such as antique storage jars, dried flowers and grasses which he ships back to the studio.'

169 See, among others, Anselm Kiefer, *Icarus—Sand of the Brandenburg March* (1981, oil, emulsion, shellac, sand and photograph on canvas, 290 x 360 cm, Saatchi Gallery, London).

170 See, for example, Anselm Kiefer, *Athanor* (1983–84, oil, acrylic, emulsion, shellac and straw on photograph mounted on canvas, 380 x 225 cm, The Toledo Museum of Art, http://classes.toledomuseum.org:8080/emuseum/view/ objects/asitem/People$0040256/2/invno-asc?t:state:flow=e694a18c-e61c-44be-a447-84ad91000a89; last accessed on 24 July 2015). 'An athanor is a legendary self-feeding furnace said to have been used by medieval alchemists to transform base metals into gold. Although the goal of the alchemist was physical, the alchemical process sometimes referred to the soul's quest for union with God. Conversely, because the process mysteriously hastened physical change, alchemy was sometimes condemned as unnatural and contrary to God's will, and therefore evil. Here [in the painting] the partly obliterated word over the doors at the end of the courtyard alludes to the doors of the ovens where millions were incinerated at Hitler's order. The black grid lines on the paving suggest the railroads that transported victims to their deaths. [. . .] The singed canvas symbolizes redemptive suffering and purification through fire. Kiefer believes that artists, like alchemists, have the power to transmute events; that art, like alchemy, can transform dross into gold, evil into good. This painting epitomizes his intense faith that in acknowledging the tragedies of history, learning from them, and transforming images associated with them into symbols of hope, humanity can achieve a better future.' For image, and more details, see https://www. google.com/culturalinstitute/asset-viewer/athanor/BQHRxvA0 G1xge A?hl=en (last accessed on 15 August 2015).

171 Honoré de Balzac, *The Unknown Masterpiece* (Richard Howard trans., Arthur C. Danto introd.) (New York: New York Review of Books, 2000), 'the story of a painter [Frenhofer] who [. . .] is either an abject failure or a transcendental genius—or both.' See also Dore

Ashton, *A Fable of Modern Art* (Berkeley: University of California Press, 1991): 'Balzac's fable is discussed not only within the context from which it emerged—early nineteenth-century romanticism—but also in its embodiment of various attitudes towards art. Ashton illuminates a web of associations linking Balzac to Cézanne, Rilke, Schoenberg, Kandinsky and Picasso as they struggle with the yearning to express the inexpressible, to make concrete the abstract.'

172 'At a conference on Heidegger held in July in Bavaria [. . .] Peter Sloterdijk, professor of philosophy and aesthetics at Karlsruhe University, presented a paper praising the possible merits of gene technology [. . .] as a highly effective technique [. . .] to create an improved human race, to optimise human potential. [. . .] Sloterdijk's argument has met with widespread criticism and outrage in German intellectual circles, and involved him in a bitter feud with Jürgen Habermas.' See the 'News' section in *Philosophy Now* 25 (Winter 1999–2000) (https://philosophynow.org/issues/25; last accessed on 24 July 2015).

173 See, among others, Anselm Kiefer, *The Milky Way* (1985–87, emulsion paint, oil, acrylic and shellac on canvas with applied wires and lead, 381 x 563.9 cm, Albright Knowx Art Gallery, Buffalo, New York, http://www.albrightknox.org/ collection/collection-highlights/piece:die-milchstrasse/; last accessed on 24 July 2015). See also Anselm Kiefer, *Light Compulsion* (1999, 280 x 760 cm, private collection, http://previousexhibitions.fondationbeyeler.ch/e/html_11 sonderaus/11anselmkiefer/03_gruppe4.htm; last accessed on 24 July 2015), the largest in his series of works done around the theme of the cosmos, representing the Milky Way and fictional stars intermingled with with NASA's alphanumeric code for marking real stars.

174 See Anselm Kiefer, *Naglfar* (1998, pile of lead books, lead boat and fingernails, 133 x 140 cm) in Arasse, *Anselm Kiefer*, p. 251.

175 See Anselm Kiefer, *Man under a Pyramid* (1996, emulsion, acrylic paint, shellac and ash on 2 canvases, 354.5 x 503.5 x 9.5 mm, Tate Collection).

176 See Anselm Kiefer, *Light Trap* (1999, shellac, emulsion, glass and steel trap on linen, 378.5 x 558.8 cm, Gagosian Gallery, https://www.

gagosian.com/exhibitions/group-show--june-07-2014/exhibition-images; last accessed 27 July 2015).

177 *Quotations from Chairman Mao Tse-Tung*, p. 128.

178 On La Ribaute, see note 5. See also Matthew Biro's essay on the subject in *Anselm Kiefer: Phaidon Focus* (London: Phaidon, 2013).

179 Perhaps Kiefer is thinking of Giovanni Segantini's *Ave Maria bei der Überfahrt* (Ave Maria on the Lake, 1886; image available at: https://en.wikipedia.org/ wiki/Giovanni_Segantini; last accessed 27 July 2015). The painting's reproductions are one of the highest-selling postcards in Switzerland.

180 Goethe, 'Welcome and Farewell' in *Selected Poems*, p. 9.

181 The horse recalls the first line and stanza of Goethe's poem which in the Middleton translation reads: 'My heart beat fast, a horse! away! / Quicker than thought I am astride, / Earth now lulled by end of day, / Night hovering on the mountainside.'

182 See, among others, Anselm Kiefer, *Painting of the Scorched Earth* (1974, oil on burlap, 95 x 125 cm) in Arasse, *Anselm Kiefer*, p. 103.

183 See Anselm Kiefer, *The Burning of the Rural District of Buchen* (1974, 210-page linen-bound book with original photographs, ferrous oxide and linseed oil on oatmeal wallpaper) in Arasse, *Anselm Kiefer*, p. 52.

184 From the Eucharistic Prayer IV, Mass of the 1970 Missal. Full version and translation available at The Catholic Liturgical Library: http://www.catholic-liturgy.com/index.cfm/fuseaction/text/index/4/subindex/67/contentindex/25/ start/9 (last accessed on 25 July 2015).

185 See Julius Caesar, *Gallic Wars*, Book V, Chapter 48: *Venit magnis itineribus in Nerviorum fines*—'He goes into the territories of the Nervii by long marches.' Sometimes also 'forced marches'.

186 A reference to Quintus Fabius Maximus Verrucosus (or Fabius Maximus, also known as Cunctator or 'Delayer'), roman military commander and statesman, whose cautious delaying tactics during the early stages of the Second Punic War (218–201 BCE) allowed Rome some time to recover its strength. According to the Roman poet Ennius: 'Unus homo nobis cunctando restituit rem', or 'One

man, by delaying, restored the state to us.'—From Ryan R. Abrecht, 'Fabius Maximus' in *The Oxford Encyclopedia of Ancient Greece and Rome*, VOL. 1 (New York: Oxford University Press, 2010), p. 151.

187 See his much later work, *Palm Sunday* (2006, palm tree and 43 works on fibreboard with clay, paint, shellac, adhesive, metal, palm fronds, fabric and paper, overall display dimensions variable, Tate Collection).

On this piece: 'The dialog between the intertwined fate of nature and humanity continues in the stirring *Palm Sunday* installation [. . .] an entire uprooted palm tree and thirty-six "vitrine" paintings containing vertically mounted branches of vegetation (palms, sunflower pods, mangroves) suspended in plaster and earth [. . .]. In both pagan and Christian iconography, the palm with its sword-like branches, was known as an immortal tree [. . . and] was adapted by early Christianity as a sign of Christ's victory over death [. . .]. Thus Kiefer intends us to register Palm Sunday as a true triumph; understanding that Christ's entry into Jerusalem inaugurated the events leading not only to the Passion but also to the Resurrection.' See the Gagosian Gallery website.

See also Simon Schama, 'Trouble in Paradise', *Guardian*, 20 January 2007, a review of one of Kiefer's exhibitions (*Anselm Kiefer: Aperiatur Terra*, White Cube, London, 26 January–17 March 2007) featuring *Palm Sunday* (http://www.theguardian.com/artanddesign/2007/jan/20/art; last accessed on 25 July 2015).

188 See Franz Grillparzer, *Medea: Tragedy in Five Acts* (Arthur Burkhardt trans.) (Yarmouth Port, MA: Register Press, 1941).

189 According to the Valentinian gnostics, the physical world was brought into being/animated by Sophia introducing into dull matter a 'divine spark'.

190 Perhaps Bob Dylan, 'When the Ship Comes In' on *The Times They Are A-Changin'* (1963, Warner Bros. Inc.). Lyrics and track available at: http://www. bobdylan.com/us/songs/when-ship-comes (last accessed on 25 July 2015).

191 A popular German Christmas carol.

192 'Pherekydes in his second book tells how Akrisios married Eurydike, daughter of Lakedaimon. They had a child, Danaë. But when her father consulted the oracle about a male offspring, the god at Pytho replied that a son would be born not to him but to his daughter, and that he himself would be slain by that son. Thereupon Akrisios returned to Argos and made an underground chamber of bronze [some versions of the myth say he put her in a tower] in the courtyard of his house. Here he brought Danaë with a nurse, and kept watch over her lest she should give birth to a son. But Zeus was enamoured of the maiden and poured from the roof in the likeness of gold.'— Arthur Bernard Cook, 'The Myth of Danaë and Analogous Myths' in *Zeus: A Study in Ancient Religion, Volume 3, Zeus: God of the Dark Sky* (New York: Cambridge University Press, 2010[1940]), p. 455.

See Anselm Kiefer, *Danae* (2008, lead, gold granules and aluminum sunflowers, 135.3 x 160 x 379.7 cm, Gagosian Gallery).

This, along with *Hortus Conclusus* and *Athanor*, was part of Kiefer's installation at the Louvre Museum, Paris, in 2007.

193 Hero, a priestess of Aphrodite at Sestos, was seen and loved by Leander, a youth of Abydos. She returned his love, and received him in her tower on the Hellespont, which he swam nightly, being guided by her lamp. Venturing the passage on a stormy night, when the storm had blown out the light, he was drowned. When his body washed ashore at the tower, Hero at once cast herself into the waters so that she might be united with her lover in death. See also Anselm Kiefer, *The Sea and the Waves of Love—Hero/Leander* (2008, gouache and chalk on paper, 62.5 x 87.5 cm, https://paddle8.com/work/anselm-kiefer/26145-the-sea-and-the-waves-of-love-heroleander-des-meeres-und-der-liebe-wellen-heroleander; last accessed on 25 July 2015).

Also the title of his 2011 exhibition at the White Cube, London, named after a play by the nineteenth-century Austrian writer Franz Grillparzer, *Des Meeres und der Liebe Wellen (The Waves of Sea and Love)*. 'The show comprises large photographs of seascapes, some of which have been subject to various processes, including electrolysis, to ensure that their surface, when exposed to the air, changes

appearance over time. Variously superimposed upon the images are obstetric implements, Euclidian drawings, a lead model of a U-boat and the presence of Kiefer himself. "It is a show about impossibilities," [Kiefer] explains. "Putting a Euclidian diagram on a seascape is about the impossibility of capturing the sea. The sea is always fluid. The geometrical figure gives the impression of fixing it at a certain moment. It's the same as us imposing constellations on the sky which, of course, are completely crazy and nothing to do with the stars. It is just for us to feel more comfortable. To construct an illusion for ourselves that we have brought order to chaos. We haven't. I might have been born into a very literal sense of chaos, but in fact that state is true of all of us." '—Nicholas Wroe, 'A Life in Art: Anselm Kiefer', *Guardian*, 21 March 2011 (http://www.theguardian.com/artanddesign/2011/mar/21/anselm-kiefer-painting-life-art; last accessed on 25 July 2015).

194 From Paul Celan, 'I Am Alone' in *Mohn und Gedächtnis* (Poppy and Memory, 1952). A translation of the poem is available at: http://paintersonpaintings.com/ 2014/05/01/virginia-wagner-on-anselm-kiefer/; last accessed on 25 July 2015.

195 Available in English as Trygve Gulbranssen, *Beyond Sing the Woods* (New York: G. P. Putnam's Sons, 1933).

196 The Hôpital de la Salpêtrière, a hospital in Paris with a large chapel where some of Kiefer's works were exhibited in 2001. See Anselm Kiefer and Catherine Strasser Kiefer, *Anselm kiefer a la salpetriere : shebirat kelim* (Paris: Editions du Regard, 2000).

197 Radetzky March, Op. 228, is a march composed by Johann Strauss Sr in 1848. It was dedicated to Field Marshal Joseph Radetzky von Radetz. Also a novel by Joseph Roth, (*Radetzkymarch*, 1932), chronicling the decline and fall of the Austro-Hungarian Empire via the story of the Trotta family. Available in English as *The Radetzky March* (Joachim Neugroschel trans. Nadine Gordimer introd.) (New York: The Overlook Press, 1995).

198 A type of popular Portuguese song and dance, with guitar accompaniment, which seems to have made its first appearance around the 1850s. Essentially cafe or tavern entertainment.

199 Caspar David Friedrich, *Cross in the Mountains* (*c.*1807, oil on canvas, 115 x 110 cm, Galerie Neue Meister, Dresden; today known as *The Tetschen Altar*).

200 It was a Tuesday.